The Aesthetics of Disturbance

Anti–Art in Avant–Garde Drama

David Graver

Ann Arbor

THE UNIVERSITY OF MICHIGAN PRESS

Copyright © by the University of Michigan 1995
All rights reserved
Published in the United States of America by
The University of Michigan Press
Manufactured in the United States of America
⊗ Printed on acid-free paper

1998 1997 1996 1995 4 3 2 1

A CIP catalogue record for this book is available from the British Library.

Library of Congress Cataloging-in-Publication Data

Graver, David, 1955–
 The aesthetics of disturbance : anti-art in avant-garde drama /
David Graver.
 p. cm. — (Theater—text/theory/performance)
 Includes index.
 ISBN 0-472-10507-8 (alk. paper)
 1. Avant-garde (Aesthetics)—History—20th century. 2. Modernism
(Art) 3. Ut pictura poesis. 4. Arts, Modern—20th century.
I. Title. II. Series.
NX456.5.M64G73 1995
700'.1—dc20 95-16289
 CIP

For My Mother and Father

Contents

Illustrations

Acknowledgments

Early work on this project was supported by two fellowships from Cornell University. Later stages of the research and writing were made possible by a Mellon Postdoctoral Fellowship in the Drama Department of Stanford University and two summer grants from the Columbia Council for Research in the Humanities. A shorter version of chapter 4 appeared in *Theater Journal* in March 1986, and a shorter version of chapter 7 appeared in *PMLA* in May 1992. I am grateful to the editors of these publications for their observations and advice. I would also like to thank the following people for comments, suggestions, and encouragement: Peter U. Hohendahl, David Grossvogel, Robert Gross, Timothy Murray, Peter J. Collier, Marjorie Perloff, Tom Reinert, Loren Kruger, Austin Quigley, David Kastan, Andreas Huyssen, Tony Kubiak, and Phil Auslander.

Chapter 1

Defining the Avant-Garde

Does *avant-garde* convey approbation or opprobrium? Contemporary usage is ambivalent. To be avant-garde can mean to be ahead of one's time, to break with conventions and forge new styles in the arts, to scorn the approval of one's contemporaries for the lonely pleasures of radical innovation.[1] The rapid advances of the avant-garde, however, suggest to some critics an inability to concentrate on matters at hand. In this light to be avant-garde is to be enslaved to a shallow notion of innovation for innovation's sake, to favor the outrageous over the well wrought, to cloak mediocrity in the robes of the rebel.[2] Thus, while some critics praise the avant-garde as the wellspring of all modern art, others castigate it as modernism's shifty and seedy companion.

In the vacillation between prestige and denigration the avant-garde visual arts of the early twentieth century have fared the best. Works of futurist, expressionist, or dada provenance, for instance, now command prominent display in New York's Museum of Modern Art (MOMA) and, more important perhaps, exhorbitant sums at art auctions around the world. The money to be made in inflating the worth of avant-garde art objects encourages, perhaps, their rapid accretions of prestige, because other forms of avant-garde art, which do not promise profitable remuneration consequent on the attention they receive, have not met with as much success. Whereas the early-twentieth-century avant-garde visual arts enjoy the attention of a sizable general public today, the literary avant-garde of the same period has a smaller, more specialized audience. The least attention in terms of scholarly treatments written and books in print and translation falls, arguably, to avant-garde drama. Again, monetary motivations may lie at the heart of this state of affairs. While connoisseurs can get rich trading in

avant-garde art objects, mounting avant-garde plays is liable only to lose money.

Without a significant cash nexus to smooth acceptance, the avant-garde's factional contentiousness and willful opacities are difficult to ignore. The goal of this book is to understand the opacities and contentions of the avant-garde both through a detailed study of the dramatic texts produced by Oskar Kokoschka, Gottfried Benn, Raymond Roussel, Roger Vitrac, and Wyndham Lewis and through a broader survey of the aesthetic contexts (on the margins of expressionism, dada, and surrealism) in which they worked. As I argue in chapter 2, the dramatic text is a particularly complex and turbulent site for avant-garde attacks upon accepted conventions of aesthetic representation and construction. These five playwrights, in particular, position themselves at some of the most sophisticated and dissident extremes to which the dramatic text can be carried without completely forsaking the autonomy of the work for the event-oriented immediacy of performative shock and revolt. Indeed, these playwrights often manage simultaneously to maintain and exacerbate the ontological ambiguities of the literary text by combining them with more theatrical modes of performative existence. The aesthetic stances developed by these playwrights are too volatile to be contained even within the aggressively innovative or dissident conventions of expressionism, dada, and surrealism. They mark a notable limit in the development of the early-twentieth-century avant-garde.

While this study aims to show the particular sophistication of the dramatic texts written by Kokoschka, Benn, Roussel, Vitrac, and Lewis, it also traces affinities among the avant-garde arts in general, showing, for instance, how aesthetic principles such as collage and montage are worked into the special representational and expressive media of drama and how concepts of theatricality and performance appear throughout avant-garde art. A full appreciation of the complexity of avant-garde drama demands careful examination of particular works, but we should not rush into an encounter with these works. Too often avant-garde works are read simply as negations, distortions, or banalizations of modernist aesthetic principles, when, in fact, avant-garde works arise from an elaborate contention of traditions concerning the form and function of art. Thus, before approaching the specifics of early-twentieth-century avant-garde drama, we need to pin down the parameters of the avant-garde in general and distinguish as clearly as possible between the avant-garde and modernism. To understand the avant-garde of the early twenti-

eth century we must understand how the concept of the avant-garde has developed and held itself distinct from other manifestations of modern culture.

The Metamorphoses of the Avant-Garde

The first use of the "avant-garde" metaphor to define a specific aesthetic stance occurred in 1825 in Olinde Rodrigues's dialogue "L'Artiste, le savant et l'industriel," which is sometimes attributed to Saint-Simon.[3] In *Five Faces of Modernity* Matei Calinescu describes a much earlier application of the avant-garde metaphor to poetry in the work of Etienne Pasquier (1529–1615) but rightly points out that here the term simply means "forerunner" or "first innovator," is not central to the characterization of the artists in question, and does not imply a conscious aesthetic position on the part of the artists (97–100). Rodrigues is the first to exploit all the implications of the martial origin of the term. Avant-garde artists act as an advance guard for the "army" of adherents to a particular revolutionary political program. They scout the enemy territory (the current sociopolitical milieu) with their vivid analyses of contemporary life and prepare it for invasion by disseminating rousing slogans and sparking hopes for a better future. They are an elite corps manning an exposed position in the fight for a better world. Although they are confirmed enemies of the current sociopolitical power structure, they define themselves in terms of their allegiance to a political cause and a vision of the future rather than solely in terms of their discontent with the status quo.

Throughout the first half of the nineteenth century all art labeled "avant-garde" conforms to the basic concept outlined by Rodrigues: it serves some sort of future-oriented (leftist) political group, usually as a didactic tool or incendiary agent for raising consciousness, rousing enthusiasm, and gaining converts. In addition to Saint-Simon's circle, the artist followers of Fourier and the Young Germans of the Vormärz are avant-garde in the sense in which the word was first used.[4] In proposing a martial metaphor for the conduct of artistic activities, these early avant-garde artists introduce two important issues with which all subsequent avant-gardes have had to deal in one way or another: a critique of aesthetic autonomy and a marginal, adversarial relationship to the established (predominantly bourgeois) culture. In these early avant-garde movements the critique of autonomy and the animosity to established culture are simple

and straightforward. Rodrigues clearly advocates making art part of life in that it should have an immediate educational and political relevance that aesthetic theory since Kant tends to deny it. Rather than an autonomous art designed for aesthetic contemplation, an oasis in and respite from the world of politics and business, the original avant-gardes proposed a politically partisan art that imparted information about the world and led to action in it. These avant-gardes did not object to the institutional configurations of the dominant culture but did object to the interests of those who generally controlled this culture.

Later in the nineteenth century naturalism developed a politically engaged, didactic artistic practice similar to but beginning to move away from the original avant-gardes. Although the naturalists usually tied their work to a leftist political program and insisted on the importance of the pedagogical function of art, they did not consider their work progressive simply because it served the proper cause. With naturalism matters of aesthetic form were introduced into the concept of the avant-garde. The earlier groups of avant-garde artists did not link their political allegiances to a particular aesthetic stance. They thought art in any form could, given the proper themes and intentions, serve the proper ends. Naturalism politicized aesthetics by suggesting that only certain ways of representing the world adequately serve progressive political ideals. Thus, while many of the practical political values and goals of the earlier movements still provided the impetus for the naturalists' work, naturalism laid the foundation for a more purely aesthetic concept of the avant-garde. This is, I think, the reason it is sometimes credited with being the first avant-garde.[5]

Near the end of the nineteenth century, in the wake of naturalism and, in part, as a reaction against it, the concept of an aesthetic avant-garde independent of political movements was born with the advent of symbolism and other forms of aestheticism. Jost Hermand claims that this marked the end of true avant-garde movements (3–5). Other critics suggest this is where avant-garde art really began.[6] Hermand bases his argument on the political engagement, antibourgeois sentiments, and ideological discipline essential to the early avant-garde movements. These qualities all disappeared when the term was taken over by the artistic trends of aestheticism. Focusing his attention on Jugendstil and art nouveau, Hermand argues that the aestheticist avant-garde was a comfortable part of bourgeois culture rather than a force working to overthrow it. These movements domesticated the notion of artistic innovation and experimentation, which had had politically dissident overtones in natural-

ism, and thereby placed the concept of an avant-garde within the capital-
ist ideology of modernization. At this point artistic innovation no longer
implied a break with the values and power structure of the dominant
culture. Instead, innovations began to be seen as part of the normal
behavior of the dominant culture, just as it was part of the standard
functioning of industrial production.

Michel Zéraffa takes the avant-garde movements of the early twenti-
eth century as the measure of the concept and, focusing on mimetic
strategies, finds the beginnings of this avant-garde in aestheticism. Im-
pressionism and symbolism set the stage for the more radical experi-
ments of futurism and dada by rejecting the notion of representational
verisimilitude in favor of an art that draws attention to its own artificial-
ity in its attempts to reproduce the idiosyncrasies of subjective experi-
ence. The aestheticist movements begin the exploration of uncharted
realms of consciousness and expression that is typical of the early-
twentieth-century avant-garde. Julia Kristeva raises the innovations in
form and content introduced by Mallarmé and Lautréamont to the status
of a revolution in the literary constitution of meaning and subjectivity.
Rather than linking these innovations with dada and futurism, Kristeva's
notion of the avant-garde seems to embrace primarily the more formally
experimental authors of high modernism such as Joyce and Rimbaud.

Whether one sees the aestheticist avant-garde as an end or a begin-
ning, one point is clear: with the rise of late-nineteenth-century aestheti-
cism the strict military metaphor no longer applies to the groups labeled
"avant-garde." Members of the aesthetic avant-gardes were elitist and
innovative but were usually apolitical in the themes they chose for their
art and the causes to which they allied it. They considered the artist an
isolated individual rather than a member of a collective and associated
with one another by virtue of certain shared aesthetic values rather than
because of a mutual commitment to a broad cultural movement. Thus,
the avant-garde was no longer a disciplined unit commanded by a fixed
set of ideals and modus operandi but, rather, a gentlemen's club, a loose
association of like-minded but more or less independent artists.[7]

In addition to forsaking the collectivist spirit of earlier avant-gardes,
the aestheticist art movements rejected the future-oriented teleology
of these politically oriented artists. The aestheticists were not attempting
to transform the world. They were not preparing the ground for a fu-
ture invasion. They did not expect their elitist values to become the
popular values of the future. Some forms of aestheticism were comfortably

integrated into bourgeois society, but even those aspects of the move-
ment discontent with the dominant cultural norms were not interested in
actively pushing these norms aside in favor of something better. Mal-
larmé's remark (1891) that the modern poet is "on strike against society"
illustrates this point well.[8] The aestheticist poet may withdraw his or her
support from society but does not then extend that support to anyone
working against the current social order. The artist offers at most an
implicit, passive approval of social revolution by refusing to endorse or
be of use to the power structures and ideology of the status quo. The
artist is on strike, rather than on the barricades.

As already mentioned, not all aestheticist movements or artists
shared even the animosity toward bourgeois culture typical of symbol-
ism. As a result, the term *avant-garde* begins to become hopelessly mud-
dled and to slide toward vacuous synonymity with *the new*. A major
cause of the growing conceptual vagueness of the term *avant-garde* is
that the aestheticist art movements appropriate and vitiate the term in
two distinct and contradictory ways. Symbolism, for instance, drops
the critique of aesthetic autonomy while maintaining an adversarial rela-
tionship with the dominant culture. Indeed, symbolism's adversarial
relationship to bourgeois culture is due in large part to the ways in
which it heightens the autonomy of the artwork. Art nouveau and
Jugendstil, on the other hand, break down aesthetic autonomy by mak-
ing art a decorative element of everyday life but eliminate the adversar-
ial relationship to bourgeois culture that defines other avant-gardes.
Whereas earlier avant-gardes attempt to make art part of the political
and intellectual life of European culture, art nouveau wants only to
make art part of the domestic life of (primarily) the bourgeoisie. While
the ideological status of art may be lowered somewhat in advocating a
decorative role for it in daily life, daily life is also ideologically enhanced
by its incorporation of aesthetic elements.

With the appearance of expressionism and futurism around 1910
avant-garde art reestablishes its conceptual clarity. Throughout the early
twentieth century, up until approximately 1930, avant-garde movements
again incorporate pronounced sociopolitical programs that draw connec-
tions between art and life and challenge the hegemony of the dominant
culture. Unlike the earlier politically engaged avant-gardes, however, the
movements of the early twentieth century do not consider themselves
subservient to and do not work closely with political parties. Some of
the elitism and aloofness cultivated by the aestheticist avant-gardes is

maintained by the programmatic avant-gardes that follow them, in that the latter think art can be revolutionary without attaching itself to a specific political platform or working explicitly for practical social reforms. The naturalists were already completely independent of political groups in the choice and development of their aesthetic theories, but they hoped their art would lead to the social reforms proposed by political groups whose values they shared. In contrast, the early-twentieth-century avant-garde movements champion social reforms that are an integral part of their aesthetic theories and only coincidentally similar to the causes espoused by political organizations. The aesthetic theories of these groups serve also as sociopolitical manifestoes. Their ideas are meant to offer alternatives to the values and power structures of bourgeois society as much as to stimulate and justify formal and thematic innovations in the arts.

While the teleology of these groups is similar to that of the nineteenth-century avant-gardes, their sense of the ways in which society should change are much more abstract and extreme, and their work often focuses more on criticizing the status quo than on delineating a future utopia. Because of this, these avant-gardes are less involved with preparing the ground for an army of the future than with exploiting whatever means lie at hand to attack the practices of the present regime. Although the martial qualities of the avant-garde metaphor reemerge with the early-twentieth-century art movements, the tactics of these movements are closer to those of a self-contained marauding horde than to those of an advance guard.

The Contours of Anti-Art

Within these early-twentieth-century avant-garde movements, and particularly with the advent of dada and surrealism, an array of concepts and attitudes that can be loosely grouped under the moniker of "anti-art" add an important new twist to the concept of the avant-garde. The dadaists provide some of the clearest descriptions of the anti-art project:

> With Dadaism a new reality comes into its own. Life appears as a simultaneous muddle of noises, colors and spiritual rhythms, which is taken unmodified into Dadaist art, with all the sensational screams and fevers of its reckless everyday psyche and with all its brutal reality. . . .

Dada is a CLUB, founded in Berlin, which you can join without commitments. In this club every man is chairman and every man can have his say in artistic matters. . . . Under certain circumstances to be a Dadaist may mean to be more a businessman, more a political partisan than an artist—to be an artist only by accident—to be a Dadaist means to let oneself be thrown by things, to oppose all sedimentation. . . . To be against this manifesto is to be a Dadaist![9]

Matei Calinescu suggests that this anti-art element marks the essentializing extreme of the avant-garde concept. Avant-garde art rejects

such traditional ideas as those of order, intelligibility, and even success (Artaud's "No more masterpieces!" could be generalized): art is supposed to be become an experience—deliberately conducted—of failure and crisis. (124)

In pursuing a course of failure and crisis, the avant-garde develops "the most extreme form of artistic negativism—art itself being the first victim" (140). Thus, the avant-garde becomes "a deliberate and self-conscious *parody of modernity*" (141).

Peter Bürger argues for a rhetorically pointed purpose to the avant-garde's anti-artistic gestures. For him the early-twentieth-century avant-garde marks the summit of this concept's force, distinctiveness, and historical significance not so much because of its extreme negativism as because of the self-conscious critique of what he calls the "institution of art" that is implied in the avant-garde's negativism.[10] Bürger credits dada, surrealism, and the Russian avant-garde with this anti-aesthetic critique of the bourgeois institution of art, but he gives particular importance to the mocking gestures made by Marcel Duchamp with his readymades:

All claims to individual creativity are to be mocked. Duchamp's provocation not only unmasks the art market where the signature means more than the quality of the work; it radically questions the very principle of art in bourgeois society according to which the individual is considered the creator of the work of art. Duchamp's Ready-Mades are not works of art but manifestations. (52)

Bürger's theory of the early-twentieth-century avant-garde is important for the historical and conceptual status it attributes to the avant-garde

but has been criticized for elevating the importance of the avant-garde by suppressing its complexity. Dolf Oehler, for example, disputes Bürger's claim that readymades are univocal cries of protest against the institution of bourgeois art:[11]

> Hypostatization of the institution of art reduces every object to one endlessly uniform gesture of protest . . . Do *Bicycle-wheel* (1913) . . . the urinal *Fountain* (1917), . . . the bird cage with marble sugar cubes *Why Sneeze Rose Sélavy?* (1921) etc. have only the one essential trait that they negate the category of individual production? Further still: is this trait their most important one? How is it that Duchamp negates this category by means of a urinal of all things? Does he not perhaps therewith negate other categories, other institutions than that of art? (*Antworten,* 147)[12]

He goes on to suggest that, taken as a whole, the readymades may be intended to negate the concept of cultural value rather than the concept of autonomous art, to place individual choice above the selections of civilization. The readymade entitled *Fountain*, for instance, is shocking not so much because it ridicules the notion of art as because it confronts the spectator with intimations of disorder, sexuality, and bodily waste. Duchamp's own account of his attempt to exhibit this piece suggests that he wanted to bring the freedom of personal choice and an unembarrassed acceptance of the body and its functions *into* the realm of art, that is, into the institution of art, rather than use these values to attack art (see *Antworten,* 149). His preference for the appellation *anartiste* over *anti-artiste* points to his tendency to ignore the boundaries between art and life rather than to use the latter to attack the former (154). Oehler suggests that the avant-garde in general is more interested in coming to terms with and transforming the banalities of the modern age than in attacking an institution that, in their eyes, could produce only *l'art pour l'art* or kitsch (155).

Indeed, the term *anti-art* can be very misleading partly because of its own internal complexities and contradictions and partly because of the way in which it arises from an avant-garde "tradition" characterized by contradictory trends and developments. I will be devoting attention to how five exemplary playwrights juggle and deploy the notion of anti-art, but for the moment I would like to make a few general remarks about the relationship between anti-art and (1) art, (2) manifestoes, (3) avant-garde movements, and (4) modernism.

Given anti-art's declaration that autonomous "high art" is part of the oppressive enemy culture, one might expect it to embrace some alternative form of social order and, thus, forge a partisan concept of the avant-garde similar to the early-nineteenth-century movements, but anti-art's preoccupation with certain kinds of "artistic" experience and activity (based, at its most extreme, on a rejection of artworks in order to make art part of life) make it difficult for anti-art artists and movements to ally themselves with practical political organizations. Despite the surrealists' enthusiasm for the Communist Party, they, as well as the dadaists, remain isolated because of their fervent insistence on the autonomy and purity of their own anti-aesthetic practices. They at times successfully remove the frame that separates the work of art from the daily life around it but do so only in order to place an aesthetic frame around the "daily life" defined and exalted by participation in their movement. Anti-art is, thus, not a rejection of art but, rather, an attempt to expand the domain of art in novel ways. "Making art part of life" is the most pervasive description of this project of expansion, but it is also, I think, a rather limiting and problematic description.

Part of the problem in taking the notion of "making art part of life" seriously is the anti-art avant-garde's relationship to manifestoes. Rather than turning artworks into manifestoes, as Bürger suggests, I think the anti-art avant-garde is much more likely to turn manifestoes into artworks. Indeed, the anti-art avant-garde is at least as suspicious of clear expressions of intent as they are suspicious of conventionally well-wrought artworks. While Bürger would like to see an enlightened critique of the institution of art, the anti-art avant-garde tends in reality to provide a critique fraught with irony, self-parody, and bewilderingly opaque elements. Discursive consistency is often undercut by a playful interest in the immediate sensual pleasure of insincere poses and bald-faced contradictions.

Anti-art's avoidance of sincere statements of purpose is exacerbated by its unpredictable tendency to manifest itself in a number of avant-garde movements without becoming an essential element of any of them. Early-twentieth-century avant-garde movements are often difficult to classify because they freely mix elements of anti-art with politically engaged art and overtly partisan art. Bürger suggests that dada, surrealism, and the Russian avant-garde all adhere to anti-aesthetic programs. Yet Russian avant-gardists such as Meyerhold and Mayakovsky could on occasion be rigidly partisan in their artworks.[13] Dada has, perhaps, a

greater reputation for its anti-art elements, but a number of dadaists either never accepted the anti-art project or eventually moved away from it.[14] Surrealism as well, despite the clearly anti-artistic pronouncements by Breton and others, produced artworks that found their place in the bourgeois institution of art as easily as any other works.[15] On the other hand, the German expresssionist movement, which is not generally credited with being anti-aesthetic, contains writers such as Gottfried Benn and Oskar Kokoschka, who experiment briefly with pointedly anti-artistic elements.

Finally, a major difficulty in discussing the anti-art avant-garde is its ambiguous relationship with mainstream modernist art. The avant-garde and high modernist art both attack and are marginalized from the center of the bourgeois institution of art. While, as Bürger points out, the manner of this attack may, in extreme cases, fundamentally differ, at some points the differences in the animosity toward modern culture exhibited by modernism and avant-garde become difficult to discern. Augmenting this difficulty is the tendency of high modernism to borrow from the avant-garde. Thus, while the symbolists may be considered avant-garde in 1870, by 1910 the aesthetic preoccupations they developed have entered the mainstream of modernist aesthetic practice.

Thus, the anti-art avant-garde of the early twentieth century requires close scrutiny both for its own internal complexities and its tendency to adulterate and be adulterated by other forms of avant-garde and modernist art. The anti-art avant-garde is also important for the ways in which critics have considered it the end of the avant-garde.[16] The arguments for this vary but share the basic observation that once the radical, iconoclastic innovations of dada and surrealism are accepted as legitimate forms of artistic expression, no innovation can place an artistic movement beyond the pale of legitimate aesthetic practice and, hence, give it the distinctive otherness enjoyed by previous incarnations of the avant-garde concept. Conceptually, these arguments are not particularly convincing, but a glance at the historical development of the avant-garde from the 1930s on makes clear the impetus for such explanations. Two historical facts in particular contribute to the view that the anti-art avant-garde occupies an important and unique position in the development of the avant-garde: first, avant-garde experimentation declines in the 1930s, and, second, when it reappears after World War II, it is a comfortable part of bourgeois cultural institutions.[17]

The problem with the theories of Bürger and Calinescu is that they

look only at the developments of the avant-garde itself and not at developments in the surrounding culture. Avant-garde movements do not decline in the 1930s because anti-art has pronounced the last words on this line of aesthetic development, but, rather, because the avant-gardes are suppressed in Germany and the Soviet Union and are drawn into the popular alliance in France under the double threats of fascism and a depressed economy. While abstract expressionism is integrated into the developing cultural institutions of the United States after World War II, adversarial movements do develop: fluxus, the situationists, pop art, and performance art all manage, at least for a while, to pursue the anti-aesthetic ideal of dada and surrealism into new realms of formal, thematic, or performative endeavor. The advent of postmodernism as a critical category and aesthetic posture is probably a more important development than the acceptance of dada in curtailing or qualifying in important ways the ideals of the avant-garde in that, as Russell Berman points out, "the historicity of the modernist work disappears in postmodernism."[18] Before postmodernism innovative art sought to move beyond the past in some way rather than to borrow from and play upon the past. The avant-gardes' adversarial relationships with modern culture have an acknowledged temporal specificity that postmodernism denies.

Categories of the Avant-Garde

If the concept of the avant-garde continues to be important through the 1950s and 1960s and even later (running alongside but still distinct from postmodernism), the forms through which it expresses its dissent from mainstream culture do not develop beyond those established in the first one hundred years of the concept's life. Thus, anti-art enters the repertoire of the avant-garde at the end of its innovative developments. After anti-art (but not necessarily because of it), the avant-garde ceases to be a series of innovations that denigrate past forms of aesthetic dissent and lay claims upon the future for themselves. Instead, the avant-garde becomes a multivalent tradition or a catalogue of aesthetic stances from which artists might draw and which is now isolated from the effects of historical change. In general, from the early twentieth-century onward the avant-garde falls into five categories:

 1. Partisan Art: artists attached to and serving a partisan political organization and engaged with that organization in criticizing the

status quo and attempting to bring some sort of utopian vision to fruition (Russian agitprop productions during the civil war, Piscator's early political revues, and more recent community-based theater such as Ngugi wa Thiong'o's work with the Kamiriithu Cultural Centre and the trade union theater groups in South Africa are distinct twentieth-century avatars of this form of avant-garde).

2. Secessionist Art: aesthetically innovative artists interested in artistic technique for its own sake but also in creating works that cannot be used to affirm the dominant, bourgeois culture and cannot be readily transformed into simple, pleasure-giving commodities (Adorno makes a good case for including Beckett in this group;[19] one might also argue for the inclusion of Paul Celan and Richard Foreman).

3. Engaged Art: artists committed to an innovative aesthetic program with future-oriented sociopolitical implications but who do not consider practical, partisan political applications a necessary part of the work of art, in other words, artists who are interested in using art to analyze and transform habits of thought and ideological prejudices rather than to incite enthusiasm for an immediate political goal (the German expressionists, Italian and Russian futurists, and English Vorticists were in the first wave of this avant-garde; Brecht's post–World War II oeuvre, the plays of Heiner Müller, and the films of Godard and Alexander Kluge are more recent examples).

4. Anti-Art: artists whose works attack the notion of art in general, or, at least, some of the basic presuppositions of art—such as the autonomy of the work, the craft with which its raw material is manipulated, and the work's availability to a public—(the pop art, situationists, and fluxus events of the 1960s and some recent performance and conceptual art take up again the anti-art project first attempted by dada and surrealism).

5. Innovatively Aestheticized Commodities: advertising campaigns and design styles that attempt to make art part of life or, more accurately, attempt to imbue products in the marketplace with an aesthetic aura of attraction that is independent of their use-value and appeals to notions of innovation and progress. These slogans, images, and packaging styles promise to make art part of life but are ultimately only interested in using art to enhance the exchange value of commodities. Of course, not all conjunctions of the aesthetic and commercial are or even claim to be avant-garde

Commercialism, however, makes its most intimate connections with the aesthetic through innovative, irreverent, or utopian gestures drawn from avant-garde art. Where commercial appeals to traditional or well-established artistic styles tend to reduce art to a quotation or endorsement, "avant-garde" commodities establish their aesthetic credentials solely through the wit and originality of their design or concept. (Art nouveau began this intimate connection between artistic innovation and commercial products, Outerbridge's and Man Ray's advertising photos helped imbue products of the 1920s and 1930s with an avant-garde cachet, and the confrontational "United Colors of Bennetton" campaigns from around 1989 onward (a black hand and a white hand handcuffed together, a baby and its afterbirth, a priest and nun kissing) would, I think, impress the dadaists with their anticommercial commercialism.)

More needs to be said about the distinctions between these five forms of the avant-garde and the potentials for overlapping or intermediate forms. Partisan and engaged avant-gardes, for instance, share a concern with the political issues of the world around them. Partisan art, however, expresses this concern primarily in a politically charged content and an overt allegiance to one party in current social controversies, while engaged art expresses this concern primarily in a politically charged form and more abstract, ambiguously aligned ideological commitments. If in partisan art the aesthetic form is also politicized (as with, say, San Francisco Mime Troupe plays), this is done because it is judged necessary to emphasize properly the political content. Piscator's theatrical productions from 1914 to 1924 are a telling example of this distinction. His early work for the Communist Party has a distinctive form, but the form serves the revolutionary message of the productions. The later, elaborate productions on Kurfürstendamm raise the form to a political statement. The content becomes a problem of representation to be solved by the form of the production rather than an indictment of or solution for social or political problems in the real world. Thus, his work shifts from the partisan to the engaged avant-garde.[20]

The anti-art avant-garde can also share certain features with either the secessionist or engaged avant-gardes. The technical experimentation of secessionist art could, for instance, become so extreme that it ridicules the aesthetic project in which it is engaged. The plays of Benn and Wyndham Lewis tend to approach anti-art from a secessionist sensibility.

An anti-art attack on the presuppositions of artistic practice could also be waged primarily for political purposes, as is the case with Barbara Kruger's photomontages and some of the activities of the Berlin Dada group.[21] Nevertheless, I hope the conceptual distinctions among anti-art, secessionist, and engaged avant-gardes are clear enough. Problems only arise when one must judge which of these forms of dissident innovation predominate in particular, exceptional instances.

Unfortunately, the conceptual clarity of the various forms of avant-garde art do not aid in arriving at a general definition. Innovation is clearly important for all five forms of avant-garde, but it is not sufficient for any of them. If to be avant-garde were to mean simply being ahead of one's time, the term would become banal in its breadth and inconsistent in its conception. Hans Magnus Enzensberger has pointed out the contradictions implicit in making *avant-garde* synonymous with *new*:

> What adversary does the vanguard expect to encounter on the terrain of history if it alone, and nobody else, operates in, or into, the future? . . . it just will not jibe with the idea of a guard that its only foe should be the tail of that very column it has the privilege of leading.[22]

Harold Rosenberg suggests that artistic innovations must be collective, ideological, and combative to be considered avant-garde:

> An individual who is an innovator spies upon the unknown, but only a phalanx can take up a foreward position, Cézanne is not avant-garde, Cubism is.

> No matter how radical its effects, an action is not avant-garde without an ideology to characterize it. The Paris Commune became an exemplary avant-garde political event when Karl Marx hailed it as a working model of the future society.[23]

> Besides being collective and ideological, avant-gardes are by nature combative. Each is bent on destroying its predecessor and stands on guard against being replaced by newcomers. The avant-gardes have brought into art the dynamics of radical politics. (89)

This definition of the avant-garde makes important points about its general character but is in some ways both too narrow and too broad. To say

that the avant-garde is combative tells us little unless we know what it is fighting against. The partisan avant-garde combats the political status quo, the commercial avant-garde combats its market competitors, and a range of other adversaries give the other avant-gardes equally immiscible qualities. To say that the avant-garde must be collective may introduce unwarranted restrictions unless one is very careful in defining the nature of this collectivity. Raymond Williams identifies a number of collective formations among nineteenth- and twentieth-century artists that obviously do not imply an avant-garde status (e.g., Bloomsbury).[24] On the other hand, Jarry and Artaud are exemplary avant-garde artists whose work belongs to a "collective" that is not established until after their deaths. Raymond Roussel's work relies neither on collective nor combative appeals. Indeed, the closest he comes to a conscious embrace of avant-garde ideology is the hope he entertained late in his brief life that his artistic talents would be appreciated by a later generation. Nevertheless, Roussel influenced and was championed by the surrealists and enjoys a prominent place in the canon of French avant-garde literature. At times it seems to be enough that the ideological pronouncements of an artist evoke or even merely imply combative and collective principles for the artist to be avant-garde, but, if the nature of the artist's work is sufficiently at odds with established tastes, it can often do without even the vestiges of combat or collectivity.

To make more detailed comments on the avant-garde we must narrow our gaze to some subgroup of the five categories, but, in doing so, we should also be aware of the ways in which the ignored categories can, nevertheless, contaminate distinctions we wish to draw. When we eventually settle on the work of five playwrights, we must remember they are not working from a fixed category of the avant-garde but from within a broad and sometimes contradictory tradition.

The avant-garde as partisan, engaged, and anti-art share two important, interrelated features. First, all these avant-gardes seek to alter significantly the social function of art. All demand more of the artwork than a rewarding object of aesthetic contemplation. Second, all these avant-gardes undermine in some way the social and aesthetic autonomy of the artwork. All demand that the significance and worth of the artwork be judged by more than its internal articulation of form and content. In general, we can say these avant-gardes alter the function of art by moving it into a broader social context than that vouchsafed it by the conventions of bourgeois high culture. The partisan avant-garde transforms art into a

promotional tool for a particular political program. The engaged avant-garde transforms art into a forum for the criticism of oppressive social relations and ideological positions. The anti-art avant-garde transforms art into a playful affront to bourgeois culture.

If the partisan, engaged, and anti-art avant-gardes share a common core definition, they also display a historical development. From the coining of the term *avant-garde* in 1825 to the flourishing of dada and surrealism after World War I, the project of changing the social function of art becomes, paradoxically, more and more aesthetic—that is, more and more autonomous from concerns outside the world of art. Olinde Rodrigues wishes to change the nature of art because he is a social reformer; the dadaists wish to change the nature of art because they are radically innovative cultural workers. The period 1910 to 1929 is particularly important for understanding the avant-garde because this is when the avant-garde's autonomy as an activity exclusively within or on the margins of the aesthetic and its discontent with the conventions of aesthetic autonomy both reach an extreme point. To understand the work of avant-garde artists during the period is to understand the historical and conceptual limits of the concept.

Secessionist art is actually closer to the aesthetic spirit of high modernism than to the radical dissidence of the partisan, engaged, and anti-art avant-gardes. In seceding from the cultural activities of the bourgeoisie into arcane manipulations and innovations of artistic technique for its own sake, the secessionist artists affirm the autonomy of art from social practice. Their work disrupts the social function of art only insofar as the difficulties created for the understanding and enjoyment of the work by a rigorously refined technique prevent the artwork from serving forthrightly as either a commodity in the budding cultural marketplace (at the turn of the century), as an ideological instrument of bourgeois identity formation, or as an escape from the pressures of modern urban life. This dissident element in secessionist art is not, however, enough to make it avant-garde. Secessionist art is avant-garde by virtue of its pointed combination of collective, combative, and innovative ideals at a particular historical moment.

Over time many of the qualities associated with secessionist art have seeped into high modernism. Indeed, many theorists suggest that if "modern art" is to mean anything other than simply "art in the modern era," it must be defined in terms of its opposition to or secession from modern society. Two of the most subtle thinkers to take this position and to draw together elements of high modernism and the avant-garde are

Theodor Adorno and Maurice Blanchot. So, after a brief look at a few general issues concerning modernism, I will turn to their discussions of modern art in order to better understand what is involved in an autonomous work of art's secession from the social world that makes it possible and how the terms of this modernist secession in the early twentieth century are both distinct from but related to the anti-art avant-garde's aesthetic principles.

The Qualities of High Modernism

The aesthetic concept of modernism arises when what is recognized as the high culture of the industrial, urban, imperial bourgeois era parts company from the sociopolitical values and ambitions of the dominant class. More succinctly, modernism defines itself in opposition to the ideology of modernization.[25] Whereas the Enlightenment hailed the discoveries of science, the rule of reason, and ideals of individual freedom associated with the rising bourgeoisie, and aided in establishing the ideological hegemony of that class, modernism casts a critical eye on all these aspects of the modern era as well as on the dominant class of which it is a cultural product. In this respect modernism is the child of romanticism, because the romantics are the first fraction of the dominant classes (predominantly but not exclusively bourgeois) to doubt the benevolence and bounty of the Enlightenment project. Modernism, however, is generally acknowledged to begin with Baudelaire.

The romantics criticize the values and structure of society by constructing dissident subjects within their works. The modernists level their criticism with the stylistic and thematic focus of their works. Style and theme are, of course, also important for the romantics, but the final justification of the romantic work is the apotheosis of the romantic subject.[26] Modernist works are much more skeptical about the power and value of the subject. The modernist artwork itself takes the place of the romantic subject as the privileged alternative to the modern world. The construction and contemplation of the work, rather than the construction and contemplation of scenarios of action in the world, becomes the primary purpose of aesthetic activity.

The shift in strategies of criticism from romanticism to modernism can be seen, at least in part, as a reaction to the way in which bourgeois society usually defeats criticism by absorbing it. Marcuse describes the mechanism of absorption as follows:

> To accusing questions the bourgeoisie gave a decisive answer: affirmative culture. . . . To the need of the isolated individual it responds with general humanity, to bodily misery with the beauty of the soul, to external bondage with internal freedom, to brutal egoism with the duty of the realm of virtue.[27]

We might add, to the general poverty and constraint of social existence affirmative culture responds with the diverting wish fulfillments of art and religion. Thus, bourgeois culture turns the romantic critique of its limitations into an affirmation of its generosity by benevolently fostering the dreams of romantic agency and freedom within the isolated realm of art. If human subjectivity is demeaned and diminished by urban, industrial, monopoly-dominated, bourgeois society, it is, nevertheless, magnified and exalted in the romantic artworks that are allowed to flourish in that society. The artworks provide an oasis from the harsh realities of the world at large.[28] Romanticism criticizes modern social problems, but modern, mainstream culture recuperates that criticism by allowing it an innocuous place within the official discourse of cultural values.

Modernism attempts more forcefully than romanticism to subvert the mechanism of affirmative culture by producing works devoid of a conciliatory or (perhaps unconsciously) collaborative content. The works of modernism from Baudelaire through Ibsen and Chekhov to Joyce and Kafka do not offer an escape from the modern world in their content. Rather, they assert an independence from and disdain for the modern world in their stylistic manipulation of their artistic media.

Of course, the dissident qualities of high modernism from, say, Baudelaire to Joyce must be contrasted with the more affirmative aspects of late-nineteenth- and early-twentieth-century culture, which are certainly not any less modern for being conservative. Nevertheless, my primary concern here is to establish the nature of a "modernist" resistance to and critique of bourgeois culture so that I can chart the ways in which the avant-garde moves away from this particular type of resistance and critique.

Adorno: The Negative Power of Construction

For Adorno the possibility of art in the modern age cannot be taken for granted.

> It has become self-evident that nothing any longer concerning art is self-evident—nothing in art itself nor in its relationship to the whole, not even its right to exist.[29]

Insofar as art is possible, this possibility depends on its ability to withdraw from and negate the world in which it exists through a rigorous concern with the formal features of aesthetic creation. Adorno champions a concept of art that is aware of the precariousness of its right to exist and that does its best to exacerbate its doubtful situation by refusing to acknowledge it. In other words, it reflects the social conditions of its existence only by negating them through its absorption in the development of its aesthetic expression.

For Adorno's secessionist-oriented aesthetic theory the question is not whether one form of art is more innovative, original, or advanced than another, but, rather, whether true art exists at all. To establish its negative autonomy authentic modern art must assert an absolute control over its internal structure. Given this perspective, Adorno tends to view collectively established artistic styles and movements as ways of blunting the disturbing negativity of authentic art by removing some structural determination from the artwork itself. Only in individual works that break away from established styles and movements can modern art find its purest being.

> Authentic artists such as Schönberg rebelled sharply against the concept of style; it is a criterion of the radical modern [work], if it denounces this concept. (*Ästhetische Theorie*, 306–7)[30]

Thus, works commonly considered expressionist, symbolist, or realist may all be radically modern as long as their formal organization refuses to apologize for itself by reference to an established style, but no individual art movement can represent an authentic development of modern art because they all establish stylistic norms that rob the works of art produced within them of the radical isolation Adorno considers essential to the modern work.

Modern art, for Adorno, evolves from and focuses on artistic "technique" in a way that earlier art did not. While technique has always been important, only in the modern era (the period following the French Revolution [*Ästhetische Theorie*, 94]) has the development of the methods by which the raw materials of art are manipulated in forming the artwork

taken on a life consciously distinct from the social evolution of art.[31] Mimesis and the social functions it serves in bourgeois society become less important in the modern work than the logical development of the artwork's formal construction. In more advanced works of art, such as Arnold Schönberg's music, the compositional technique obtrusively calls attention to itself through the dissonant tones it produces and unmistakably marks the musical composition as something *made*. The notion of the organic artwork, the artwork that grows naturally from an initial idea and is all one living whole, gives way in modernism to the man-made artwork. The living artwork becomes a constructed one. The work exists by virtue of technique rather than spirit.

Formally advanced construction is, for Adorno, a necessary but not sufficient condition for the realization of a radically modern work of art. To embrace only the absolute made-ness of the work of art is to forsake an essential element of the artistic project. Ultimately, art must involve mimesis. But art's imitation of nature must be the result of a rigorously artificial construction, a construction so thorough that the world it presents cracks into fragments.

The fragmentary work bears the wounds of the modern world while resisting submission to it. The fragmentary work constitutes a utopian refuge from the marketplace and from totalizing reason, but this refuge is purely negative. It is a point of absolute refusal rather than a land in which one can live. It is a vision of truth about rather than an anesthetizing escape from the social conditions of modern existence. Fragmentation is not, however, a sufficient criterion for being advanced, authentic, and radical. In the distinction Adorno draws between what he calls "the modern" and "modernism," he credits only the former with a progressive, critical stance. Modernism is made up of the "fellow travelers" who imitate with less success the achievements of the radical modern artworks (see *Ästhetische Theorie*, 44–45). Genuine modern art is, for Adorno, always the individual work. Here we see most clearly Adorno's commitment to the ideals of high modernism and his disdain for the twentieth-century artistic practices associated with the avant-garde. He sees nothing in the avant-gardes that is both unique to them and worthy of praise. He is, however, willing to credit modernism and the avant-garde with some of the negative strengths that only reach their full power in individual works.

Most important for Adorno, modernism is a manifestation of the art movement phenomenon, which is a radical transmutation of the

conventionally sanctioned phenomenon of artistic schools. Movements acknowledge to a certain extent the artificiality and impermanence of style and hence subvert the illusion of seamlessness, transparency, and constancy with which affirmative, conventional art purports to represent the world. Adorno suggests that, when conservative critics attack this subversive artificiality in avant-garde movements, they do so only because they are incapable of attacking it in its strongest, most powerfully negative manifestations in individual modern masterpieces (see *Ästhetische Theorie*, 45–46).

Adorno concedes that besides faintly shadowing forth some of the qualities of truly radical art, avant-garde movements can articulate impulses whose significance would be lost in individual works. But he does not feel that this makes the critical power of art movements equal to that of the individual work. Art movements privilege concepts of *art* over the articulation of the artwork, but the concept of art remains, for Adorno, trivial in relation to the artwork.

To understand better Adorno's objections to art movements we must understand the powers, difficulties, responsibilities, and complexities he attributes to the work of art. Adorno sees the individual artwork as the last repository of truth in a world falsified by the totalizing oppression of instrumental reason. The "truth" it contains has two fundamentally distinct forms: first, an accurate reflection of the material and ideological conditions of the external world and, second, a "negative utopian" rejection of those conditions. In opposition to orthodox Marxist aesthetic theory that champions socialist realism, Adorno insists that the reflection and negation performed by the artwork takes place on the level of form as much as on the level of content, should be much more cautious and critical of its own utopian moment than orthodox Marxism requires, and should be judged by its ability to balance mimetic and rational impulses rather than by the dexterity with which it communicates a message.

The artwork's rigorous internal organization of the artistic material must sacrifice nothing to the exigencies of an easy reception in its efforts to re-present the forces at work in society in a controlled and critical mode. It must, indeed, forsake communication in order to avoid easy commodification, to assert its autonomy from the modern world, and to focus more intensely its expressive negation of the status quo.

> That works refuse communication is a necessary but in no way sufficient condition of their unideological essence. The central crite-

rion is the power of expression through whose tension the artwork is discussed with wordless gesture. In expression they expose themselves as social scar tissue; expression is the social ferment of their autonomous form. (*Ästhetische Theorie*, 353)[32]

The mimetic impulse in the artwork mitigates the totalizing tendencies of reason by bringing into the artwork's expression (*Ausdruck*) the sensuous, concrete objects denied, subjugated, or ignored by the abstract subjectivity of rationality. Mimesis provides the utopian moment in art but only when balanced with the rationality of construction. An unmitigated or seamless mimesis would provide a false picture of the world and in rejecting rationality might serve the mythos of fascism. Even a fragmented mimesis such as Stravinsky develops is to be condemned because it allows a regressive appeal to the mythic qualities of mimesis to overpower the constructive element in the work (see *Philosophie der neuen Musik*, 62). For Adorno the ideal work of art is a monadic force field removed from but reproducing in a critically altered form the forces at work in the world. The mimetic and constructive impulses provide the two major poles around which other forces and moments arrange themselves.

Adorno's suspicion of art movements is motivated by what he considers their overemphasis on the mimetic moment in the work of art. Artworks that accept uncritically the conventions of an art movement are tainting their internal organization with unprocessed fragments of the external world because the conventions in question have not been formed within the work itself. To accept the conventions of an art movement is to surrender part of the work's constructive impulse to the dictates of the external world. Adorno is, to be sure, more sympathetic to some movements than to others because the regressive qualities of conventions can vary significantly, but, to his mind, no work formed through an appeal to previously set standards and methods of construction can be noteworthily radical and authentic. Each work must take into account the development of constructive conventions and the current aesthetic and social context within which it is being formed, but the work must then transcend the current state of artistic conventions by extending, distorting, or breaking these conventions in ways appropriate to the artistic material being manipulated and the expression warranted by the social context (in the case of the modern, the expression must, Adorno insists, be one of pain and irreconcilable negation).

Blanchot: The Annihilating Questions of Literature

Blanchot also stresses the negative utopia of the modern literary work but draws into the dynamics of that negativity a number of important concepts not treated by Adorno. Adorno's analysis of the modern work is restricted somewhat by his emphasis on its resistance to social conditions. Adorno's privileging of the gestures of resistance often overshadows both the autonomy of the work and the interactions between the autonomous work and the world. Adorno is right in showing how the secessionist form of aesthetic resistance allows the artwork to be independent from social conditions and yet connected to them by its negative reflection of them. This is not the resistance of political engagement but the resistance of a wound that refuses to heal, that asserts an autonomy from the resuturing coagulants of the social body. Adorno fails to note, however, how secessionist autonomy moves beyond the gesture of resistance that establishes it.

Blanchot does not confine the negativity of the artwork to resistance. The autonomous negativity of secessionist art moves beyond resistance to create a disturbingly emptied world of its own, a world marked by the absence of both author and ending, frozen in the eternal present of a death that never knew life.[33] Besides elaborating on the ontological implications of the modernist work's radical autonomy, Blanchot devotes considerable attention to the interactions of the autonomous work with the world, the interactions essential to its autonomy, defining as well as compromising it. The author, the reader, the book, the market, instrumental language, and the imaginary all lay certain stresses or spins upon the autonomous work that condition and define its removal from the world.

Blanchot agrees with Adorno that the chief feature of authentic modern literature is its questionability, its failure to fit into affirmative culture, and its consequently problematic existence.[34]

> If the book is not useful for anything, it appears as a disruptive phenomenon in the totality of human relations . . .[35]

> Let us suppose that literature begins at the moment when literature becomes a question . . . this question is addressed to language, behind the person who is writing and the person who is reading, by language which has become literature.[36]

Adorno, of course, believes the question of literature is addressed to society rather than to language, but Julia Kristeva's study of innovative modern literature suggests that the signifying power of language and the political constitution of society spring ultimately from the same source: the imposition of a symbolic order upon the chaos of prelinguistic, egoless existence.[37] The thetic moment that establishes symbolic order upon the free-floating "semiotica" of egoless desires is marked by a violent suppression of certain social and linguistic possibilities. Kristeva joins Blanchot and Adorno in declaring certain modernist texts "poetry that is not a form of murder"—that is, texts that breach the thetic moment to move out of the realm of symbolic (political and linguistic) order and dip into the semiotic sea of free associations, where they can wash the blood of civic and psychological repression from their hands (*Revolution*, 80–85).

Blanchot is closer to Adorno than is Kristeva in that he considers constructive technique (rather than play across the thetic threshold) the linchpin of aesthetic autonomy. For Blanchot and Adorno true works of art are created when the aesthetic material from which they are made is completely mastered and molded into forms that extend logically its immanent evolution.

> When [the writer] writes, his starting point is a certain state of language, a certain form of culture, certain objective elements—ink, paper, printing presses. In order to write, he must destroy language in its present form and create it in another form, denying books as he forms a book out of what other books are not. ("Literature and the Right to Death," 34)

Blanchot, however, does not accord the autonomous work the unquestionable dignity implicit in Adorno's theory. His evaluation of autonomy is more dialectically elaborate in that he acknowledges that freedom from the world implies being out of touch in some ways. The autonomy of the work makes it everything and nothing, a radical manifestation of freedom and just a book. With the disruptive truth that the literary work seems to offer also goes deceit and mystification (30). Hence, Blanchot approves of the way surrealism reveals the emptiness of literature, whereas Adorno worries that surrealism has given up on the project of the autonomous work.

While Blanchot's criteria for significant literature is somewhat

broader than Adorno's, he does finally draw distinctions very similar to those Adorno makes between affirmative culture, art movements, and the modern work. Blanchot's tripartite division of aesthetic forms might be called traditionalism, nihilism, and the literary work. Traditionalism corresponds roughly to Marcuse's notion of affirmative culture in that the autonomy of the work is compromised by its integration into social life. The traditional artist sacrifices his or her life for the work because the work will immortalize him or her ("From Dread to Language," 9). Since traditional works fit into social life rather than disrupting it, they do not exhibit a secessionist autonomy (although they certainly do exist under the conceit of autonomy) and, hence, are not strictly literary according to Blanchot.

> Only the nonliterary book is presented as a stoutly woven web of determined significations, as an entity made up of real affirmations: before it is read by anyone, the nonliterary book has already been read by everyone, and it is this preliminary reading that guarantees it a secure existence.[38]

Blanchot's nihilistic literature describes the most extreme of the anti-art avant-gardes:

> [The nihilist] negates everything at once, and he is obliged to negate everything, since he only deals with everything. ("Literature and the Right to Death," 37)

For Blanchot the trouble with nihilism is not that it relinquishes control of the aesthetic material. He approves nihilism's irreverent lack of control over its creative endeavors because this reveals the deceitful arrogance bound up in the activity of making art. Nihilistic literature is, however, involved in a self-deception.

> [The writer] sees into . . . the naive scheme of the [nihilist], who offers men, in the form of limited upheavals, an infinite vision of renewal. ("From Dread to Language," 9)

The nihilist's destructive negation is built on a hope for reconstruction and, hence, slides from the space of literature to the world of ordinary

speech—abandons the hopeless negativity of the autonomous work for the hope of practical constructions that can only be made by ignoring the ambiguity of existence that literature makes plain.

Blanchot maintains that language has two distinct aspects, the ordinary and the literary.

> Every time we speak we make words into monsters with two faces, one being reality, physical presence, and the other meaning, ideal absence. ("Literature and the Right to Death," 59)

Ordinary language distorts and misunderstands the monstrosity of words. It behaves "as if the living cat and its name were identical, as if it were not true that when we name the cat we retain nothing of it but its absence, what it is not" (44). Ordinary language assumes that the meaning of a word presents in some sense the object to which the word refers. Although ordinary language acknowledges that the object does not actually exist in the word, it maintains that the object is in fact there in a sense more refined and stable than that of existence: it is there in its idea, cleansed of the contingencies of existence.

The dubious dogmatic beliefs of everyday language grant us the peace we need for practical communication, but literature is not interested in practical communication. Literary language acknowledges the sickness of words ("Literature and the Right to Death," 44). It realizes that significance entails the irrevocable absence of the signified but that the pure absence in which meaning and understanding manifest themselves is irrevocably contaminated by the physical presence of the words themselves. Whereas ordinary language suppresses this fact, literary language embraces it. It revels in the distance from the world afforded by both words and meaning and struggles constantly to reveal that distance by manipulating the ontological disparities between the materiality of words and the immaterial abstraction of meaning. To use Adorno's terminology the literary work balances the construction of abstract meaning against the sensuous immediacy of the words. The simultaneous assertion of the absence attendant on the making of meaning and the presence implicit in the materiality of the word insures the autonomous negativity of the work: it allows the work to affirm its own integrity while denying the integrity of the world that makes the work possible.

Anti-Art Manifestoes and Silence

Paradoxically, Blanchot's criticism of nihilistic literature is the opposite of Adorno's. Adorno claims the nihilism of dada is a capitulation of the constructive principle before the sensuous charms of an unprocessed aesthetic material. Blanchot, on the other hand, suggests nihilistic literature destroys the sensuous presence of the word along with its meaning (guaranteed by absence) in order to construct an infinite vision of renewal.

Bürger sides with Blanchot on the phenomenological effect of the nihilistic avant-garde but gives the avant-garde's nihilism a positive valuation. This is not to say that Bürger buys into the dubious "infinite vision of renewal" of the avant-garde, but he sees in the manifesto-inspired breaks from traditional artistic practice in dada, surrealism, and the Russian avant-garde a historically distinct change in the thrust of artistic practice: a move from concern for the aesthetic material of the artwork to a concern for the institutional parameters of aesthetic practice. Bürger argues that the future renewal the avant-garde desired failed to materialize but that this failure is not as important as the iconoclastic fervor with which the traditional concept of art is attacked.

The chief drawback in Bürger's account of the "historical," anti-art avant-garde is that he reduces its iconoclasm to a manifesto-supported, discursive rejection of art. In place of a force field of mimetic and constructive impulses, the avant-garde work produces a cry of protest, which takes on value and significance only in relation to the object against which it is hurled (i.e., the institution of art). Whatever vestiges of mimesis and construction appear within the work are there only as effigies of the institution of art destined for ridicule and destruction.

Bürger suggests that the differences between his account of the avant-garde and Adorno's arise primarily from his interest in avant-garde movements and Adorno's interest in avant-garde works of art: the first point of view privileges dada and surrealism, the second Schönberg.[39] Adorno would probably agree but maintain that art can only be understood by looking at artworks and that art movements are tainted with extraneous issues. Insofar as Adorno would admit to an institution of art, he would see it as something the artwork must withdraw from and negate.

As movements, dada and surrealism may want to fight the institution of art, but, ultimately, they must wage their struggle as individual works of art, and, as such, Adorno judges them powerless. He claims

their weakness lies in their use of montage as a constructive principle. Montage gluts the artwork with undigested bits of the external world that inevitably overwhelm the artwork's critical potential by undercutting the thoroughness of its aesthetic formation. He compares surrealist montage to pornography and suggests that the means the surrealists employ for achieving a new freedom of expression leads only to the freedom of aesthetic death, the defeat of constructive mimesis in the face of oppressive external objects:

> One will be permitted to understand surrealism not as a language of immediacy but rather as testimony to the recoil of abstract freedom into the predominance of things and therewith into mere nature. Its montages are true still lifes. In composing the obsolete, they create *nature morte*.[40]

In contrast to Adorno, Blanchot judges the individual works of surrealism considerably formidable adversaries to the pretensions of control exerted by society upon literature:

> Literature is not only illegitimate, it is also null, and as long as this nullity is isolated in a state of purity it may constitute an extraordinary force, a marvellous force. To make literature become the exposure of this emptiness inside, to make it open up completely to its nothingness, realize its own unreality—this is one of the tasks undertaken by surrealism. ("Literature and the Right to Death," 22)

Exposing the nothingness of literature is, however, not the same as making literature nothing. Blanchot distinguishes between two types of nothingness in two types of silence:

> It may happen that a certain individual temporarily silences all the words that express him, by dismissing discursive knowledge, by seizing a current of silence that emerges from his deep inner life. . . . But for the writer the situation is different. He remains attached to discourse; he departs from reason only in order to be faithful to it; he has authority over language, and he can never completely send it away. . . . In the center of garrulousness he finds the zone of laconicism where he must now remain. ("From Dread to Language," 7)

Bürger seems to attribute the first form of silence to the avant-garde work. For Bürger the avant-garde speaks only in its manifestoes. The artwork silences itself in an act of provocation that shifts the discourse of aesthetic practice from the autonomous sphere of the work to the socially instituted field of cultural practice. Here Bürger and Adorno agree: the avant-garde work has nothing to say. Given Blanchot's observations, however, we should ask to what kind of silence the avant-garde reduces itself. In Bürger's terminology, does a rebellion against the institution of art necessarily involve the destruction of the individual work?

This study attempts to analyze the sensuous dynamics by which the avant-garde dramatic text silences itself. I side with Blanchot in maintaining that silence is not necessarily self-effacement. Indeed, against Bürger's claim that anti-art's silence destroys the individual work in order to let the manifestoes of a programmatic attack on bourgeois culture speak, I maintain that anti-art's silence can swallow all discursive rationale's for the artwork's existence in order to allow the work to shine more brightly in the mute immediacy of its existence.

The kind of mute anti-art to be found in the plays of Kokoschka, Benn, Roussel, Vitrac, and Lewis develops the notion of aesthetic negativity in directions unimagined by both Adorno and Bürger. These plays undercut the discursive stability needed for manifestoes and the technical proficiency demanded of high modernist works. These plays turn against the notion of a transcendent anti-art as much as they turn against the notion of an exalted artwork. The mute immediacy of these works becomes a kind of white noise that drowns out attempts to give the works a discursive context and contaminates the construction of the work with extraneous, heterogeneous material.[41]

As Adorno notes, the anti-art avant-garde draws "unprocessed" foreign elements into the artwork in order to kill it, to weigh it down and stretch it out like a life stilled by rigor mortis (see *Ästhetische Theorie*, 90, 232). What Adorno fails to appreciate, however, is the eloquence of anti-art's morbidity. The buzzing sound of disorder and contamination that repels Adorno can be seen on close examination to be an elaborate layering and interweaving of disparate aesthetic forms and discursive themes. As long as we do not expect these forms and themes to speak in unison, much can be said about their individual natures and the manner and effect of their juxtapositioning. To understand better the deployment of heterogeneous elements within the anti-art avant-garde work we must first distinguish between collage and montage.

Montage and Collage

The early-twentieth-century anti-art avant-garde incorporates unaltered found elements of the external world in the artwork in a number of ways that can be defined broadly as either montage or collage. Not all theorists agree on the subtle distinctions between montage and collage, but those who do recognize the difference between these two constructive principles generally agree on basic points.[42] In montage the disparate fragments of reality are held together and made part of the work of art by the work's constructive principle. All elements are related rationally to the whole despite the obvious heterogeneity of their sources. In collage the fragments of reality are not fully integrated into the representational scheme of the work of art. Unsubjugated elements of their external life shine through and disrupt the internal organization of the piece. In montage the principle of construction uses elements of the external world to undercut the principle of imitation; in collage the principle of imitation uses elements of the external world to undercut the principle of construction—the extreme of imitation being the presence of the object itself.[43]

Collage emphasizes the radical heterogeneity of its elements.[44] The unprocessed elements of the external world within it have been alienated from their original circumstances but have not settled within the frame of the artwork. While the artwork strips away the quotidian context of meaning and use from the heterogeneous objects and transforms them into aestheticized *objets trouvés*,[45] the foundness of the objects points persistently back to the world from which they came and endows them with a disruptive autonomy from the formational powers of the artwork. At its most extreme the process of collage eliminates direct reference to the world and the indirect representational references of artistic creation to highlight the unmediated presence of material objects. Lindner and Schlichting identify this form of collage as what they call "material image" (*Materialbild*) and refer to the work of Kurt Schwitters for examples of it:

> The material almost completely loses its reality-delineating character, which is in no way restored through the pictorial composition. The effacement of the painter's signature is in no way generally sought by this method; rather, the materials foreign to art, precisely in their deformation and reordering are subjugated to a singular formation process. ("Die Destruktion der Bilder," 213)[46]

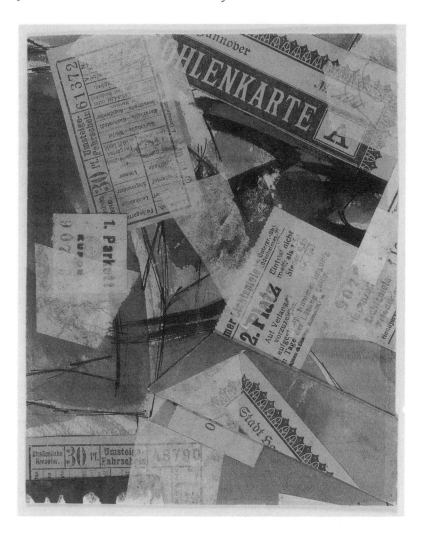

Fig. 1. Collage as the presence of physical material. *Aufruf* (1919), Kurt Schwitters (German, 1887–1948), collage and pen and black ink, 18.1 × 14.6 cm, Art Institute of Chicago, gift of Mr. and Mrs. Maurice E. Culberg, 1953.24. Photograph courtesy of the Art Institute of Chicago.

The formation process here, however, is no longer the aesthetic construction that Adorno champions because the material it forms is no longer strictly aesthetic. External objects such as (for Schwitters) ticket stubs, buttons, spools, and bits of wood or wire have been reduced to an immediate

materiality, but the paint and gesso have also been transformed from their *aesthetic* materiality into a more immediately objectlike existence. The formation process, tied certainly to the productive skills of the artist, has abandoned the historically mediated development of artistic expression to play at gluing together the detritus of daily existence. In collage paint becomes another found object and the painter a bricoleur.[47] Both the surface of the artwork and the process of its creation are made more immediate and concrete than in the realm of conventional or high modernist art.

In montage the emphasis is on construction rather than on the concrete materiality of the objects. There is, of course, construction in collage as well, but there the constructed whole is never greater than the parts. Rather, collage construction allows the parts to shine forth in their heterogeneous individuality. The formative principle to which the elements of collage submit allows them to be more their immediate selves than they ever could be when they were part of daily life. In montage, on the other hand, the individual elements participate in a project that is greater than themselves. This project differs from the expressive unity of conventional and high modernist art in that the heterogeneity of the elements is in no way suppressed. Indeed, the seams, disjunctures, and inconsistent material juxtapositions of montage contribute to the unifying purpose of the work just as the homogeneous material in conventional art does. The unity of montage is, however, an extraordinarily artificial one. Moving beyond a highlighting of the artwork's madeness (of which Adorno might approve), montage flaunts the cohesive power of its constructive procedure through its intentional incompleteness. Montage construction is too cheeky to withdraw into the negative autonomy of the thoroughly fashioned work. In its incompleteness it establishes irreverent connections (1) among the elements of which it consists, (2) with the sources from which these elements are drawn, and (3) to the central purpose that holds the elements together.

The common dynamics of montage can be seen in the very different uses made of this constructive principle by John Heartfield and Max Ernst.[48] The central purpose of Heartfield's montages is political, so the elements of each work always join in a pointed comment on a contemporary social issue. In a montage captioned "War and Corpses—the last hope of the rich" a larger-than-life hyena wearing a top hat and medal that reads "Pour le profit" (rather than "Pour le mérite") stalks through a corpse-strewn battlefield.[49] The obviously disparate sources of the picture elements and the artificiality of their juxtaposition is important for

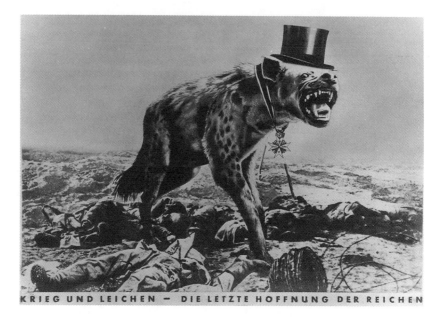

KRIEG UND LEICHEN — DIE LETZTE HOFFNUNG DER REICHEN

Fig. 2. Montage with a strong discursive element. "War and Corpses—the last hope of the rich," John Heartfield. *A.I.Z.* 18 (27 April 1932): 420–21. Photo courtesy of the Stiftung Archiv der Akademie der Künste, Berlin, Bereich Bildende Kunst, John-Heartfield-Archiv. © John Heartfield Community of Heirs. Reprinted by kind permission.

the message of the work. This is a scene that could never be documented with a straightforward photograph because the relationship between war dead and corporate profits is generally well concealed. Yet it is important that each individual element is a photograph because this affirms the reality of (1) the forlorn battlefield corpses, (2) the self-satisfied grandeur of a ruling class bedecked with formal hats and jewel-encrusted medals, and (3) the existence of vicious animals that feed on the dead. In transforming the hyena's reality to allegory, Heartfield connects the reality of the battlefield to the reality of the capitalists and condemns that connection. While the manufactured image supports wholeheartedly its political message, its vivid power prevents it from being reduced to this message. Like the real social situation it indicts, the image has a gruesome presence for which words are no substitute.[50]

 Although Ernst called his cut-and-glued constructions collage, I agree with Lindner and Schlichting that they are more appropriately

considered montage. Unlike the collages of Schwitters or Picasso, the foreign elements within the image frame of Ernst's picture books do not disrupt the integrity of the work with their persistent foreignness. Rather, as with Heartfield's work, the foreignness aids in creating the unique reality of the work. Whereas Heartfield's images appeal to the reality of a particular political discourse, Ernst's images make more ambiguous (i.e., surreal) references to various social, psychological, and cultural forces.

Ernst's "Drum-roll among the stones," although built from nineteenth-century book engravings, is intriguingly similar to Heartfield's "War and Corpses."[51] Upon a battle scene depicting an explosion and fleeing soldiers Ernst has glued a sedate bourgeois gentleman standing in the lower center of the scene, gazing calmly at the viewer, holding a ceremonial cane in one hand, and wearing a large, elaborate ribbon pinned to the front of his coat. Is the gentleman unstartled by the explosion because he set it or because the cane and ribbon provide some sort of talismanic protection from the stones crashing around him? The lack of explanation charges the image with a disturbing power not contained in the individual elements from which it is made. The individual elements still make reference to their origins—that is, to the sensationalism and formality of nineteenth-century mass-produced art—and seem to have joined together here in a hallucinatory, spectral reunion of dead images. But the hand of the artist in this construction and the logic of the scene suggest contemporary references that exceed the simple collage of outdated engravings. Indeed, one could argue that Ernst has depicted here from a different but no less incisive perspective the same modern problem that concerns Heartfield. It is, perhaps, comforting to think that the captains of industry resemble hyenas, but it is more likely that they pursue their profit making with the same obliviousness to consequent destructions that is exhibited by the gentleman in Ernst's picture. Rather than explain the causes of state terrorism, Ernst displays "the tranquility of the assassins."[52]

The difference between the montages of Ernst and Heartfield have less to do with the constructive method employed than with the extent to which the central purpose in which the assembled heterogeneities participate is predominantly figural or discursive.[53] Heartfield is intent upon telling a particular story. His montages have messages; they are held together by a discursive line of intent. Ernst's montages, on the other hand, do not make their intentions clear. We can read them as I have just done, but we can never be entirely confident of the accuracy of our

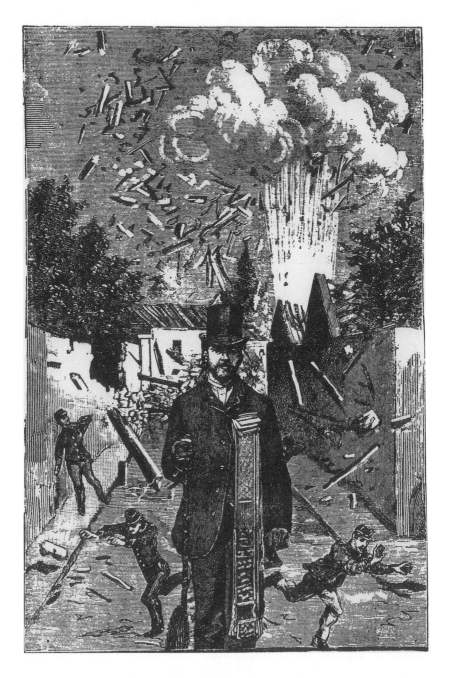

Fig. 3. Montage that subverts discourse. "Drum-roll among the stones," Max Ernst. Originally published in Ernst, *La Femme 100 Têtes* (Paris: 1927). Reprinted in *The Hundred Headless Woman* (New York: Braziller, 1981), 197. Caption translation © 1981 by Dorothea Tanning. Reprinted by permission of George Braziller, Inc.

reading, because Ernst's works are ultimately mute: they will not confirm or deny our reading. Ernst's montages participate in the disturbing silence of the anti-art avant-garde, while Heartfield's chant loudly the firm political ideals of the partisan avant-garde. Whereas the partisan avant-garde stakes its right to exist on a particular reading it has made of the world, the anti-art avant-garde stakes its right to exist on the sensuous discomforts and delights of ambiguous presences, the immediacy of the figure (delineated with clay, ink, words, or simply taken from the world) and the multiple worlds to which the figure might call us.

All art contains both figural and discursive elements. The visual impact of Heartfield's "War and Corpses," for instance, cannot be reduced to its discursive condemnation of capitalism's fondness for war profiteering. The images of his photomontages expand beyond their messages and assert a figural presence that arises from the immediate density of the visual field. In this particular montage the figural presence can be sensed in the compelling juxtaposition of the hyena's voracious snarl, the comic quality of the top hat and medal, the poignant victimhood of the corpses, the anger of the caption, and the bold appearance of the image spread across two facing pages. In Heartfield's work, although the figural element expands beyond the discursive element, it does not escape the discursive element. Word and image are fused into a theatrical gesture rather than simply a message. While the message certainly takes precedence, we hear it because of the figural density and weight of the artistic gesture that hurls it at us.

Anti-art also fuses word and image into a kind of gesture, but, because anti-art is more ambiguous or contradictory in its deployment of discursive elements, the gesture is more disconcerting—we do not know where it is coming from. When there is no clear message to accept or dismiss, we are confronted more noticeably with the discomforting presence of mute figural immediacy. Without an exchange of words it is difficult to break off an encounter satisfactorily. Without a dialogue of words or other meaningful signs a meeting cannot have a beginning, middle, and end (aesthetic closure). The anti-art montages of Ernst create such disturbingly mute encounters between audience and artwork. The discursive elements in these works are reduced and refined to an undecipherable mumbling that is even more disturbingly mute than a straightforward silence. In subsequent chapters I show how playwrights can create similarly mute montages by fragmenting and convoluting their discursive elements.

Having established some clear distinctions between collage and montage, it is also worth noting that in individual cases these distinctions are not always easy to draw. Collage and montage represent the two extreme poles between which lies a continuous band of constructive possibilities. Schwitters's work is a notably pure instance of collage. Picasso also displays a collage sensibility in his emphasis on the material textures of objects and their references to their past lives, but he sets the material immediacy of his collage elements off against the representational impulses of the picture plane. In *La Suze* (1912), for instance, the layering of paper strips, newsprint, wallpaper, and a bottle label is similar to the celebration of quotidian detritus in Schwitters's *Aufruf* (1919). In Picasso's picture, however, the cutout shapes figure forth a tabletop, bottle, and glass, and the past life of the glued-down elements whisper vaguely of the scene their shapes depict—the bottle label, newspaper, and wallpaper could be common objects from a Parisian café-bar. The collage elements in this work do not completely submit to the scene they depict, as in montage, but they do flirt with the possibility of such a submission. Thus, Picasso's collage constructions move provocatively toward the possibilities of montage. We have already seen that Ernst's montages are haunted by subdued suggestions of collage in that they celebrate the world of book engravings more persistently and disruptively than Heartfield's montage elements draw attention to their origins. Suffice it to say that sometimes it is difficult to say whether a particular incorporation of foreign elements favors the individuality of those elements or the unifying effects of their juxtaposition.

If one takes as a requirement for "aesthetic" work the notion of mastery over artistic themes and materials that are accepted as legitimate by conventional and high modernist art from, say, 1910 to 1929, then the radical heterogeneity of collage during that period is, I think, inherently anti-aesthetic.[54] Montage, on the other hand, can be either aesthetic or anti-aesthetic. Because montage works are assembled around a central purpose, the character of that purpose will determine the relationship of the montage to current artistic practice. Although montage may not seem entirely legitimate in the eyes of critics such as Adorno, it does have a self-justifying potential that collage lacks. Thus, the cinematic montage that Griffiths uses in *Intolerance* (intercutting four separate stories), Braque's integrations of wood-grained paper into his cubist drawings, and Pirandello's juxtaposition of theatrical and novelistic elements in *Six Characters in Search of an Author* all respect the autonomy of the individual

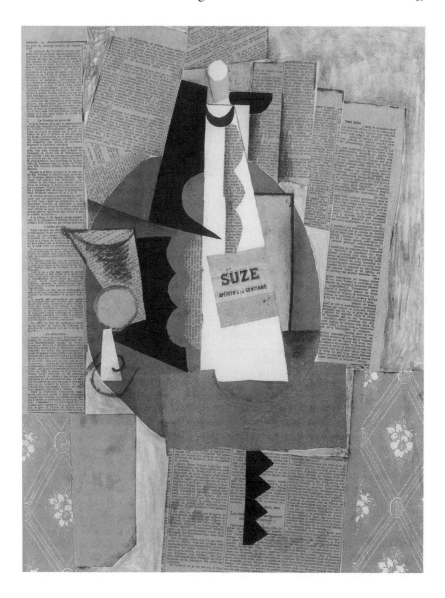

Fig. 4. Collage in which the presence of the material contends with the representational suggestions of the image. *La Suze* (1912), Pablo Picasso (Spanish, 1881–1973), pasted papers, gouache, and charcoal, 25 3/4 × 19 3/4 in., Washington University Gallery of Art, St. Louis, University purchase, Kende Sale Fund, 1946. Photograph courtesy of Washington University Gallery of Art.

work and adhere to conventional notions of artistic mastery and a stable mimetic field to a very high degree.[55] Heartfield's photomontages, on the other hand, violate the conventional social function of art by placing art at the service of proletarian political causes. The position of Ernst's montages with respect to conventional aesthetic notions of mastery, stability, and autonomy is more difficult to determine. I deal with other difficult cases of montage in my examination of avant-garde dramatic texts.

The Fine Art of Disturbance

I hope this discussion of montage and collage has established (1) the complexity of avant-garde constructive principles and (2) the distinctions between the avant-garde and both conventional art and high modernism. While Bürger makes an important point in noting how the manifestoes of the historical avant-garde call for an anti-aesthetic transformation of the social function of art, he is mistaken when he suggests that, in the avant-garde, "the act of provocation itself takes the place of the work" (56). This may be true in some of the more extreme dada performances, but in much of the avant-garde the formal and thematic developments of the artwork, rather than dissolving in a provocation to received notions of aesthetic construction, actually embody that provocation. Thus, the artwork absorbs and contains anti-aesthetic protest as an aesthetics of disturbance, rather than immolating itself in its protest against dominant aesthetic values. The quarrel between those members of the avant-garde who considered themselves artists and those who considered themselves anti-artists is long and elaborate.[56] Rather than siding with either of these groups, I wish to show the extent to which the concerns of both differ from high modernism and are manifested in dramatic texts.

To understand the avant-garde work one must look beyond broad general qualities, such as chance, fragmentation, and shock, to the ways in which it moves away from a modernist aesthetic by particular manipulations, degradations, and enrichments of the aesthetic material in question. Calinescu's observation that, for the avant-garde, "art is supposed to become an experience—deliberately conducted—of failure and crisis" (124) should be taken as the starting point for investigating the peculiar structures and strategies of avant-garde works rather than as an excuse for dropping the search for method in the avant-garde's madness. As Bürger points out, the "failure and crisis" of the avant-garde make a point about the position of art in bourgeois society, but they also make

points about the potentials of aesthetic expression. The avant-garde's failure to develop the aesthetic material along the lines indicated by the material's inner logic does not necessarily imply a collapse into conventionality as Adorno fears. Rather, failure and crisis can lead to the exploration of new realms of artistic form and subject matter and to sophisticated games of aesthetic brinksmanship in which the artwork is pushed to the edge of self-destruction.

If high modernist art, what Adorno calls "the Modern artwork," cultivates an aesthetics of negation and withdrawal energized by its commitment to the latent possibilities of the aesthetic material, the avant-garde cultivates an aesthetics of disturbance, lashing out at the world around it, altering the composition of its aesthetic material in unexpected, unorthodox ways. "An experience—deliberately conducted—of failure and crisis" is one way of creating a disturbance, but the more sophisticated artists of the avant-garde are quick to realize the limits of such a strategy. While gestures toward failure appear frequently in the avant-garde, I wish to uncover more elaborate methods of creating disturbances within the artwork, methods that might involve exploiting contradictory potentials in the aesthetic material, bringing collage and montage to bear on construction, or setting up inimical relationships between words and images, discourse and spectacle, within the work of art.

Oskar Kokoschka, Gottfried Benn, Raymond Roussel, Roger Vitrac, and Wyndham Lewis provide a good range of examples of the disturbing ploys of the avant-garde and demonstrate the extent to which anti-aesthetic concerns are articulated outside the cadres of dada. Kokoschka and Benn began their work in drama before the advent of dada, remained independent of that movement, and associated primarily with the cultural formations and publishing ventures of German expressionism. They demonstrate the nihilistic, anti-art trends in expressionism that refused to embrace the utopian hopes for a New Man that gave much of that art movement a discursive rationale. Roussel, an eccentric Parisian millionaire, was an inspiration to the surrealists, but working in isolation from both avant-garde groups and mainstream bourgeois cultural institutions, with little training or interest in the conventional ways of creating drama, Roussel developed a concept of art so idiosyncratic and peculiar that he ranks as an arch anti-artist without ever embracing the concepts of any avant-garde movement. Vitrac associated with both dada and surrealism in Paris, but after dada had faded from the cultural scene and surrealism failed to foster any interest in drama he broke from all broader movements to work with

Artaud in bringing some of his disturbing notions of anti-art drama to the stage. Lewis's one major play, *Enemy of the Stars*, written while he was developing (but had not yet fixed) the concepts that became the avant-garde movement called Vorticism, offers a nihilistic English reaction to futurism and expressionism that holds nothing sacred in its dizzying manipulation of aesthetic forms.

Analyzing the disturbances of the avant-garde must begin with a thorough understanding of the aesthetic material upon which the avant-garde operates. To manage this we must narrow our focus from art in general to a particular genre and a particular historical moment. The dramatic text seems to me an especially important medium in which to examine avant-garde texts because the intricacies of the dramatic aesthetic material are particularly well suited to the construction of avant-garde artworks and merit an extended investigation. The period 1910–29 is important both for the critical developments in the avant-garde it contains (from the beginning of expressionism through the rise and fall of dada to the second major breakup of surrealism) and for developments in the aesthetic material of drama and theater. Avant-garde drama has been the subject of other studies, but none of these have accorded the formal and thematic organization of the plays the close attention they deserve. The purposes of this book are, first, to demonstrate the lines of inquiry most important for understanding the avant-garde dramatic text and, second, to highlight five playwrights who take the project of avant-garde drama to noteworthy extremes with considerable degrees of sophistication.

Negotiating the Aesthetic Material of Drama

To appreciate the anti-aesthetic innovations of avant-garde drama, the ways in which playwrights can abuse and contaminate the dramatic genre in ways inimical to the principles of both high modernism and conventional bourgeois drama, it is useful first to examine the sociohistorical state of the aesthetic material of drama in the early twentieth century. The aesthetic material of drama is particularly complex in this period due to three important factors: (1) the intrinsic complexity of drama, (2) the crisis in conventional dramatic representation, which prompts a florescence in formal experimentations, and (3) developments in theatrical styles that challenge the conventional relationship between script and performance. In noting briefly how high modernism moves away from conventional drama in its negotiation of these factors, we will be better placed to understand how the avant-garde moves away from high modernism.

The Intricacies of Dramatic Form

The complexity of drama begins with the manner in which it represents reality. Aristotle was the first to suggest that at its most sophisticated realization drama is "the representation of a serious, complete action which has magnitude."[1] An "action" involves a significant change from an initial situation to a concluding one that is brought about by the purposeful decisions of characters powerful enough to exert some influence on the world and with personal flaws and strengths balanced to elicit both criticism and sympathy from the audience. Characters and situations are the medium in which the action develops, but the action dominates dramatic mimesis through the sinuous fluidity of its reversals and recognitions.

Plays that neglect the technical demands of a well-developed action in favor of, say, a particular character's display of bravado or suffering are, according to Aristotle, failing to take command of drama's full palette of aesthetic material (*Poetics*, 9). High modernism maintains an interest in the possibilities for representing human actions dramatically, while conventional drama is often happy to drop such onerous interests for the culinary delights of suffering and sympathy offered by the theatrical display of stock characters.

For Aristotle action reveals the worldly consequences of human judgments and decisions. Through action subjective values, anxieties, and desires are injected into and transformed by objective circumstances. Yet Aristotle does not confine the representation of action exclusively to the dramatic genre. Indeed, he suggests that even Homer understands and exploits the intrinsic aesthetic appeal of a well-focused, unified action in *The Iliad* (*Poetics*, 42). Hegel, in contrast, tries to define the project of dramatic representation in terms more specific to the genre. Whereas Aristotle suggests action springs from individual decisions, whether by Oedipus on the dramatically scaled steps of his palace or Achilles on the epically scaled plain of Troy, Hegel suggests action springs from conflicts between individuals that develop and are resolved within a precisely delimited external setting.[2]

According to Hegel, the formal features of drama are designed to represent more effectively than any other type of art the concrete, immediate unfolding of an action (*Handlung*) through the agency and conflict of individual, free characters. Since Hegel, with Aristotle, considers the representation of an action the central purpose of all art, he considers drama the highest form of art because it delineates both the subjective and objective aspects of the central action more completely than any other artistic medium. Drama combines the objectivity of epic with the subjectivity of lyric[3] and goes beyond the representational powers of literature by presenting plastic forms upon a stage (*Poesie*, 504–5). The use of the stage allows drama to incorporate elements of the visual arts but, most important, allows the living human being to become part of the work of art, thus making possible the most articulate and complete portrayal of the spiritual and corporeal presentness and reality (*Gegenwart und Wirklichkeit*) of "character," which initiates and embodies the action, in any form of art. Narrative and lyric fall short of the mimetic vividness of drama (apropos a present action) by dispensing with the "full, sensuous reality

of an outer appearance" (*Poesie*, 504), by confining their representative powers to a purely verbal medium.

In describing what might be called the traditional project of dramatic mimesis, Hegel also touches on one of the central ambiguities of the dramatic medium. Drama develops as a mode of physical performance before an audience and, according to him, expresses itself most fully only in performance. Yet the demands of performance, what we might call the aesthetic material of the stage, are not the same as the demands of literary dramatic representation. The modernist project of refining and interrogating the dramatic representation of human action can lead to the creation of plays that can, for any number of reasons, be impossible to perform on the stage or, when performed, actually diminish rather than gain in expressive power.[4]

If we take the aesthetic material of drama to include the historically developing possibilities of both the stage and the dramatic script, we find the modernist urge to develop the aesthetic material confronted with the dilemma of two divergent realms of expressive possibility that threaten to break up the integrity of the dramatic artwork. This threat is, of course, negligible if we look at plays designed unmistakably for the stage or for the page. Yet many plays in the late nineteenth and early twentieth century purposely wander into the dubious zone between stage and page where the development of the aesthetic material becomes as much a confrontation with the institutions and values of bourgeois culture as an immanent advance in the expressive powers of the dramatic medium. Ibsen and Strindberg are good examples of this kind of high modernist, dissident aesthetic development. Benn, Vitrac, and Lewis open the gap between stage and page with more pointedly iconoclastic intent.

In general, the anti-aesthetic avant-garde expresses its social and aesthetic dissidence in a manner far less respectful of the development of dramatic representation than does high modernism. Of the playwrights we will examine Roussel is the most disrespectful of dramatic representation, but the others are also cheeky in their own distinct ways. Kokoschka is particularly dismissive of the expressive powers of well-defined dramatic characterization allowing identities to overlap and potentially well-focused conflicts to dissolve in the theatrical space. Benn undermines the definitiveness of spacial and temporal presence and often leaves the dramatic issue of character motivation vague in his pursuit of more philosophical points. Lewis allows narrative and imagistic forms of expression

to overlay and interfere with his articulation of dramatic material. Vitrac is the most serious and masterful "dramatist" in this study, but he allows his palette of dramatic aesthetic material to ridicule itself by virtue of the varied and contradictory forms he piles on top of one another.

Yet even without Vitrac's prompting we can find in the aesthetic material of drama itself a disturbing lack of respect among the potential elements of expression. Working, in particular, against the mimetic potentials of drama are the theatrical potentials of the medium. Where dialogue, setting, costumes, and characters can be used to articulate the representation of human actions, they can just as easily be used to display the sensuous immediacy of spectacle and performance. The slapstick of puppet plays and the mechanical machinations of farce, for example, tend to draw drama away from the ontological depths and complexities of human actions to the simple surface pleasures of gesture, posture, exclamation, and movement. Thus, the dramatic artwork can be either a medium of representation or a medium of theatrical display.

Since high modernism favors autonomous artworks that develop with rigorous precision their aesthetic material, it favors the dramatic text as a medium of representation. The dramatic representation of human action has, after all, a long and elaborate history of development from which the modern artist can draw to create an autonomous artwork. Performance, on the other hand, has a murkier history, it is not usually acknowledged as an element of high art, and, in privileging performance, the playwright would automatically undercut the autonomous integrity of his or her own work.[5] Indeed, the dual nature of the dramatic text as literary mimesis and format for performance fights against itself when trying to come to terms with the notion of high modernist autonomous art. If, on the one hand, the literary text of drama claims precedence as an original mimetic artwork, the performances of the text (which Hegel suggests should mark its most complete realization) become embarrassingly superfluous copies of the original. If, on the other hand, the literary text passes the title of artwork to the performance, the text leads a shadowy, fragmentary, indeterminate existence.

This confusing state of affairs is, of course, the sore point at which Adorno's brand of high modernism loves to prod. Ibsen, for instance, in *Ghosts* constructs a play on the page which represents action on a stage that Ibsen knew was unlikely to be realized for some time given the controversial themes he depicted. The meticulously stage-worthy set descriptions amount to a kind of ironic joke in what was written and

published initially as a closet drama. As long as plays such as *Ghosts* are *only* closet dramas, they are also indictments of the timidity and vapidity of bourgeois culture. Ibsen's plays were, thus, at the time of their initial publication, often wounds in the body of bourgeois culture, but, over time, due to changing values, these wounds healed. If high modernist drama is committed to exploring the weak points and unstable ground of its aesthetic material, it, nevertheless, as the example of Ibsen shows, attempts to lend stability to these weak regions through the balanced articulation of the autonomous work. When the anti-aesthetic avant-garde approaches these regions, however, the aim is to aggravate the disturbing instabilities. Where Ibsen, Strindberg, and Kaiser use their constructive powers to constitute artworks from the intrinsically fragmenting aesthetic material, Kokoschka, Vitrac, and Lewis (who manipulate comparatively large and varied palettes of aesthetic material) use their constructive powers to augment the disintegration of the dramatic medium.

The Crisis in Dramatic Representation

Besides the intrinsic complexities of the dramatic text, early-twentieth-century playwrights must contend with historical developments in the aesthetic material of drama particular to their age. By the beginning of the twentieth century the concept of human action has become more complex and conditional than Aristotle or Hegel envisioned it, and, hence, the dramatic representation of human action has become more problematic. The subjective consciousness, from which human action springs and which contains the will, the values, and the anxieties motivating it, is no longer considered volitionally independent of external conditions, nor are its motivations and movements unambiguously readable. Obscure subconscious forces and complicated social situations both exert strong influences upon the course and character of human action, and dramatists feel an increasing reluctance to leave these factors out of consideration in their plays. We can, of course, find these forces at work in plays from many earlier periods (Büchner, Shakespeare, and Euripides come to mind), but only toward the end of the nineteenth century do playwrights begin to feel a compulsion either to overtly represent these forces in their work, rather than letting them act behind the scenes, or to declare the mimetic powers of drama inferior to the mimetic powers of other arts. Julius Brand, Hermann Bahr, and Edmond de Goncourt all lament the

inability of drama, or, at least, conventional drama, to portray the "secret inner workings of the spirit."[6]

The external facts with which characters must deal also change significantly in the move from the nineteenth to the twentieth century. Concrete political opponents, the dictates of the gods, and precisely articulated moral codes give way to amorphous, insidious networks of power and confusing convolutions of material and ideological domination. This is not to say that earlier drama does not deal thematically with complex, impersonal, and shifting power structures. What makes early-twentieth-century high modernist drama unique is its insistence on the inadequacy of the traditional dramatic milieu, in which characters act upon one another in a relatively narrowly defined world. Whereas an earlier age might have used allegorical figures to portray complex forces within the narrow interpersonal confines of drama, the modern age demands a more straightforward mimesis for which drama is inadequate. Those artists who do not consider drama hopeless feel compelled to broaden drama's focus in one way or another, to allow forces outside the characters and beyond overt, interpersonal moral and political imperatives to participate in the action of the play.

The conventional means of articulating the dramatic representation are, in the early twentieth century, no longer considered sufficient requisites for mimesis. Dialogue and gesture cannot adequately illuminate the inner workings of the human mind, nor can they delineate the external forces that impinge upon and alter the intended actions of the individual. Likewise, the dramatic unities of time and space do not, in the twentieth century, intensify the representation of the action but, rather, limit the ability of drama to examine fully the sources, significance, and consequences of human actions. In general, the modern world seems too complex to be represented on the stage, and, even if some of its complexity could be reproduced, an audience would be hard-pressed to follow with comprehension the confusingly elaborate and multivalent details of an adequate representation as it unfolds in the irreversible and unretardable presentness of the theatrical performance.

Peter Szondi examines the ways in which modern drama attempts to overcome this crisis of representation.[7] Certain forms of modern drama fall within what he calls "rescue attempts" (*Rettungsversuche*). Where the movement of human action can no longer be represented dramatically, these forms of drama attempt in various ways to represent static "situations" in the Hegelian sense of the word.[8] The milieu in which humans

move and which colors and defines their existence is delineated upon the stage, even though, within this milieu, characters are incapable of initiating measures that impact upon and change the situation in any significant way. Hauptmann's *Die Weber*, Hofmannsthal's *Der Schwierige*, and Maeterlinck's *Les Aveugles* are examples of this type of drama.

The mimetic powers of situational drama are, according to Szondi (and Hegel), significantly circumspect. The situation is intrinsically static and impersonal. It suppresses the articulation of individuality possible when the character can react to and alter the contours of his or her environment. The interaction of subjective and objective impulses is stifled by the lack of development in the staged situation.[9] In place of the movement of human action, plays develop more and more elaborate depictions of the confinement and control of characters. Where changes in situation do occur, the social milieu, rather than the characters in the milieu, is often represented as the chief agent of the change. Georg Lukács notes how the furnishings of the home both determine and describe behavior in bourgeois drama, while such furnishings were still usually absent or marginal in Renaissance drama.[10] Szondi suggests that the events unrolling on the stage in Ibsen's plays are largely determined by forces that cannot be represented dramatically, particularly the past, which has a grip on the characters' behavior that is much more pervasive and ineluctable than the presence of the murdered king's ghost in *Hamlet*.

Szondi groups under the rubric of "tentative solutions" (*Lösungsversuche*) drama that strives to represent more than the decaying powers of individual human initiative. These approaches to the genre expand, rather than contract, the field of dramatic representation by eschewing the ideal of *dramatic* mimesis in favor of the lyrical qualities of introspection or the epic qualities of narration. Szondi speaks of a general "epic" quality common to most successful twentieth-century drama, by which he means that a voice external to the dramatic conflict controls and aids in various essential ways the delineation of the action. This voice may be a character within the play (as in *"monologue intérieur"* and "Memory"), a subjective, emotionally saturated authorial voice (as in "*I*-dramaturgy"), or an emotionally featureless but didactically or ideologically motivated structuring intentionality (as in "Political Revue," "Epic Theater," and "Montage").

Szondi does not suggest that in becoming more "epic" modern drama becomes more objective. Rather, in its attempts to find new forms with which to represent human action it shifts its focus from the intersubjective

conflicts of characters to a conflict between a narrative voice and the world with which that voice (or, rather, the mind implied by it) attempts to come to terms. The nature of the voice and the world that it attempts to order differ according to the ontological prejudices of the playwright concerned. The types of conflict represented vary from introspective attempts to order the protean and volatile phantoms of a psychologically complex self, as in Strindberg's late "*I*-dramaturgy," to confrontations between the subjective force field of ethics, rationality, and compassion and the objective force field of avaricious and oppressive networks of social, political, and ideological power, as in Brecht's epic theater, to meditations upon the interpenetration of fiction and reality and the impossibility of true dramatic conflict, as in Pirandello's plays.

In the struggle between the subjective narrating consciousness and the inimical material it attempts to master, the action of modern drama arises and some of the interpenetration of subjectivity and objectivity that Hegel attributes to ideal drama is preserved. Thus, Szondi's notion of "epic" is dramatic in that it involves the representation of an action through the interplay of subjective and objective elements, albeit on a general formal rather than mimetic level. The "drama" in Szondi's epic drama has more to do with the construction of the play than with the interactions of the characters on the stage. The avant-garde sometimes does make use of similar conflicts and contrasts on the level of form, but in the avant-garde the instability of these conflicts and contrasts makes them more liquid than drama. Compare, for instance, the carefully articulated struggle between social problems and their representations in Piscator's "political revues" and the erratic, pranksterish juggling of love and its representations in Vitrac's *The Mysteries of Love*.

Szondi's description of the shift in mimetic strategies involved in the development of modern drama is, I think, accurate but does not account for all the trends in early-twentieth-century drama. The reactions to the crisis of dramatic representation he analyzes are all motivated by a desire to make drama capable of representing the modern world as accurately and completely as possible, but the more radical elements of the avant-garde are perfectly content to drop the representational project. The avant-garde is more interested in powers of expression than powers of representation and pursues expressive innovation into regions that often work against standard forms of artistic imitation. Thus, while we may take the dramatic crisis Szondi describes as an important influence upon the development of early-twentieth-century avant-garde drama, we

should not expect the avant-garde, with its antimimetic tendencies, to follow consistently any of the courses traced by Szondi. The avant-garde is not interested in saving or renewing the mimetic powers of drama. Benn, for instance, is quite happy for the mimetic inadequacies of the dramatic form to become glaringly obvious. Even when something like an epic voice is apparent in avant-garde drama, we should be cautious about attributing its presence to a desire to improve the representational powers of drama. Kokoschka's plays, for example, sometimes approach the epic qualities of *I*-dramaturgy, but the central ego in these plays is so delirious that it clouds rather than clarifies the represented world.

The early-twentieth-century avant-garde drama with which I am concerned, the drama in which anti-aesthetic principles are beginning to ferment, in contrast to the modern drama Szondi examines, embraces the dramatic crisis rather than attempting to overcome it. The representational shortcomings of drama at the turn of the century allow avant-garde playwrights to explore other aspects of the dramatic artwork while implicitly denigrating the mimetic project simply by refusing to salvage it. Avant-garde drama is not, however, the only drama to ignore the crisis of representation. Theatrical innovators such as Craig, Fuchs, Appia, and Copeau, as well as their more radical successors (e.g., Meyerhold, Schwitters, and Bragaglia) also show little concern for the difficulties of dramatic mimesis. Indeed, one weakness in Szondi's account of modern drama is his failure to discuss the relationship between the breakdown of conventional dramatic mimesis and the blossoming of theatrical innovation in the early twentieth century. While this study is primarily interested in dramatic scripts as artworks with marked anti-aesthetic features, it is useful to devote some attention to the theatrical performance styles developing within modernism and the avant-garde in the early twentieth century in order to take note of how the avant-garde dramatic literary text relates to the possibilities of performance. Kokoschka's and Vitrac's plays, in particular, incorporate aesthetic material drawn from modernist and anti-art concepts of performance. Lewis, in contrast, develops a literary concept of performance in reaction to developments on the European stage.

Performance: Modernist Artwork or Anti-Art Event

An important shift in the character of drama occurs when, from the late nineteenth to the early twentieth century, the technical apparatus of the

theater becomes increasingly sophisticated. Electric lights, revolving stages, movable backdrops, more intricate and varied styles of set design and costuming, and an increasingly flamboyant repertoire of special effects take on prominent roles in European theaters.[11] Simultaneously, the director, or metteur-en-scène, becomes the coordinator and final artistic authority for all the details of the increasingly rich theatrical work of art. Various modifications of Wagner's *Gesamtkunstwerk* concept and notions of a purely theatrical art independent of the literary qualities of the playwright's text rise to prominence during this period.[12] The actions of characters, which Aristotle and Hegel place at the center of the dramatic artwork, become just one small group among many equally important elements manipulated by the central theatrical artist, who, as E. Gordon Craig, among others, insists, is the director rather than the playwright or actor.

This shift away from the actions of characters toward the unfolding of spectacle is consistent with the loss of individual autonomy and the rise of complicated networks of social, economic, and political power (and the resulting disappearance of autonomous human action) that concern many modernist playwrights of the early twentieth century, but the modernist theater directors' reaction to the dramatic crisis differs significantly from that of the modernist playwrights. Whereas the playwrights seem primarily concerned with making the explanatory and ordering powers of dramatic representation equal to the complexities of the modern world, the directors seem preoccupied with exploiting new technology and innovative gestures and stage design to increase the emotionally expressive power and complexity of the performance.

The unity of emotive and intellectual expression that Hegel notes in the use of human bodies to depict human actions disappears in twentieth-century drama. Some directors eschew a rational representative scheme and an intelligible message more or less entirely in favor of a purely emotive spectacle.[13] When directors do attempt to maintain a balance of emotive expression and semiotic representation, their strategies and the resulting configurations of mimesis and affect often differ radically from one director or stylistic school to the next.

"Modern" theatrical practice can be distinguished from the avant-garde by its use of formal structures reminiscent of Hegelian and Aristotelian drama. While modern theater may turn away from the representation of human action to the mounting of elaborate stage spectacles, the human actor is usually placed at the center of the spectacle, just as Hegel

Fig. 5. Theater that emphasizes the scenic image. *The Steps, 2* (1905), E. Gordon Craig. Photo and reproduction permission courtesy of Ohtani Women's University Library, Osaka, Japan. For other images from *The Steps*, see *Craig on Theatre*, ed. J. Michael Walton (London: Methuen, 1983).

places him or her at the center of the dramatic action. Indeed, in the stage designs of Appia and Craig (among others) the elaborately detailed depiction of concrete social milieux, which became increasingly important throughout the nineteenth century as a context for and force within the dramatic action,[14] is stripped away in favor of a stylized articulation of light and shadow within which the actors' movement and speech become paramount.

Although a historically specific delineation of the conditions governing human action is impossible within the rarified, aesthetically abstract scenes designed by, say, Appia, individual human beings, freed from the layers of realistic costume and social setting that determine their behavior

and within which they almost disappear, become, in these productions, the central figures in the movement of the theatrical spectacle. Human action is made the focal point of the theatrical production by making it a question of aesthetic performance, the presence and movement of the actors upon the stage, rather than a question of the representation of sociohistorical facts. Adolphe Appia's work with Émile Jaques-Dalcroze at Hellerau (1912–14) and Georg Fuchs's productions at the Münchner Kunstlertheater (1908–19) were among the first to place a central importance upon the bodies of the actors in the mise-en-scène.[15] Brauneck points out how Appia's original interest in simply strengthening the control of the director over the theatrical production developed into an insistence that the director use his power to increase the importance of the actor within the mise-en-scène:

> While in the beginning Appia treated the performer as merely one element in the hierarchy of all production elements, under the influence of Dalcroze, who always placed the human being at the center of his pedagogical work, Appia now also gave central significance to the performer. Appia's stage designs of 1909, which he called "rhythmic spaces," are typical of this new emphasis.[16]

Even in Appia's earlier music-oriented theories, however, he was already interested in making the actors' bodies as expressively powerful as possible. He claimed his production methods were intended "to make possible the highest expressive capability [for the actor]."[17] Extending Appia's emphasis on the actor, Meyerhold's incorporation of acrobatic skills in the theatrical spectacle made the physical presence of human bodies the dominant element of the scene (see fig. 6).

As Joachim Fiebach points out, one of the salient features of early-twentieth-century modernism is that "art and theater appear to be the only areas of creative activity,"[18] that is, the only areas in which the individual can create through his or her own actions. In all other sectors of society creation has migrated from the actions of individuals to the machinelike functioning of organizations. Theater artists such as Craig and Appia turn away from mimesis and toward performance (although never completely) in order to attain the freedom of movement that only the autonomous realm of art can offer. When Craig suggests that marionettes take the place of actors, he is not conceding that all human activity is determined by forces beyond the individual's control but, rather, is

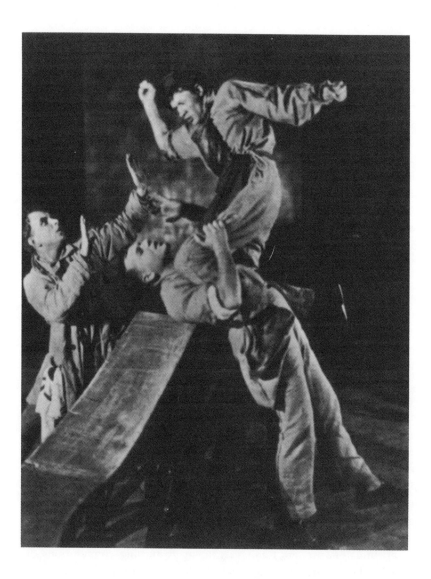

Fig. 6. Theater that emphasizes the virtuosity of the actors' bodies. *The Magnanimous Cuckold* (1928), dir. Vsevolod Meyerhold. Actors: Zaichikov, Ilinsky, Kelberer. Photo from *Meyerhold on Theatre*, ed. Edward Braun (London: Methuen, 1969), facing page 160.

moving the realm of absolute (aesthetic) freedom from the boards of the stage to the mind of the metteur-en-scène.[19]

One would not expect anti-aesthetic avant-garde drama or theater to make the human being the center of the movement of the theatrical spectacle any more than one would expect it to attempt uncritically to represent human action. The former retains too much of the formal conventions of the latter. In avant-garde drama that is moving away from a modernist autonomy grounded in the thorough manipulation of the aesthetic material toward a less mediated, more confrontational display of a fragmented aesthetic material, the human being, rather than forming the focus of the theatrical spectacle, should disintegrate into or become lost within a bewildering flux of impulses. In subsequent chapters we will see this disintegration at work in dramatic literature. Wyndham Lewis's *Enemy of the Stars* is particularly notable for the ways in which it uses the narrative powers of literature to create turbulent countercurrents both between the theatricality of the scene and the human body and between the visual extensions of the stage image and the interior emotional lives of the characters. For the moment, however, I would like to consider how these anarchic denials of rational mimetic conventions are manifested in anti-aesthetic theater.

Brauneck identifies three distinct traits exhibited by most radical twentieth-century theater innovators: (1) suppression or elimination of the human actor in favor of an abstract visual display, (2) use of styles and media normally excluded from the bourgeois institution of art, and (3) a breakdown of the boundary between audience and spectacle, between life and the artwork.[20] In general, modernist theatrical innovation such as Appia and Craig champion can be distinguished from anti-art avant-garde theater, of which Jarry was a precursor, by the unambiguous precision with which modernist innovation manipulates the aesthetic material. The avant-garde is constantly obscuring boundaries (between life and art, high art and folk art, etc.) and stirring up disturbing convolutions of material, whereas modernist innovation rationally justifies itself and anchors itself firmly within the realm of autonomous art.

In some instances human characters are not the center of the action in modernist theater. Stage aestheticism (in the vein of Craig), which sometimes seeks to eliminate characters in favor of an abstract and idealized play of emotive sound and color, is the obvious example of a modernist theater without human characters, but one might argue that some popular bourgeois entertainments in which stunning special effects and elaborate cos-

tume and stage design are the focus of attention and the more radical strains
of naturalism, for which the physical milieu is the most eloquent and active
participant in the action, have also significantly suppressed the part played
by human characters. While popular melodramatic spectacles and meticu-
lously thorough naturalism are certainly concerned with human events,
these often take place without the participation of fully formed, traditional
characters—that is, self-conscious free individuals who, from a position of
relative subjective autonomy, act upon and within the objective contours
of their milieu. In melodrama and naturalism the humans can become less
the source of the action and more accessories to the action carried out by
the stage machinery as a whole.

Modernist theater that eschews the importance of human character,
no matter what form this theater takes, can be distinguished from the
anti-art avant-garde by its reliance on or privileging of an aesthetic focus
or center for each stage piece. Although human characters are not the
center of attention, some other element of the work is thrust forward,
and the audience is invited in various ways to rest its attention upon this
element, to use it as a point of stability and order. Anti-art theater, in
contrast, attempts to interrogate and undercut the concept of the work in
order to avoid the aesthetic stability with which modernist theater is
imbued. In Craig's most radical recommendations for theater reform, for
example, he remains thoroughly modernist. The human character is
eliminated, but sound, light, and motion become the focal points of the
work,[21] and the use of the Über-marionette insures that each perfor-
mance is a perfect realization of the "stage manager's" concept, thus
eliminating the contingencies of a live performance that normally sepa-
rate theater from other forms of high art.

In contrast, Marinetti's futurist soirées exhibit a strong anti-art ele-
ment because the spontaneous and unpredictable outrage and aggression
of the audience are welcomed as part of the spectacle.[22] Similarly, Kurt
Schwitters's Merzbühne embodies some anti-aesthetic principles because
the various visual and aural elements are juxtaposed with no rational hierar-
chy, order, or composition: they play freely upon one another rather than
in the perfectly planned manner extolled by Craig (see Brauneck, *Theater
im 20. Jahrhundert*, 110–12, 200–203; and Motherwell, *The Dada Painters
and Poets*, 62–65).[23] We can see from these examples that anti-art theater
ideally involves a constant play of contrary forces rather than a stable
hierarchy or clearly ordered arrangement of themes and impulses. The
aesthetic focus of avant-garde theater is constantly changing, points of

stability constantly dissolving. The audience is denied a convention-authorized center around which to order its response to the piece.

Both modernist and avant-garde theater innovators tend to stress the immediacy of the theatrical spectacle over its representative powers. As already noted, this aesthetic trend can be attributed to a desire to avoid both the problems of dramatic representation and the constrictions on individual behavior exerted by high capitalist civilization, but the freedom that modernism seeks in theatrical immediacy is markedly different from that sought by the anti-art avant-garde. Modernist theater practitioners seek a freedom for the constitutive powers of art: they break away from the constraints of realistic representation in order to freely produce new forms of theatrical spectacle. Even when a modernist work forsakes mimesis completely for the immediacy of performance, it still focuses this immediacy on the aesthetic material's rational and complete development by a central creative consciousness.

Anti-art theater practitioners, in contrast, seek a freedom that brings a more ontologically fluid immediacy to the events in the theater. For this avant-garde, theater is not so much the realization of a fixed work constituted through performance as the unfolding of a unique event. This is particularly true of the soirées organized by the dadaists, in which the reactions of the audience and the spontaneous improvisations of the performers made each evening unique and unpredictable, notable not for its mastery of aesthetic material but, rather, for the spontaneous outbursts of emotional energy and the real rather than representational involvement of spectators and actors alike in the aesthetic event.[24] Whereas modernist theatrical innovations are designed to allow the artists involved some measure of creative activity, to allow their actions to create an aesthetic work, anti-art innovations are designed to allow only a participatory activity. Audience and actors both participate in the aesthetic event, but this event has no implied existence beyond its unique, spontaneous occurrence. The anti-art performance aims at a more radical form of freedom than that involved in modernism, because aesthetic activity denied the telos of aesthetic *production* can or, at least, threatens to pour out into all aspects of life rather than coalescing in the autonomous realm of the artwork. Unfortunately, as Bürger points out, the trace or record of the anti-art avant-garde event is easily reified by the art institution into a work of art. When the productive intention does not come from the artist, it can be forced upon the artistic activity by the social institutions that maintain art's public existence.

A further problem for anti-art performance is that the distinction between a constitutive and a participatory immediacy is not absolute. The ideal of a completely spontaneous event sweeps away the ontological facts of the artwork and embraces the lie of simple meaning that Blanchot criticizes in both nihilist art and daily life. Aesthetic events tend to become aesthetic works as soon as their participatory spontaneity is seen to be engineered in some way. Some of the most interesting aesthetic events are those that acknowledge this aporia in the very terms of their existence. Some productions of Kokoschka's and Vitrac's plays have manipulated the tension between constitutive and participatory immediacy, and the disturbing instabilities of this tension are embedded in their play scripts as well.

Anti-Art Performance and Dramatic Literature

In light of the art institution's recuperation of anti-aesthetic trends that strive for the furthest extremes of nonproductive, spontaneous performance (witness the rooms devoted to dada and surrealism at the Museum of Modern Art in New York), the less ambitious position of the avant-garde playwright committed to some anti-art principles is not necessarily also more conservative. By choosing to produce a literary text, the playwright accepts from the start the autonomous, work-oriented nature given to art by the established configurations of modern social and cultural practice but is also in a position to explore and exploit the ontological ambiguities of the artwork and its place in society. Rather than abandoning aesthetic construction from the start, as happens in the Berlin dada events, the avant-garde playwright can subvert it from within, exploit contradictions and ambiguities inherent in the aesthetic material of drama in such a way that the material refuses to coalesce in a stable formal array, refuses to speak more definitively and absolutely than even the most mimetically opaque of modernist works.

Through the stability of their form or their relation to the artistic tradition, even the most idiosyncratically abstruse modernist artworks say, "I am an autonomous, well-constructed artwork." This signal or caption frames the work by placing it within the institution of art and, thereby, to a certain extent, subdues its figural immediacy in favor of its discursive submersion in the ideology of bourgeois culture. In speaking with the voice of the social institution of art, the modernist work loses some of the force of its presence. It becomes more ethereal, part of the

language of bourgeois culture, rather than an object that obstructs the flow of that language. The anti-aesthetic trend in the avant-garde attempts to avoid this discursive reduction by maintaining a figural immediacy unsanctioned by the legitimating structures of bourgeois art. In avoiding a discursive message, however, the anti-art avant-garde is vulnerable to messages being imposed upon it by the discursive machinery of bourgeois cultural institutions.

Duchamp's *Fountain*, for instance, was radical in the context of its creation: in submitting it to an art exhibition, Duchamp was, in essence, engaged in a small, private, anti-art performance the significance of which evaporated once the performance had ended, and all that remained was the ceramic urinal with "R. Mutt" scrawled on its side. The anti-art protest of *Fountain* was contained in the gesture of submitting it to an art exhibition with certain pretensions to being on the cutting edge of aesthetic innovation. The signed ceramic artifact, because it is not a complete, autonomous work of art, does not contain the radical critique of the art institution involved in the original gesture of submitting it to the exhibition and reporting on the incident in *The Blind Man*.[25] Because *Fountain* has very little discursive or figural power of its own, it can do little to resist the autonomizing frame and reductive, discursive content imposed upon it by the art institution. The enduring elements of dada performances are generally incapable of protesting their recuperation: they cannot speak when removed from their original context.

Because of the anti-art, performance-oriented avant-garde's vulnerability to recuperation by the art institution, it would be interesting to know to what extent and in what ways literary anti-art can approach the figural immediacy and iconoclastic discursivity sought by anti-art performance outside the parameters of artistic practice sanctioned by the dominant institutions and formations of bourgeois culture. Within the autonomous artwork a sense of performative immediacy can be established by focusing the constitutive elements of the work (e.g., the words) on the moment of aesthetic creation (e.g., the moment when pen approaches paper). This is, I think, an important part of the symbolist project. The playwrights I examine in the subsequent chapters carry this project further in the direction of dada spontaneity by dramatizing or theatricalizing, in various ways, the constitutive elements of their works (from dialogue, scene, and character to broader stylistic conventions and generic expectations).

Whereas many modernist playwrights, as Szondi suggests, focus

subjectivity into some sort of epic voice, these avant-garde playwrights aim at a dispersal of subjectivity. They purposely avoid the unifying strategy of a central consciousness in favor of an interplay and conflict between various elements of the aesthetic material. Like the modernists, these avant-garde playwrights make questions of form an integral part of their work's content, but they exploit, rather than avoid, the naturally unstable characteristics of drama. They develop turbulent, multivalent mises-en-scène of their aesthetic material. While remaining faithful to the notion of the autonomous artwork, due to the conceptual and institutional constraints of the printed text, the avant-garde playwrights, nevertheless, insistently emphasize notions of ontological immediacy, without which the significance of their work would evaporate. They insist upon the immediacy of the aesthetic material, its figural density, rather than allowing the material to recede into the discursive abstraction of representation. Their artworks attempt to avoid both the banal affirmative discourse of conventional bourgeois art and the more sophisticated and ironic discursive constructions of high modernism.

The insistence upon the immediacy of the aesthetic material to be found in anti-art drama should not be confused with a deference on the part of the printed text toward its physically immediate stage realization. When I speak of an immediacy arising from the multivalent mise-en-scène of the aesthetic material, I am referring to the immediacy of the printed dramatic text itself, to a decentering, figural intensification of the semiotic field (*scène*) of the written work. We find in the following chapters that the figural intensification of the written work actually prevents or seriously disrupts the normal sort of physical presence available to dramatic texts through their realization upon the stage. The anti-art dramatic text has a figural weight that hinders its transposition to the stage. The sensuous immediacy of the text's convoluted signs is too dense and rooted in its literary presence to be dragged from the page to the stage. Producing the plays I examine is inevitably more like collage than like realization (the conventionally assumed relationship between playscript and performance), interpretation (which most modernist theater practitioners advocate), or even montage. On the one hand, the anti-artwork's refusal to articulate a straightforward, discursive set of mimetic parameters prevents it from authoritatively guiding a traditional realization—or modernist interpretation—oriented mise-en-scène; on the other hand, the autonomous facticity of the avant-garde play's arrangement of the aesthetic material prevents the printed text from melting into a theatrical

montage such as those constructed by Piscator. In any mise-en-scène of the type of plays I am analyzing, the figural presence of the playwright's work inevitably shines through the part it is given in the stage production with an autonomy that declares its ineffaceable foreignness to the theatrical work in which it has been placed.

All the playwrights I examine produce works that cannot be unproblematically molded to the medium of the theater,[26] although some of the works are intended for the theater. The points of resistance to a move from printed text to stage performance differ from playwright to playwright, but, in creating these problems for a mise-en-scène, all the avant-garde playwrights are attacking the same fundamental convention of mainstream, bourgeois drama: the subservience of the printed text to the temporal and physical immediacy of theatrical mimesis. In leveling this attack, however, the avant-garde playwrights are not simply replacing theatrical with literary mimesis, as do writers of closet drama. An unambiguous mimetic telos would undermine the radical immediacy of the avant-garde play, so the playwrights, drawing upon the inherent ambiguity of the ultimate purpose of the dramatic text, as well as upon their own innovations, obfuscate, fragment, and contradict the telic impulses in their works. In this way the discursive notion of a purpose is transformed into an intractable roughness in the figural presence of the work.

In the following chapters I have chosen to examine the work of Kokoschka, Benn, Roussel, Vitrac, and Lewis, because they exemplify a number of distinct methods of antagonizing the concept of the autonomous dramatic artwork without explicitly attempting to escape or overturn the formal and institutional structures within which that concept is formed. These playwrights radically undercut the discursive etherealization implicit in the conventions of the institution of art and attempt to increase the figural immediacy of their works within the institution, rather than searching for a figural immediacy outside the bounds of bourgeois art. I do not intend to suggest that the works of these playwrights embody the only methods of striking from within against the notion of the coherent, mimetic, autonomous artwork, but they offer, in my opinion, some of the most sophisticated means of doing so. As examples of the variety of ways in which anti-art elements can be nutured within dramatic artworks and as superlative achievements of the anti-art avant-garde, the work of these playwrights deserves close attention.

I start my survey of anti-aesthetic trends in drama with Kokoschka

because he is one of the first in his generation to embrace anti-art in drama, and, as one of the initiators of the expressionist style in drama and performance, he demonstrates the presence of anti-art in a movement prior to dada. Benn comes next because he is also working within the style of German expressionism but develops tensions in drama's literary possibilities that contrast nicely with the more theatrical iconoclasm of Kokoschka. Roussel stands in the middle of the group of five because of his extraordinary singularity. He outrages the proprieties of drama's literary and theatrical aspects more thoroughly than Kokoschka or Benn yet seems oblivious to the import of his work because of his naive commitment to an extremely eccentric notion of aesthetic value and a lack of attachment to or understanding of the demands of the cultural institutions of his time. Vitrac and Lewis follow the others because their plays are more complex, and my analyses of them will benefit from the familiarity with anti-art ploys afforded by the examinations of Kokoschka, Benn, and Roussel. Vitrac follows Roussel because Vitrac's mastery and manipulation of dada, surrealist, and traditional dramatic material contrasts interestingly with Roussel's naïveté concerning the avant-garde trends flourishing around him. Lewis's one play, *Enemy of the Stars* (1914), was written early in the period under examination, but the sophisticated manner in which it carries anti-art issues to notable extremes argues for its appropriateness as the last play I examine.

Kokoschka: Disturbing Spectacles

Although primarily a painter, Oskar Kokoschka is also credited with producing some of the first expressionist drama. His theatrical experiments while a student at the School for Arts and Crafts in Vienna (1907–9) anticipated the expressionist movement in Germany and Austria with their stark and violent portrayal of emotion and conflict and their sometimes lyrical and sometimes parodic dedication of stage imagery to emotive expression rather than objective mimetic representation. Kokoschka consistently ignored the utopian aspirations toward a "New Man" around which much expressionist drama circled but brought, to both drama and theater, imagery and character development drawn with the bold, erratic strokes and garish hues typical of expressionist painting.

While expressionist drama often attempts to justify its fascination with grotesque images and overwrought emotions by an appeal to a (vague) agenda of social change, Kokoschka was interested from the beginning of his dramatic work in the playful spontaneity and emotive immediacy that his plays allowed the actors to conjure on the stage. The initial student performances of his first two plays were improvisational rather than based on a fixed text. During rehearsals Kokoschka stressed the importance of the cadence, focus, and emotional content of the gestures, voice, and musical accompaniment more than the words being spoken. Concerning the first performance of *Mörder, Hoffnung der Frauen* (*Murderer, Hope of Women* [1909]), he says:

> Actually, I had simply improvised it at a night-time rehearsal in the garden with my friends. I gave the principals and other players an outline of the action and wrote down each of their parts in short key

phrases on slips of paper, after first acting out the essentials of the play for them, complete with all the variations of pitch, rhythm and expression.[1]

In the published versions of Kokoschka's plays the elaborate, inventive, and expressive stage directions reflect the essentially theatrical quality of his work, while the parody of bourgeois dramatic conventions and the aggressive, fragmented language and action testify to his disdain for established forms of theater. His first two productions of the very short and farcical "Sphinx und Strohmann, Komödie für Automaten" (1907 and 1909) were presented to fellow students in informal surroundings and seem to have been more or less successful. His third production (4 July 1909, on a double bill with *Mörder*) was given to a wider, more bourgeois audience at the Garden Theater of the Kunstschau and ended in a riot. The subsequent publication of *Mörder, Hoffnung der Frauen* in *Der Sturm* (1910), although prompting many readers to cancel their subscriptions, won him the respect of artists, writers, and critics. From 1917 to 1922, while the expressionist visual aesthetic was popular, his plays were performed in Zurich, Dresden, Frankfurt, Berlin, and Stuttgart. Kokoschka was in charge of the mise-en-scène in Dresden and Berlin, and the Frankfurt productions were modeled on his work. These performances exploited fluid shifts in lighting, lithe body movement, and intense emotive expression to create vivid scenes shifting constantly through an often bewildering variety of moods ranging from the parodic to the tragic. Only the dadaists in Zurich, with their masked and aggressively crude production of *Sphinx und Strohmann,* and Oskar Schlemmer in Stuttgart, with the clean, linear, Bauhaus lines of his staging of *Mörder,* offered mises-en-scène significantly different from Kokoschka's own. After 1922, because he wrote no new plays and expressionist drama fell out of fashion, Kokoschka's work never again appeared in major German theaters.

The critical reception of Kokoschka's work, when favorable, has usually fallen into one of two categories: (1) praise for the visual power implicit in the texts and realized in Kokoschka's productions and (2) close readings that discover order and meaning beneath the chaotic surface of the plays. Critics in the first group were, naturally, those who saw the plays performed. Their observations stress the astonishing visual qualities of the works and suggest that these qualities are all one need notice. Here are two examples:

A play of Kokoschka's is only a variation on his paintings, and vice versa. The tone and melody, rhythm and gesture of his words are parallel to those of his paintings.[2]

Visual impact. Soul-spots, painted. Throughout the feeling that one is encountering the strongest of all living directors. Not, however, God protect us, the strongest poet. But, nevertheless, where concepts fall short, O. Kokoschka, the painter, steps forward in the nick of time.
Everything shimmers, mists, and evaporates.
Sometimes I think: it's as if someone had colored an etching by Klinger and placed it on the boards in magical, slow-motion cinematic hues.[3]

More recent studies of Kokoschka's plays have discovered in them a more rational order than was noticed at the time of their performances. Denkler and Schvey both note Kokoschka's use of Otto Weininger's popular theses concerning the distinctions between and incompatibility of male and female attributes. Weininger (an extraordinarily overwrought misogynist) suggests that women do not have the rationality and self-consciousness of men. Women are really only talking animals: the ordered psychic life they appear to possess is for the most part merely the male's charitable projection of his own rationality upon the confusion of instinctual, erotic impulses that is womanhood's true nature.[4] Schvey produces elaborate analyses of Kokoschka's plays based on the Weiningerian themes of the conflict between sexual desire and spiritual love and the irreconcilability of "male" and "female" values. Denkler suggests that the ideological order and rationale of Kokoschka's plays evolves from an essentially Weiningerian position through a more generalized expressionist program into private, subjective concerns.[5]

The two groups of critics just described both miss the point of Kokoschka's drama. The point, I think, lies disturbingly between the visions of his work as pure spectacle and cryptic program. Schumacher comes closest to identifying Kokoschka's aesthetic principles when he notes the complex ambiguities at work in the plays:

Nonsense and profundity mix indiscriminately here. The truth is pronounceable only in parody; with everything turned on its head, the illusion that takes itself seriously is unmasked.[6]

While not attaching the same importance to Kokoschka's use of ambiguity and incoherence as does Schumacher, Denkler does briefly take note of it when he points out that Kokoschka's revisions of his plays always tended to make them more enigmatic. Schvey, on the other hand, tries to interpolate meaning into the cryptic aspects of Kokoschka's plays. While much of what he says is valuable, it ignores the considerable confusion that the plays provoke even in audiences thoroughly familiar with the Weiningerian concepts with which Schvey tries to rationalize the plays. Note, for example, Diebold's reaction to *Mörder, Hoffnung der Frauen*:

> From explanations of the drama one learned that the Man would break away from the sexually obsessed Woman and thereby free himself and her. One wants to accept this in good faith—every interpretation aids in clarifying the sparse text. The Man screams, the Woman screams; the Man brands her with a hot iron. What is it? Phallus or scourge? . . . Whether it concerns liberation from animal nature or enslavement to bestiality, there is such bestial squalling and gesticulating here, without an antiphony of purer voices, that the muse of such a lascivious orgy can only be named Vagina.[7]

Surely the confusion and obscurity of Kokoschka's appeal to the Weiningerian program is as much a part of his drama's aesthetic as the traces of order suggested in the appeal. Denkler's analysis of the various drafts suggests that Kokoschka was, in fact, more concerned with obscuring the ideas upon which he built his plays than in elucidating and elaborating on them. I believe the implications of this obscurantism go beyond the mixing of "nonsense and profundity" noted by Schumacher and contribute to a uniquely anti-aesthetic form of aesthetic construction that Kokoschka helps develop for drama.

In this chapter I seek to show that, rather than moving from Weininger through expressionism to a self-absorbed *I*-dramaturgy, as Denkler suggests, Kokoschka cultivates an iconoclastic aesthetic that grows in complexity from 1907 to 1917. The density of his dramatic works increases, but he never appeals to the principles of coherence underlying conventional bourgeois art nor to the principles of thorough construction typical of high modernist artworks. He creates his aesthetic density by laying contorted fragments of traditional art upon one another. This method of construction creates astonishing patterns and juxta-

positions but has no substantiality. One is always in danger of falling through the layered fragments into the vacancy at the heart of each work.

Theatrical Form, Fragmenting Content

Mörder, Hoffnung der Frauen is one of Kokoschka's first plays (first version 1909, final version 1916) and the simplest, both formally and thematically. In one act, set in a vague, Gothic past, it depicts a battle to the death between two characters, Man and Woman. Schvey is right to point out the debt this play owes to Weiningerian stereotypes, but the play's themes are not confined to fin-de-siècle notions of the battle of the sexes. Equally dominant in the words and actions are themes lifted from the passion of Christ and fragmentary references to war, intrigue, and, perhaps, an intrafamilial blood feud. The movements among and mixing of these motifs combined with the lack of development or resolution for any of them led Diebold and others to consider the play complete chaos. Although the play certainly lacks the unifying programmatic order Schvey tries to find in it, its disorder is not groundless nor its partial appeals to contradictory orders ill conceived or frivolous.

Kokoschka uses programmatic theses as most playwrights would use characters, milieu, and plot. He places imagery from the passion of Christ and the battle of the sexes within the play's action rather than using theses generated by these images to justify the action. Kokoschka is more interested in creating a stunning spectacle than in making definitive statements. He draws upon Weininger in order to create images of irreconcilable opposition rather than in order to take the bourgeois male's side in this opposition. Weininger's program is not the explanation of the play but, rather, one of the props on the stage. The male-female opposition is used to initiate the play's violence but is ultimately consumed by that violence along with the set and most of the characters.

> THE MAN goes directly towards them [the soldiers and maidens]. He kills them like flies. The flame jumps over to the tower and rips it open from top to bottom. Through the path between the flames the man quickly departs. Far, far away, cock crows.[8]

Kokoschka's illustrations for *Mörder*, published in conjunction with his play in *Der Sturm*, confirm that the Weiningerian contrasts to which he alludes are more of a grim joke than a consistent thesis. Note, for

Fig. 7. *Murderer, Hope of Women*, Oskar Kokoschka. This image accompanied the publication of Kokoschka's play in *Der Sturm*, 14 July 1910; reprinted by Kraus, 1970. © Sina Walden. Reprinted here by permission.

example, how the drawing entitled *Heavenly and Earthly Love* (*Der Sturm*, 25 August 1910) denies any visual distinction between the Man and Woman and reduces both to the flailing limbs, frayed nerves, and hideous grimaces of beings enthralled in a morbid attraction.

Kokoschka's disingenuous use of programmatic material is part of his general strategy of *Bürgerschreck* (shocking the bourgeoisie). As Diebold's protest confirms, refusing to follow through with ideas broached can be

Fig. 8. *Heavenly and Earthly Love*, Oskar Kokoschka, *Der Sturm* 25 August
1910, reprinted by Kraus, 1970. © Sina Walden. Reprinted here by permission.

just as disturbing as the use of lewd and violent imagery. Other aggres-
sive transgressions of public mores and taste are also rife in Kokoschka's
plays. Blasphemous use of religious motifs, vivid sexual imagery in lan-
guage, costumes, and stage business, disturbingly graphic portrayals of
violence, and a calculated denigration of plot and character development,
which figure prominently in *Mörder*, appear repeatedly in Kokoschka's
dramatic oeuvre. In program-oriented avant-garde plays *Bürgerschreck* is

employed for its polemical value,[9] but Kokoschka uses it solely to enhance the visual and emotional power of his plays. The shocking elements in his plays are like hard, dangerous objects jutting up from the chaotic swirl of the action or glinting in the vacuum of his work's refusal to fulfill conventional expectations. The disturbing elements stand resolutely on their own rather than bowing to the rationalizing rule of a sociopolitical agenda, as does much expressionist drama. Although less forceful and persistent than Kokoschka, Gottfried Benn also uses shock in his plays for its own sake rather than in the service of a thesis.

Shock and outrage lay claim to an existence outside the frame of the artwork, because, in the context of early-twentieth-century cultural norms, the evocation of shock and outrage is not a function vouchsafed the work of art. For Kokoschka's audience disgust and vexation signify some sort of mistake. When a play begins to anger or appall, the spectators cease to see only the representation of an action and begin to notice the gestures of actors, the dictates of a director, or the words of a playwright, whichever seems to be the source of the play's problems. Kokoschka uses this fact to instill in certain elements of his plays an ontological density and vividness impossible to create within the institution of art's conventions for the representation of an action.

Neither *Mörder* nor any other of Kokoschka's early plays (I exclude only *Comenius*, which he wrote in his old age) attempt the dramatic representation of an action, as this project is outlined by Aristotle and Hegel. The schematic quality of the characters and the fragmentary, contradictory themes invoked also preclude the delineation of a dramatic situation. In place of these representational projects Kokoschka constructs an aggressively immediate spectacle. This project is easiest to see in *Mörder*, where it is not obscured by other concerns. The events depicted develop swiftly and vividly. In place of character development, psychological motivation, and thematic consistency, the play concentrates on physical movement, vivid colors, changes in lighting, aggressive verbal exchanges, and startling tableaux. This emphasis on spectacle is as true for the printed play as for its performance. To corroborate this, one need only note the frequent use of detailed, arresting didascalic descriptions, such as:

> She creeps round the cage like a panther. She crawls up to the cage inquisitively, grips the bars lasciviously, inscribes a large white cross on the tower, cries out.[10]

Denkler and Schvey both suggest that one can detect a change in thematic interests between the 1910 and 1916 versions of this play, but the distinctions they draw are based on the erroneous assumption that the thematic focus per se is the central concern of each version of the play. If one takes the position I propose, that Kokoschka is primarily concerned with the pure emotive power of visual imagery (either represented in a printed text or produced upon a stage), then his purposes are basically the same in the two drafts of *Mörder*, and the changes made can be explained as refinements in the pacing of the work or alterations necessitated by the different audiences for which the two versions were intended. Note, for example, the changes made to the Woman's last speech.

1910 version:
I don't want to let you live, you vampire, you feed on my blood, weaken me, woe to you, I kill you—you fetter me—I trapped you—and you are holding me—let go of me, bleeder. Your love pinions me—as with iron chains—throttles me—let go—help! I lost the key that held you fast.
Lets go the grille, writhes on the steps like a dying animal, her thighs and muscles convulsed.[11]

1916 version:
WOMAN (*more and more violently, screaming out*)
I don't want to let you live. You! You weaken me—I kill you—you fetter me! I trapped you and you hold me! Let go of me—you pinion me—as with iron chains—throttled—away—help! I lost the key which held you fast.
lets go the gate, collapses on the ramp.[12]

While the Woman's words are less vivid in the 1916 version, Kokoschka emphasizes more emphatically in this draft the strident quality of her voice: "more and more violently, screaming out." He increases the intensity of her emotional outburst but reduces the verbal and gestural eloquence of this outburst. The vampire imagery and reference to love have been dropped in favor of a stark description of a struggle between two pronouns, You and I. The Woman's words here refer more forcefully to the struggle between herself and the Man than do the words in the 1910 version, in which the richer imagery draws more attention to the intensity of the Woman's loathing than to the intensity of her war

with the Man. Her quivering death throes in the first version are a gestural corollary to her vivid talk of vampires and enslaving love: they bare the wounds inflicted on her soul rather than drawing attention to the clash of arms between herself and her adversary. In the 1916 version the Woman is held more securely to the battlefield of the dramatic action. Her screams rise more sharply and are more piercing in this version, but they rise from the smoke of combat and not from the depth of her soul. At the climax of the 1916 version the tension of introspection gives way to the horror of open conflict.

The externalization and simplification of the agony in the Woman's last words should not, however, be seen as a significant shift in emphasis. Both plays end with the open conflict occasioned by the Man's resurrection and exit, so the 1916 version's revisions simply provide a more effective transition from the smoldering paranoia developed earlier in the play to the explosive violence at the end. Indeed, while de-emphasizing characterization in favor of conflict in the Woman's last words, the 1916 version adds emphasis to other character-delineating moments. Note, for example, the more elaborate descriptions of the Man and Woman made early in the second version (cf. 36–37 and 46–47). Since the 1910 version arose from an intimate performance, at which Kokoschka was responsible for costumes and makeup, and was accompanied, in its printed form, by his own drawings, he may have felt that elaborate delineation of character would only be distracting. The 1916 version, on the other hand, was intended for performance at the Albert-Theater in Dresden. In this larger venue, I imagine, Kokoschka felt the bodies of the actors would not be sufficiently imposing without a more elaborate verbal augmentation of their emotional energy. In a way the words added to the 1916 version replace the nerves Kokoschka drew on the faces of his actors in 1909.

I suggest an equivalence between the intricate, aggressive makeup of the 1909 production and the intricate, aggressive verbal augmentation of the 1916 version in order to stress Kokoschka's exteriorization of emotional energy. Denkler suggests that the verbal detail of the 1916 version increases the ambiguity of the play, because he only sees how this detail obscures the articulation of a dramatic situation among and around the characters. Taken individually, however, without attempting to relate them to a definable intersubjective milieu within which the characters have their psychic existence, the details added to the 1916 version are remarkably vivid and direct.

Banished boy-child of the mother of sorrows
Fled with serpent-encircled head.

(*Seven Expressionist Plays*, 26)[13]

FIRST MAIDEN *slyly*

Our Lady is lost in the web of her thoughts,
Has not yet reached full shape.

SECOND MAIDEN *boasting*

Our Lady rises and falls,
but never is brought low.

THIRD MAIDEN

Our Lady is naked and smooth,
but ever of open eye.

(27)[14]

These descriptions do not contribute constructively to an understanding of the inner emotional life of the characters but do display an aggressive emotional charge all their own. Spectacle has replaced drama as the central focus of the play. The ontological spring of the play's emotional impulses lies in the gestures made and words spoken rather than in the inner life of the characters. Kokoschka uses thematic motifs to subvert the characters' claims to an independent mimetic existence and then undercuts the existential primacy of these motifs by making them fragmentary and inconsistent. Nothing insists upon its own existence but the visual images conjured in the immediate space of the drama or in the mouths of the actors. Kokoschka's other plays maintain the insistence upon the visual at the expense of the dramatic made in *Mörder* but complicate and problematize in various ways the visual spaces they create.

Melodrama and Myth

The primacy of the visual space is, perhaps, more obvious in *Das brennende Dornbusch* (*The Burning Bush* [1913]) than in *Mörder*, because *Dornbusch* moves away from the shell of dramatic representation maintained in *Mörder*. Despite the exteriorization of emotion in *Mörder*, the play exploits a conventional dramatic form: a struggle between two

figures. In *Dornbusch* a number of auxiliary figures emphasize, echo, complement, criticize, and extend the vacillating but ultimately doomed love relationship articulated between the central couple. Hence, in this play Kokoschka's concerns about the dynamics of sexual attachment find embodiment in the fluid interplay among the entire cast of characters, rather than in the conflict between the two main characters.

Because the characters have no inner lives from which to generate dramatic situations, their actions take the form of an interplay rather than an interaction. Their relationships to one another are closer to the relationships between musical chords and motifs than to the relationships between dramatic characters. In other words, the ontological autonomy of the characters is sacrificed to the unity of the spectacle just as the particularity of a musical chord or motif is always dependent upon its place in the musical piece as a whole. Note, for example, how the maiden takes the place of the Woman at the end of the third scene (*Werk*, 104) and how the Mother and Child at the beginning of the fifth scene set off and comment on the pietà tableau formed by the Man and Woman (107–8). These are the only appearances made by the maiden and the mother and child. These "characters" have no inner life, and no attempt is made to rationalize their appearances under the conventions of dramatic mimesis. They are simply part of the exteriorized manifestation of anxieties and desires that constitute a certain type of love affair. They are elements of the Man and Woman that Kokoschka cannot articulate clearly enough upon the surface of these main "characters."

Besides making the entire cast of characters part of the visual display of the relationship between the Man and Woman, Kokoschka draws the space around them into a direct concern with the principle themes. Lighting and scenery do not delineate the space within which the events unfold but, rather, form a part of the events themselves. Their sentient polymorphousness often equals that of the characters. In place of the internal-external duality of drama Kokoschka articulates an animated external space in which the lighting and scenery emit emotional impulses almost as eloquently as do the characters:

> Whitish light, open door, which now throws light in, beams of light rise from the two rooms, cross, and seek each other in the middle elevation. (*Werk*, 98)[15]

Man and Woman opposite one another on two crags . . . as long as
he speaks, white light, which is interrupted with red as soon as she
answers. (104)[16]

While allowing other characters and the lighting and scenery to
articulate emotional and volitional states that would, under the conven-
tions of drama, be reserved for the separate and interactive eloquence of
the two lovers, Kokoschka diminishes drastically the dramatic force of
the lovers' words and gestures. The dialogue is often abstractly lyrical,
concerned with remote mythical landscapes rather than with concrete
events in the dramatic here and now.

> The deep waters slept,
> The mountain stood empty of shadows
> And there was no time
> And no beast heard
> And no fire warmed
> And no flame singed,
> When there was no love.
>
> (98)[17]

At other times the characters talk past each other, absorbed by com-
pletely different issues, as in, for example, the stichomythic nondialogue
between the Woman and the men at the beginning of the third scene.
When the lines of dialogue do in some sense match up, it is often not
because two distinct characters are communicating with each other but,
rather, because the characters' independent lines of thought converge for
a moment.

MAN . . .

> The fire asks, what shall I do with myself!
> And lies down in the ashes.
> Already oddly and without sorrow . . .

WOMAN

> . . . the day's glow closes above me.
>
> (99)[18]

The lack of true dialogue—that is, a direct verbal interaction among distinct psychological entities—highlights the peculiar ontological status of the characters. They are not characters in the Hegelian sense, that is to say, psychological entities whose anxieties and desires are articulated in and shaped by an unfolding intersubjective present. They are, rather, emotional beacons that broadcast images of subjectivity but do not receive; or, to use Artaud's terminology, they are hieroglyphs, part object and part sign, frozen forever in the state of being they symbolize.

To increase the immediacy of the hieroglyphic characters and sentient milieu, Kokoschka undercuts their ability to articulate one unified theme (and, hence, undercuts the possibility of characters and milieu becoming a medium of discourse) by coloring them with disparate styles and moods. Already in *Mörder* the mythic style of the piece is fractured into sexual, Christian, and pagan-heroic modes. In *Dornbusch* the confusion of styles and moods reaches a higher level: the mythic strand, just as polyglot as in *Mörder*, is augmented by a melodramatic strand. The aggression and terror of the mythical elements is balanced precariously against the sentimentality and pity of the melodramatic elements. The richer, more profane imagery in this play also gives it a strong subjective, lyrical quality that works against dramatic interaction and sides at times with the mythic and at times with the melodramatic elements. At times these distinct stylistic elements create a vertiginous seesawing effect (note, in particular, the spectacular close of scene 1, in which the Man leaps from a railroad bridge into a river, and the jarring change in scenic character in scene 4, in which realism gives way entirely to allegory with the Man and Woman isolated on rocky crags), while, at other times, particularly the last scene, in which the man dies, the two modes of representation overlap in an eerie equilibrium and coexistence.

That the last scene seems able to hold the disparate elements of the play together should not be taken as a sign of some sort of resolution. The last scene is a pietà in which death and mourning draw together the heroic and sentimental in a sober recognition of the impossibility of their coexistence. On the level of representation this final scene is, of course, the central couple's realization of their inability to live together, but, given the tenuous, diffuse existence of this couple, the failure of the play's motifs to cohere is at least as noticeable a line of action in the play as the lovers' personal fates. Indeed, to a significant extent the warring of mimetic conventions throughout the play and their momentary equilibrium at the end take the place of the etherealized conflict between the Man and

Woman. Conversely, the judgment the Chorus passes on the failure of the couple's relationship could stand equally well as an admonition to an audience expecting a more conventional and coherent drama:

CHORUS (*Question*)

> Why are you not good?
> Why are you not good?

CHORUS (*Answer*)

> Because they should have simply existed
> but they wanted to persist in appearance.

<div align="right">(<i>Werk</i>, 110)[19]</div>

Kokoschka avoids the frozen appearances of conventional representation in favor of the labile contradictions and contrasts that give the visual and verbal surface of his plays an existence all their own.

Theatrical Collage

In his farcical plays, *Sphinx und Strohmann* (*Sphinx and Strawman* [principal published version 1913]), and its expanded revision, *Hiob* (*Job* [1917]), Kokoschka uses a collage construction to flatten out and add decorative textures to the spectacle of the male-female relationship. Since even conventional farces are only marginally dramatic in that the motivating force behind their actions arises from a stock repertoire of theatrical gestures, rather than from the free interaction of significant characters, we should not be surprised that Kokoschka's strategy for heightening the visual immediacy of this genre differs from his approach to the material of his mythic plays. The emotional charges at play in farce do not tend to build up in the internal space of the characters' egos, but they do tend to inhere in fixed gestures and conventions. In Kokoschka's farces this ordered channeling of theatrical emotion is broken up by appealing to a vertiginous array of distinct and sometimes contradictory conventions. The protagonist of *Sphinx and Strohmann*, for instance, is alternately and sometimes simultaneously presented as a puppet (the straw man of the title), a circus clown, the fall guy in a cabaret skit, the deceived husband in a bedroom farce (with parodic borrowings from domestic tragedy), and a mouthpiece for philosophical and theological speculation and blasphemy.

Hiob suppresses the puppetry of the earlier play but keeps all the other motifs and adds to them songs drawn from the Viennese *Volksstück* tradition (popular theater incorporating song and spectacular scenic effects) and parodic visual and verbal quotations from high culture's aesthetic masterpieces, particularly Goethe, Greek mythology, and the Bible. The hero of this play (Job rather than a straw man) is allowed a more realistically human repertoire of emotional expression than is the hero of the play's earlier version, but the deployment of this repertoire lacks the stylistic coherence necessary for a character to become a unified psychological entity. Job is at times a circus clown, a cabaret comedian, a melodramatic *Volksstück* character, or a parodic reincarnation of Faust or Christ. The various shapes and colorings the protagonist takes on contribute to the wild theatrical spectacle of the whole but prevent him from playing the part of a volitionally autonomous character engaged, through an interaction with other characters, in the creation of a dramatic action.

Whereas the mythic plays concentrate their emotional energy in the surface imagery of what they represent, the farces move the emotive focus to the space between the spectacle and the audience. In *Sphinx und Strohmann* the deployment of emotional energy resembles, in a twisted way, that at a children's puppet show: the audience, rather than the actors, provide the emotional outbursts. This play comes closer than any other by Kokoschka to the traditional use of dialogue to create an interpersonal space in which the intensional contours of autonomous egos interact in the material extension of a here and now, but in this case the here and now is not the world of the play but, instead, the play's reception by its audience. Notice with what nuances of feeling Firdusi (the protagonist) addresses and reacts to the emotive impulses of his audience:

> FIRDUSI: (*To the public.*) When I grab my handkerchief you all start to cry, how touching. But why do you look at me now so cooly, one hundred indifferent people against a single desperate person? Only a nuance separates the hero from the audience. Do you believe in a bluff? I am only exploiting your intelligence and your nerves and our mutual romantic interest in ghosts.[20]

The direct addresses to the audience in both farces are unusual because they are not cases of characters speaking aside or out of character but, rather, of inanimate objects speaking. The lifeless quality of the characters is most apparent in *Sphinx und Strohmann*. Despite the fact that

the protagonist plays the roles of circus clown, cabaret comedian, and bedroom-farce character, he is first and foremost a straw-filled puppet. Many other "characters" in the play have even less claim to life than him. His son, for instance, is a rubber finger puppet, and the ten men in black suits are painted on a curtain. The events that unfold in the play also have a rigid, artificial quality. Actions proceed from a fixed script rather than through unforeseeable developments in real time. To stress this mechanical quality, Firdusi, the straw man and protagonist, in his first long speech, recounts in the past tense what is about to happen on stage:

> I had a wife, I treated her like a goddess and she left my bed. She said to our sad little chambermaid, "Help me on with my traveling cloak" and then disappeared with a healthy muscle man. (*Expressionist Texts*, 31)[21]

In the first version of this play Kokoschka clearly intends the action on the stage to be a repetition of what has already happened.[22] When the play begins Firdusi declares that his wife has left him, then he remarries only to discover that his new bride is his old wife and that she has cuckolded him once more. In subsequent versions, however, references to concrete events are more obscure. The physically and psychically distinct Lily of the first version becomes the ethereal Anima in later versions, part female archetype and part Firdusi's imagination. More generally, the clockwork unfolding of events takes on the quality of an obsessively repeated dream. This oneiric mood is disturbingly uncanny, because, while it ridicules its own obsessiveness by means of the toy characters it employs and its self-conscious comments on the predicaments it delineates, it is, nevertheless, incapable of turning away from its obsessions. The oneiric quality of the play is also uncanny in that the dream seems to be watching the audience as they watch the dream. In this way the play implicates the audience in its spectacle of obsessions and leaves them no solid ground on which to stand.

In moving to a more human protagonist in *Hiob*, Kokoschka is not abandoning or seeking to lessen audience/spectacle interaction in favor of a more autonomous action. Making Job human allows Kokoschka to play more fully with the conventions of bourgeois drama. The fragmentation and flattening of drama's mimetic material, which Kokoschka accomplishes with his collage construction style, is, indeed, more startling in *Hiob* than in *Sphinx und Strohmann* because of the initially more human

quality of the characters. In *Hiob* Kokoschka paints with purer colors than in *Sphinx und Strohmann*. He manipulates and distorts primarily the conventions of bourgeois drama—that is, domestic tragedy, bedroom farce, melodrama, and thesis play. The play is designed to exploit the emotional reactions of the audience to these conventions rather than the emotional interactions among characters placed within these conventions. The collage-like juxtaposition of the play's elements deanimates them, makes them as lifeless as puppets. This adds further piquancy to the audience address: that which should be alive and is patently dead, nevertheless, speaks.

The eloquent morbidity of *Hiob* stems to a large extent from the eerie way in which Job stands in for the archetypal, bourgeois male and in which the play organizes itself around him. The idea that Firdusi's imagination has produced Anima is present but heavily veiled in *Sphinx und Strohmann*. When Firdusi first asks: "Who are you? What's your name?" it is the parrot, a sort of animate echo, that answers, "The female soul, Anima, sweet Anima" (*Expressionist Texts*, 31). This suggestion that Woman is only Man's own ideals and prejudices thrown back at him receives fuller treatment in *Hiob:*

> JOB (*sings*): How love has twisted me since in this empty house a gentle woman's voice has called to me to search for her—has vexed me into a labyrinth. From it an echo teases, and a breeze of air makes me run helter-skelter everywhere. "As ye sow, ye are like to reap." Because in a moment's breath she metamorphoses by some back door into a creature that—is I myself![23]

The parrot sums this up succinctly: "Anima—your soul, your wife." Near the end of the play Adam touches on the same idea when he declares that Job's suffering and death was not brought about by other characters or forces intriguing against him but, rather, by the untenable extremes of his own ideas.

> You've placed your wife too high in the heavens. Only now when she falls can you see through her and view her bottom. (169)[24]

Anima's metaphysical fall is embodied in her comically corporeal fall from a second-floor window. Whether this is meant to raise the comical to the allegorical or reduce the metaphysical to the ridiculous is never

clear. This scene and many others are too farcical to take seriously and yet too serious to be farce. Kokoschka uses the dream/illusion motif and the conventions of farce to undercut the psychic integrity of the characters, but he allows neither the dream/illusion motif nor farce to provide a foundation and organizational scheme for the play as a whole. As a result, the mimetic conventions upon which *Hiob* is based remain troublingly vague. If Kokoschka had used conventional dramatic mimetic conventions, or had wholeheartedly adhered to the mimetic conventions of clowning or of the *Volksstück*, the meaning or intentional lack of meaning of the various elements of the play would be clear. If he unambiguously declared his play the representation of a dream or fantasy, the characters would recuperate their individual integrity and their dramatic force within the new nonrealistic mimetic conventions: they would cease to be representations of distinct individuals and would become representations of distinct psychic forces. But Kokoschka is constantly shifting his ground, quoting from contradictory sets of mimetic conventions, and refusing to establish a mimetic frame within which messages could be unambiguously articulated and characters could have a clearly defined form of individual integrity and generate stable forms of intersubjective conflict. Similar shifting appeals to numerous mimetic conventions and contradictory theatrical styles appear in the plays of Vitrac and Lewis.

Of all the indistinct characters in *Hiob* Anima is the most important. She is more than just an image in Job's mind, but exactly what more she is cannot be pinned down. She flutters butterfly-like between being Job's fantasy and being the archetypal woman. Kokoschka does not make clear which of these alternatives is the right one, but an examination of the various drafts of the play makes clear his intention to connect Anima's behavior with the desires and prejudices of Job, to suggest that her being is in some sense generated by him or by men in general.

In the first version the female lead is named Lily. This is clearly a reference to Lilith, the first woman, molded from clay, as was Adam. Lily exhibits the same defiantly independent behavior as that attributed to her eponym. Changing her name to Anima makes her ontological status more ambiguous, and adding the references to Eve suggests a male source for this image of womanhood. When Anima, at the end of *Hiob*, speaks of herself in the third person ("Anima . . . is truly—Eve") and complains of the insults cast upon her in the play, Kokoschka seems to be suggesting that real women (in particular, the one playing the female lead in this piece or a true female voice rising suddenly from the printed text)

do not conform to the archetype exemplified by Anima. But then what are women really like? We do not know—because the stage is dark, we cannot see who is speaking.

In a way this ending seems to adhere to the misogynistic ideas about women current at the turn of the century and articulated with repellant precision by Weininger. From this point of view the black stage at the end of the play does not declare the author's ignorance of the female but, rather, represents her in her purest form: negativity and night. But in adhering so closely to Weininger's ideas does not Kokoschka, in fact, upset them? Sex, the body, chaos, etc., disturb fin-de-siècle Vienna. To suppress these disturbances the dangerous material becomes the archetypal features and fixations of femininity, society's internal, comfortingly repressed other. Kokoschka's plays, however, revel in the uncontrolled outpouring of this dangerous material. Anima does not concede to the subjugation of women but defiantly embodies the forces that bourgeois society is trying to suppress.

The anarchy welling up around Job (which is, perhaps, the result of his own morbid obsessions) brings this play closest of all Kokoschka's work to an absolute defeat of the mimetic impulse, but even here flickers of representational signification maintain the ambiguous quality of Kokoschka's stage space and prevent the action from sliding into a univocal parody of art. Consider the role of Death in the play and the numerous cryptic generalizations such as Job's:

> The soul of man or magic lantern. . . . Times were when it projected God and Devil into the world; these days it casts women on the wall! (*Expressionist Texts*, 168)[25]

Such elements are a vertiginous combination of farce and serious thesis. They ridicule the hackneyed gestures of profundity rife in conventional drama but do not forsake all claims to meaning. Vague intimations of significance are pasted beside, under, and across fragments from bedroom farce, domestic tragedy, melodrama, *Volksstück*, and thesis plays to create an uninhabitable milieu of contorted and broken structures of meaning. These structures, which usually lend support to bourgeois ideology, are, in *Hiob*, reduced to ridiculous uselessness. They have become comically opaque shards of dramatic material obscuring the view through the proscenium posited by the conventions of drama. The aggressive opacity of Kokoschka's theatrical collage probably explains why the 1919 Berlin

audience found this play more disturbing than *Das brennende Dornbusch*[26] and why the dadaists in Zurich initiated their theatrical endeavors with a performance of the earlier draft of this work, *Sphinx und Strohmann, ein Curiosum.*

The dadaists drove the notion of an opaque theatrical collage to one of its logical extremes, but this extreme is not one toward which Kokoschka directed his work. Kokoschka did not want the heteroclite realities of the elements he glued together to destroy the autonomy of the work. He was interested only in using such elements to give his works a vertiginous piquancy. With this end in mind he drew back from the edge of autonomous art, represented by his theatrical collage in *Hiob*, and applied his play writing efforts to a montage aesthetics that subjugated the heteroclite realities of his aesthetic material to the autonomy of the work as a whole. While this project might be considered less radical than his accomplishments in *Hiob*, it is also more formally sophisticated and still far from the concerns of contemporary conventional or modernist drama.

Drama as Palimpsest

In conformity with Kokoschka's other plays, *Orpheus und Eurydike (Orpheus and Eurydice* [1919]) lacks a coherent plot. Unlike the other plays, perhaps, here the intentionality of the incoherence is manifest: Kokoschka purposely dismantles and discards the sound plot potentials offered by the myth of Orpheus. By the criteria of a well-made play, Kokoschka's *Orpheus und Eurydike* lingers upon the stage much longer than it should. After Eurydike is reclaimed by Hades, the logical culmination of a well-made version of the myth, we are given a long scene in which Orpheus returns in rags to his ruined home, plays a dissonant tune upon a broken lyre, and is hung by a drunken crowd of servants, peasants, and soldiers. This is followed by a brief scene concerning Psyche and Amor and then another long scene in which a column of smoke representing first Orpheus's mother (perhaps) and then Eurydike pleads and argues with the corpse of Orpheus. The spirit of Eurydike materializes from the smoke and tries to reconcile Orpheus to her. He becomes hysterical, and she strangles him. But then even this climactic moment is followed by an epilogue, in which Psyche soliloquizes over her relationship with Amor.

Kokoschka's rendition of Psyche and his use of her in the Orpheus and Eurydike story bear even less resemblance to established myths than

does his delineation of the two main characters and their deeds. Here Psyche acts as Eurydike's child, younger sister, and helpmate. Orpheus explains her origins to her thus:

> He who has no body yet moves us mightily has freed you for a while from the open air in order to serve Eurydike here. (*Werk*, 116)[27]

In Kokoschka's version of the myth Eurydike's death is not accidental but planned by Hades, who sends three Furies to accomplish it. For a few moments Psyche prevents them from crossing the threshold to Eurydike's chamber. They respond to this resistance by threatening to frighten away Psyche's lover, Amor, who only comes at night, and then by promising to illuminate Amor's face with their torch so Psyche can see him for the first time. When he arrives the light from the torch blinds him, and he falls from his chariot. Psyche runs to his aid, and the Furies are free to seize Eurydike. Later Psyche's assistance, rather than Orpheus's skill on the harp, secures Eurydike's release from Hell, and Psyche makes a brief ministering appearance in the final confrontation between Eurydike's spirit and Orpheus's corpse. Her affair with Amor is not followed in any detail but is touched upon by a scene in which she soothes his wounded eyes and by her musings on him in the epilogue—both these scenes indicate there is no animosity between them, despite Amor's injuries.

Vague approximations of causal coherence are hinted at from time to time but never consistently nor with an intelligible completeness. Eurydike's death is a case in point. At the onset of this segment the Furies seem the primary material movers of the plot. Like a protofascist death squad, they invade Eurydike's chamber in the dead of night and command her to follow them. After some arguing and pleading, she agrees to go if she can first take leave of Orpheus. Here the physical presentness and efficacy of the Furies begin to disintegrate: at times they interact with Orpheus and Eurydike, and at other times they recede to little more than ominous shadows on the wall. The direct instrumental cause of Eurydike's death is a snake bite, but the ontological force of this cause is drained away by the context in which it occurs. Her last moments with Orpheus take on a dreamy, ritual character. She places a bowl of milk on the floor for the snake, forces herself into a cheerful mood, and, after some effort, banishes Orpheus's funereal demeanor. At the apogee of the couple's last cheerful embrace the snake bites Eurydike on the heel, and the Furies carry her off.

This turn of events is particularly perplexing because the snake does not belong to the Furies. It first appears in act 1, scene 1, cradled in the arms of Psyche. In this scene Orpheus suggests that, while Psyche is responsible for Eurydike's protection, she also represents some sort of threat:

> You, shaped like her, her playmate, should moderate the lightning bolts and turn back the storming fate, which winds forth through you! (*Werk*, 116)[28]

Throughout this play vague, anxious threads of culpability and aggression are spun and disintegrate, drawing the characters together in constantly changing patterns. Simultaneously, the ability of characters to act upon one another in concrete ways, through their words and actions, is constantly undercut. Verbal exchanges are fraught with ambiguities and break off inconclusively. Note, for example, the moment of Eurydike's death:

> *the snake bites Eurydike on the heel.*
> ORPHEUS: Why do I feel drunk with happiness?
> EURYDIKE: So we see all too well that we have met in the same thoughts. Misfortune still remains in my hand. Take this, ei! misfortune, it's a gift—
> *falls dead in the arms of the Furies*
>
> (*Werk*, 129–30)[29]

Physical actions also often fail to have the definitive efficacy one expects from them. Orpheus's untimely gaze, for instance, does not send Eurydike back to the underworld. She returns to Orcus only after a long, heated conversation reveals to them both that Orpheus does not love the woman Eurydike has become after several years in the land of the dead. At the end of this encounter Orpheus threatens Eurydike with a knife, but, by virtue of a sudden scene change, we do not know whether he kills her or she simply wills herself back to Hades. The encounter between Eurydike's spirit and Orpheus's corpse in act 3 shows that even death has no definitive effect on the behavior of the play's characters.

When the characters do accomplish physical actions that alter the situation in which they exist, the intersubjective presentness that would allow these deeds to produce the rudiments of a dramatic action is

suppressed by veiling the characters with sleep, madness, and intoxica-
tion or by giving them an inhuman, mythic existence free of the psycho-
logical weight of the here and now. Insofar as the play contains decisive
turns of events, these turns are not accomplished by the interplay of
characters acting upon the matrices of anxiety and desire that define
their selves but, rather, by impersonal forces that seize possession of
certain characters or well up within the stage space as a whole.

The literary and mythological history of the characters in this play
gives them an ontological integrity lacking in the characters of Ko-
koschka's other plays, but they are not allowed to exploit this integrity
within the world of the play. Their intricate individuality and potential
openness to the influence of other characters is suppressed when they
speak and act in their sleep, as Psyche does when confronting the Furies,
or in a drunken stupor, as do the mad sailor and the lynch mob, or from
beyond the grave. Human actions, rather than being anchored in the
psychological motivations of the characters and thereby giving rise to a
dramatic action in the Aristotelian sense, intermingle and blend into the
stage spectacle as a whole.

In act 1, scene 1, Kokoschka does allow the main characters a few
moments of lucid humanity in which their communication with one
another creates an interpersonal dramatic space, but this traditional repre-
sentation of a loving couple flickers and dissolves as the play progresses.
First, the intersubjective dramatic energy coalesces in isolated points of
solipsistic, lyrical subjectivity: characters talk to themselves rather than to
one another. Then, in turn, these points disintegrate, and the energy of
the work flows into the flux of images and ideas that is, in the end, the
main concern of the play. Dramatic interaction and the integrity of indi-
vidual characters are both sacrificed to the fluidity of the overall stage
effect.

Act 2, scenes 3 and 4, provide a good example of how the emotional
concerns of the characters blend with the visual spectacle. The setting is a
black boat languishing in a dead calm. A mad sailor is at the helm, three
Furies sew a net, and the other sailors are asleep on the deck. In their sleep
the sailors pray to Amor to bring a wind. The mad sailor casts the Furies'
net into the sea and brings up a skull, from which rolls Eurydike's lost
ring (a love token from Orpheus). In the next scene, below deck, Or-
pheus finds that the inscription on the ring has changed from "One
happiness in each other" to "—happiness—is another's" and learns that
Eurydike gradually forgot him during her sojourn in Hell. He draws a

knife, Eurydike says she will return to Hell, the scene shifts suddenly to the deck, the wind rises, the sailors awaken, Orpheus bursts from the cabin screaming woe, and the set is enveloped in clouds.

This ploy of cranking emotional tension to an excruciating tautness then releasing it in a dazzling visual display is repeated six times throughout the play, sometimes with Orpheus and Eurydike the agents generating the tension and sometimes other characters, such as the sailors or Psyche.[30] With these episodic visual and emotional climaxes rather than a character-based action serving as the chief source of structural stability in the play, the characters tend to soften and blend into one another. Changes in their character do not seem so much instances of psychological development as instances of aesthetically or thematically motivated changes in shape.

Despite Kokoschka's clear interest in the visual power of the theatrical spectacle, he does not follow the suggestions of contemporary advocates of a purely theatrical art and reduce his characters to Übermarionettes, whose significance is determined solely by participation in the visual spectacle. Besides exploiting the scenic value of characters, he draws upon their emotive and thematic potentials. Psyche and Amor provide the best example of the thematic value of characters. In terms of the mythological and literary tradition and the demands of dramatic action, these two characters are out of place in this play. Kokoschka introduces them because the emotive impulses generated by their love affair reinforce or play counterpoint to the impulses generated by Orpheus and Eurydike and because the god Eros and the human soul (*psyche*, in Greek) are important concepts in Orphism, of which Orpheus is the putative founder. This thematic affinity between the two couples explains the unusual shift of focus at the end. Since the play is less concerned with the fate of Orpheus and Eurydike than with the articulation of themes they embody, it makes perfect sense to end the play by shifting to characters that embody the legacy Orpheus bequeathed to Western civilization: love and the soul.

Yet we should not allow the importance of broad themes in *Orpheus und Eurydike* to seduce us into believing that in this area lies the order and coherence of the work. Kokoschka uses the thematic value of characters to undercut their dramatic value but does not give the themes invoked a coherent prominence of their own. He is interested in identifying and exploiting to the full the expressive potentials of the dramatic form that are not tied directly to the representation of a dramatic action. The thematic

and visual value of characters serve this end both in their own right and as means of separating the characters' emotion-generating psychological intensionality from the intersubjective interplay that creates dramatic action. The resulting three distinct aspects of character prominent in this play—namely, the thematic, the emotive, and the visual—do not combine to form a nondramatic, coherent whole but, instead, maintain a multivalence bordering on an iconoclastic rejection of aesthetic representation in favor of aesthetic play.

The iconoclastic impulse is, indeed, stronger in this play than in the plays of the purer iconoclasts within the dada movement, because here it is maintained by the continual destructive warring of aesthetic motifs. Dada (in its most radical Berlin manifestation) simply turns its back on representation, while Kokoschka continually attacks representation on its own ground. He draws the aesthetic material for this play, the material used to create the characters and milieu, from three potentially discordant universes of discourse: mythology, lovers' tragedy, and theatrical spectacle. Then he destabilizes the ontological integrity of the characters further by separating their thematic, emotional, and scenic values. Consequently, the characters break into polymorphous fragments that inhabit a theatrical space quivering with contradictory aesthetic currents.

The fractured, multivalent space conjured up in this play bears some resemblance to the oneiric mode of *I*-dramaturgy developed most strikingly by Strindberg.[31] A letter Kokoschka wrote in 1950 adds to the evidence for the ego-centered organization of this play by noting the very personal agonies and hallucinations from which it sprang:

> The play *Orpheus und Eurydike* still means a lot to me today because it . . . was not written with ink but with blood that still came profusely from my lung, which was wounded—and it wasn't written, because my hand was still paralyzed from the head wound, but spoken, whispered in ecstasy, in delirium, sobbed, implored, howled in the anguish and fever of approaching death.[32]

Despite the similar reliances on polymorphous fragmentation in this play and Strindberg's late work, Kokoschka's drama differs profoundly from Strindberg's. Although Kokoschka's personal ghosts and demons may have provided the impetus for *Orpheus und Eurydike*, the play does not group these spirits around a central ego as does Strindberg's *I*-dramaturgy. Kokoschka's play is more "id-drama" than "ego-drama." *I*-dramaturgy

internalizes both the spectacle and dialogic interactions of drama, setting the play in the intensional space of a single consciousness; *Orpheus und Eurydike* externalizes emotional impulses, making them part of a centerless spectacle.

The seductive otherness and discordant multivalence of Kokoschka's play resemble the world of the id more than that of the ego but do not represent the subconscious realm of libidinal drives in the way that Strindberg's oneiric drama represents the ego's attempts to control its animal and idealist drives. Two factors prevent *Orpheus und Eurydike* from achieving a coherent unity under the aegis of id-drama. First, the forces at play in this piece are not entirely libidinal nor even easily divisible between the allies of the id and of the superego. The characters, their motivations, and the scenes they inhabit are all uneasy amalgamations of the idealistic and the animal, the rational and the erogenous. Second, the classical status of the myths Kokoschka invokes counterbalances with its impersonal, institutionally sanctioned aura the dark, chthonic anxieties and desires set loose within the play. Consequently, the id-drama of *Orpheus und Eurydike* remains, like the mythical tale, the lovers' tragedy, and the theatrical spectacle, an element in rather than the foundation of the play.

Unlike the elements of Kokoschka's farces, the elements of *Orpheus und Eurydike* do not form an opaque, mimesis-defeating collage. Events are represented, but the montage-like construction of the work obscures them. In place of the transparent mimesis vouchsafed by consistent adherence to a coherent set of conventions, Kokoschka establishes a translucent mimesis in which represented entities and events are faintly shadowed forth beneath layers of intervening aesthetic material. What makes this play particularly uncanny is the multivalent ontological status of the aesthetic material and objects represented. Neither the screen through which the spectators/readers are forced to look nor the objects upon which they attempt to focus their gaze are stable. The elements of the represented object and the obscuring screen are constantly changing places: at some moments subconscious passions seem to hold the privileged place of represented object; at other moments the mythical action, the lovers' relationship, or the visual spectacle take the privileged place. Where the collage of *Hiob*, despite its aggressive rejection of the mimetic project, allows the mind's eye to rest upon its opaque surface, the montage of *Orpheus und Eurydike* requires a constant, vertiginous refocusing of the eye. The play is an animate palimpsest, its various scripts constantly moving through and intermingling with one another.

In the palimpsestic montage of *Orpheus und Eurydike* Kokoschka's exteriorization of drama reaches its apogee. Here all solid bodies vanish, so that the notion of an interior becomes meaningless. The space of the drama becomes a dense haze of fragmentary aesthetic conventions and shards of *boulomaic* energy (wishes, intentions, and willingness) that hover in a void. Kokoshcka in effect reduces drama to pure spectacle not by eliminating the interiority of characters but, rather, by exploding this interiority. He forces psychic obsessions into the visual space of the play, simultaneously objectifying anxiety and desire and dissolving the objective world into a shifting mist of spectacular subjective hallucinations.

While Kokoschka forces drama to disintegrate into pure visibility, Gottfried Benn creates dialogic tensions between the visible and verbal aspects of drama. The aesthetic disturbance that Kokoschka cultivates on the (implied) visual plane of his play scripts Benn transfers to the more ontologically ambiguous plane of dialogue.

Chapter 4

Benn: Staging Impossibilities

Gottfried Benn is best known for his poetry, but early in his career (1914–17), as he was beginning to acquire a reputation for the gruesome imagery, cynical parody, and solipsistic nihilism of his poems, he was also writing plays. These plays, published in expressionist literary magazines, were intended not for performance but, rather, to explore paradoxes of representation and a depth of metaphysical skepticism out of reach within the conventions of lyric poetry. Whereas the interiority of Kokoschka's characters tends to dissolve into vivid stage images, Benn's closet dramas subvert the possibility of both a straightforward stage image and a purely literary dialogue. Set predominantly in medical schools and clinics, Benn's plays dissect the moral and ontological foundations of existence with a thoroughness that borders on annihilation.

When scholars of Benn's work mention the dramatic texts, they either dismiss them as experiments secondary to Benn's major concerns and accomplishments[1] or simply treat them as part of an oeuvre homogeneous for the purposes of the investigations in which they are involved.[2] Occasionally, fleeting reference is made to the fact that Benn's plays were never performed (e.g., Wodtke, *Gottfried Benn*, 25), but never do the critics discuss in detail the reasons for this. The critical literature on Benn shows little interest in discussing either what motivated him to work briefly in a dramatic medium or how this medium influences the shape and force of his literary project. Buddeberg discusses in one paragraph the ways in which Benn uses the dramatic form to expand upon his theme of "reality disintegration" (*Wirklichkeitszerfall*), but her observations touch on little more than the evident way in which the characters fail to address one another in the "dialogue":

The disintegration of reality, as it occurs in the Rönne pieces [Benn's early novellas], is even more strikingly noticeable in the two "dramas" concerning "Pameelen." Dramatic opposition appears to assert, at least, the reality of face-to-face contact. But this contact is also only illusion, because address and response run in each case on two different planes—they neither touch nor appeal to one another in any way. (137)[3]

To better appreciate Benn's interest in drama and the degree to which he participates in the anti-art avant-garde of the early twentieth century, we must first examine carefully the aesthetic position from which he created his early work.

Disruptive Aesthetics

At least one of Benn's aesthetic principles would find theater a powerful medium in which to work its effects. Like Kokoschka and most of the expressionists, Benn produces works designed to confront and shock, and nowhere is shock so forceful and confrontation so threatening as in the physical immediacy of the theatrical performance. Although Benn makes his most unalloyed use of the aggressively distasteful and unexpected in *Morgue*, this collection of poems assaults its reader in much the same way as anti-art theater does its audience. Titles such as "Little Aster" ("Kleine Aster") and "Beautiful Youth" ("Schöne Jugend") hold the promise of a culturally affirmative work of art in the same manner that the furnishings and staff of a respected theater do. Just as Kokoschka's audience at the Kammerspiel Theater in Berlin was outraged by what had been allowed to enter that honored theater, Benn's readers are shocked by the obscene and revolting images that he displays within the hallowed structure of the lyric poem. The ways in which Benn exploits, distorts, and desecrates the formal and thematic properties of the lyric poem also bear marked similarities to the ways in which Vitrac mutilates and transforms the themes and conventions of *boulevard* drama. Both authors play upon and ridicule the audience's or reader's expectations by rudely juxtaposing the most decorous and conventionally appropriate images or phrases with the most awkward, ugly, and unmotivated material imaginable. In *Morgue*, after inviting his readers to expect the conventional, genteel aesthetic values associated with delicate flowers and idealized images of childhood, Benn

overwhelms them with nauseatingly vivid apostrophes to eviscerated corpses and necrophagic rats.

In his plays Benn produces shock effects with images even more violent and obscene than any in his contemporaneous prose or poetry.[4] In *Ithaka* Professor Albrecht is beaten to death; in *Etappe* (Occupied Territory) political and commercial corruption ooze from every page and Dr. Olf periodically explodes with gruesome descriptions of battlefields or bodily functions; and in *Vermessungsdirigent* (Survey Director) a forced abortion takes place offstage, while onstage are displayed a gynecological examination, the poisoning of a child, a rape, and a bloody self-blinding. Enacting these scenes before an audience could easily raise the shock effect to unbearably excruciating levels, but it would be wrong to suppose that this has not been done simply for lack of a sufficiently courageous or sadistic director and producer. Benn's interest in discomforting his readers is mitigated by his desire to problematize the conventions of aesthetic representation. He turns to drama to exploit the relationship between word and image peculiar to this genre rather than to exploit the immediacy of the theatrical spectacle.

The dramatic genre calls for physical images more emphatically than does poetry or narrative prose. Readers of the latter need not actively construct a setting for the words. Because they consider the text before them a complete work of art, they expect it to describe and draw attention to all relevant aspects of the scene. In poetry and narrative prose physical images are only as important as the words at any given point make them. In drama, on the other hand, the form alone often guarantees the primacy of physical images. Readers of drama tend to consider the text a set of parameters for a mise-en-scène as well as or instead of a self-sufficient literary work of art. Even when not intended for the stage, the dramatic text conjures up in the mind of the reader a physical setting within which characters speak and move. Even when the text describes the scene with only the barest, most mundane facts, the reader will imagine vividly whatever details seem necessary for the prosecution of the action.

Benn exploits shock effects in his plays to open up a troubling distance between the words of the text and the images they provoke. Descriptions of violence are purposely laconic: the more outrageously brutal the deed, the more vague and commonplace the words used to describe it. A rape, for example, is described as follows: "Goes to the woman. . . . Grabs her. . . . Something happens."[5] In the dramatic medium these laconic

descriptions have a disturbing vividness that they would not enjoy else-
where, and Benn often pits this stage-oriented vividness against the more
purely literary powers of expression also present in his plays. The dramatic
text's double function as work of literature and schematic prompt book
allows Benn to draw attention to the gap between words and what they
represent by offering contradictory means of crossing the gap. To produce
Benn's plays on a stage would close the gap between the words and the
images they conjure up and would resolve the conflicts between literary
and theatrical images. A mise-en-scène of one of his plays could not avoid
interpreting the text—that is, transforming the words into images—in a
way that would destroy the confusions and ambiguities of interpretation
that Benn wishes to explore.

Attributing Benn's use of violence to his interest in the difference
between word and reality aids in explaining the lack of violence in
Karandasch. If Benn were using violence solely to shock, then *Karandasch*
would seem to testify to a weakening of his attack on his reader. The
incoherence in this play is certainly not as disturbing as the violence in
Vermessungsdirigent, but, insofar as the violence in the latter is a manifesta-
tion of the problematic of representation, the incoherence in the former
sharpens and magnifies this problematic. In this light, looking at the devel-
opment of Benn's drama from *Ithaka* to *Karandasch*, we can see that Benn's
aesthetic project involves an attack on the conventions of dramatic mime-
sis more than an attack on the emotional viscera of his audience, and
Karandasch advances the front of this attack from the representation of
violence to representation per se.

> As if words had meaning. We don't believe it any more, Renz, we
> don't believe it any more. All words, into which the bourgeois brain
> slavered its soul, for thousands of years, are dispersed, to where I
> don't know. (*GW* 2:358)[6]

Benn's doubts about the ability of words to mean, about the possibil-
ity of moving unambiguously from signifier to signified, form part of a
general motif of aporia and caesura. This motif finds further embodiment
in Benn's metaphysical solipsism, his moral and epistemological nihil-
ism, and his manipulation of the conventions of dramatic mimesis. For
our purposes, the last of these embodiments is of first importance, but
the manifestations of aporia and caesura in Benn's articulation of the

dramatic mode of mimesis are bound up with the ways in which solipsism and nihilism impinge upon his mimetic project.

In the late 1920s and early 1930s Benn describes the worldview of his early years as follows:

> In war and peace, at the front and in the occupied zone, as an officer and a doctor, between racketeers and aristocrats, before padded or barred cells, beside beds and coffins, in triumph and decline I never escaped the trance-like idea that nothing was real. (GW 4:30)[7]

> We invented space to strike time dead, and time to motivate the duration of our lives; nothing becomes and nothing develops, the category in which the cosmos becomes manifest is the category of hallucination. (GW 4:8)[8]

In questioning the existence of the external world, Benn's epistemological nihilism also questions the value of artistic representations of this world. Conventional themes and modes of representation affirm the importance of a world that Benn considers illusory.

Benn's extreme epistemological skepticism would make all artistic representation vain and meaningless were it not for the saving grace he finds in solipsism. In affirming the existence of the self-conscious subject, Benn creates some shelter from the emptiness and meaninglessness to which his nihilism reduces the outside world. In 1934 he describes his early poems as moments of monological stability that materialize briefly in a world of otherwise desolate formlessness:

> Again and again we come upon a form of "I" that, for a few moments, warms itself and breathes and then sinks into cold, amorphous life. (GW 4:46)[9]

Benn's "I" does not, however, enjoy the epistemological priority and ontological stability that Descartes, for example, attributes to his cogito. The existence of this "I" is both bound to and threatened by the concepts of "YOU" and "IT":

> Every IT is destruction, the scattering of the I; every YOU is destruction, the dilution of forms. (GW 4:14)[10]

Objects (every IT) break up the all-encompassing ontological integrity of the subject by converting a large portion of the entities of consciousness into the phenomenal ghost images of an external world. The more one accepts the ontological independence of this external world, the more the self withers to a thin phenomenological mist covering an alienated locus of noumenal objects and events. Other subjects (every YOU) adulterate the form of the self. They suggest other ways of constituting an ego, and in so doing, weaken the ontological priority and rigidity of form upon which the solipsistic self rests its case for order and stability—its defense against the chaotic and illusory world that surrounds it.

By 1934, and in all his subsequent work, Benn uses literature as a means of establishing some order, a momentary verbal concretion or "enunciation world" (*Ausdruckswelt*), in what he considers a fundamentally chaotic universe. Before and during World War I, however, his project is more radical. In the plays he wrote between 1914 and 1917 he embraces uncertainty and chaos rather than attempting to create an ordered moment separate from the formlessness of reality. In this period art is for him a means of measuring and playing upon the senselessness of the world rather than a method of creating order independent of the world. Drama is a particularly appropriate type of art for Benn's project because dialogue (YOU) and mise-en-scène (IT) can easily be used to disrupt the monologic stasis that Benn considers the only possible source (and, at best, a dubious one) of stability and meaning. In drama Benn can depict the disintegration of the self in the face of other minds and an external world. Moreover, the inappropriateness of this genre for his subject matter makes it the most appropriate medium for his art. He unfolds his doubts about the ontological constitution of the universe in an art form whose constitutive powers shudder and disintegrate under the burden of his themes. From *Ithaka* to *Karandasch* his nihilistic aesthetic increases progressively in power and scope. He starts with a parodic critique of the mimetic conventions and expressive power of drama and ends with a sardonic questioning of the ontological presuppositions that shape the reality all art attempts to represent.

Antirational Drama

Ithaka provides a fanfare entrance for the irrationality that will eventually rise to a more or less systematic nihilism. In this play Dr. Rönne and two medical students disrupt a lecture by Dr. Albrecht to call into question his

pretentious faith in and petty practice of instrumental reason and to champion an intoxicating, vitalistic irrationalism. Rönne's objections to reason go far beyond the obvious shortcomings in Dr. Albrecht's use of it to a fundamental questioning of the value of human thought:

> I've chewed the whole cosmos to pieces inside my head. I've sat and thought till I drooled at the mouth. I've been so out and out logical I nearly vomited shit. And once the mists had cleared, what did it amount to? Words and the brain. Over and over nothing but this terrifying, everlasting brain.[11]

The play ends with fragmented images of a vitalist utopia invoked by the students as they beat Dr. Albrecht unconscious:

> The hills of the south are swelling up already. Oh soul, open wide your wings; soul! soul! We must have Dream. We must have Ecstasy. Our cry is Dionysos and Ithaca! (94)[12]

As one should probably expect from a play that scoffs at rationality, *Ithaka* contains a number of contradictory impulses. On a purely conceptual level Benn's choice of drama as the medium in which to voice his dissatisfaction with language and thought is appropriate: of all the literary genres, drama, insofar as it is part of theater, is the least completely committed to the mimetic powers of word and imagination. Yet *Ithaka* is an unusually wordy and cerebral play that makes little appeal to the theatrical, nonlinguistic aspects of drama. Entrances and exits are minimal; the scene never changes; the characters never move or make gestures important enough to be noted in the text; and the emotional expression and interaction delineated in the script is remarkably straightforward and almost univocal. These limitations in the expressive power of the play are, I think, intentional gestures rather than unintended shortcomings. The play fails to be a completely adequate representation of its subject matter, just as Dr. Albrecht's science fails to give an adequate representation of the world.

The tendentious qualities in this play make a similar gesture of inadequacy and inconsistency, which touches ironically on the tendentious aspects of some expressionist drama. Lutz's cry—"We are the young generation. Our blood cries out for the heavens and the earth and not for cells and invertebrates" (*Expressionist Texts*, 94)—with its demand for an

explosion of the old, narrow parameters of experience, resembles expressionist celebrations of the New Man and the enlightened, vital age these new people would usher in,[13] but, whereas the programmatically inspired expressionists enshrine their paeans to the New Man within vigorously innovative and articulate dramatic forms, Benn lets Lutz's call of youth languish within a conventional dramatic form that is threatened by the criticism it expresses. In purposely using an inadequate means of expression, Benn allows the irrationality of Rönne, Lutz, and Kautski to spill over and taint the artistic project. But *Ithaka* does not taint the artistic project in order to remove art from the realm of affirmative bourgeois cultural practices and isolate it in a realm of rigorous inutility nor to foster the disintegration of the concept of autonomous art in favor of something akin to dada or surrealism. Rather than accepting or rejecting the conventional social function of art, the play strives to disturb this function.

Dialogue versus Mise-en-Scène

In *Etappe*, set in the health administration headquarters of German-occupied Belgium during World War I, Benn makes a more wholehearted use of the theatrical resources of drama. Stage directions are employed sparingly but pointedly. Through such stage business as aristocrats spitting, the distribution of black-market cigarettes, and an elaborate knighting ceremony, gesture vies in expressive force with the dialogue. Even where stage directions are absent the dialogue implies a mise-en-scène: that is, it calls forth a vivid image of the groupings and movement of the characters.

With the increased emphasis on gesture and tableau in *Etappe* comes also a weakening of the autonomous, self-sufficient expressive power of the spoken words. For all the difficulties and disadvantages of language that are played upon in *Ithaka*, all the characters mean what they say—and what they mean is as clear to us as we read the printed page as it would be if the disembodied voices of the characters were anchored in flesh and blood. In *Etappe*, on the other hand, words are often used to disguise and deceive rather than to communicate, and behind the words move the avaricious and coldly calculating bodies of corrupt doctors, noblemen, and politicians. The play bears a marked resemblance to Sternheim's *Nineteen-Thirteen* in its often scintillatingly hypocritical dialogue, the unspoken emotional tension welling up among the characters periodi-

cally, and the busy, intrigue-laden exits and entrances. Indeed, *Etappe* would be little more than a competent, stage-worthy imitation of Sternheim's social satire, were it not for the presence of Dr. Olf.

Dr. Olf comes to *Etappe* from the world of *Ithaka*. Unlike the other characters in *Etappe*, he does not hide behind a mask of hypocritical platitudes and manners. He attempts alternately to communicate with and to confront the other characters. The other doctors and officials come from a Sternheimian salon, in which superficial social maneuvering plays upon the stage while dark and powerful social forces rumble menacingly in the wings. Without Dr. Olf the mimetic strategy of the play would be very close to Sternheim's, in which the sociopolitical reality of the modern world is hinted at rather than explicitly represented on the stage. The action around which *Etappe* is organized, the knighting of Dr. Paschen (an important administrator of health services), is ultimately trivial, while the passing references to the corruption and intrigue associated with the black market and prostitution in the occupied territory outside Paschen's welfare office are the true motivation for the work.

Dr. Olf is disconcertingly out of place in this world of the trivial and euphemistic. Throughout the action he attempts repeatedly to break through the deceptive veneer of the expressions manipulated and deployed by Paschen and his colleagues. He importunately demands to be shown the referent lying behind the high and noble expressions. His questioning often presses toward the ontologic roots of the values upon which Paschen hangs his authority and with which he disguises his aims.

> PASCHEN: . . . who is making a new fatherland here, you or I? (*Strikes with his fist*) I!
> OLF: Who is that, as what do you designate yourself? (*GW* 2:311)[14]

> PASCHEN: . . . Five million strong, humanity cleanses itself in the war, and you, you snot—
> OLF: Cleanses itself? What? This ragged vermin, forever enraptured by the component of air pressure and peristalsis, which they call the soul, moved to tears by their upright walk . . . (*GW* 2:318)[15]

While Olf's interjections momentarily disturb the other characters, his remarks are ultimately of no consequence to the state of affairs in the government of occupation. After an instant of discomfort or surprise the other officials shrug off his challenge and elaborately disguise their

self-serving schemes with ever more impenetrable, hackneyed appeals
to the public weal. Olf's mind begins to slip in the face of such patent
lies proving so overwhelmingly powerful. He sees that words as
Paschen and his friends use them need have no basis in fact, and he
begins to criticize Paschen not for ignoring facts but, rather, for persist-
ing in appealing to the content of words—surely a timorous and unnec-
essary practice when the power of words seems to reside primarily in
their forms (see 2:317).

In his excited state Olf thinks he has found in the purely formal
aspects of language a way of opposing Paschen by moving closer to the
fountainhead from which Paschen draws his strength.

> I dream of a male-humanity, which, conscious in the most concrete
> way of the purely formal character of its spiritual construction,
> thinks only in forms, tangential, functional, with hollowed-out idea
> and emptied word. That would be the dance, that would be happi-
> ness. (*GW* 2:317–18)[16]

The sensual, mythic vision he offers in response to Paschen's idealization
of the administered world is not meant to be a viable plan for the future
so much as a demonstration of the vitalistic powers inherent in language
itself. His is a vision for the sake of vision. It does not refer to a lost past
or a coming utopia but exists solely and simply in its formal expression.

A certain kind of power inhabits the words Olf utters, but this is
not a power with which he can confront Paschen. In becoming preoccu-
pied with the purely formal character of thought, Olf loses any effective-
ness he might have had in the offices of the occupational forces, in
which the actions that language conceals are the prime movers. His
visionary alternative to the plans of the doctors and politicians is dis-
missed by the latter as the ravings of a madman. His attempt to create a
dramatic dialogue by confronting Paschen's mode of discourse with an
equally powerful mode that does not accept the values implicit in
Paschen's, that meets the mendacious instrumentality of Paschen's words
with a language freed from reference and reason, fails because, in con-
fronting Paschen's discourse, Olf remains vulnerable to the powers hid-
den behind it. These powers ultimately eliminate even his ineffectual
attack on the conventional manners of speaking employed by Paschen
and his colleagues.

Olf laments his powerlessness just as he is about to be led away:

Come on, brains, mother-sows with your dirty word-farrow, now the country is stuck, Europe reels, a screaming moon and raving stars—where is the star for my brood. (*GW* 2: 321)[17]

The world has been overwhelmed by the verbal brood of the brain to which Olf wants to oppose a discourse of corporeal sensuality ("Bodies, murmuring beautifully around their genitals, anemone forests of love" *GW* 2:320).[18] There is, however, no room in this world for Olf's way of thinking. The land has been completely and definitively usurped and subjugated by a duplicitous instrumental reason, and Olf searches in vain for a star around which his words could mean something. In Paschen's welfare office he is only a momentary and minor distraction. Nothing of what he says can penetrate the machine-like motions of the administration of the occupied zone. In being committed to an insane asylum, Olf becomes a mute fixture in Paschen's corrupt but rigidly regulated world. The last words of the play—"What language!"—spoken by the highest official to enter Paschen's office, declare the ineffectuality of Olf's words and stand as his epitaph.

If the play were produced, Olf's words would be almost as ineffectual onstage as they are in the action represented. Against the powerful postures, gestures, and physical presence of the other characters, Olf's image-laden language would lose its sting. In the final scene his words, for all their pictorial power, would be decisively overwhelmed by the ceremonial pomp of the other characters in any but the most carefully balanced mise-en-scène. On the printed page, however, the contest is more equal, because it ranges beyond the mimetic frame of the action to questions of form and the ambiguities of the dramatic mode of mimesis. Whether Olf or Paschen and company have a greater impact upon the reader depends on the extent to which the text is read as a script for performance or as a purely literary dialogue. Olf's words are more powerful than those of the other officials, but the physical presence of the officials is more powerful than Olf's, even when only conjured up in the mind of the reader.

Olf's words cry out to be taken for themselves, while those of the other characters carry with them an implied mise-en-scène. In place of a dramatic engagement of the characters on the level of dialogue, Benn creates in this play a dialogue between two ways of using language and between two styles of representation. Olf exploits the evocative force of language, Paschen and his colleagues its ability to obscure,

deceive, and conceal. The former lives most vividly in the words flowing from him, the latter in a mise-en-scène only outlined by the words on the page.

Questions of truth and morality, which would be at the center of this play if it faithfully followed Sternheim, are so strangely contorted by the conflicting uses of language and the clashing modes of mimesis that they become unanswerable. Olf, who seems, at first, the only character interested in curbing the use of language by a rigorous examination of imputed referents, ultimately forsakes reference as a measure of truth in favor of a truth measured by the lyric and vitalistic intensity of the expressions themselves. Reference is important only insofar as the words conjure up an image in the mind. The vividness and cathectic power of this image is more important than any correspondence between it and the real world. Paschen and his colleagues claim to have a more sober, conventional attitude toward language. They assert the existence in the real world of the things they discuss. Yet they deftly avoid ever actually showing the objects to which they refer. The ennobling effects of the war and the beneficent work of the welfare office turn out to be little more than figures of speech. Rather than grounding their claims on real referents, Paschen and his friends support their claims with an elaborate and deceptive system of purely linguistic cross-references. One cliché is supported by another, and the whole network is stretched, masklike, over a visage of corruption and intrigue that is only vaguely and fleetingly hinted at in the text. In this way the entire play withdraws from settling the social questions it has raised. It dances above these questions with hollowed-out ideas and words drained of substance. Because the play has first posed the social questions, the dance seems either dangerously irresponsible or a mad reaction to the hopelessness of the situation.

In place of the tendentious raison d'être of Sternheim's social satire, Benn substitutes a dialogue of attitudes toward art that are irreconcilably at odds with one another. Aesthetic elitism and amorality argue incessantly with vitalistic activism and moral engagement, but neither finally asserts itself as the privileged aesthetic concept that motivates the play. Rather than a work of art firmly set on a foundation of fixed mimetic principles and aesthetic values, Benn has created with *Etappe* a work of art that slides about on shifting sands, carefully poised on the verge of collapse.

Lyric Solipsism versus Dramatic Mimesis

While a nihilistic attack on representational conventions is present in Benn's first two plays, it is realized in these works only by formal tensions that undercut the integrity of the mimetic content. In *Vermessungsdirigent* and *Karandasch* Benn thematizes the formal ambiguities of his earlier plays. The gap between word, image, and object is part of the subject matter of the work rather than only a condition affecting the mimetic conventions used to describe the subject matter. Of course, taking up this theme in the dramatic mode of representation requires a number of formal innovations and leads to interesting conflicts on that ambiguous middle ground where form and content play in intimate convolutions upon each other.

Vermessungsdirigent conforms less to the Aristotelian and Hegelian standard of drama than do either of the earlier plays. As the introductory synopsis makes clear, the play is less concerned with the representation of an action than with the elaboration of ideas. The synopsis declares that what happens is not as important as the epistemological issues lurking at various depths beneath the words and actions. Rather than placing Pameelen within a socially or psychologically motivated dramatic context, this introduction singles him out as a representative of a certain cognitive methodology.

> The drive towards definition, for him more agonizing than hunger and more disturbing than love, turns in him against the so-called proper self. (*GW* 2:322)[19]

Rather than preparing readers for the drama that follows, the synopsis confuses them by using an expository, third-person prose to broach subjects singularly inappropriate for dramatic representation.

The prologue has the outward formal features of drama but continues the development of nondramatic, if not antidramatic, themes begun in the synopsis. In more conventional plays a prologue usually launches the dramatic representation by establishing certain parameters within which the action will unfold. In *Vermessungsdirigent*, however, it subverts the notion of a dramatic representation. Rather than delineating the physical and conceptual milieu that will enclose the action, the prologue stresses Pameelen's independence from his physical surroundings and

plays discordantly upon mimetic conventions foreign, if not inimical, to drama. The dramatic form is reduced to a skeletal structure fleshed out by words whose content and expressive power relies on nondramatic forms of representation that clash against one another as well as against their dramatic frame. The dialogue here has little to do with the intersubjective exchanges of conventional plays. Pameelen manifests an interest in the contours of subjectivity so intense that communication with other minds seems a bothersome distraction and even passive sensory perception becomes a willed act:

> I want absolutely nothing here. I come from a completely different place. But I want to incorporate you in my existence. You should enter into my general constitution. (*GW* 2:324)[20]

Only in Lewis's *Enemy of the Stars* do we encounter a hero whose nihilistic solipsism is as inimical to conventional dialogue and dramatic situations as is Pameelen's.

In place of a dialogue, a Voice exhorts Pameelen to describe his surroundings; he responds with short, narrative vignettes, and the Voice passes judgment on his creative efforts. Thus, two sets of mimetic conventions alternate control of the representation: Pameelen and the Voice produce a *monologue intérieur*, which is interrupted periodically by Pameelen's third-person narrative prose. At the end of the prologue, once the doors to the examining room are opened, two more representational styles clash and reverberate against each other: (1) the shocking visual tableaux of gynecological examinations and (2) the lyrical ruminations of Pameelen, whose presence is never acknowledged by the other characters.

In the body of *Vermessungsdirigent* a dramatic mode of representation is cultivated only to obstruct and set off Pameelen's attempts at defining the contours of his self. The three acts do not delineate a dramatic action but, rather, depict Pameelen's efforts to carve a monologic, solipsistic space out of the center of a dramatic representation. For Pameelen the intersubjective world of autonomous psychological entities that live and define themselves by expressing their distinct values and desires to one another only obscures the outline and features of the self. He systematically frustrates the development of a dramatic action in favor of a single-voiced, narrative action controlled solely by himself. Setting the first act in Pameelen's medical office immediately reduces and intensifies the possibilities of dialogue by confining them to the intrusively narrow etiquette of the medical

exam. Pameelen exacerbates this rarified intimacy by using it to attack and dismantle the constituent elements of drama as well as the personal integrity of his patients. His first patient, Picasso, starts him on this road of destruction by challenging him to define the essence of self and world. In the subsequent scenes personal relationships that have histories and complexities extending beyond the confines of the scenes portrayed are devalued or destroyed: Pameelen estranges himself from his lover and forces an abortion on her, while Pameelen's father is ridiculed by Picasso, who has become so much an alter ego for Pameelen that his father cannot tell them apart. In the second act, living in a mountain cabin, Pameelen violently transgresses more basic tenets of human value and personal integrity by poisoning a child and raping its mother when they stray into his shelter. Picasso appears to rescue the woman and chide Pameelen for the lack of sophistication in his brutal attempts to isolate the self. Whereas Picasso is interested in experiencing the essence of human consciousness, he accuses Pameelen of trying only to measure human consciousness. Pameelen is nothing but an old survey director. In the third act Pameelen blinds himself to make his isolation complete and continues to struggle against the general concepts YOU and IT (other minds and an external world), which persistently recontaminate his thoughts and frustrate his efforts to purify and define his subjective being.

In the end Pameelen succeeds in isolating himself from the emotional and moral demands of human society, but he fails to carry out his project of rational self-definition. He manages to carve away the content of conventional dramatic mimesis—that is, an intersubjective action—but he cannot escape the basic structuring principles of drama, the importance of IT and YOU, objects and other minds, the scene and the characters. Even when blinded and locked in his mountain hut his mind dwells on images of objects and people rather than on the self he hoped to isolate.

The failure of Pameelen's project differs markedly from the defeat of the protagonist in conventional drama, because, whereas most protagonists succumb to forces represented within the mimetic frame of the play, Pameelen succumbs to the force of the mimetic frame itself. Drama is an impossible medium in which to delineate the internal features of the self. The flux of physical facts manifested on the stage or implied in the text (the action, scene, and voice) prevent the introspective, monologic stasis in which subjective being might momentarily reveal its features.

Pameelen's defeat is not, however, a victory for drama. In the struggle

between the two, Pameelen inflicts his own share of fatal wounds. He fails to establish a fixed definition of his self, but his efforts to do so prevent the drama from justifying its existence with a seamless, articulate, and stylistically univocal representation. In the prologue Benn aids Pameelen by burdening the dramatic form with nondramatic mimetic ploys such as third-person narrative and lyric meditation. In act 3, he turns against both drama and Pameelen in three scenes separated by noticeable expanses of time. Pameelen's investigation of his subjective consciousness holds the scenes together, but neither Pameelen's project nor the requirements of dramatic representation explain or motivate the time gaps between the scenes. Drama is usually about the temporal unfolding of the present moment, as Szondi points out:

> In the Drama, time unfolds as an absolute, linear sequence in the present. Because the Drama is absolute, it is itself responsible for this temporal sequence. It generates its own time. Therefore, every moment must contain the seeds of the future. (*Theory of the Modern Drama*, 9)

In act 3 of *Vermessungsdirigent*, however, time seems to pass of its own accord, independent of the "dramatic action," which has been reduced to a series of introspective monologues. Temporality intrudes upon the dramatic representation as something foreign and beyond its control. The passage of time in this act is also beyond the control of Pameelen and, along with other factors, disrupts his efforts to establish a static self-awareness. Distinct chronological moments marked by his aging intrude upon and contaminate the subjective experience he attempts to gather together in his monologues.

When Picasso breaks into the hut at the end as young as he is in act 1, Benn makes clear that time is fictional, that Pameelen's desire for a rationally delineated, monologic stasis is frustrated by an opponent as ontologically insubstantial as the self he seeks to define. The epistemological questions that dramatic mimesis and Pameelen's rationality beg prove each other unanswerable. Benn pits subjective being against aesthetic representation and lets the two annihilate each other. All order and value are denied authenticity. Rather than exploiting nihilism as an aesthetic ploy, he presses art into its service. The failure of Pameelen's introspective quest for the substance of being is broadened and deepened by the disintegration of its representation.

Disintegrating Dialogue

If *Vermessungsdirigent* is concerned with the limitations and aporia implicit in the concept and representation of subjective being, *Karandasch* interrogates the concept and representation of social being. Pameelen appears again in this play as a representative of nihilistic rationality, but here, rather than attempting to establish the borders of his inner self, he examines critically the meaning and substance of the outer world. Whereas the focus of *Vermessungsdirigent* narrows as the play progresses, the focus of *Karandasch* widens, not by building systematically on what has already been presented but by a haphazard accumulation of unrelated details. No overarching action holds the various scenes together. No thematic development or formal structure gives direction and order to the progression of independent vignettes. But, while the play as a whole is unified only by Pameelen's presence and a general thematic focus, each act does form an attenuated whole based on one of the traditional unities. The unity in question, however, differs from act to act.

Unity of place reigns in act 1. All the scenes transpire in or near a medical clinic. Aside from this, however, very little holds what happens together. Pameelen appears in all the scenes, Renz appears in two and is called to in a third, and Renz's meditation on aesthetic coherence in the second scene ("How does one connect something . . . ?" [*GW* 2:357]) is echoed in the fourth ("Renz, something is connected here!" [2:364]). But these tenuous connecting threads mean little in relation to the more obvious discontinuities that isolate each scene in this act from the rest. Nothing that the characters do or say in one encounter has any consequence in subsequent ones. Because of the lack of connecting actions, it is impossible to judge the passage of time between scenes. Each episode transpires in a different part of the clinic and involves, for the most part, distinct groups of characters and issues. The clinic is not so much a concrete location at which the various events take place as an abstract principle of unification, an invisible container for four unrelated incidents.

Act 2 is one long scene, so one might argue that the unity of place is more obvious here than in act 1. But here the place is markedly indefinite. It might be a tavern or a club, but which and of what particular kind is never made clear. One of the principle characters in this act, the Voice, is not even bodily present at the vague scene of events. One might suggest unity of action for this act but for the fact that nothing much happens. Pameelen talks voluminously on various subjects, and other

characters chime in periodically with short remarks. Pameelen's words do not even focus on one unifying *narrative* action in lieu of a dramatic one. His remarks range over a bewildering variety of topics and give no hint of linear argument ("A mongoose, whoever still thinks linearly—I swell nodular" [*GW* 2:370]).[21] Only the unity of time holds this act together. The comments of Pameelen and his friends are uttered in one continuous stretch of time, and this temporal continuity is the only thing uniting them.

Act 3 owes its cohesion to the unity of action: although the type of activities and dialogue in which Pameelen engages vary widely in the act's three vignettes, his desire to make contact with the essence of existence remains constant. Pameelen's first encounter, with a young woman in his examining room, is carried out in a staccato stichomythia of single-word exchanges and moves from the medical details of a gynecological exam to a hesitant sexual proposition from which the woman flees. Pameelen's failure at physical intimacy with the woman leads him to resolve upon establishing a more metaphysical intimacy with his next patient, to "take notice of the thing-in-itself" (*GW* 3:374). This leads to a comical encounter in which Pameelen bubbles over with effusive images of sympathy and social solidarity with his patient but refuses to sully this idealized fellow feeling by performing the physical exam for which the man has come. The following scene takes place in a museum to which Pameelen has come in pursuit of his disconcerted patient. Unable to locate the man here, Pameelen's interest in essences shifts from dialogue and interpersonal relationships to a lyrical soliloquy on antiquity and myth.

Pameelen's role in this play is significantly different from his role in *Vermessungsdirigent*. One could say that *Vermessungsdirigent* is an I- or ego-drama (provided one notes Benn's reservations concerning the possibility of defining the ego) because Pameelen directs the course of the action in this play, and the action moves away from dialogic drama toward an isolated, introspective monologue. In *Karandasch*, on the other hand, Pameelen neither desires nor is placed in isolation. He does often engage in long, lyrical monologues but always within some sort of social context: he is either lecturing a friend (1.2), speaking to drinking companions (2.1), or, when his words finally are directed to no one, in a public museum and responding periodically to the official who overhears his meditations (3.2).

All of the action in *Karandasch* takes place within public spaces and

involves various forms of public speech acts. Nowhere in this play do we find characters at home engaged in the private dialogues between close friends, family members, or lovers that conventional drama often uses to represent the more intimate aspects of subjectivity and that Benn mutilates and dismisses in *Vermessungsdirigent*. The characters in *Karandasch* relate to one another as professional colleagues, casual acquaintances, doctors and patients, supervisors and subordinates, or in any of a number of other relatively formal and impersonal custom-condoned, rather than emotion-motivated, fashions. The world portrayed in *Karandasch* resembles that portrayed in *Etappe* but without the intrigue and power. Just as Pameelen's magic word, *Karandasch*, is a sequence of syllables with no meaning behind them, the world of this play is a series of social rituals with no social forces moving behind them. There is, at most, a periodic flicker of individual perversity discernible behind some of the actions.[22]

The emphasis on vacuous or inconsequential public speech acts, rather than on private attempts to define subjectivity, suggests that this play is about the meaninglessness of representation rather than the impossibility of representation. Whereas *Vermessungsdirigent* deals systematically with the inability to delineate accurately the contours of the soul, *Karandasch* cavalierly treats all verbal description as ultimately superfluous and ridiculous. Sundry forms of speech are employed in the play, yet none of them have the slightest effect on the course of events. Various sorts of vivid images are conjured up, but they have no consequences. Connections and sources of unity appear as, at best, artificial forms pressed upon a fundamentally chaotic world. When Renz claims that aesthetic coherence is a purely mechanical problem, he is right, insofar as art and all other forms of representation are just meaning machines that function by convention and are not sources in themselves of significance. If, however, he thinks art can actually close with (*anschliessen*) and elucidate something, then he is laboring under "the brutal hypothesis of the self as total encircler" (*GW* 2:357).[23]

Rather than attempting to connect with some sort of reality and represent it, Pameelen counsels closing with the basis of verbal representation itself:

Renz, there are so many words: chaff on the floor, shadows of the lost, but the old words, Renz, the original words—Karandasch—Karandasch. (*GW* 2:358)[24]

Karandasch is for Pameelen an exemplar of those ancient, original words—isolated outbursts of meaningless sound, not yet made false by the dubious claims of denotation. *Karandasch* is as close as verbal representation can come to the eloquence and truth of silence.

> For [Pameelen] happiness begins where the lips are mute and, rigid and white, a row of teeth gape to feed and against fish (Triton). (*GW* 2:351)[25]

If the events in the play lead anywhere, it is to this ancient, original silence, which Benn associates with the ocean and the vague origins of myth. It is the same image and the same silence with which he ends the play:

> On my knee, sweet Triton: two rows of teeth, rigid and gaping—mandible and maxilla, beloved, mute—(*GW* 2:378)[26]

Benn gets to this silence not by development but by attrition. The rapid succession of dazzlingly different forms of verbal expression fatigue the reader with their ineffectuality. Words begin to seem of no more value than chaff (*Spreu der Tenne*), so the reader welcomes the silence that clears the air of them.

This is, at least, the thesis of the play that the synopsis suggests. It strikes me as somewhat disingenuous, because what makes the silence at the end so striking is the image of the mute, fish-catching Triton imparted by the last few words. Benn refutes his thesis on the uselessness and meaninglessness of words by the eloquence and precision with which he proves it. *Karandasch* by no means suggests that language is the medium of knowledge and truth, but it does seem to champion the decorative, imagistic, playful, and rhythmic qualities of speech, none of which can be found in silence.

Thus, the synopsis, which offers a statement of the play's meaning, proves a red herring—and, thus, the value of representation is both denigrated and celebrated. These aporia suggest that disingenuousness and paradox are key aspects of Benn's aesthetic, a position of which Blanchot would approve. In 1919 Benn makes clear that sending a message or making a statement, which his use of a synopsis suggests is central to his drama, is of little importance to his aesthetic project. How

could any act of communication be important to Benn given his commitment to epistemological solipsism?

> I never see persons but always only the self and never events but always only being, . . . I am familiar with neither art nor faith, nor science, nor myth but always only consciousness, forever senseless, forever agonizing . . . (*GW* 4:189)[27]

Benn is not interested in the informational content of art: he concerns himself with the emotional charge of the act of signification rather than with what signs signify.

> The word thrills me even without consideration of its descriptive character, purely as an associative motif, and then I perceive its quality as a logical concept, with complete objectivity, as a cross-section of condensed catastrophes. (*GW* 4:188–89)[28]

Given this "aesthetic" position, the paradoxical status of verbal representation in *Karandasch* is understandable. The drama neither represents nor refuses to represent but, instead, plays with the concept of representation.

The ambiguous status of representation is most obvious in the play-within-the-play, which appears in act 1, scene 4 of *Karandasch*. While the fragmented structure, the odd, often unmotivated behavior of the characters, and the various forms of schematic or imagistic dialogue clearly distinguish the mimetic strategies of *Karandasch* from more conventional forms of representation and implicitly criticize the latter, only in the play-within-the-play do Benn's own mimetic strategies become the overt subject of the text.

There is no motivation or explanation for the play-within-the-play here. The other scenes in act 1 all take place in or near a medical clinic, but in this scene "Sternheim's" play, rather than the encompassing action, is located at the medical clinic. The framing action quivers with contradictory motivations. At first Pameelen seems to have become the author of the text. He speaks directly to the reader or audience and starts to offer what seems like an explanation for the forthcoming break from the mimetic strategies employed thus far in the play:

> In order to puke forth once more the bone splinters of my world view . . . (*GW* 2:363)[29]

But his soliloquy breaks into fragmentary images before he completes this sentence. He discusses two modes of perception (hearing and smell) and ends by asking what the dramatist does given the popular acknowledgment of "assault and resistance as the manner in which we meditate" (*GW* 2:363).[30] This abstract discourse is shattered by the dramatist's reply: "He allows breakfast." The question Pameelen asks after this statement is motivated by the supposition that all aspects of a work of art add to it in some way and perform some sort of function, but Sternheim's answer suggests that the caprice of the public is all the motivation needed for at least some of the features of drama.

As this scene progresses, Sternheim begins to seem more the author's surrogate than does Pameelen. In the rapid exchange of short phrases in which the two engage, both describe artistic motifs of which Benn is fond, but then Sternheim takes decisive control of the action, when he introduces the play-within-the-play:

> STERNHEIM: *The Health Officer!* Typical spiritual conflict! Left and right of the spectators! Toilet entrance to the side!
> Characters: The Health Officer. The Young Man.
> <div align="right">(<i>GW</i> 2:364–65)[31]</div>

His control does not, however, remain decisive, because the Young Man proves incapable of contradicting the Health Officer and thereby creating a dramatic conflict. In admonishing him, Sternheim reveals the demand for dialogic discord to be not so much something he believes in as something that the bourgeoisie wants to see:

> You little snot, the bourgeois wants something to open up: conflict! The breath of decay! Abysses above the white vests! (*GW* 2:365)[32]

In place of a polarized conflict between characters, Sternheim settles for an elaborate and carefully controlled stage spectacle. He calls for props from the wings and coaches the Health Officer through his lines. The play-within-the-play becomes an elaboration of meaningless surfaces. To add to the confusion, it is not clear whether Sternheim speaks for Benn in his reliance on stage spectacle as a substitute for dramatic conflict or enunciates features of modern drama that Benn intends to criticize. As in the play as a whole, no definitive thesis is established.

While no unifying argument motivates act 1, scene 4, a number of

minor points suggest that this lack of a sharply delineated perspective is motivated by Benn's avant-garde, self-critical aesthetic. Several remarks by Pameelen and Sternheim suggest that the formal and thematic features of drama have less to do with the most effective means of representing certain aspects of reality than with the predilections of the public: taste and prejudice are given as explicit reasons for using a dialogue of attack and resistance and for portraying the comfortable habits and appurtenances of the bourgeois world.

> STERNHEIM: The public wants to see breakfast.
> PAMEELEN: Contentment?
> STERNHEIM: Tout comme chez nous!
>
> (GW 2:363)[33]

While less clear, the text also seems to suggest that a thematic preoccupation with the conflict between the bourgeoisie and genius and an avoidance of the conflict between rich and poor is also due to the desires of the well-to-do, theatergoing public. This point is interesting because it touches on Benn's own thematic preoccupations in that the long list of subjects appropriate for drama that Pameelen and Sternheim recite all appear in at least some of Benn's plays. In this scene he seems to be suggesting that, despite his own aggressively antipopular reasons for writing drama, his themes and forms are to a significant degree determined by public taste.

The course of events within the play within this scene opens to further question the playwright's ability to control his material and also questions the extent to which the demands of the public influence dramatic form and content. Despite the bourgeoisie's desire for conflict and the playwright's willingness to fulfill this desire, no conflict takes place. Sternheim compensates for this by marshaling the resources of stage spectacle and the expressive abilities of his one competent character, the thoroughly bourgeois Health Officer.[34]

Pameelen applauds Sternheim's extemporaneous covering up of the failure of the dramatic project and the playlet's lack of any serious content as "digging into reality" (ein Griff in die Wirklichkeit [GW 2:366]). Pameelen may be naively praising Sternheim, but Benn is using this line to criticize both "reality" and art's attempts to come to grips with it. A number of interpretations are possible here: (1) Benn might be saying that reality is as shapeless and shallow as the dramatic action Pameelen

praises; (2) he could be suggesting that the failure of the dramatic action is itself the action Sternheim is representing and that this acknowledgment of the inadequacies of drama is praiseworthy; or (3) he could be claiming that the concept "reality " is ultimately only a play of meaningless motifs and images with no firm ontological grounding. I find the last of these interpretations the most convincing because it is consistent with his contemporary devotion to nihilism,[35] and it does not preclude the other two interpretations. Throughout his plays Benn undercuts conventional notions of reality and ridicules the formal and thematic shortcomings of art. We have seen how Benn's attacks on art and reality often work against each other, making any sort of clear statement impossible to discern. If Benn considers reality nothing but a play of meaningless images, his lack of interest in making clear statements by separating his critique of art from his critique of reality is easier to understand.

Rather than articulating a given topic with accepted mimetic conventions in the interest of a specific aesthetic theory, Benn throws sundry topics and conventions violently against one another in the interest of annihilating both aesthetics and epistemology. Like the dadaists, Benn questions the value of art, but his critique is based on his nihilistic vision of the universe rather than on a dissatisfaction with the functions art performs in modern society. Benn's nihilism, however, does not preclude an interest in representation, and, as I hope my analysis of his plays has shown, he does not think that any chaotic collection of images whatsoever is an adequate representation of the chaotic illusions that constitute reality. For him conventional notions of art and reality are fallacious constructs of the human mind. Art is genuine only when it reproduces some of the emotionally charged confusion of existence. It adequately represents reality when it is equally threatening, disorienting, and inimical to order or systematization and when its own representational presuppositions quiver and disintegrate along with the objects of its critique, the presuppositions upon which reality is constituted. To this end Benn denies his readers the comfort of an easily understandable text, the pleasure of discovering the ordering principles at work in a difficult text, and the relief that would come from accepting the text as purely gratuitous play. The result is not something "real" but, rather, a confrontation with the aggressive, vertiginous nothingness that most minds ignore or deny by an appeal to their favorite ontology. Rather than raising art to the ontological solidity of the real, Benn reduces it and reality to a liquid swirl of

fundamentally meaningless images, insubstantial to the grasp of the intellect yet powerful in their sensual, self-destructive motion.

In contrast to the aesthetic turbulence I have analyzed in the plays of Kokoschka and Benn and which we will encounter again in the drama of Vitrac and Lewis, Roussel offers an unusually stable approach to aesthetic construction. Nevertheless, the peculiar nature of Roussel's aesthetic preoccupations run so much against the grain of conventional aesthetics that the stable worlds he creates in his plays are as forbidding to early-twentieth-century audiences as the shifting realms conjured up by Kokoschka and Benn. Whereas Kokoschka and Benn break down conventional dramatic material into a storm of visual spectacle or a delirious dialogue of ontological contention, Roussel constructs plays from an eerily lifeless but intricate material that has few affinities with the stuff from which drama is usually made.

Roussel: Objectifying Invention

Throughout most of his personally financed literary career the million-aire eccentric Raymond Roussel displayed a fascination for the human and mechanical appurtenances of theater.[1] His first major poem, *La Doublure* (1897), concerns an actor onstage and wandering through the costumed spectacle of a carnival parade.[2] A short story, "Chiquenaude" (1900), in describing in minute detail a single performance of a play, dwells with vertiginous persistence on instances of doubling, repetition, disguise, and representation/imitation.[3] Roussel's first novel, *Les Impressions d'Afrique* (1910), revolves around a lengthy and elaborate series of performances ranging from ritualized executions to peculiar displays of freak show talent. His second novel, *Locus Solus* (1914), involves a series of "performances" and tableaux rendered by robots, sea horses, animated corpses, and other unlikely actors. Both these novels were adapted for the stage, and Roussel followed them with two more works written specifically for the theater: *L'Étoile au front* (*The Star on the Forehead* [1925]) and *La Poussière de soleils* (*The Dust of Suns* [1927]).[4] The care and expense he lavished upon his theatrical productions give further evidence of the importance he attached to this artistic medium. Indeed, in his increasingly desperate attempts to obtain public recognition for his peculiar inventive talents, Roussel spent most of his inherited fortune in producing his plays with the best actors, directors, set design, and publicity that money could buy. His efforts won him the admiration of the surrealists, but most of the theater critics of Paris's cultural establishment greeted his work only with dismay or ridicule.

In itself Roussel's fascination with theater and spectacle would not be particularly pertinent to an investigation of anti-art avant-garde drama, but it is accompanied by a complete disdain for most of the formal and

thematic conventions of dramatic representation. Psychological character-ization (beyond the most rudimentary outlines), emotional interaction, and the unifying powers of intrigue or some other overarching human action are either extremely weak or completely absent from all Roussel's works. In his plays the dialogue—rather than communicating the states of mind of the characters or manifesting the struggles, manipulation, and allegiances that link them—is used exclusively as a medium for semi-autonomous anecdotes only tenuously related to the presumed, but com-pletely unexpressed, psychological life of the characters that recount them. Even Pierre Frondaie's dramatic adaptation of *Locus Solus*,[5] which preserves the general structure of the original and its emphasis on bizarre inventions but attempts to transfer the burden of explication from a dauntingly concise and psychologically featureless narrative voice to a more diffuse and emotionally colorful repartee, was condemned by Roussel as inconsistent with the tone and intentions of his original work.

In the works Roussel wrote specifically for the stage the characters quickly escape the interpersonal immediacy of dialogue to efface their personalities by reciting anecdotes or solving puzzles. *L'Étoile au front* presents an intimate community of curiosity collectors who spend more time recounting the histories of the bizarre objects they possess than they do inquiring into one another's thoughts and desires. *La Poussière de soleils*, although organized around a potentially adventurous race toward hidden treasure in the jungle of French Guiana and a romantic matrimo-nial subplot, swamps the implicit human drama with an elaborate concen-tration on the solving of clues and a touristic attention to the colorful scenes and characters encountered during the treasure hunt.

Roussel's indifference to the standard themes and conventions of drama won him the enmity of public and critics and the admiration of the surrealists. All of his detractors and some of his fans were most impas-sioned by his failure (or heroic refusal) to gratify the expectations of the theater audience with even the minimal adherence to dramatic conven-tions that is found in the work of Kokoschka and Benn. Gaston Liberty's remarks are typical:

> The new work by Raymond Roussel, *L'Étoile au front*, is like its predecessors a play without consequence and, alas, without end. Nothing happens; there is no plot, not even a stupid one. It contains nothing but a mass of absurd remarks.[6]

According to Henri Béhar, of all the nonsurrealist critics only Louis Laloy (*L'Ere Nouvelle*, 4 February 1926) gave a positive evaluation to the deficiencies in Roussel's theater. For Laloy *La Poussière de soleils* is a work

> cleared of all the false pretenses of material exactitude or the vain moral details that an ordinary author would feel obliged to introduce. Nothing, throughout the piece, but the plain responses that the situation demanded and that appear to come immediately to mind.[7]

Béhar and some surrealists were impressed by Roussel's innovative additions to the art of theater as well as by his break from mainstream conventions:

> By unintentionally scorning dramatic know-how, he opens the curtain to a theater of the marvelous, responding to the sole necessity of the imagination, that unconscious current that speaks under the influence of the "process." (Béhar, *Le Théâtre*, 131)[8]

Whereas Béhar and Éluard are most impressed with the marvelous, autonomous spectacle of the imagination in Roussel's plays, Robert Desnos enthuses over a fusion of art and life that he feels Roussel's theater encourages. Of *L'Étoile au front* he notes:

> The protagonists of these three acts are in the auditorium as well as on the stage. The actors could as easily be distributed from the balconies to the orchestra seats, the theater is transformed into a giant drawingroom where a thousand persons listen to seven or eight among them tell stories.[9]

While Michel Foucault's rich study of Roussel does not discuss directly questions of dramatic form or the purposes of Roussel's theatrical productions, it does identify certain theatrical qualities in Roussel's literary work as a whole:

> The language inclines toward things, and the meticulousness of the details that it incessantly supplies slowly reabsorbs it in the muteness of the objects. It is verbose only in order to drive itself toward their

silence. It is as if a theater were tipped neither comically nor tragi-
cally . . . into the inanity of spectacle and had nothing more to offer
but the contours of its visibility. (*Raymond Roussel*, 133–34)[10]

The divergence of opinion in these brief excerpts testifies to the com-
plexity of Roussel's dramatic innovations. To understand his interest in
and manipulation of the dramatic and theatrical modes of artistic produc-
tion and the places that the marvelously imaginary, the anti-artistically
matter-of-fact, and the mute presence of the visible occupy in his works
for the theater, we must first look closely at the strategies and ideals that
govern his literary poesis as a whole.

Aesthetics as Cognitive Construction

The first point to consider is the conception and writing process Roussel
describes in *How I Wrote Certain of My Books*:

> I chose two almost identical words. . . . For example *billard* [billiard
> table] and *pillard* [plunderer]. To these I added similar words capable
> of two different meanings, thus obtaining two almost identical
> phrases. . . . The two phrases found, it was a case of writing a story
> which could begin with the first and end with the second.[11]

Roussel cites numerous instances in which he employed this process or a
few variations on it to initiate tales in *Impressions d'Afrique* and claims to
have used it with a similar frequency in *Locus Solus*, the two plays, and a
few short works. Some applications of the process established the outline
of lengthy works, while other applications only yielded short anecdotes.
His description of the process and the use to which he put it belies the title
of the book devoted to it, because it does not explain how he wrote his
books but only how he arrived at certain images or accessories that figure
prominently in certain episodes. The high degree of personal, idiosyn-
cratic choice involved in employing the method coupled with the fact
that many of the generative, homonymic phrases have been dropped
from the final versions of the stories makes it extremely difficult to
reconstruct the wordplay upon which any episodes not already accounted
for by Roussel are based. Jean Ferry does seem to have uncovered some
additional seed phrases,[12] but even Roussel sometimes confesses himself
unable to trace an image back to its source.[13]

The impossibility of enlarging to any significant degree the inventory of motivating words and phrases provided by Roussel in *How I Wrote* should not be particularly disturbing because knowing these words and phrases gives one no insights into the organizing structures of his works. Roussel claims that the choice of similar words or of a commonplace phrase to be distorted into a new phrase is arbitrary and fortuitous.[14] The only methodically consistent element of the process lies in Roussel's penchant for picking the richest and most diverse words or meanings (in the case of homonyms) from which to build his stories:

> To the results that he derives from chance . . . he gives complete precision and plenitude; he strives to draw out the maximum of their tensions and particularities.[15]

The arbitrariness of the originating phrases coupled with the ingenious permutations and distortions through which Roussel filters them permits knowledge of his process to provide, at most, an excuse for the bewildering variety of objects and situations deployed in Roussel's works; the process cannot predict or explain any of the formal and thematic features with which Roussel's works are infused. Indeed, the use of chance expressions and random homonyms revealed in *How I Wrote* only makes the logical precision and meticulous order of Roussel's works all the more surprising. The chaos that his process would seem to encourage is masterfully subdued, shining through only in the extravagantly bizarre variety of surface details (e.g., a mosaic of human teeth or rails manufactured from calf lungs) that decorate a rigorously ordered narrative structure.

While we should not underestimate the importance of the resolutely unrelated, heterogeneous details with which Roussel's process saturates his works, we should bear in mind that of at least equal importance for his approach to aesthetic poesis as a whole are the relationships obtaining between his process and his powers of imagination. He stresses repeatedly in *How I Wrote* his high valuation of the imagination: "Imagination accounts for everything in my work" (14). The excerpt from Pierre Janet's psychoanalytic study of Roussel (who was, for a time, his patient) corroborates and extends this point:

> Martial [pseudonym for Roussel] has a very interesting conception of literary beauty: the work must contain nothing real, no observations

of the world or the spirit, nothing but completely imaginary construc-
tions. (*Comment j'ai écrit*, 132)[16]

To a certain extent his process aids his imagination by suggesting combi-
nations of images that would not otherwise occur to him, but it also
burdens his imagination by demanding, first, stories that fuse obstinately
heterogeneous elements and, second, a rational narrative framework in
which to place these stories. These difficulties are, of course, probably
part of the appeal the wordplay process holds for Roussel. The strength
of his imagination would, he might have thought, appear all the more
impressive for having overcome the problematic demands of the process
with which he burdened it. Use of the process might have been his way
of attempting to approach, if not surpass, the inventive skills of his idol
Jules Verne: he may not have thought himself Verne's equal in raw imagi-
native power, but surely the ingenuity with which he navigated his narra-
tive through the intractably heteroclite produce of his process was wor-
thy of some esteem.

Roussel's privileging of imagination was probably the chief reason
for his endearment to the surrealists. In reviewing *L'Étoile au front*, for
example, Éluard praises his marvelously exotic powers of invention:

> All the world's stories are woven in their conversation, all the
> world's stars are on their foreheads, mysterious mirrors of the magic
> of dreams and of the most bizarre and marvelous deeds. . . . Ray-
> mond Roussel shows us everything that has not been.[17]

Nevertheless, the surrealists and Roussel's notion of imagination differ
significantly. For the surrealists imagination provides a link with the
unconscious and with the realm of surreality in which contradictions join
in defiant opposition to the Law of the Excluded Middle.[18] Imagination is
a means of breaking the conceptual bonds of bourgeois culture and experi-
ence. The surrealists did not consider their activity artistic insofar as the
concept of art is based upon bourgeois social formations and convention-
alized notions of production, form, and content; rather, they looked
upon their work as a means of refining and amplifying the iconoclastic,
liberating powers of mental fantasy. Roussel, on the other hand, uses
imagination as an ordering rather than a liberating principle. To some
extent his process pushes him into weird, quasi-surreal surroundings,
but, once the process has set the outlandish parameters of his stories, he

turns all his powers of invention upon the task of rationalizing and subduing to a clear, psychologically uncomplicated order the strange, perhaps inchoately surreal, images he has committed himself to using.

Indeed, in terms of the fundamental motivations for his work, Roussel is much closer to the thoroughly conventional ideals of playwrights such as his collaborator, the popular writer Pierre Frondaie, than he is to the anti-artistic ambitions of the surrealists. Roussel was genuinely and passionately concerned with producing works of art; he craved the accolades of public and critics, wanted a prominent place in the artistic canon enshrined by the bourgeois institution of art, and thought that with a little encouragement the public as a whole could admire and enjoy his works. What marks Roussel off from the hordes of conventional writers who share these values and ambitions is his obstinately, if not courageously, singular notion of the aesthetic material with which it was his task to create his works. With the possible exception of Hugo the standard bourgeois canon of great writers is of little significance to Roussel. When he does refer to prominent figures within the institution of art, such as Hugo, Wagner, Dante, and Shakespeare, it is usually in reference to their "*gloire*," their reputations, a quality they share with other historical figures such as Napoléon.[19] Their approaches to art and literature, their precise contributions to various notions of tradition and to the general repertoire of expressive forms that constitute the aesthetic material, with which all modernist and most avant-garde writers work, never seems to concern Roussel.

Characterization, emotional interplay, the articulation of ethical and metaphysical values, and the development and resolution of a unifying plot, which have been among the central concerns of Western literature from the Ancient Greeks to the present day, are pointedly ignored by Roussel. For him Jules Verne attains the summit of literary art, not by mastery of characterization, plot, or philosophical subtlety and precision, but by his powers of invention. For Roussel the aesthetic material from which literary works are molded consists of puzzles, codes, rigorously logical intricacy for its own sake, and the manufacture ex nihilo of bizarre anecdotes and fantastic inventions. His interest in popular theatrical spectacles, music hall, and detective fiction is probably tied to the inventive apparatuses of stage illusion used in the first two and the deployment of puzzles and clues in the latter. He, no doubt, considered the sentimentality and emotion-engaging intrigue of popular theater and pulp fiction a distasteful and irrelevant adjunct to the real artistry of these works,

because Michel Leiris reports that he could not stand the sight of tears or detailed accounts of fear or pain.[20] Based on conversations with Roussel, Roger Vitrac suggests that,

> far from being interested in drama, he applied himself solely to studying the differences of staging, verifying the order of entrances, noting the actors' gestures, their intonation, the arrangement of the scenery, the fall of the curtain, in short, everything that plays within the limits of the author's stage-directions, everything in the margins, floating. . . . This concern for precision lies beneath all Roussel's preoccupations.[21]

The privileging of imaginative powers completely removed from all questions of psychological and social being could hardly lead anywhere other than to questions of technical precision. In Roussel's work such questions tend to focus, in the first instance, on the visible surfaces of things. A number of scholars have noted the obsessive emphasis Roussel gives to meticulous descriptions of the visible world.[22] Nevertheless, while some early poems are devoted exclusively to details of a static, emotionless visibility,[23] his novels and plays are rife with descriptions of heated passions, complex intrigues, and outbursts of violence.[24] From *L'Étoile au front*, for example, Jean Ferry has compiled a catalogue of eighteen femmes fatales, six attempted or successful murders, three tragedies, and four elaborate acts of fraud.[25] The crimes, plots, and emotional outbursts depicted in the novels are even more numerous and sensational. The public, however, never appreciated in Roussel's works the sort of anecdotes they would have avidly read in the newspapers and any one of which could have served as the plot of a complete detective novel, because Roussel always unfolds these stories at one or more removes within the narrative structures of his works. Passionate outbursts of human emotion are always carefully buried deep within multilayered narratives that, at their surface, remain meticulously technical in their devotion to descriptions of the visible contours of physical objects.

Roussel always insulates carefully the surface of his narratives and his dramas from the emotional charges of suffering and desire, but these forces always play somewhere beneath the surface, often swathed in intricate layers of aesthetic frames within aesthetic frames. Roussel's attitude toward emotion and the agonizing contingencies of any but the most rationally idealized human action may bear some relationship to his

attitude toward the breasts of music hall dancers. Michel Leiris notes that, although Roussel was not particularly prudish, he disapproved of naked breasts on the music hall stage, because the charm of female breasts depended on their concealment, on their being "forbidden fruit" (see *Épaves*, 14). Roussel may, of course, have found the female anatomy threatening or distasteful just as he found intense outbursts or vivid representations of emotion threatening or distasteful, but the important element of this analogy is Roussel's acknowledgment and approval of the forbidden fruit's existence. In his literary works he clothes human emotion in layers of intricate, sterile garments, but allows the garments to take their form from and corroborate the existence of the scenes of suffering and desire they conceal.

Foucault makes an important point in noting the dominance of the visible in Roussel's oeuvre. It is, however, equally important to realize that for Roussel visibility or explicitness could taint and degrade certain aspects of human existence and that the value of the visible, what motivates Roussel to dwell upon the surface features of objects, is inevitably tied to certain invisible or concealed aspects of these objects. In the novels and plays an obsessively intense gaze is focused upon objects, the minutest details of visibility are painstakingly described, but the eye is ultimately denied access to the secret inner essences and worth of the objects it examines. The visible surfaces of things only provide veiled, cryptic hints of the actions and emotions that have formed or marked them. Desire and suffering only reveal themselves completely within the carefully ordered, sterile abstractions of the imagination. Roussel's treatment of the visible and emotional stands in marked contrast to Kokoschka's. For Kokoschka the visible world is a shifting, threatening nakedness, while for Roussel it is characterized by stability and propriety. Whereas Kokoschka agitates the internal world of emotions by making them violently visible, Roussel embalms emotions in coolly recounted anecdotes that are carefully distanced from both the visible world and the heated interiority of dramatically presented characters.

Roussel's approach to mimesis is interesting, I think, for the dexterity and eloquence with which it indulges and betrays his fixations and fears. The cancerous profusion of exotic surface detail multiplies in a crazed attempt to convince the reader that its lush, teeming variety is all that matters, but every detail points to hidden facts and histories: the more complex the visible, the more pervasive and elaborate the invisible powers that have marked it. The extremes to which the visible is pushed

in an attempt to make its uniqueness arrest further inquiry often makes it ridiculously comic (e.g., a statue made of corset stays or sauterne transformed into a golden putty), so that its dignity (always important for Roussel) can only be restored by an explication of the elaborate, rational inventiveness that led to its creation. Since, however, the visible features of the objects are often, in fact, chosen by means of Roussel's "process," the putatively exhaustive rational explanations are often tinged with the mysterious uneasiness of an alibi.

Even before Roussel revealed his process some critics suspected that some secret code underlay his work. That the code proved to be the nonsensical wordplay of the process shows, I think, that it was the suspicion of hidden meanings—a vague intuition of essences buried beneath the facts hidden in the past histories or abstruse purposes of the objects exposed to view—rather than the content of these hidden meanings, that was of primary importance to Roussel. The visible and the invisible, the imaginative and the concrete, are saturated with reticent suggestions of double entendre that, with cautious modesty, hint at without ever fully disclosing mysterious, repressed zones of erogenous meaning.

The importance of the connections between the visible and the invisible, the surface of objects and the explanations of the marks upon their surfaces, gives Roussel's works a broken vertical rather than a smooth horizontal organization.[26] Rather than unifying each novel or play with an overarching action that moves unambiguously from beginning to middle to end, Roussel presents each as a series of declivities falling away from spectacular visual tableaux through the strange histories of their creation into the motivationally opaque promptings of his automatic process. These vertical structures whose organizational principles are always very clearly and logically laid out, whose parts are always carefully soldered together, are only tenuously attached to one another. The unifying contexts in which they are presented (the gala of the *Incomparables*, a tour through Locus Solus, the polite conversations of curiosity collectors, or a treasure hunt) have relatively little significance or interest in their own right. In face of the precise order and vivid detail of the individual knots and hierarchies of anecdotes, the rather desultory and arbitrary unifying gestures of the framing narrative tend to dissolve, leaving the reader with a fragmented collection of individually autonomous narrative clusters.

The formal isolation of the narrative clusters is echoed in Roussel's persistent thematic emphasis upon isolation. In *Impressions d'Afrique* the

European *Incomparables* are marooned in a distant African country, *Locus Solus* takes place at Canterel's solitary estate, and *La Poussière de soleils* concerns the search for the treasure of a hermitlike misanthrope in distant French Guiana. The anecdotes in *L'Étoile au front* usually revolve around exotic objects that have been removed from their natural contexts, have become the autonomous exhibition pieces of curiosity collectors. The contents of the individual stories within these works also often revolve around individuals who are set apart from others by virtue of their location (e.g., in prison), some special knowledge or training (applies to animals as well as people), or a special mental or physical property. Roussel seems to be asserting with this thematic emphasis that value and meaning are related to isolation and autonomy. Just as Trézel's collection of odd artifacts depends for its value on the number of completely unrelated, individually complex objects it contains, Roussel seems to think the value of his literary works depends on the number of individually autonomous episodes each contains. His lack of concern for the unity of the literary work as a whole is evidenced by his willingness to publish a collection of excerpts from *Impressions d'Afrique* and *Locus Solus* as a work in its own right.[27]

Much more could be said about Roussel's general aesthetic principles, but this would lead us away from the intended subject of this inquiry.[28] The points I have delineated thus far should be enough to guide us into Roussel's conception of drama.

Limiting Dramatic Mimesis

Although Roussel's two novels contain strong elements of spectacle in general and theatrical themes specifically, these elements do not transfer successfully to the stage. I think the staging of the two novels is best explained as an unclearly considered, unsuccessful attempt to reach a larger audience. The dramatic adaptations of the novels, from what we know of them, lose much of Roussel's unique aesthetic vision and gain little in the realm of more conventional dramatic forms.[29] In his two plays, however, Roussel has radically altered the conventional contours of drama to conform to and extend his idiosyncratic aesthetic ideals.

The most obvious major difference between the novels and the plays is the retreat of spectacle evidenced in the latter. While it would certainly be difficult to stage the large, elaborate tableaux described in the novels, the plays seem to avoid them on principle rather than for pragmatic

reasons. Roussel might, after all, have described his spectacles at second-hand, as Frondaie (his ghostwriter) does in the adaptation of *Locus Solus*. Instead, Roussel forsakes large, elaborate, one-of-a-kind spectacles in favor of more intimate anecdotes involving modest properties and focus-ing on the fortunes and emotions of individuals. The second and third scenes of *L'Étoile au front* carry an implicit announcement of this change of subject matter. In the second scene anecdotes prompted by a souvenir section of tightrope wire culminate in the story of a renowned artiste's petition for permission and financial support to walk a tightrope between two islands. Such a grand, unrepeatable spectacle would be similar to those in the novels, but the petition is not granted, the spectacle does not take place, and the artiste, consequently, does not fulfill the (intentionally impossible) conditions for marriage set by the woman he loves.

In the scene following the tightwire anecdote, two stories of endur-ing love relationships (set in Renaissance Spain and czarist Russia) are associated with two distinctly more modest forms of spectacle: a shadow cast on a statue and the flight of a pigeon. Moreover, in the Lope de Vega anecdote, the simple heart-shaped shadow cast, by surreptitious design, on a statue depicting the young nude form of an aged mother superior to commemorate the affair she had with de Vega years ago, upstages the elaborate spectacle officially mounted to honor his current literary fame when he visits her convent. Claude, who listens to his fiancée relate this story, notes that de Vega, in devoting his attention to the statue and

> in honoring thus the past, forgot to savor complaisantly the intoxica-tion of sensing himself encircled by his triumphal arch. (*L'Étoile au front*, 30)[30]

Thus, we see that even in the reported anecdotes, where questions of stage practicality are not at issue, Roussel has chosen, in the plays, to focus on relatively modest actions and tableaux.

In the visible scenes of his plays, Roussel makes frequent use of simple objects such as a manuscript bound by tightrope wires, a stuffed pigeon with an edict attached to its leg, and an ordinary butterfly. Besides being smaller and manufactured from more common materials than the central objects in the novels (such as a mosaic of human teeth or railroad tracks made of calf lungs), these objects contain less overt reference to the significant events of their pasts. J. H. Matthews, in his study of Roussel's theater, takes note of the mundane appearance of the objects in the plays:

Having selected an object too banal to retain the spectator's atten-
tion . . . Roussel sets himself the task of assuring it a completely
unexpected value, thanks to the story concerning it that he will
recount. (Matthews, *Le Théâtre de Roussel*, 77)[31]

In the novels the complexly marked objects need only be described in
detail for the salient features of their histories to find a voice, but the
objects in the plays tend to be more reticent, the marks on their surfaces
less detailed and evocative. This point is driven home repeatedly. Gene-
viève wants to throw away an old stuffed pigeon, not realizing it is "a
historic bird"; Joussac scoffs at the commonplace butterfly, not knowing
that it is "illustrious," "because its last flight had grave and resounding
consequences" (102). The enrichment that unusual histories lend to ob-
jects is often stressed, but these histories are also often shown to be only
tenuously connected to the objects that played important parts in them.
The objects upon the stage as well as the actions of the characters there
tend to separate from the elaborate anecdotes carried in the spoken
words. As in the novels, Roussel usually avoids natural dialogue.[32] This
lack of a verbally mediated intersubjective engagement of conflicting
anxieties and desires combines with the gap between objects and their
histories to separate markedly the signifying potentials of the mise-en-
scène (the set design, props, and actor's bodies) from the signifying
potentials of the spoken words. Roussel opens up the gap between theatri-
cal words and images that Benn plays with tentatively in *Etappe*.

In constructing his plays, Roussel exploits the immediacy of the stage
to sharpen the dichotomy (already present in the novels) between the
surface representation and the subordinate representative levels. Since the
sole immediate medium of representation in the novels is the printed
word,[33] a certain formal homogeneity obtains despite the thematic distinc-
tions separating the framing situations (the gala of the *Incomparables* or the
promenade through Locus Solus) from the actions described at various
removes within these situations (e.g., the battle of Tez or the murder of
Andrée by François-Jules Cortier). Moreover, it is easy to forget the fram-
ing situations and get caught up emotionally in the events of the structur-
ally subordinated stories, because the subordinating frames are all carved
from the same semiotic material: in their diachronic presentation nothing
prevents the innermost shell of the representation from feeling just as
present as the outermost. The words that describe, for example, the mur-
der of Andrée cannot simultaneously signal that they are, in fact, only the

words the narrator is using to decribe Canterel's account of the events leading up to the suicide of François-Charles Cortier that determine the movements made by his corpse when it is reanimated. The elaborate arrangement of quotation marks within quotation marks, so important to the structure and aesthetics of Roussel's works, tend to sink beneath the horizon of awareness in the diachronic process of reading.

In his plays Roussel exploits the semiotic multiplicity of drama to widen and maintain the gap between the representation of the framing situation and the mediated representations within it. The representative powers of the mise-en-scène are devoted exclusively to delineating the framing situation in which true dialogue and human action make, at most, brief, inconsequential appearances, while the anecdotes and actions quoted or represented within the dramatic representation are fleshed out only in the words the actors speak. The nature and purpose of the dichotomy Roussel cultivates between the physical presence of the mise-en-scène and the representational evocations of the spoken words are best appreciated by examining closely the intricate details of this dichotomy.

The most salient and essential element of the dichotomy is the lack of dialogue. I do not mean to suggest that Roussel's plays are completely devoid of dialogue. Small excrescences of intersubjective, verbal exchange do form upon the surface of the plays, but, rather than develop and forward a dramatic action, these moments serve only to highlight the pervasive lack of intersubjective linguistic engagement in the utterances of the plays' characters. In *L'Étoile au front* the brief, secretive conversations between Çahoud, commissioned to hunt down and murder for obscure ritualistic reasons the twin Indian girls under the protection of the wealthy collector Trézel, and Meljah, Trézel's maid, Çahoud's sweetheart, and recently converted to Christianity, approach the status of a minor, self-contained, dramatic action. Act 1, scene 5, in which Meljah's description of the attraction Christianity has exerted upon her prompts Çahoud to propose forsaking his assassin's mission in hopes of endearing himself more deeply to her is particularly saturated with the dramatic immediacy of intersubjective dialogue. Significantly, however, even in this scene, in which the intellect, will, and emotions of the character's— that is, all the elements of their subjective being—thrust themselves unreservedly into the words, the dramatic action is not allowed to complete itself. Meljah postpones her decision to leave with Çahoud to the following day, and, then, neither of this pair of lovers appears again upon the stage. All the other conversations usually avoid immediate, personal is-

sues from which a dramatic dialogue might spring. The intersubjective display of emotions and desires make only brief appearances at some of the interstices of the autonomous anecdotes. Note, for example, the beginning of act 1, scene 3:

> GENEVIÈVE: . . . I want you always near so I can impart to you my slightest thoughts, share with you my joys and pains . . .
>
> CLAUDE: Is that true? I also miss you during the hours my work keeps me away.
>
> GENEVIÈVE: Oh, yes! Because I enjoy nothing that I can't share with you. When I'm moved by a spectacle of nature, the emotion is immediately augmented by the desire to describe it to you. If a lecture pleases me, I must make it the subject of a chat between us as soon as possible.
>
> CLAUDE: Are you still immersed in Lope de Vega?
>
> (*L'Étoile au front*, 23–24)[34]

Geneviève declares that amorous intimacy is not so much a matter of physical contact or revealing to each other hidden anxieties and desires as it is the mutually enjoyed obliteration of subjective being in the contemplation of spectacles of nature or charming stories. In general, characters reveal an emotionally charged, psychological presentness in moments of dialogue only to slip immediately away from it into the comfortable impersonality of some anecdote. In act 2, for example, Trézel devotes most of the first scene to the elaborate discussion of coded letters he is attempting to decipher in order to avoid mentioning his distress over Meljah's decision to return to India with Çahoud (revealed in a letter after she has departed) and the departure of the Indian twins for a safer hiding place (accomplished before the scene opens). After finally dealing briefly with these more emotionally engaged matters of the recent past, Trézel and his companions quickly become absorbed in quizzing their new maid for the minute details pertaining to a twig that hangs from her belt as a religious token and lucky charm. In place of interpersonal communication *L'Étoile au front* is filled with monologic and choral recitations of often thematically related but fundamentally autonomous impersonal anecdotes.

La *Poussière de soleils* contains more incidents of dialogue than *L'Étoile au front* and makes greater use of it in the structure and development of its action but still does not vouchsafe dialogue its conventional

central position in the dramatic representation. Other important elements in the play intrude upon or develop independently of the moments of true dialogue. While fully developed autonomous anecdotes are more rare in this play than in the earlier one, large portions of the verbal exchange in this play are concerned with matters equally impersonal and removed from intersubjective, dramatic interaction as the anecdotes. The central characters, Julien Blache and his assistants, devote almost all their utterances to discussions and deciphering of the clues leading to the treasure. Insofar as any kind of life is delineated by this technical dialogue, it is the life of Guillaume Blache, who sets up the long elaborate chain of clues before dying and is not physically present in the play. The verbal exchanges of the treasure hunters tend to contribute to a protracted choral narration of the last few years of Guillaume Blache's life. His life, however, is represented not as a vibrant process of becoming, the development of the potentials of a human spirit in time, but as a meticulously predetermined ritual. Guillaume's real life is completely concealed by his misanthropic withdrawal from human society. He ventured into the world and conversed with people only as a means of laying down clues to the location of his treasure. His conversations, reconstructed through the investigations of his nephew, are not so much acts of direct communication as depositions of arcane artifacts, whose significance must be laboriously deciphered.

The scenes devoted to the love trysts of Jacques and Solange conform more often to the conventions of dramatic dialogue than do the conversations of the treasure hunters but, nevertheless, tend to slide away from the delineation of an intersubjective present into accounts of long-standing collective rituals. The lovers meet repeatedly at locations consecrated to lovers by some past event, and the milieux inevitably encourage Jacques to discourse at length on the elaborate marriage rites of French Guiana. Through the thematic focus of the locations and conversations Roussel transforms the lovers' dialogue into a social ritual.[35] The words as well as the love affair lying behind them retreat from an interpersonal signification of subjectivity to become an avatar of a ritual action devoid of the psychological nuances and motivation that flesh out concrete human existence.

The only scenes in which intersubjective dialogue is allowed an unrestrained preeminence are those devoted to the villains. In this fact we see proof that Roussel, far from not appreciating the fundamentals of traditional drama or being unable to work with them (as Matthews

suggests), is definitely hostile to the aspects of reality stressed by the conventions of intersubjective dialogue. The only characters in *La Poussière de soleils* who use words to talk directly to one another (rather than to refer to something beyond their subjective existence) are the characters the play ridicules. Roussel does not formulate an explicit thesis that equates villainy and dialogue, but he unmistakably aligns conversations devoted to personal desires and emotions with the low-life elements in the play. The lovers and the (rightful) treasure hunters predominantly concern themselves with matters more elevated than the psychological ebb and flow of quotidian subjectivity. Their refinement reaches its apogee in the final image of the play. The two lovers vow to attempt to mitigate the pain of their imminent (short) separation by contemplating together, at a fixed time, an immense dustlike cloud of stars. Julien Blache suggests that when they are reunited the lovers will want to continue contemplating, side by side, that vast *poussière de soleils*, losing all thought of their selves by wandering mentally among the billions of possible attributes of the millions of worlds rotating around those suns.

Roussel's principle strategy for avoiding conventional dramatic dialogue is to keep the subject of the conversation out of the mise-en-scène. Characters normally talk about themselves, their intentions, emotions, and actions, but Rousselian characters spend as much time as posssible talking about other things—curious anecdotes, the encoded actions of a now dead recluse, or a vast dust cloud of suns. A major difficulty facing Roussel in the composition of his plays is to motivate the characters' adhesion to a depersonalized, displaced discourse without allowing this motivation to draw the conversation back into the subjective presentness of the characters within the mise-en-scène. Roussel accomplishes this feat through the use of stage props, small, self-contained objects, in *L'Étoile au front* and an objectified modification of a conventional intrigue plot in *La Poussière de soleils*.

Although the objects in *L'Étoile au front* are much more modest and commonplace than the extravangantly bizarre constructions rife in the novels, they are just as essential to the character of this play as the grand spectacles are to the character of the novels. The objects act as catalysts for the anecdotes to which most of the spoken words in the play are devoted. Encountering an object is enough to initiate a story, and, hence, the use of an interplay of thoughts and speech acts for developing the themes of conversation, which is common in conventional dialogue, is obviated. The objects' presence in the mise-en-scène, rather than the

movement and interaction of the characters' subjectivities upon the stage, motivates the anecdotes.

Roussel's use of objects fuses the words of the characters with the physical properties of the mise-en-scène without recourse to the psychologically oriented, unifying strategies of conventional drama. Indeed, the objects create a sense of connectedness between mise-en-scène and spoken word while simultaneously destroying the conventional forms of this connectedness because, in attaching the verbal anecdotes to the autonomous physical objects, Roussel detaches the anecdotes from the emotional life of the characters and the social and physical forces of the milieu. Although the objects are visually modest, they stand quite capably as advertisement and testament to the stories within which they play parts. Indeed, their visual banality heightens their effectiveness in linking the verbal discourse with the mise-en-scène. In the novels, where the problem of two separate spheres of signification does not arise, Roussel's meticulously impersonal diction tries to sink beneath or disappear behind the lavishly bizarre visual scenes it describes, but in *L'Étoile au front* the words surge up out of the objects. The verbal component of the play, rather than simply reinforcing or accompanying the striking visual imagery, must justify the presence on the stage of seemingly uninteresting objects. The objects, thus, depend upon the words for a justification of their existence; their aesthetic relevance comes from the verbal remarks they draw out of the characters.

Of course, not all of the anecdotes in *L'Étoile au front* are introduced by objects. Other excuses and associations are sometimes appealed to, but the objects anchor the conversation, providing motivation for sudden shifts in subject matter or a point of stability in the more bewilderingly knotted narratives. Moreover, even when no object is physically present onstage, one is often invoked to initiate a string of anecdotes. The works of Lope de Vega, for instance, motivate the anecdote of the plaster torso; a fraud against an insurance company puts Geneviève in mind of a lecture on a painting by Gros, which leads to an elaborate explication of another attempted fraud (see *L'Étoile au front*, 137–49); and, in act 1, scene 4, songs and music, rather than physical objects, provide the points of departure for the anecdotes.

In *La Poussière de soleils* the autonomous glory of objects, their involvement in elaborate stories completely removed from the situation delineated in the mise-en-scène, is sometimes suggested but never dwelt upon with the elaborate persistence evidenced in *L'Étoile au front*. The

importance of objects in *La Poussière de soleils* is usually tied to the exigencies of the treasure hunt. The history of an object that comes under scrutiny is not revered as an autonomous anecdote but, rather, for the light it can shed on the search for Guillaume Blache's fortune. Instead of separate, autonomous objects, the elaborate chain of clues leading from a letter and a book to the casket of jewels provides the primary link between the mise-en-scène and the verbal discourse.

The unity that the chain of clues gives to *La Poussière de soleils* makes this play seem, at first sight, more conventional than *L'Étoile au front*, but there are some important distinctions between Roussel's chain of clues and the traditional, causally motivated dramatic plot that it resembles. The mood of Roussel's play is more like that at an archaeological dig, as layer upon layer of an extinct civilization is brought to light, than like that in a detective novel, as the sleuth rushes from clue to clue to the ultimate unraveling of the crime. Roussel's chain of clues resembles an elaborate fossil more than the plot of a dramatic action. The path from the book or letter to the treasure is not forged in the way a detective forges by insight and audaciousness a path from the crime to the culprit; rather, the treasure hunters uncover a fixed, rigidly ordered set of clues laid out long ago by Guillaume Blache. The absolute fixedness of the chain of clues gives it an objectlike quality similar to the objects in the earlier play.

Moreover, the rightful treasure hunters, that is, Julien Blache and his associates, maintain an emotional distance from the task they have set themselves, which gives the chain of clues a significant autonomy from the subjective states of the characters uncovering it. Julien Blache is already wealthy and has no need for the treasure. He resolves to find it simply because he is its rightful owner. His associates assist him because they feel bound to by friendship or professional responsibility. They all treat the search as a challenging intellectual puzzle but nothing more. Only the villains' search for the treasure is motivated by a longing for personal gain—only their avariciousness touches the treasure with the existential presentness of human desire. The course of the action, however, clearly repudiates this connection of the treasure hunt with the movements of the subjective spirit: the villains lose the treasure and are imprisoned.

Besides carefully separating the search for the treasure from the emotional life of Julien Blache and his colleagues, Roussel is also at pains to prevent the audience from becoming too intimately attached to the

movement from clue to clue. The suspense that might naturally build as the treasure hunters move closer and closer to the jewels is purposely played down, undercut, or sidestepped in four basic ways.

First, the quality of the chain of clues itself makes it impossible, before reaching the penultimate clue, to know how close or far away the treasure lies. The cryptic messages never point further than to the next in the series, and the series could continue indefinitely. Only the audience's conviction that the treasure must be found by the end of the play and that the play cannot last much longer than three hours could lead it to view the later links in the chain as significantly closer to the treasure.

Second, Roussel does not allow a smooth movement from clue to clue to build within the mise-en-scène. Gaps are left in the representation of the chain of clues upon the stage. The treasure hunters often decipher one or two of Guillaume Blache's cryptic messages between scenes then explain in condensed, abstract terms, which discourage the audience's emotional involvement, the reasoning they used to arrive at the current stage in their search.

Third, Roussel frequently introduces extraneous issues that sheer the mise-en-scène away from the development of the treasure hunt. Besides the two subplots involving the lovers and the villains, a number of short anecdotes arise to block for a moment the continuation of the chain of clues. The explanation of Buluxir's parentage, birth, and ancient age in the second tableau, the story of François Patrier's death in quicksand in the sixteenth tableau, and Angelicus's prayer to Treïul, which occupies the seventeenth tableau, are examples of these fragmenting anecdotes.

Fourth, Roussel tends to ban from the stage all scenes or tableaux with a potentially high emotional charge. When one character eavesdrops upon others, the audience is never made aware of it until the spy recounts what he has learned in a subsequent scene. The tension that might be created by letting the audience see the spy while the spy's victims do not is clearly something Roussel wishes to avoid. The climactic scenes in which, first, the villains beat the rightful treasure hunters to the jewels and, second, the police capture the criminals red-handed are also set off the stage, safely beyond the reach of the audience's emotional engagement.

These four emotion-neutralizing strategies, in distancing the audience from the chain of clues, increase the objective quality of that chain, make its presence in and effect upon the mise-en-scène that of an autonomous, concrete thing, similar to the objects in *L'Étoile au front*, rather than a developing action or event. The chain of clues glows with mo-

ments of the past and offers access from the rational, refined, static world of the mise-en-scène to the emotionally overloaded but safely expired world of the misanthropic recluse Guillaume Blache, but only by means of a coolly rational, methodical decoding and verbal explication of the carefully organized marks, alterations, and references Guillaume left in the world around him.

The love affair subplot exploits a ploy similar to that of the main plot for ontologically separating while thematically connecting mise-en-scène and verbal discourse. The characters talk more about an absent chain of events, in this case the nuptial rituals they will perform, than about the emotions, thoughts, and desires animating them at the moment. The settings in which their conversations take place, which are the sites of their future engagement and marriage ceremonies, link the mise-en-scène with the verbal discourse, but the optative and conditional moods of the issues they discuss ontologically separate their conversation from the immediacy of the scenic milieu.

This subplot complements the main plot in the task of avoiding the pure presence of dramatic dialogue in that, whereas the main plot refers constantly to the past, the subplot refers to a chain of ritualized events in the future. The implicit message of the play seems to be that one is never constrained to talk about the present. As the main plot reaches its conclusion, the subplot carries the focus of the play quickly over the present moment and projects it into the future, first into the chain of imminent nuptial rituals and then on into the myriad possibilities suggested by the dust cloud of suns.

The Aesthetics of Anecdotes

Although the objects presented within the (implied) mise-en-scène of Roussel's plays and the verbal anecdotes they elicit ultimately refer to or delineate representations of reality in line with the conventions of bourgeois art, these objects and anecdotes are themselves beyond the pale of drama's culturally sanctioned aesthetic material. Roussel's major contribution to avant-garde aesthetics is his advocacy of a kind of "aesthetic contemplation" of objects that violates the norms of such contemplation. Although Roussel's work is not overtly anti-aesthetic, it does cultivate an aesthetics unsanctioned by either conventional or high modernist artistic practice. I use the phrase "unsanctioned aesthetics," first, to point out that the pleasures involved in telling or hearing a conversationally

presented story or of solving an intellectual puzzle are not the same as the more formally legislated pleasures involved in creating works for or enjoying works presented within the social formations that constitute the bourgeois institution of art and, second, to withhold judgment upon whether or not this storytelling and puzzle solving is aesthetic. If we assume that the concept "aesthetic" is defined exclusively by the contours of the art institution, then Roussel is celebrating a non-aesthetic (but also nonutilitarian) form of verbal discourse, but, if some form of aesthetic experience exists outside of the art institution, then Roussel's work may be championing this extra-institutional form of aesthetic experience. With Roussel we see again that the avant-garde need not simply negate the concept of art to distinguish itself from the conventions of high modernism.

The privileged objects in Roussel's plays are usually not artworks, and, if they are, their significance and value accrues from their nonaesthetic properties. Roudnitski's fountain, for example, is valued for being his first major work, rendered from a granite outcropping near his home when he was still an obscure peasant with no art training; Baron Gros's portrait of the Vicomte de Timbert is important for its forensic precision and the decisive role it played in a trial for fraudulent impersonation; and Alfred Magdalou's *oeuvre sans prétentions*, painted on a picnic menu, merits attention for using for the first time a recently developed pigment. In *La Poussière de soleils* the significance and value of artworks, as well as other objects, is measured almost exclusively by their worth as clues in the treasure hunt. In the few exceptions to this rule—objects examined or revered by the engaged couple Jacques and Solange, for example—the art objects are important for a moral lesson or cultural more they represent.

In *L'Étoile au front* the type of unsanctioned contemplative value attributed to artworks differs markedly from object to object. The value may be tied to some aspect of the object's construction (e.g., strands of tightrope wire or an aquamarine pigment), some past event in which the object was involved (the type of events deemed interesting vary markedly), or some use to which the object can be put (e.g., a book may be important as the key to a secret code [2.1] or as a talisman [3.5], rather than as a work of literature). The anecdotes in Roussel's plays also maintain their distance from high culture's approved ways of telling stories— that is, from the conventions of literature. They celebrate the unsanctioned aesthetic pleasures of sharing a curious tale among friends or of solving an ingenious puzzle, riddle, or coded message. Although the

anecdotes are often taken from literary sources, these sources are usually, in some respect, marginal to the literary canon of bourgeois culture. The anecdotes are never short stories or poems recited verbatim; they are, rather, the plots of operas, biographical sketches, or excerpts from letters. Moreover, the informal, conversational, stylistically naive manner in which they are presented effectively strips away any vestiges of a high art aura that may have attempted to follow them from their more aesthetically conventional source.

To a certain extent the objects and anecdotes of the plays share their unsanctioned aesthetic with the objects and anecdotes of the novels, but the plays make a more pointed use of this quality. The anecdotes and objects in the novels have a more conventionally literary veneer in that the narrative voice, aside from the peculiarly methodical manner in which it presents information, behaves, when it describes the anecdotes, more or less as conventional narrators usually do: the innovativeness of the novels lies in the subject matter described more than in the manner in which the subject matter is presented or in the ontologically significant features of the narrative voice. The characters in the plays, on the other hand, do not behave as do conventional dramatic characters: that is, they do not, in their dialogue, gestures, and movements, represent the intersubjective relationships of a developing action in its constantly advancing present moment. Through the characters' fascination with anecdotes Roussel denies the importance of the present moment and refuses to take up the task of dramatic representation. The anecdotes are more foreign to the ontological presuppositions governing the existence of dramatic characters than they are to the ontological presuppositions governing the existence of a novel's narrative voice.

To accentuate the foreign quality of the anecdotes (and the objects associated with them) within the dramatic world of the mise-en-scène Roussel gives them a tighter structural organization of motifs, images, and themes than he gives to the anecdotes in the novels.[36] Note, for example, the series of anecdotes Geneviève recounts from Bezin's lecture on Baron Gros's portrait of the Vicomte de Timbert (*L'Étoile au front*, 2.4). Joussac has just described a successful insurance fraud involving the substitution of a dead man, whose physical features are not important, for a living one and how, in the end, the insurance company, which never suspected that it had been cheated, was reimbursed the full amount paid out on the fraudulent claim. This anecdote prompts Geneviève to present an elaborate knot of stories-within-stories, all of which

relate to an unsuccessful inheritance fraud scheme involving the substitution of a living man, whose physical features are of critical importance, for a dead one and how the trustee paying the inheritance suspects and uncovers the fraud but is unable to recover any money.

Geneviève's anecdotes are initially presented like a set of Chinese boxes (narrative shell within narrative shell) in which each shell encloses those within it by a kind of spectatorship or critical gaze: Geneviève attends Bezin's lecture, Bezin examines Gros's painting, Gros studies the visage of Timbert, and Timbert sees his likeness in the baritone Damaresse and gets his swindle scheme from watching the opera *Le Crime impuni*. Timbert's gaze softens and twists the inner shells of Geneviève's presentation into an elaborate knot. Initially, Timbert's life is described separately from Damaresse's, and both are set apart from the events in the opera, but then Timbert notices the physical similarities between himself and Damaresse by virtue of the makeup Damaresse wears at the critical moment in the play that the two men will later attempt to reenact in real life. The opera centers on a representation of an unpunished crime involving the forced exchange of unsimilar babies (a boy and a girl) and the murder of one of them. Timbert's attendance at the opera prompts a crime (that is eventually punished) involving the mutually agreed upon exchange of similar, mature men (in this case "across" narrative shells, in that Damaresse and his pertinent biographical details were initially presented by virtue of coming under the gaze of Timbert) and the natural death of one of them. (Damaresse stands in for Timbert after his death so that his wife can continue to receive the benefits of a trust fund set up exclusively for Timbert.)

The numerous reversals involved in Timbert's and Damaresse's imitation of the operatic fraud (similar versus unsimilar, mature versus newborn, etc.) bring to mind the concave mirror (which, at the proper distance, creates an upside-down reflection) that acts as the catalyst for the fraud delineated by Joussac (see *L'Étoile au front*, 135): where a concave mirror appears physically at the major turning point in Joussac's anecdote, the abstract effects of such a mirror (i.e., inversion) permeate the events of Geneviève's anecdote. The conviction of Damaresse and Timbert's widow for fraud adds another loop to the narrative knot by pulling Gros's painting into the plot and showing that the imitation of art in life attempted by Damaresse and the Timberts in their mimicking of the opera was not as precise as the imitation of life in art accomplished by Baron Gros in his painting. (Gros's painting is a more accurate representa-

tion of Timbert than is Damaresse, who is attempting to impersonate him.) Similarly elaborate thematic connections can be found throughout *L'Étoile au front*. Particularly cohesive groups of anecdotes appear in act 1, scenes 2–3,4; act3, scenes 1–3; and Lissandreau's story in act 3, scene 4.

The anecdotes in *La Poussière de soleils*, while lacking the convolutive interconnectedness exhibited in *L'Étoile au front*, are laid out in long chains and broad categories of thematic homogeneity. Rather than jumping abruptly from one group of anecdotes to another, as in the earlier play, the anecdotes in *La Poussière de soleils* proceed along two distinct causal lines: the treasure hunt and the love story. The anecdotes that lie along these chains usually concern acts of heroism, prophets and visionaries, or crowd scenes and social movements.

The cohesive nature of the anecdotes in the two plays should not be considered a return to a more conventional style of literature after the fragmentary construction exploited in the novels. Indeed, the thematic cohesion of the anecdotes pushes the overall fragmentation of the plays to an extreme never reached by the novels. The novels rest content with a pervasive thematic fragmentation, whereas the plays cultivate a fragmentation of the formal underpinnings of aesthetic mimesis. The anecdotes separate themselves from the characters by virtue of their lack of psychological motivation and separate themselves from conventional art by virtue of their unsanctioned, anecdotal form and subject matter. The anecdotes' domination of the verbal field of the plays and their intestine cohesion enhance the contradictory juxtapositions at work within the plays. The cohesion of the anecdotes, rather than holding the artwork together, creates a semi-autonomous center of force that works against other centers of force to pull the work of art apart. The artistic cohesion of the anecdotes jars against their unsanctioned qualities, and both jar against the dramatic context of their presentation, colliding with equal force against the dialogic structure of the verbal text and the physical presentness of the mise-en-scène.

Rousselian Collage

The dissonance and fragmentation rife in Roussel's plays achieve coherent resolution only in terms of an idiosyncratic, collage-oriented aesthetic. Roussel's use of collage is most radical and noteworthy for its elaborate insinuation into all aspects of the artwork and for its peculiarly hermetic ontology. Whereas in the collage aesthetic practiced by

avant-garde painters the principle of imitation undercuts the principle of construction by placing unprocessed bits of the external world within the work of art, in Roussel's collage aesthetic a principle of imaginative construction undercuts the principle of aesthetic construction by placing within the artwork raw bits of intellectual invention conspicuously unsuited to the conventional contours, textures, and constructive principles of the genre of art in which they appear. Roussel's collage places within the work of art objects from the imagination rather than from real life. The autonomous madeness of these objects, rather than their natural reality, shines through the constructive logic of the work as a whole. Whereas other forms of avant-garde collage usually posit some sort of ontological dichotomy (real life versus aesthetic artifice) that disrupts the conventional autonomy and integrity of the artwork, Roussel's collage is thoroughly monistic. Rather than bring elements of the real world into the artwork, Roussel allows aesthetic artifice a cancerous growth that cracks and dissolves the (conventional) mimetic integrity of the work from within. Roussel's collage preserves the ontological autonomy and homogeneity of the artwork while disrupting its internal organization with the dissident facticity of an "uncontrolled" (vis-à-vis established aesthetic conventions) inventiveness glued upon, rather than fitted into, the mimetic conventions of drama.

Kokoschka's theatrical collage has a greater heterogeneity and shock value than Roussel's collage of anecdotes and inventions in that Kokoschka draws into his plays marginally processed bits of external reality such as Weiningerian misogyny as well as a broad range of disparate theatrical modes of representation and expression, all of which Kokoschka fragments and thrusts aggressively at the audience. Roussel's collage, however, despite its relative aesthetic homogeneity, does more damage to the unity of the artwork than does Kokoschka's collage.

The collage created by Roussel's exuberant invention spreads across the thematic surface of the plays and penetrates deep within their formal structure. On the level of fundamental subject matter *La Poussière de soleils* is a collage of actions: the race to the treasure, the courtship of Jacques and Solange, Angelicus's ethical worries, and Oscarine's superstitious anxieties are glued beside one another on the surface of the play, where each maintains its individual integrity, refusing to surrender its sovereign existence for the benefit of the whole, as happens in montage. *L'Étoile au front* is a collage of anecdotal monologues, which are often cut up and distributed among groups of characters. This play suppresses action in favor of

patchwork storytelling, and the later play suppresses the autonomy of storytelling in favor of action-oriented chains of vignettes.

Roussel's development and differentiation of characters in both plays also proceeds from a logic of collage. Vague hierarchies reminiscent of *Locus Solus* are suggested (Trézel playing the protagonist savant in *L'Étoile au front* and Julien Blache the corresponding central figure in *La Poussière de soleils*), but these hierarchies are soon obliterated by the ad hoc collection of exotic characters plastered upon the dramatic structure of the plays. Although some characters appear more frequently than others, almost everyone is saturated with surprising physical traits or biographical incidents that invite attention in their own right and refuse to serve any overarching concerns of the play as a whole.

Indeed, the less frequently the characters appear, the more elaborate and unusual their histories or appearance become, thus preventing a hierarchy of characters based on the frequency of their appearance. Compare, for instance, the rather flat characters of Trézel, Claude, and Geneviève with the exotic details given to Joussac, Çahoud, Meljah, Zéog, and Leidjé. Or, in *La Poussière de soleils*, compare the mundane, frequently appearing treasure hunters with the bizarre collection of prophets, necromancers, and hermits they encounter on the trail to the jewels.

The lack of true dialogue enhances the isolation of the characters from one another, while the strange physical or biographical traits Roussel gives them prevent this isolation from becoming embarrassing. As in collage, each character in Roussel's plays has a formidable individual facticity completely independent from the play as a whole and from the facticity of the other characters. Each is a semi-autonomous, interesting type, which has sprung from Roussel's imagination and now glows with an aesthetically sovereign existence.

The themes delineated in the anecdotes and actions of the plays also exhibit a pasted-on quality in relation to one another. But, of course, whereas standard collage elements come from different parts of the real world, Roussel's thematic collage elements arise from different movements of his imagination. As with the clustering of anecdotes in *L'Étoile au front* and the chains of vignettes in *La Poussière de soleils*, however, the broad thematic foci of the plays exploit conventional forms of coherence in order to more sharply display their collage qualities. Each play develops a pair of central themes, as often occurs in conventional drama, but then fails to resolve and rationalize the choice of themes with a coherent thesis. As in standard collage, the themes display a certain affinity in tone

and texture but resolutely refuse to be absorbed by one unifying aesthetic effect.

In *L'Étoile au front* the majority of the anecdotes concern love affairs or financial fortunes, while in *La Poussière de soleils* prophets and social or cultural events figure most prominently. In both cases the two central themes simply exist side by side with few affinities upon which to base a rational synthesis. The love affairs described in the first play are each interesting in their own right and as affirmations and expansions of the central theme of love, but neither these individual anecdotes nor the general theme they articulate say anything about the equally central theme of financial fortunes articulated in other anecdotes. The lack of discursive connections between the two themes is enhanced by the distinct ontological values associated with them: the love theme concerns emotional matters, while the money theme is exclusively material. A similar discursive and ontological gap separates the themes in *La Poussière de soleils*. In this play the individual, and often disingenuous, visions of prophets and necromancers are set beside the collective customs and actions of various ethnic groups, classes, or nations, with no attempt to draw any connections between these worlds. The two thematic currents in each play seem to flow immiscibly from distinct sources, although both these sources spring from Roussel's imagination.

The heterogeneity of the themes is not absolute. Although neither play allows enough connections between the themes for a coherent thesis to arise (as would happen in montage), a broad, general focus is discernible in each play (just as it often is in standard, visual art collage). Roussel, however, undercuts the significance of each play's general focus by making the two foci contradictory, reversed images of each other. *L'Étoile au front* emphasizes the importance of the autonomous ego by constantly dwelling in its anecdotes upon either the emotional or material fortunes of individuals. *La Poussière de soleils*, on the other hand, denigrates individualism in favor of collective groups by emphasizing positively social movements and customs (particularly the nuptial rituals of French Guiana) and selfless acts of heroism, while marginalizing or disparaging the metaphyscial assumptions and material motivations of the various prophets, necromancers, and visionaries that embody individualism in this play.

The titles of the two plays reaffirm their oppositional thematic emphases: the star on the forehead is an image that affirms the value and autonomy of the individual, whereas the image of a dust cloud of stars

makes the individual insignificant in face of the elaborate histories of myriad worlds. In contradicting one another, the thematic emphases of the two plays deny themselves the unifying significance one might be tempted (on conventional aesthetic grounds) to attribute to them. The themes reduce themselves to heterogeneous patches of exotic, imaginative invention glued upon rather than built into the plays.

The sovereign facticity of the themes is enhanced by their separation from the life concerns of the characters. In *L'Étoile au front*, while the characters talk incessantly about the vicissitudes of love and wealth, their own emotional and material lives are luxuriously comfortable and unperturbably secure: Trézel is wealthy beyond desire, and Claude and Geneviève make a perfect couple. In *La Poussière de soleils* the characters are concerned with questions of love and wealth, but the thematic emphases of the vignettes steer clear of these issues in favor of a critical juxtaposition of ego-centered and ego-denigrating situations. In the characters' search for the jewels and their marriage preparations, they are completely oblivious to the play of themes around them. In Kokoschka's collage, in contrast, the characters are consumed by the heterogeneous images and themes swirling through the play.

The implied mises-en-scène of Roussel's texts exhibit collage qualities in three fundamental ways. First, each scene or vignette stands more or less on its own: it separates itself from all implied through lines of action in order to elaborate anecdotes and showcase objects. This independence of the scenic moment from the dramatic totality fosters the impression that each vignette has a life of its own independent of its place in the play. Second, the language seems arbitrarily glued to the stage rather than fitted upon it. Both plays would be difficult to follow in a performance.[37] Names come fast and thick at times; narratives are enclosed within narratives and twisted into elaborate knots or strung out in confusingly long chains, so that the audience can easily lose track of the development of the action or even of one anecdote. The bewilderingly concise density of the language imparts to it an ontological autonomy; the virtually opaque complexity of the words constitutes a world independent of the movements and scenery on the stage and aloof from the comprehension of the audience.

The independence of words from staging is enhanced by the third type of collage manifested in the mise-en-scène: the gluing of narrative anecdotes upon the presentness of the actors' bodies. Here again the words move away from the staging but do so due to their narrative mode

of representation rather than due to the density of their informational content. Whereas true dialogue blends the presentness of effect-oriented speech acts with the presentness of the actors' bodies, Roussel's "dialogue" accents the foreignness of the words by juxtaposing their aesthetically mediated and abstracted narrative past tense with the existential immediacy of the actors. As John Ashbery has noted, "The anecdotes cast on the characters who tell them an unearthly glimmer" ("On Raymond Roussel" in *How I Wrote*, 53). I think this glimmer emanates from the gap between the world of the words and the world of the bodies speaking them.

The gap between words and bodies that guarantees an independent integrity to each similar to that enjoyed by the objects incorporated into artworks through collage is replicated between almost every formal element of the plays. Plot, dialogue, characterization, thematic emphases, and mise-en-scène each have an independent existence that shines through and undercuts their participation in the play as a whole. The concerns of each of these formal elements is always at least slightly out of alignment with the concerns of the other elements. The courses of events in the plays have little to do with the anecdotes the characters exchange, these anecdotes contribute almost nothing to the articulation of the various characters, the characters are only minimally involved in the major themes of the plays, and the mise-en-scène contributes little to and gets no support for its scenic effects from any of the other formal aspects of either play. Roussel's use of famous actors and a well-known set designer, director, and musical composer exacerbates the discontinuities present in his text by adding to it the autonomous auras of these prestigious artists, whose participation in the spectacle created centers of interest quite independent from the play itself. Each element of the dramatic structure has been carefully severed from the rest, filled, molded, and finished according to a set of concerns unique to that element, and then reglued to the other elements. The disparities between dramatic elements that Benn often cultivates multiply in perplexing profusion in Roussel's plays.

One might even suggest that Roussel exploits a form of meta-collage in the collocation of constructive conventions he accomplishes. The constructive principles of drama, narrative anecdotes, and collage are set side by side, intertwined, and bounced off one another in his plays. Perhaps, however, the concept of collage breaks down here because, at the level of constructive conventions, it is not clear what is being glued to what. Roussel's meta-collage forsakes the backboard or canvas of drama

and lets the fragmentary autonomies of the collage elements cling to one another as they will, free-floating in a featureless void. Drama is the nominal genre of Roussel's work, and the theater is its primary mode of presentation, but the plethora of anecdotes and fragmenting collage impulses often obscure or shunt to one side the constitutive conventions of drama. Lewis's *Enemy of the Stars* reveals a similar extreme in competing forms of aesthetic construction.

In Roussel's anecdote-ridden collage-drama the mimetic mechanisms create a world of fragmented stasis. Actions are infused with an eerie sense of predestination and are generally considered inferior to the fixity of the past. The final struggle for the jewels in *La Poussière de soleils*, for example, is passed over and only allowed to enter the work as a story told about what has already been accomplished. The glue that holds the parts of the collage-drama together seems to have permanently fixed the representational realm in an established past or an assured future. The shifting present of bourgeois subjectivity has been banned from the plays. Human action is obsessively examined but only in the context of an obsessive aesthetic framing accomplished by multiple layers of narrative intrusion and collage. The collage-effects act as an even greater insulating force than does the narrative intrusion, in that, whereas the latter filters the human action through a number of narrative voices, collage destroys even the immediacy of the narrative voices. All the elements in Roussel's plays seem to come from somewhere else. The representation elicited by the collocation of these elements is petrified by the invisible, uneasily arbitrary glue that holds them together.

The invisible glue binding Roussel's collage-dramas is, I think, the bourgeois institution of art. The institution is essential to Roussel's work in that the convention of the autonomous work that it upholds delineates the space in which the heterogeneous elements of his works come together. The radical moment in Roussel's work lies in the manner in which the elements come together in the autonomous space sanctioned by the institution of art. The various elements of conventional artworks tend to point inward toward the coordinating, cohesive center of the work. In this way the conventional work reaffirms in its internal structure the focused isolation attributed to it by the institution of art.

The various elements of Roussel's works, in contrast, refuse to point in the same direction. Each element champions its own distinct value-affirming vector. The treatment of character, for example, celebrates exoticism for its own sake, the actions (engaged in or described in the

anecdotes) celebrate the inventive elaboration of intrigue, the thematic emphasis shifts back and forth between praising and denigrating individuality, and the mise-en-scène often glorifies (among other things) the fetish or souvenir value of inanimate objects.

While some of the elements in Roussel's plays direct their value-affirming vectors in various directions within the space constituted by the institution of art, exploring the far-flung corners of this space rather than turning inward upon one point within it, other elements affirm values outside the institution-sanctioned space in various quasi-aesthetic practices of real life (e.g., telling anecdotes, developing or deciphering codes, participating in cultural rituals). Hence, while remaining within the artistic practice sanctioned by the institution of art, Roussel's works refuse to accept the constructive principles that reaffirm, through the aesthetic forms they create, the isolation of art within bourgeois culture.

The extra-institutional vectors propagated within Roussel's collage aesthetic suggest realms of aesthetic experience lying outside the institution of art without suggesting that the artwork can or should seek to attain these other aesthetic realms. The multidirectional, institution-bound vectors fly wildly through the culturally sanctioned space, pressing against its limits and propogating disturbingly discordant waves throughout the institutional medium, rather than contributing to the stabilization of this medium by focusing inward upon one point. Through collage an extra-institutional, unsanctioned aesthetic is allowed to glow within a work of art that seeks to fill rather than affirm the space accorded it and art in general by bourgeois culture.

The stasis of Roussel's drama results from the emptying of its center. The centrifugal momenta of the value-affirming vectors fragment and disperse the mimetic movement of the work to remote corners of the aesthetic space it occupies. In attempting to fill the institutional space, Roussel's works become airily thin: what movements are left at the center of each play (the treasure hunt or the plot against the Indian twins) do not have sufficient inertial force to disturb the stasis of the play as a whole. In this state of affairs Roussel has reversed the normal relationship between the work of art and the art institution. Whereas conventional and high modernist works generally strive for a concentration of mimetic action within the artwork and leave the institution of art largely unacknowledged and undisturbed, Roussel's works cultivate a mimetic stasis that sends ripples of disturbance across the aesthetic space defined by the institution of art and conjures up quasi-aesthetic fragments of the real

world. Roussel's plays maximize both the decentering, fragmenting motions possible within the work of art and the static fixity of the work as a whole.

In contrast to the unified aesthetic vision that Roussel brings to all his literary works, Roger Vitrac attempts a more varied exploration of the disturbing heterogeneities of dramatic material, to which I now turn.

Vitrac: Confronting Conventions

Roger Vitrac committed himself more completely than any of the other authors I have examined to writing drama. Nevertheless, although he wrote several well-received, financially successful plays and remained active as a playwright throughout his life, his involvement with anti-mimetic, order-undercutting aesthetic principles was as brief as that of Kokoschka, Benn, and Roussel. Henri Béhar suggests that certain defiantly unconventional aesthetic impulses are present throughout Vitrac's theatrical oeuvre, but he joins the other major Vitrac scholars in dividing the plays into three basic catagories: (1) the "surrealist plays," up to and including *Les Mystères de l'amour* (published 1924, performed 1927); (2) plays that work surrealist themes into more conventional representations of "life as it is," especially *Victor* (1928), *Le Coup de Trafalgar* (1934), and *Le Sabre de mon père* (1951); and (3) plays based on a classical tragedy model (1936 and on).[1] The German studies of Vitrac have made slightly different distinctions between the plays and been more critical of the later work. Vilshöver and Jürgen Grimm note independently that all the works after *Victor* and *L'Ephémère* (1929) uncritically accept many tenets of conventional, *boulevard* drama.[2] Antonin Artaud noticed Vitrac's increasing acceptance of bourgeois dramatic forms in *Le Coup de Trafalgar*:

> A word, a meeting of words, an image, even an idea, the automatism of an entrance, the suddenness of an apparition seem as though they should produce the spell, provoke the sacred trigger, but in the end everything unravels, becomes banal, returns to the order or disorder of a simple cafe terrace.

Roger Vitrac did not know how to choose between the gratuitous but poetic surrealism of *Mystères de l'amour* and the explicit satire of

an ordinary *boulevard* play. His piece smells of parisianism, the reality
of the *boulevard*.[3]

For the purposes of this study I will leave out of consideration the
middle phase of Vitrac's work, the masterpiece of which is *Victor*, as well
as the later works. Although *Victor* is in many ways Vitrac's most com-
plex and certainly his most successful drama, it shares with his subse-
quent work a fairly conventional, although humorously irreverent, no-
tion of dramatic mimesis. The development of themes and characters in
Victor remains exhiliratingly idiosyncratic and aggressively experimental,
but these innovations are embedded in a traditional articulation of dia-
logue and dramatic action that is at odds with the concept of an aesthetics
of disturbance. I do not wish to suggest that *Victor* is in anyway inferior
to Vitrac's earlier plays, but it certainly is not engaged with the same
intensity in an attack on the conventions of dramatic mimesis as are his
earlier plays. *Victor* is closer to the aesthetic temperament of high modern-
ism than to that of the anti-art avant-garde trends exemplified by
Kokoschka, Benn, and Roussel. In mounting its scathing critique of
bourgeois cultural values, *Victor* accepts the constitutive parameters of
the bourgeois dramatic tradition.[4] This play and others of the middle
period exploit traditional notions of character, place, and action that are
radically distorted, ridiculed, or rejected in the drama he wrote up to
1927. Whereas Vitrac's middle period is characterized by an attempt to
maximize the expressive potentials of drama, the early works attempt to
problematize and interrogate these potentials. The early works draw
attention to form by rendering it disturbingly opaque, while the middle
works celebrate form by expertly faceting and polishing its surface.

In examining Vitrac's early work, one must avoid the temptation of
characterizing them as simply surrealist.[5] Although Vitrac was a central
member of the surrealist movement in its early years, his plays, in particu-
lar, draw upon the dying embers of dada (not a significant cultural pres-
ence after 1924) as much as upon the nascent sparks of surrealism (the
first manifesto of which appeared in 1922) for the initiating heat of their
aesthetic conflagrations. Vilshöver, Grimm, and Heed have all noted the
pronounced influence of dada on Vitrac's drama, and, as this chapter will
show, an interest in the aesthetics of theatrical representation for its own
sake also plays a prominent role in Vitrac's dramatic creations. Unlike
more programmatic artists, Vitrac is not interested in subjugating the
aesthetic material with which he is working to the telos of a fixed doc-

trine nor even in aligning himself unmistakably with one aesthetic move-
ment. Dada, surrealism, and dramatic mimesis form three autonomous
centers of energy in Vitrac's plays. Their configurations differ markedly
from work to work, and they often war with one another, but none ever
gains unmistakable dominance over the others in any of the early pieces.

Unlike the other playwrights I have examined, Vitrac develops a
number of markedly distinct approaches to radical drama in his early
works. Each of his short plays attacks the conventions of dramatic mime-
sis in its own idiosyncratic way, and only in *Les Mystères de l'amour* do
these heteroclite tendencies form a purposely troublesome, anarchic
unity. To appreciate the iconoclastic synthesis Vitrac accomplishes in
Mystères it is useful first to examine each of the earlier, shorter plays in
turn; before I do that, however, I shall take note of the general organizing
principles, stylistic qualities, and thematic motifs common to all the plays
and discuss the ways in which these elements separate Vitrac's work from
that in the mainstream of dada and surrealism.

Formal Density

Vitrac's early plays (1922–23), often short, always odd, and published in
avant-garde journals rather than performed, exhibit a formal density not
shared by most dada and surrealist drama. Works wholeheartedly commit-
ted to either of these movements are characterized by a transparency or
immediacy that serves the central program of the movement. Surrealist
and dada works either clearly articulate and display elements of their respec-
tive programs or present an unmistakably opaque, impenetrable surface
whose existence is explained and given value by the program of the move-
ment. In other words, the semiotic conventions determining the mode of
representation and type of message articulated by the dada or surrealist
work strives for an unproblematic transparency when viewed through the
lens of the appropriate program or displays an opaque immediacy, which is
itself an unambiguous sign referring back to the tenets of the movement to
which the work in question owes allegiance. The sensuous densities and
multivalent terrain of the autonomous artwork, the riddle-like amalgama-
tion of the artificial and the natural—that is, the immediate material and
the abstract constructive principles of artworks—are not, as Adorno
points out, a major concern of "artworks" in the mainstream of dada and
surrealism. Dada and surrealist works, insofar as they remain strictly faith-
ful to their movements, sacrifice their autonomy to the godhead of their

theory of artistic practice. The works produced within these movements are not so much autonomous works as affirmations of their programs. Content and form, or the form alone when the content is purposely illegible, strive for total absorption in the explicitly formalized intentions of dada and surrealist practice.

As mentioned in chapter 1, the programmatic intentions of dada and surrealist works do not necessarily prevent them from exhibiting the formal complexities of autonomous artworks. What separates Vitrac's work from that of other dada and surrealist artists is, hence, not so much a radical difference in aesthetic form as simply a distinct approach to the concept of the autonomous artwork. Instead of creating works that tend toward a general, socio-aesthetic program, Vitrac bends the elements of the dada and surrealist socio-aesthetic programs away from a general, prescriptive theory of legitimate artistic practice into specific autonomous works. He differs from his movement-oriented contemporaries in choosing the aesthetic genre of drama rather than the sociopolitical positions of dada and surrealism as the formative ground for his work. He differs from high modernist artists (including playwrights) in introducing the disruptive, form-threatening impulses of dada and surrealism into the autonomous artwork.

The factor in Vitrac's aesthetics most important to the present investigation is the character of his interest in drama. The early works he published in the journal *Littérature* display an irreverent, ridiculing, dadaist attitude toward all forms of literary representation except the dramatic and theatrical. This suggests that his interest in theater and drama, rather than being based on drama's status as an established form of bourgeois art, is based on an esteem for the peculiar qualities of dramatic representation— that is, dialogue and mise-en-scène. As Vilshöver has mentioned, most surrealists (as well as dadaists) have a rather flippant attitude toward all forms of artistic representation (see *Die Entwicklung*, 53), but Vitrac values the complexities of dramatic situation, action, and display and uses these mimetic elements for their own sake as well as in pursuit of goals related to dada and surrealism. In *Les Mystères de l'amour* (*The Mysteries of Love*) Vitrac manages, paradoxically, to create a complex dramatic world and cultivate within this world an iconoclastic disrespect and disruption of mimesis. In his earlier plays he often more relentlessly abuses or forsakes the tenets of conventional mimesis, but even in these plays he shows a respect for and mastery of the dramatic and theatrical image that gives to

his work a formal weight missing from more doctrinaire dada and surrealist plays.

The dada and surrealist works have a centrifugal orientation. The vectors of significance thrust away from a more or less hollow or mundane center to burst the barrier between artwork and life and shake the institutional foundations and ideological affirmations of established aesthetic practice. The force of Vitrac's drama is divided between centrifugal vectors following lines of force laid down in the dada and surrealist programs and centripetal vectors that move inward through the textured layers of the artwork. "Mademoiselle Piège," for instance, a fragmentary group of conversations pronounced by vaguely defined characters as they pass through a hotel lobby, exploits a thematic opacity illuminated by violence similar to that produced at dada "evenings" but bases this opacity upon a perversely intense acceptance of the institutional parameters of the artwork rather than upon an anarchic denial of aesthetic standards.

Whereas Tzara's *La Coeur à gaz* breaks all the rules set down for dramatic representation, "Mademoiselle Piège" adheres madly to the tenets of dramatic naturalism. This short fragment reproduces a slice of life so true it is incomprehensible. The play opens with the hotel proprietor's one-sided telephone conversation, which is limited to a series of informationless affirmations: "Good. Good. Good." The opacity of this vignette continues unbroken to the end, when proprietor and porter arrange the body of a suicide in a lifelike pose, propped on his elbows, before they exit with the same calm, unsurprisable professionalism they exhibit throughout the play. No dialogic explication and development or narrative continuity is allowed to contaminate the representation of reality in this play. Here Vitrac manages to couple his dadaist distaste for the institutionalized conventions of aesthetic construction with a love for the sensuous density of the artwork: he rejects the conventional rationality of the artwork by plumbing the depths of naturalistic representation. The centripetal vectors of this indulgence in the autonomous subtleties of the artwork deftly reverberate from the opaque interior of the piece outward in centrifugal lines of force directed against the reader attempting to understand the scene.

While Vitrac never again uses the tenets of naturalism as he does in "Madomoiselle Piège," he does devote himself constantly to the tenets of drama and the mise-en-scène. Vitrac sees that naturalism is not the only set of aesthetic conventions that can be turned on its head, but he

does seem to feel that only in the ambivalent, ostensible environment of the dramatic artwork can the subversive use of aesthetic form create vectors of force that thrust both inward and out. Vitrac shares with the surrealists an enthusiasm for a *"lieu suprême"* in which the rational strictures of bourgeois culture disintegrate in the presence of more fundamental, egalitarian, anarchic, and vital forces, but the surrealists locate this supreme realm "above" reality in dreams, automatic writing, and the uncanny correspondences of chance events, while Vitrac (closer to Artaud than to Breton) locates his supreme realm on the stage. Vitrac's notion of surreality is necessarily tied to a form of theatrical/dramatic representation. For him the work of art is not a means of delineating or provoking a surrealistic state but is itself a surrealistic state. For Vitrac surrealist impulses can reach critical mass only within the compression chamber of the autonomous dramatic work.

Vitrac's privileging of dramatic artworks was one of the grounds for his banishment from the surrealist movement. Nevertheless, while his interest in drama certainly distinguishes him from the surrealists as a whole, it does not preclude an interest in some surrealist issues, nor does it imply an attitude toward art more conventional than the surrealists'. Vitrac's interest in theater is based on values and ambitions as radical as those of any other avant-garde playwright and significantly more heteroclite and subversively self-contradictory than most movement-oriented manifestations of the avant-garde. As my analysis will show, Vitrac uses the notions of drama and the mise-en-scène as points of stability upon which to mount the volatile, contradictory impulses of dada, surrealism, and aesthetic representation for its own sake.

Vitrac's notion of mise-en-scène differs radically from the notion operating in conventional drama in that it prompts discordance and instability rather than the harmonious, architectural soundness of the conventional autonomous work or the fractured but stable constructedness of the high modernist work. The discordance and instability of Vitrac's theatrical texts penetrate to the heart and undercut the existence of the mise-en-scène. The complexity of these texts invites the gaze of the spectator (or the hypothetical gaze of the reader) but fails to provide an understandable object upon which this gaze can fall and feed. The scene develops no coherent meaning but remains obstinately present upon the bare stage of the text in its own mute, opaque display.

"Monuments" provides the purest example of Vitrac's absolutist approach to the notion of mise-en-scène. As Béhar says in regard to this

quasi-theatrical collection of fragments, "Here Vitrac does not explain or demonstrate; he displays."[6] "Monuments" hovers on the edge of coherence. The various vignettes all concern members of the Pelucheux family and two (or perhaps more) mysterious females, *"une femme"* and *"une jeune fille."* The suggestion of a fixed set of characters arranged in diverse tableaux holds the work as a whole together, while almost every other aspect of the work tends to pull it apart. No sense of an embracing situation or a developing action connects the scenes. Moreover, the information presented in each scene is never enough to get a clear picture of the tableaux suggested: the locations remain vague, or the physical traits and emotional states of the characters are disturbingly imprecise. In addition, each scene is presented using radically different descriptive conventions: narration and dialogue, either separate or in combination, a song, a letter, and a newspaper clipping are all exploited to delineate various vignettes. The words form a clouded glass that obscures and distorts the tableaux more than explaining them. While the appeal of this work clearly rests on an aesthetics of surprise—vivid, unexpected details such as emotional outbursts, a notice of death, and a fit of insanity crop up at every turn—the coherence that underlies the surprising details issues from an obscured mise-en-scène. In "Monuments" Vitrac is testing the power of theatrical display by cloaking it in distracting literary formalities. In later works the powers of the mise-en-scène are allowed to shine through more completely but never with the naive directness of conventional theater.

Because Vitrac's notion of mise-en-scène is heavily influenced by his interest in dada and surrealism, he attempts to work into it elements that are in some sense "real." While resting content with the aesthetic autonomy of the theatrical work as a whole, Vitrac attempts to insert into the mise-en-scène elements with an ontological weight that transcends or breaks away from the ethereal realm of the artistic. The bits of "found" conversation and the newspaper clipping in "Monuments," the opaque, fragmentary realism of "Mademoiselle Piège," and the equally opaque representations of dreams in *Mystères de l'amour* (but not in "Entrée libre," which uses psychoanalytic conventions to render dreams virtually transparent representations of particular anxieties or desires) are all elements that at least strive for an ontological autonomy from the works within which they are placed. Vitrac's use of violence and his provocation of laughter have a similar claim to some autonomous reality, in that they are often only tenuously connected with the dramatic situation or action.

Their visceral influence upon the audience is valued for its own sake rather than for its affective reinforcement of the dramatic representation.[7]

Vitrac's use of elements that claim some autonomy from the work of art differs, however, from the more straightforward claims of anti-artistic reality voiced by dadaists and surrealists because Vitrac's "real" objects are deployed in the aesthetically autonomous field of the mise-en-scène. This makes Vitrac's theater neither completely anti-artistic nor completely modernist. The ontological heterogeneity of the elements break up a modernist autonomy, while the foundation of the mise-en-scène affirms an, at least, quasi-artistic space within which the theatrical artwork develops. Whereas doctrinaire dadaists would want the gestures of their performance to forsake the cloistered mews of the artwork and become real,[8] Vitrac wants to force disruptive elements of reality into the artwork.

While exploiting notions of the real in his works, Vitrac does not dedicate his works to the real. Reality is for Vitrac just another source of quotations to deploy within the mise-en-scène. Hence, dadaist anti-art gestures mix with the surrealist fascination for the subconscious as well as with motifs from detective novels, melodrama, *drame à thèse*, and domestic tragedy to create tableaux that often float eerily free from definitive debt to any particular artistic tradition or straightforward reference to any sociopolitical reality. The mise-en-scène of these disparate elements draws away from all notions of art as well as life to establish for itself a vertiginously heteroclite autonomy. To better appreciate the nature and organization of this autonomy it is useful to examine the plays in which Vitrac cultivates it.

The Opacities of Tableaux

In the proto-surrealist journal *Littérature* Vitrac published three short pieces that explore the modes of figural density possible in theatrical tableaux that refuse to tie their visual being to an unambiguous, discursive meaning. These pieces are "Monuments," "Mademoiselle Piège," and "Poison."[9] In the first two of these Vitrac shows that a sense of theatrical tableau can be exploited even when this tableau is impossible to visualize—in other words, that an audience (a reading audience) can be tantalized with enigmatic motions upon a stage hidden by a curtain. In these two plays the curtain is formed by the words upon the page and the conventions of representation to which these words appeal. The two

pieces suggest the existence of a situation or action but refuse to unambiguously represent it. "Monuments" obscures its subject matter with a disruptively heteroclite collection of mimetic conventions—description and dialogue, silent tableau, interrogation, song, a letter, a real press clipping; "Mademoiselle Piège" obscures its subject matter by deft interweaving of the dramatic conventions of neoclassicism and naturalism.

What makes the obscurity of Vitrac's texts different from the obscurity of Benn's texts is the former's ability to assure the reader that a human situation, perhaps an action, lies behind the words on the page even though it is impossible to tell what this situation or action is. Béhar points out that, despite the gaping discontinuities in "Monuments,"

> these snapshots, these traces of reality allow one to imagine a cursory plot: the woman in the first tableau has a son in the colonies; he dies leaving a few things to the Pelucheux family, whom we catch a glimpse of on three occasions and to whom the woman writes an explanatory letter before losing her mind. (Béhar 1980, 56)[10]

Nevertheless, while allowing one to imagine a unifying action, the work constantly undercuts and discourages this hypothetical unification. Each episode focuses attention on elements that have the least in common with the elements of the other episodes. What constantly comes to the fore is not an overarching action but, rather, moments of inexplicable tension or surprise. In the first episode, for example, the old man's exclamation— "You should be careful, Gustave. You bother me a bit"—suddenly opens to the audience the old man's emotional turmoil, in which his feelings toward his grandson and the mysterious woman are entangled in a vague knot of anxiety and displacement. This moment marks the culmination of the vignette, but no aspect of this moment has any relevance for any of the other vignettes. In the second episode the brief appearance of the young girl and, in the third, M. Pelucheux's bizarre description of his profession—"I twirl a hoop with a red wand on the roof at night. During the day I have a glass ball in each hand"[11]—mark similar moments of climax fraught with mysterious references that are neither explained nor repeated in the other episodes. Laced among these perplexingly diverse vignettes are just enough common elements to suggest the possibility of unity.

Béhar points out that the title of the piece, "Monuments," should be understood

in the archaic sense of the word, designating not a public edifice but
an object that conserves the trace or memory of a person, a docu-
ment, an archival element of some sort. (Béhar 1980, 56)[12]

We can go further and say that what is important in this work is the state
of being a "monument," of being marked with the trace of some situa-
tion or event, and that Vitrac wants to separate this state of being from
the situation or event that creates it. In other words, Vitrac stresses the
figural imprint of the memorial mark left upon the object and denigrates
and obscures the discursive content or implications of that mark. Each
vignette glows with an importance imparted by an action or situation
from which it is forever cut off. What is important is not to recover or
reconstruct the lost drama but, rather, to appreciate the figural glow that
persists even after the discursive life of the drama has been lost from
sight.

The nature of this glow is troublingly complex, for it derives, first,
from both an attachment to and a detachment from an unspecified but
significant event, situation, or action and, second, from a disdain for and
aloofness from the exigencies of rational mimesis. The play's concluding
vignette, a "found" newspaper article entitled "Illuminée" and describing
a woman's insane outburst at a church service, is troublingly powerful
because it suggests some catastrophe has disrupted her life, while refusing
to offer any description of this catastrophe; likewise, all the fragmentary
vignettes of "Monuments" acquire their figural density by suggesting the
possibility of a dramatic action while refusing to represent it and by
obscuring the issue of the unrepresented action with a crazed prolifera-
tion of unrelated representational conventions.

In "Mademoiselle Piège" the figural presence of the vignette is still
cut off from the drama that gives it life (and might impart to it a discur-
sive significance), but here the discursive component (i.e., the story that
explains what transpires) exists in the unfolding present of the fragment's
events and is obscured by the narrow frame of the representation rather
than being set in a narrative past and obscured by diverse representational
conventions and thematic foci, as in "Monuments." The dialogue consti-
tuting "Mademoiselle Piège" unfolds in the antechamber of the dramatic
situation. The significant events to which the words obscurely refer are
taking place, we are sometimes led to believe, in room 49, in which
Mademoiselle Piège, perhaps, sets her unexplained traps. The mise-en-
scène, set in the lobby of the hotel, acts as a curtain obscuring the real

scene of the drama through the vague language and lack of exposition inherent in the naturalistic style to which Vitrac adheres. The obfuscating effects of the mise-en-scène are so profound one cannot even be sure where the confrontation of wills making up the drama that motivates the piece's dialogue and stage business really takes place. Although room 49 is in some way central, a number of significant offstage milieux seem to have obvious, although unarticulated, influence upon the shape of the play's events: Mademoiselle Piège's room and her and M. Chêne's obscure network of business contacts (hinted at in Chêne's amusingly minimalistic telephone conversations) are the offstage scenes to which most of the dialogue persistently refers, but significant references are also made to the social life of Musée fils (the suicide) and to the family life of the Musée father and son pair. Hence, the sources as well as the character of the forces driving events (and, perhaps, capable of establishing a discursively coherent action) are impossible to pin down.

I think Béhar misses at least part of Vitrac's point when he suggests that the constant reference to offstage situations and events is meant to prompt the audience to become engaged actively in reconstructing the dramatic action from the fragments presented on the stage (see Béhar 1980, 57). In the first place, Béhar does not draw enough attention to the fact that the dramatic action in "Mademoiselle Piège" is impossible to reconstruct. Insofar as Vitrac encourages readers to attempt to make discursive sense of the play's events, he does so only to ridicule them by leading them to a dead end. Nevertheless, while this dadaist ploy is certainly part of the play and a major obstacle to Béhar's interpretation of it, an appeal to dada will not exhaustively explain the plays's structure. Indeed, I am not sure that Vitrac's primary interest in creating this play was to frustrate his readers.

"Mademoiselle Piège" is not constructed on the principle of obscurity for obscurity's sake but rather on the principle of obscurity for the sake of material density. In this case the material density comes from combining the tenets of naturalism with the tenets of French neoclassicism. The play is set in a public vestibule, neither inside nor outside, a place to pause and converse on the way from one place to another, similar to those so often used by Racine. This is the sort of place in which a neoclassical dramatic action could be most effectively represented, but Vitrac sabotages the representational assets of this milieu by furnishing it with the mimetic appurtenances of naturalism. Instead of lucid, richly detailed alexandrines, the characters speak in short, fragmentary phrases

that constantly refer to knowledge common to the characters but inaccessible to the reader. The naturalism and neoclassicism cancel each other out. Neoclassicism relies on language to construct the dramatic situation, and naturalism relies on milieu, but here Vitrac purposely sets opaque, naturalistic language in an informationally impoverished classical milieu. The conventions he employs evoke two formidable mimetic traditions but in such a way that the reader cannot pass over the material presence of the conventions into the discursive elaboration of the action. The conventions command attention but cannot speak.

The notion of a nonsignifying display is extended and enriched in "Poison," a "drama without speech" consisting of twelve descriptions of theatrical tableaux. Whereas the previous two pieces mix various representational conventions to obscure a (dramatic) situation that one feels could be understood if only it was articulated in the appropriate mimetic medium, "Poison" deploys innovative visual imagery that calls attention only to itself. Whereas the scenes displayed in the earlier pieces justified their existence by appeals to hidden events or situations, in "Poison" the scenes rely only upon their own vividness. Both discursive significance and the disingenuous appeal to a hidden significance that the first two plays exploit give way in "Poison" to a semiotically mute display of the purely sensual. The tantalizing mysteries of unknowable events are banished in favor of the sensual immediacy of visual and aural sensation.

Here Vitrac plays more directly with the desire for meaning. Rather than fixating on some unknown, offstage situation, the desire for meaning clings to the stage imagery itself. Vitrac provides just enough continuity to provoke a search for significance but not enough to satisfy it. Each of the first six tableaux displays at least one barrier that is broken through by at least one intruder. In scene 1 a mirror breaks to reveal a white wall from which a plaster statue emerges and cracks open to reveal a nude woman. In scene 2 a number of strange objects intrude upon a bedroom (black liquid, a horse's head, smoke, a huge diamond), culminating in the invasion of soldiers from a wardrobe. This particular image and the pandemonium it causes, disrupting a lovers' tableau, is imitated in scene 6, in which oranges roll from kitchen cupboards to disrupt a family tableau.

The fourth and fifth scenes form an even more tightly connected pair. Both scenes contain a man alone (violinist, painter) and a couple (two couples appear in scene 4, but they do not appear simultaneously); both scenes contain one piece of furniture (easy chair, bench) and a broad,

relatively featureless backdrop through which the scenes' intruders break. Scene 4 is filled with strange sounds, and the solitary man makes music with his violin, while scene 5 is mute, emphasizes colors, and has a solitary man who paints. In scene 4 an aural distress signal (the siren) accompanies the rending of the backdrop, while in scene 5 a visual distress signal accompanies the rending.

The third scene (a poem projected on a screen) has the least in common with the rest of the first six scenes, but even here one could interpret the senselessness of the poem as the barrier and the shadow figures projected upon it as the intruders. When one turns to the subsequent six scenes, however—all but the last described with just one word—the motifs common to the first six scenes disappear, or, perhaps, sublate from the level of an encounter among entities within each scene to the level of the reader's encounter with the text. One might suggest that the aggressively incoherent heterogeneity of "Poison" breaks through the barrier to immediate reception formed by the institutionalized conventions of theatrical representation or that the last six scenes invade and throw into disorder the repertoire of images nurtured by the first six scenes, but the last scene suggests that we should be wary even of these readings.

One is tempted to take scene 12 very seriously because it ends the piece and breaks decisively away from the senses of order established in scenes 1–6 and 7–11. But, if scene 12 comments on the work as a whole, its message is devastating: "The stage represents a mouth that pretends to speak."[13] Just as the mouth appears to be talking and only appears to be talking, the text appears to signify coherently on various levels but only *appears* to do so. This final scene provides a visual embodiment of the semiotic gestures saturating the work as a whole. The figural contours of enunciation are vividly delineated, but nothing is said. The sensuous surface of signification shimmers tantalizingly before the reader's eyes, but the discursive content of a logically consistent signification is resolutely absent.

Besides provoking and frustrating the desire for meaning by manipulating the reader's expectations diachronically from scene to scene, Vitrac exploits the synchronic ambiguities of the dramatic form. As in the plays of Gottfried Benn, "Poison" creates a tension between word and image, but, whereas Benn uses this tension to dissolve the epistemological foundations of existence—that is, the coherence of the external world and of the ego—Vitrac uses it to problematize the signifying power of language.

This project is particularly pronounced in the last six scenes. In scenes 7 through 11 the laconic phrases with which the tableaux are described make it difficult to form a visual image of them. The brevity of the descriptions conspires with the multiple meanings of the words used to generate a plethora of possible significances and frustrate all attempts to choose between them.

The movement in scenes 7 through 11 from *gare* to *bureau* to *cheminée* to *livre* to *tableau* might suggest a movement from a train station to an office in the station to a fireplace in the office to a book on the mantelpiece to a picture in the book. Alternatively, the scenes might represent a train station, an office building, a smokestack, a masterpiece of literature, and a famous painting—all important components of bourgeois society. Yet, again, some sort of reflective or self-referential motif might be coaxed from these scenes by suggesting they represent, say, a train station, a business office, a smoking chimney (symbolizing destruction or transcendence?), a book about business, and a painting of a train station (or, by stretching the meaning of the words, the last two scenes might represent a business ledger and a train timetable or chart). As with Benn's work, the number of possible interpretations presented by these scenes is more important than the nuances of any particular interpretation. Hence, even more paradoxically than in the case of Benn, Vitrac presents us with a purely visually oriented theatrical spectacle that cannot be staged or even always unproblematically visualized.

One of the many possible qualities of scenes 7 through 11 that one may want to privilege to some degree is the progressive diminution of the objects and increasing vagueness of the descriptions. The meaning of *gare* is clear. *Bureau* could be an office, study, or desk; *cheminée* a smokestack, chimney, or fireplace. *Livre* is definitely a book, but of what size and on what subject? *Tableau* might be a picture, painting, or chart (in any case it is physically the simplest object in this group). The cadence set up by this interpretation of scenes 7 through 11 is simultaneously continued and contradicted in the final scene in that the mouth depicted here is smaller than any of the objects in the previous five scenes but described with greater detail than these other objects.

The final scene draws together scenes 1 through 6 and scenes 7 through 11 but only by exacerbating the confusing qualities of each group. The mouth is visually vivid, as are the first six scenes, but, like the five scenes immediately preceding it, the manner in which the stage represents it is not clear. Rather than unifying the heteroclite images of

the piece in an articulate statement, the final scene pulls the images and themes together in one grand, corporeal refusal to communicate: it makes the sensuous motion of speech but says nothing.

Disturbing Confrontations

The two remaining early, short plays by Vitrac, "Le Peintre" and "Entrée libre," engage in a dialogue with conventional dramatic forms more directly than do the three plays published in *Littérature*. Whereas the *Littérature* plays promote and play upon tensions between signifier and signified (i.e., mimetic gestures and the reality represented by these gestures), "Le Peintre" and "Entrée libre" concentrate their attention upon the contours of the signifiers. The first of these plays manipulates and juxtaposes various theatrical conventions with no regard for the "reality" that these conventions usually seek to represent, while the second strips away the conventions of dramatic mimesis and replaces them with oneiric modes of representation.

"Le Peintre" begins with an unmistakable abdication of the responsibilities of dramatic mimesis:

> THE PAINTER: What's your name?
> THE CHILD: Maurice Parchemin. (*Silence*) And yours?
> THE PAINTER: The same.
> THE SMALL MAURICE PARCHEMIN: That's not true.
> THE PAINTER: That's not true? (*Silence*) You're right.
> *He paints the child's face red. The small Maurice Parchemin exits crying.*[14]

The conventions of farce rather than drama are invoked in this play. Whereas drama seeks to represent a posited reality, farce aims only at presenting physical and verbal gags. Farce creates its own reality, a reality immediately present in its conventions. Vitrac invokes farce in order to cultivate the self-sufficiency of surfaces, the immediate (rather than representational) powers of dramatic form, but he is careful not to let the ordering principles of farce enter the work along with farce's privileging of the surface values of dramatic signs. In "Le Peintre" the anarchic impulses of farce are given free rein; they never dissolve in the rational closure of a punch line. Vitrac has twisted the conventions of farce into a Möbius strip upon which absurdities are continually piled one atop another without relief.

Vitrac's formal strategies and aims in this short play bear a marked affinity to those of dada. As in dada, farce is turned away from the foibles of human interaction and directed against the conventions and social affirmations of art. "Le Peintre" comments less upon how people behave than upon how human behavior is represented in various forms of drama. Rather than constructing a farce from distorted fragments of human manners, values, and fears, this play constructs a farce from distorted fragments of vaudeville skits, domestic drama, and detective drama. Quick, schematic confrontations and slapstick stage business, pathetic immersion in the familial pieties and anxieties of the bourgeoisie, and the spectacle of intrigue, anagnorisis, and denouement clash against one another in absurd collocations. The play, a potpourri of *boulevard* theatrical clichés concerning love trysts, family crises, and detective intrigue concatenated without regard for causal justification, resembles dada in that its anarchic richness ridicules the bland conformity of convention-bound drama and frustrates the conventional audience's expectations of order. Vitrac's play, however, differs from the central works of dada by virtue of its meticulous ordering of its anarchic impulses.

Dada works such as *The Gas Heart* (Tzara) and *The Mute Canary* (Ribemont-Dessaignes) pulverize the elements of conventional theater they use so finely that few gestures or remarks cohere in any recognizable order. These manifestations of dada at its most extreme reduce theatrical spectacle to a kind of white sound, the significance of which depends almost exclusively upon the cultural context within which it is presented. "Le Peintre," on the other hand, cultivates enough internal order to maintain a life independent of the moments of its presentation. The elements of conventional drama from which it is built cohere in a parodic imitation of aesthetic unity. Repetition of phrases and gestures form dadaesque leitmotivs throughout the work, while the dominant tone of the work (not always discernible in the din of conflicting conventions) subtly shifts from vaudeville, to detective story, to domestic drama. The love tryst between Auguste Flanelle and Madame Parchemin forms the axis upon which the drama turns. This is the only scene from which the painter is absent. Before this scene the painter is an obnoxious stranger, while after it he reveals himself to be Monsieur Parchemin, and only in this scene do the characters really talk to one another. This scene creates one moment of mimetic stability (although of a very idiosyncratic sort) before the rapid disintegration of the action into fragmentary vignettes of bourgeois family crises.

"Entrée libre," a one-scene drama concerning the violent denouement of an adulterous love triangle framed on each side by three scenes depicting the dreams of the three characters, follows the lead of "Le Peintre" in the use of a pivotal scene, but, whereas the axial construction of "Le Peintre" is mounted with a frivolous playfulness that pokes fun at the conventions of aesthetic construction, the axial construction of "Entrée libre" is mounted with serious mimetic intentions. These mimetic intentions are, however, far from those that usually motivate drama. Rather than creating a dramatic situation that reproduces certain elements of external reality, Vitrac attempts in this play to draw together diurnal and oneiric realities. His purpose is not to produce a unified representation of an unusual mode of "reality," as, for instance, Strindberg does in *A Dream Play*, but, instead, to produce a proliferation of competing realities. Whereas various mimetic conventions clash against one another in "Le Peintre," various realities clash against one another in "Entrée libre." Besides juxtaposing the disparate logics of waking and dream reality, Vitrac articulates conflicting dreamworlds. The pivotal realistic scene does not hold the drama together but, rather, serves as an axis around which Vitrac generates centrifugal forces of mimetic disintegration.

More than any other play examined here, "Entrée libre" flirts with two of the unifying, mimetic strategies described by Szondi, *I*-dramaturgy, organized around the ego responsible for each dream, and the one-act play, presented in its concentrated entirety in scene 4 (see Szondi, *Theory*, 54–57 and 63–65), but, rather than embracing these strategies, the play undercuts them. *I*-dramaturgy attempts to overcome the mimetic shortcomings of drama by turning the mise-en-scène into a manifestation of one character's psychic world. Vitrac embraces this strategy in each of the first and last three scenes of the play but forsakes whatever unity it might have lent to the work by using it to articulate the desires and anxieties of three distinct characters. Rather than rejecting drama in favor of the epic qualities of *I*-dramaturgy, Vitrac inscribes the solipsistic fixations of *I*-dramaturgy within the dialogic space of drama proper. The discursive richness with which the three psyches represent themselves in their dreams encounters its opposite in the communicationless vacuum surrounding and separating the psyche in each scene from those in the other scenes. Where Kokoschka undercuts *I*-dramaturgy with intrusions of the id and Benn does so by developing a self-consuming solipsism, Vitrac does so by dramatizing *I*-dramaturgy. Thus, Vitrac leaves the form of *I*-dramaturgy intact but undermines its

constitutive powers by thrusting it into a dramatic space rather than allowing it to hold up its own dramatic world.

The one-act play, according to Szondi, attempts to save dramatic mimesis by forsaking the impossible task of representing an interpersonal action in favor of representing a concentrated moment of tension (see *Theory*, 54–57). Vitrac portrays such a moment in the fourth scene of "Entrée libre" (the reference reality scene around which the dream scenes turn) but then stretches and breaks it up in the other six scenes. The movement among the autonomous, oneiric worlds of the three characters reinforces and elaborates certain themes encountered in the realistic scene, but this movement also breaks up the ontological integrity and homogeneous concentration with which the one-act form usually generates its tension. This dispersal of emotional energy is particularly apparent in the last three scenes. The first three dream scenes, in delineating symbolically the characters' anxieties and desires concerning one another, increase the psychic tension of scene 4 much more effectively than any additional interpersonal dialogue or stage business could and saves the one-act form from the meditative stasis common to it in the late nineteenth century (see Szondi, *Theory*, 55), but the three dreams that follow the waking reality drain off this concentration of energy, marking the characters' disengagement from one another in scenes of regret, rejection, and shifting interests. Since the tension in scene 4 is founded on the distance between the characters, the solipsistic concentration of the first three scenes enhance this tension, but, whereas conventional one-act plays hover in the excited anxiety on the verge of a catastrophe, Vitrac pushes his one-act play through the moment of catastrophe and charts the dispersal of psychic energy that follows. What makes this play unusual is that it treats a catastrophe without recourse to dramatic action. The intense isolation generated in the dream scenes seems to hold the characters at unbridgeable distances even in scene 4. The brief moment of violent contact that they make with one another happens in the dark, and the subsequent three dreams show that even the husband's attack on his wife has failed to draw the characters into one common world, in which a dramatic action might unfold.

The paradoxes set up by a simultaneous emphasis on the tension of a dramatic situation and the self-absorption of the participants in this situation are not meant to be resolvable. Unlike, say, Pirandello in *Six Characters in Search of an Author*, Vitrac refuses to provide this play with a

framework within which the heterogeneous mimetic strategies can rationally coexist. Vitrac tells us which dreams belong to which characters, but he does not allow the dreams to happen in a realistic setting. A spectator wishing to make this play consistent with conventional representations of reality would find it impossible to say when the characters fall asleep and dream their dreams. The dreams do not really happen in any realistic sense but, rather, enjoy a quasi-autonomous existence in the moments immediately before and after the violence of scene 4. Vitrac wants dream and "reality" to encounter each other, and, to this end, he is careful not to allow one of these modes of being to swallow the other.

Although Vitrac certainly evinces more interest in the objects of representation in this play than in any other of his early works, this does not preclude his continued preoccupation with the medium of representation. The purpose of this play is, I think, as much to juxtapose representations of dream and waking reality as it is to juxtapose these states of consciousness themselves. The manner of this juxtaposition reveals Vitrac's strong sympathies for surrealism. The realistic scene is, in a sense, the scene most divorced from reality, because the vocabulary of the situation depicted in it appeals almost exclusively to the conventions of bourgeois drama, in particular the love triangle of domestic tragedy. The dream sequences, on the other hand, provide a fresh and vibrant portrayal of human emotion because they rely so little on established theatrical conventions.

Because the dreams are not realistically framed, as in Grillparzer's *Das Traum, ein Leben,* nor given a psychologically motivated unity, as in Strindberg's *Dream Play,* they enjoy a distinctly autonomous existence. Indeed, the one waking scene seems more a reflection of the dreamworlds than the dreamworlds seem a reflection of reality. This privileging of oneiric states of consciousness and denigration of conventional aesthetic representations of reality is typical of surrealism, but Vitrac carries his surrealist values away from the programmatic stance of the movement back into the work of art itself. Rather than allowing the artwork to disintegrate along with its discursive moment, Vitrac uses the heterogeneous shards of meaning to bolster the work's figural density. He takes a conventional situation of bourgeois drama, strips away the moralizing, voyeuristic, repressive apparatus with which it is usually surrounded and tamed, and then encrusts the tense kernel of this situation with the magnified anxieties and desires of the participants.

The Mysteries of Representation

Les Mystères de l'amour, which follows the developing love affair of Patrice and Léa (Patrick and Leah) through shifting dada and surrealist landscapes, exploits the confrontations and opacities developed in the earlier short works and adds to these traits a critical self-referentiality uniquely Vitrac's own. In keeping with the restless shifting of aesthetic strategies Vitrac exhibits in his earlier works, in this play he thematizes earlier formal properties and transforms earlier themes into formal structures. The treatment of dream in "Entrée libre" is expanded here to provide some of the primary constructive principles of the play as a whole—namely, condensation, displacement, and the polymorphous fluidity of free association. Whereas "Entrée libre" seeks to represent dreams within the dramatic format of mimesis, *Les Mystères de l'amour* seeks to be a dream by virtue of its structure. Rather than a dramatic representation of dream, it is a dream of dramatic representation.

As Vitrac notes in his description of the Théâtre Alfred Jarry production of his play: "For the first time a real dream was realized in the theater."[15] What makes this dream real, as opposed to the presumably artificial dreams realized upon the stage in productions of Grillparzer's *Das Traum, ein Leben* and Strindberg's *Dream Play*, is the conspicuous absence of a dreamer. Grounding the dreamworld in the psyche of an individual (whether explicitly as in Grillparzer's play or implicitly as in Strindberg's) would inevitably place the dream at one remove from the boards of the stage—even Strindberg's play is ultimately the representation of a (hypothetical) character dreaming rather than the representation of a dream. The dream world of *Mystères*, however, is not created by one identifiable dreamer. In a note written later in his life Vitrac suggests that the play was his own dream (see *Théâtre* 2:9), but an analysis of structure and themes suggests at times that Leah is the dreamer. While the ambiguity surrounding the identity of the dreamer prevents the play from being the representation of one character dreaming, certain formal and thematic concerns strongly suggest that the theater itself is dreaming. Dreams are in essence the condensations and displacements of subconscious desires, and *Les Mystères de l'amour* is most pervasively the condensation and displacement of conventions of dramatic mimesis. The self-consciousness and artificiality suffusing these conventions is analogous to the subconscious character of the desires motivating the dreamwork: they are the aspects of mimesis

that are hidden and suppressed in traditional forms of representation. Insofar as the theater itself is dreaming, this play is, indeed, a real dream, but, like real dreams, it dissolves and disperses under examination. It may be a real dream on the stage, but in the hands of critics and scholars it can only be a cryptic confession of mysterious anxieties and desires—the mysteries of love, certainly, but also the mysteries of representation.

As a whole, the play moves back and forth between two poles. In the first, third, and fifth tableaux the action is disrupted by overt references to the author and audience of the representation, while in the second and fourth tableaux the situational focus of the milieu is erased by portraying a number of disparate scenes simultaneously. Within this structure Vitrac cultivates a claustrophobic atmosphere, which is all the more overwhelming because it is articulated with a formal vocabulary that would in most circumstances connote openness and freedom. The troubling mysteries of the action, ranging from the shifting anxieties and desires of the central couple through intrusions of Grand Guignol stage violence and characters who metamorphose into Mussolini and Lloyd George to meddling remarks from the author and the audience, crowd in upon and stifle the characters despite their frequent attempts to break away from such confining situations. The explosion of the milieu, which propels the characters from cramped domestic scenes enacted in a theater box to a variety of rooms, some without walls or rigid adherence to the laws of nature, only spreads the tension of the individual situations across the fields of experience portrayed.

The mixing of aesthetic conventions is, as we have seen, a prominent strategy in all Vitrac's early work, but in *Mystères* this strategy is pushed to a more radical, multivalent extreme than it is in the earlier pieces. Complicating the infusion of oneiric organizational and representational principles into the dramatic structure of the play are the thematizations of dadaistic theatrical gestures and the turbulent mixing of the dada and surrealist moments with thematic motifs and formal structures from *boulevard* theater. Jürgen Grimm notes the mixture of heterogeneous, avant-garde motifs in this play but says little about the structures underlying this juxtaposition or the possible reasons for it:

> Les Mystères is a highly heterogeneous play in which dada and surrealist elements are overlayed in a manner that renders them difficult to differentiate. (*Das avantgardistische Theater*, 321)[16]

While many of the aggressively unconventional or distasteful aspects of this play may be hard to identify as strictly dada or surrealist, some of the prominent elements have very clear allegiances, assuming we can equate dada with an anarchic dismantling of aesthetic conventions and surrealism with an attempt to turn art away from an affirmation of bourgeois culture and make it a countercultural venue for the conjuration of the subconscious.

Mystères hangs the raucous impertinences of dada upon a structure built with the ontological priorities of surrealism. At the beginning of the play one might think that Vitrac means to place dada at the service of surrealism. The ridiculous spectacle of a fragmented, illogical bourgeois domestic scene enacted in a theater box and frequently interrupted, first, by remarks from the audience and, finally, by the bizarrely incongruous intrusion of the author (who shoots himself and appears onstage drenched in blood and shaking with laughter), might be taken as a means of demolishing the spectators' conventional expectations in order to make them more receptive to the oneiric otherworldliness of surrealism. The first tableau certainly does wreck havoc upon the popular conventions of bourgeois theater, but the following scenes do not allow a surrealist world to flower upon the ground cleared by Vitrac's dadaist bulldozer.

The surrealist moments in the play are constantly attacked and undercut from two sides: (1) further intrusions of dadaist self-ridicule and disintegration and (2) nagging reappearances of conventional theatrical gestures and situations. While cultivating an unmistakable antagonism toward the institution of bourgeois drama, Vitrac does not banish the gestural coherences of that institution from his work, as do Breton and Soupault in *If You Please* and Tzara in *The Gas Heart*. Conventional dramatic situations and interactions continually reassert themselves, intrude upon the dadaist and surrealist moments of the play, and then disintegrate. Note, for example, in act 1, tableau 1:

> PATRICK: . . . (*Screaming.*) Oh! Oh! Oh! Oh! I will shout it out. I will shout it out from the rooftops, from the stars, from above the stars! (*Taking the audience into his confidence.*) Leah loves me, Leah loves me, Leah loves me. She confessed it. She loves me. (*To Leah.*) It's your turn now. Shout it out, Leah. Go on my little Leah, my Lele, my Leah–Leah. Shout it out, now, shout it, my Leahleahleah.
>
> LEAH (*to the audience*): I love Patrick. Oh! I love his guts. Oh! I love the clown. I love the clown. From every viewpoint, from every

seam, from every form. Look at them, Patrick. Listen to them. Oh! Oh! Oh! . . . (*She bursts into laughter.*)

 A VOICE (*in the audience*): But why? Merciful heavens! Why? Are you both ill?[17]

and in act 2, tableau 4:

Whistles. Steam noises. The train starts.

 LEAH (*at the door*): Stop! Stop! Stop! I've been given a child. . . . Yes, the child isn't mine . . . the woman . . . there!

 THE CONDUCTOR (*laughing*): Come now, Madame, that one's been tried on us before. You keep the child; you'd come to regret it later on.

 Leah sits down again.

 LEAH: What have they done? Me, a child-stealer? I should say not! But now how to get rid of it? A cherub is such a nuisance!

 (*Modern French Drama*, 253–54)[18]

The persistent reappearance of these conventional dramatic motifs, coupled with the ambivalent mixture of dada and surrealist motifs, turns the relationship among institutionally established dramatic mimesis, the destructive anarchy of dada, and the transformative agenda of surrealism away from the clearly anti-artwork programs of dada and surrealism and into a self-absorbed game of cat and mouse. Various contradictory aesthetic and anti-aesthetic lines are spun about one another, and no clear statement gives a discursive place to the whole.

 The nominal subject of the play are the mysteries of love. Insofar as the play pursues this subject, the mysteries remain mysteries. Neither the characters nor the situations in which they find themselves provide any explanation of the persistent desires and anxieties that hold Patrick and Leah together. While unveiling without attempting to untangle the jumbled knot of love's longings and fears, Vitrac simultaneously parodies and ridicules conventional representations of love, but, rather than maintaining a clear distinction between these two projects, he allows them to clash and intermingle. Hence, on the one hand, the mysteries of love often become the butt of dada or surrealist jokes, as when Patrick says to Leah, "Do accept these few flowers," then slaps her (*Modern French Drama*, 230).[19] On the other hand, however, the ontic vitality generally associated with love's mysteries also enlivens the

representation of these mysteries and, by extension, representative ges-
tures in general.

While the mysteries of love are the thematic starting point for the
play, the mysteries of representation become one of the play's most cen-
tral concerns, as the story of emotional attachments persistently unfolds
despite the inappropriate milieux, inconsistent characters, and intrusions
by a hostile author and audience. Just as love seems to blossom despite
the violence and ridicule directed against it, the representation of this love
affair persists despite the profusion of antimimetic gestures directed
against it. I think Artaud identifies this quality in *Mystères* when he sug-
gests that the play is very nearly a work

> from which the logic of action is banished and in which every feeling
> becomes instantaneously an act, in which each state of the spirit
> inscribes itself with its own immediate images and takes shape with
> lightning speed. The abstract marionette becomes object and re-
> mains feeling and does not draw from matter. (*Oeuvres complètes*
> 2:145)[20]

The site of representation in *Mystères* is confined to individual sentiments.
The scenes themselves, as in "Mademoiselle Piège," are too public to
carry much dramatic representational power in themselves: the first tab-
leau is a theater box, the second both a bank of the Seine and the apart-
ment of Lloyd George (who seems to be a child murderer), the third a
hotel room, the fourth a series of public waystations stretching from a
Paris train station to a holiday resort, and the fifth a hotel hallway. In
place of the opaque dialogue of "Piège," however, *Mystère* fills these
scenes with raw surrealist visions of the emotional core of individual
experience. The play proposes a mise-en-scène of emotion rather than a
mise-en-scène of characters and their sociopsychological milieu. The da-
daist nonsense, such as inconsistent behavior and abuse from the audi-
ence, and parodically conventional *boulevard* motifs, such as the love
triangle and meddling mother, break up the representational space
around the individual outbursts of emotional energy and, thus, set these
mimetic outbursts off as much as they destroy the mimetic coherence of
the play as a whole.

The excrescences of anxiety and desire are not confined to an articula-
tion of the dynamics of love. The dynamics of authority, power, and
violence are also central concerns of the mimetic moments in this play.

These motifs, in contrast to the self-absorbed autonomy of love, bristle with aggressive vectors of outward-propagating force. Love involves the mutual absorption of reciprocating subjects and objects, while authority, power, and violence establish a brutal hierarchy of subject and object. Rather than isolating this hierarchy in an autonomous mimetic field, Vitrac allows it to assert itself on every level of the artwork's existence. The exercise of authority and perpetration of violence occurs among the characters, among the aesthetic stances invoked and exploited, and between the artwork and the audience. The gestures of subjugation and terror replicate and reverberate within the artwork, giving it, at once, a thematic unity and anarchic tension. The formal contradictions that are set up by juxtaposing dada, surrealism, and *boulevard* motifs and that disrupt the amorous action at the center of the work are themselves undercut and resolved by an aesthetic frame that makes the theater the scene of a dada or surrealist action, but then this frame is in turn shaken and breached by the self-contradictions of its own existence (since representation is inimical to the dada and surrealist idealization of spontaneity). The mutual dissolution of all the aesthetic frames frees the moments of authority and violence, allowing them to thrash and whip threateningly at the audience while being held in the ambiguously autonomous space of the unframed artwork.

In *Mystères* Vitrac lays bare more completely and with a greater articulation of detail than anywhere else the mysteries of representation, mysteries that might pervade the entire world or exist only in the bourgeois institution of art, mysteries that are life threatening and that cannot be taken seriously. In dismantling and ridiculing conventional modes of representation, the work obstinately becomes a representation of its own destruction. The resilience and inconsequence of representation is driven home by the ending. When the author interrupts the two lovers, Patrick shoots him, but his bullet cannot cross the ontological barrier that separates the playwright from his characters. The author wants Patrick to kill Leah, or vice versa, so that the play can end on an appropriately tragic note, in line with *boulevard* conventions, but the strange meta-aesthetic space into which the entrance of the author has thrust the drama makes the lovers just as invulnerable to destruction as the author himself. The bullet destined for Patrick kills a spectator. Here the play must stop because, unlike the violent interaction between stage and auditorium in the first tableau, the death of the spectator is meant to be real. The drama does not end (in an Aristotelian sense) but instantaneously vaporizes in its

final attempt to transcend its representational existence. Vitrac realizes that the volatile mysteries of mimesis can break up and recombine in astonishingly complex and chaotic combinations as long as they are held in the pressurized vehicle of the autonomous work and that within this vehicle the conventional notion of the artwork can be subverted and fragmented but never completely shaken off. In ending *Mystères* as he does, he also concedes that the energies generated in the artwork, no matter how threateningly antimimetic, must immediately disperse once the aesthetic sphere is resolutely abandoned.

Of all the five playwrights in this study Vitrac is the most keenly aware of how the ontological status of performance can be manipulated by innovations in the play script. He is most similar to Kokoschka in the heteroclite disturbance he imparts to performance, but he is more conscious than Kokoschka of the gap between the script and performance. Vitrac is interested in the ironies of representing performance in print as well as in the paradoxes that can be generated in the aesthetic material of drama and its performance.

In Wyndham Lewis's play we find, as with Benn, a purely literary approach to drama, but, whereas Benn generally lets the trace of performance possibilities in the play script wither in the iconoclastic heat of his ontological skepticism, Lewis imparts a performative charge to his printed text that bears some affinities to the theatrical collage aesthetics of Vitrac and Kokoschka. Like Vitrac especially, Lewis develops the ironies and paradoxes that can arise where text and performance meet.

Lewis: Performing Print

ADVERTISEMENT

THE SCENE.	SOME BLEAK CIRCUS, UNCOVERED,
	CAREFULLY-CHOSEN, VIVID NIGHT.
	IT IS PACKED WITH POSTERITY,
	SILENT AND EXPECTANT.
	POSTERITY IS SILENT, LIKE THE
	DEAD, AND MORE PATHETIC.
CHARACTERS.	
TWO HEATHEN CLOWNS, *grave booth animals*	
	cynical athletes.
DRESS.	ENORMOUS YOUNGSTERS, BURSTING EVERY-
	WHERE THROUGH HEAVY TIGHT CLOTHES,
	LABOURED IN BY DULL EXPLOSIVE MUSCLES,
	full of fiery dust and sinewy energetic air,
	not sap. BLACK CLOTH CUT SOMEWHERE,
	NOWADAYS, ON THE UPPER BALTIC.

VERY WELL ACTED BY YOU AND ME.[1]

With this enigmatic opening Wyndham Lewis's play *Enemy of the Stars* (published June 1914) throws the aesthetics of advertising, circus, and avant-garde art movement against one another to create a spin that shatters the traditional coherence of the work and carries it through a dizzying array of aesthetic fields and clashing forms. This page's posterlike form suggests the literary values and ambitions of advertising, its thematic focus is a circus world, and its placement in the polemically innovative and abusive *Blast* signals the interests of the avant-garde. Other aesthetic and meta-aesthetic issues spring from these appeals. The

advertising's blending of word and image and its commodification of cultural artifacts mixes with the circus's crass commercial interests, rigorously refined skills, and casual fraud and with the avant-garde's attack on high culture, vitalistic fusion of art and experience, and bohemian marginality, to create a disruptive series of pages in *Blast* that resist conventional protocols of reading and representation.

Lewis and Pound coined the concept "Vorticism" to identify the artistic trend that includes *Enemy of the Stars*, but the existing studies of this movement do not go very far in explaining the play's complexities. Hugh Kenner and Timothy Materer discuss the concept of the Vortex in detail, but neither bothers to examine closely the formal affinities between *Enemy of the Stars* and the avant-garde movement sweeping around it.[2] William C. Wees, on the other hand, claims that Lewis's play is "the *pièce de résistance* of literary Vorticism" (*Blast 3*, 48) and notes some important affinities the play has with Lewis's paintings and theoretical writings, but Wees is reluctant to examine the intricacies of the play in their own right.[3] Other studies of the play have made valuable observations, but none have been able to explain thoroughly the lines of force and metamorphic logic that inform the whole.[4]

Since this play is the major literary text to appear at the founding of Vorticism, it is natural to look in it for the practical application of Lewis's theoretical pronouncements. We should, however, be wary of forcing upon the play a concept of Vorticism developed from a backward gaze across the life work of Lewis, Pound, and others. When Lewis wrote *Enemy of the Stars* his notion of Vorticism was not as refined or fixed as the concept delineated by Kenner and Materer. His first Vorticist proclamations were, in fact, the last pieces he wrote for *Blast*.[5] Taken as a whole, Lewis's work in *Blast* does not suggest that "a Vortex is a circulation with a still center: a system of energies drawing in whatever comes near" (*Pound Era*, 239), nor does it imply "that a culture's most vital ideas would be gathered in the Vortex and brought to a still point of clarity" (*Vortex*, 219). Lewis does say "the Vorticist is at his maximum point of energy when stillest" (*Blast*, 148), but in the same manifesto he claims "our Vortex desires the immobile rythm [*sic*] of its swiftness," (149) and in another manifesto he declares:

2. We start from opposite statements of a chosen world. Set up violent structure of adolescent clearness between two extremes.

4. We fight first on one side, then on the other, but always for the SAME cause, which is neither side or both sides and ours. (*Blast*, 30)

Clearly, in *Blast* Lewis is more interested in provocative paradoxes than in a coherent aesthetic program. The studies by Kenner and Materer make the mistake of assuming Vorticism is one coherent concept. Wees notes that Lewis and Pound interpreted Vorticism quite differently:

> For Lewis, the Vortex was a whirling, arrogant, polished monster of energy; for Pound, it was a stable, strong source of creative energy.[6]

The notion of a central point of stability essential to Materer's and Kenner's concept of the Vortex certainly finds no formal corollary in *Enemy of the Stars*. Lewis's play is too volatile and agitated a fluid to form one well-focused vortex. My reading will show that the still point around which the world turns is (to borrow a phrase from the protagonist Arghol) "always à deux." In other words, the terms of existence under which the play lives are always threatened and displaced by rival terms. Lewis pits the cool prestige of modernism against the heated rebellion of the anti-art avant-garde, the appeal of the image against the appeal of the word, allegory against realism, and narrative against drama. Nothing is left unchallenged by a nemesis, not even the autonomy of the work itself. The play's vortex spins, but it does not converge.

This chapter charts the wandering course of *Enemy of the Stars*'s eccentric vortex. The broad array of aesthetic forms and thematic focuses through which the play proceeds creates a number of distinct discursive or representational realms ranging from an avant-garde critique of the social apparatus and ideological assumptions of high culture through an allegorical meditation on the foundations of human consciousness and action to a wheelwright's yard on the Russian steppes, where Arghol and Hanp enact a clownish agon that anticipates both the physical humor and metaphysical desolation of Beckett's plays.

Understanding the heady mixture of aesthetic modes turning upon one another in this work has implications beyond a fuller appreciation of this particular play. The unique features of *Enemy of the Stars* expand the possibilities of a nonprogrammatic avant-garde well beyond the works I have examined thus far. The notions of Vorticism developed by Materer and Kenner apply better to later works by Lewis in which his aesthetic

interests have reached a discursive stability. In *Enemy of the Stars* he is not so much defending a particular aesthetic position as he is playing with the notion of aesthetic positioning. If, as Wees suggests, this play is the pièce de résistance of Vorticism, we are talking about a performative Vorticism rather than a programmatic one—that is, a Vorticism that dances and spins through a variety of aesthetic and meta-aesthetic worlds rather than one that attempts to make a particular aesthetic statement. In the complexities of the concept of performance we can see some of the complexities involved in an avant-garde art that forsakes both a conventional mode of aesthetic existence and a dissident existence supported by manifestoes. In *Enemy of the Stars* we can see how a predominantly literary text can manipulate the constructive principles upon which it is built to move into the fluid world of performance.

Uneasy Autonomy

The play begins with a conventional assertion of its existence as an autonomous literary work: a title page with 1 1/2-inch letters sets it off from surrounding material in *Blast* and encourages the reader to expect unity and coherence in a literary representation of some sort. The second page (53), however, immediately begins to trouble the reader's expectations by announcing "Synopsis in Programme." As one reads further, it becomes clear that *Enemy of the Stars* is not conceived as the text of a play that might be performed but as a performance in itself. The readers find themselves in a theater of printed words, confronted with a confusing spectacle, and unfortunately lacking the "programme" that might aid in explaining the events before them.

The matter is complicated further when the third page advertisement declares that this play is "Very Well Acted By You And Me" (55) and the six following pages feature reproductions of Lewis's visual art, only the last of which has any connection with the themes announced in the preceding text. The complexity and individuality of the visual images demand a concentration of attention that effectively cuts off the first three pages of *Enemy of the Stars* from the rest of the text and suggests, at least momentarily, to the reader that this is the entire play. The interruption caused by the autonomous visual artwork allows the "advertisement" to turn the spectacle away from the pages of the book for a moment, to suggest that the play is proceeding in the life of the reader and writer ("You and Me") and that all *Blast* is doing is giving the spectacle a title

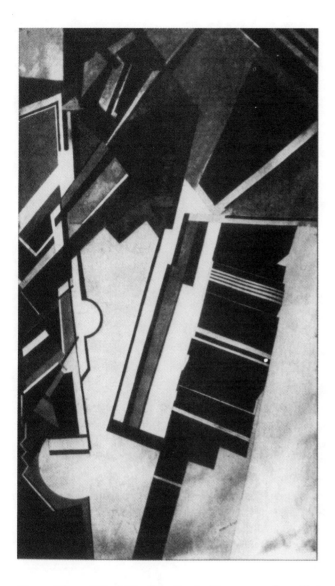

Fig. 9. "Plan of War." Wyndham Lewis. Figures 9–15 from *Blast* (1914). © Wyndham Lewis and the Estate of the late Mrs. G. A. Wyndham Lewis by kind permission of the Wyndham Lewis Memorial Trust (a registered charity). Reprinted from *Blast 1* with the permission of Black Sparrow Press.

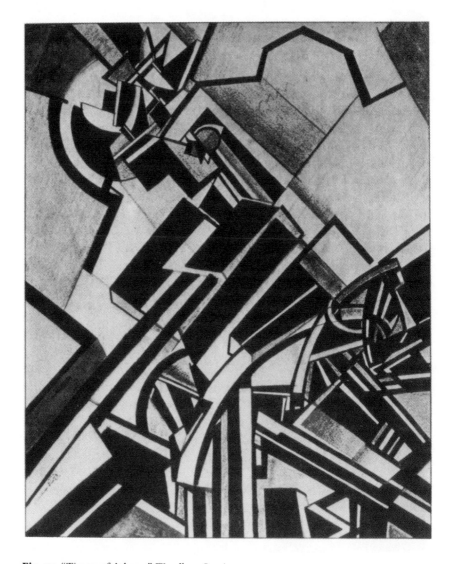

Fig. 10. "Timon of Athens." Wyndham Lewis.

and drawing attention to it with an advertisement. If the first three pages
were the entire text (and Lewis does provoke the reader to believe this),
then they could be viewed as a sardonic signature on an "anti-work" that
takes in parts of quotidian reality just as do the readymades of Marcel
Duchamp. Rather than being a complete work, the three pages could be

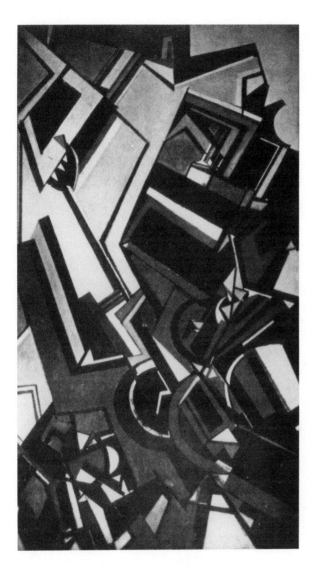

Fig. 11. "Slow Attack." Wyndham Lewis.

seen as a gesture of artistic closure that encircles and aestheticizes the daily drama acted out by "you" and "me."[7]

Only the title of the fifth picture ("Enemy of the Stars") and the sudden announcement on the following page—"The Play"—brings the

Fig. 12. "Decoration for the Countess of Drogheda's House." Wyndham Lewis.

reader back to the project broken off by the unrelated visual images. The reaffirmation of aesthetic autonomy is, however, destabilized by the shifting significance given to the last words of the advertisement. After noting that the characters come from "where Europe grows arctic, intense, human and universal," the play reintroduces the issue of "You and Me":

Fig. 13. "Portrait of an Englishwoman." Wyndham Lewis.

"Yet you and me: why not from the English metropolis?"—Listen: it is our honeymoon. We go abroad for the first scene of our drama. Such a strange thing as our coming together requires a strange place for initial stages of our intimate ceremonious acquaintance. (59)

Fig. 14. "The Enemy of the Stars." Wyndham Lewis.

The casually familiar tone here suggests that the writer is speaking directly to his readers and, hence, implies that the drama concerns the act of reading, the drawing together of author and audience. The circle of aesthetic autonomy encloses the authorial voice and the eyes that draw it

from the page. Two pages later, however, the familiar tone is gone, and the readers and author have been replaced by "the cream of Posterity, assembled in silent banks," and the spectacle they gaze upon: "a gladiator [Arghol] who has come to fight a ghost, Humanity—the great Sport of Future Mankind" (61). At this point "You and Me" is laden with two overlapping meanings. It is the audience and the play, but it is also a parodic materialization of the great work (Me, the text) and its canonization (for posterity—You). Here the circle of aesthetic autonomy expands to include the meta-aesthetic, social conditions of artistic existence, making the temporal endurance and box office success that contribute to canonization in high culture part of the artwork itself.

After posterity "sinks into the hypnotic trance of Art" (61) the play's autonomous field of aesthetic display and the universe inhabited by its "You and Me" contract to the scene occupied by Arghol and Hanp. The honeymoon of "You and Me" takes place in a "Rough Eden of one soul, to whom another man, and not EVE, would be mated" (62). The couple have numerous symbolic significations: gladiator and ghost, a god ("built by an architectural stream") and humanity, sacrificial victim and executioner, abstraction and nature, truth and falsehood, intellect and self-interest, master and disciple, and, in the broadest sense, the archetypal dramatic protagonist and antagonist. The shift of "You and Me" to the narrow representational realm of Arghol and Hanp restores the natural order of the drama by making clear that this is a representation rather than some sort of meta-spectacle that plays either upon the act of reading, the social institution of high art, or the contemporary cultural milieu of Lewis's London, but the representation remains unstable. Dramatic action is usually anchored to a protagonist and antagonist with fixed forms of existence, but here the polymorphous characters erode the significance of the dramatic action with their ambiguous proliferation of meanings. Even with only Arghol and Hanp on the stage, the action vacillates between the realistic, allegorical, ritualistic, mechanical, oneiric, parodic, and hallucinatory. The aesthetic autonomy of the play remains unstable both because of its dubious beginnings and because of the ambiguous, shifting ground upon which it finally appears to settle.

The shifting claims on autonomy made in the early pages of the play are complicated by the general ambiguity in the relationship between a dramatic literary text and the possibilities of its staged performance. The dramatic form itself usually implies the question, "Does this text stand on its own as a literary work, or is it merely the outline of a theatrical work

that exists in its entirety only in performance?" The extravagant stage directions and elaborate prologue material in *Enemy of the Stars* decides the question of the text's status in favor of the first alternative: the play is a closet drama meant only to be read. Closet dramas have a long history in European literature, which includes contributions by authors such as Hrotswitha, Goethe, and Ibsen, but Lewis's play stands out in this genre by virtue of the strength with which it resists the possibility of a theatrical staging.

Since closet dramas usually stage themselves before the mind's eye when read, transferring the mise-en-scène from the visual field of the mind to the visible boards of a theater rarely presents insurmountable obstacles. Lewis's play resists such a transfer because it is not simply staged before the mind's eye and its existence does not unfold solely in the act of reading. The work's shifting circle of autonomy and the visual delights of layout and graphic art that it offers independent from any act of reading create a performance impossible to contain upon the closet stage in the reader's mind. To perform this play on a physical stage would necessarily involve suppressing the performance that is already taking place upon the pages of *Blast*.

Despite its distance from conventional closet drama, the performance on the pages of *Blast* still necessarily involves the act of reading. This gives the performance an intimacy and insidiousness missing from physical theater. At the theater, audience and spectacle have a significant degree of autonomy from each other. The audience can ignore the spectacle, and the spectacle can proceed without the audience's attention. (This autonomy is significant enough for Artaud to wish to overcome it and for Brecht to wish to refine it.) But for the performance of *Enemy of the Stars* to proceed the reader's mind must take it in. Once there, however, it asserts its performative autonomy, drawing attention to the distance between reader and text and to the ideological rituals involved in "such a strange thing as [their] coming together."

Narrative Drama

In addition to the multivalent status of the play's representational significance and the play's manipulation of the intimacy of reading, Lewis generates a disturbing duplicity in the play's representational mode by couching it almost entirely in narrative prose. Indeed, the only approximations of dramatic dialogue are a few episodes of extended direct-

discourse quotation. This play is, hence, not a drama by virtue of its form but solely by virtue of its subject matter, its thematic focus.[8] Lewis uses the narrative form to explore areas of dramatic representation that are usually beyond the reach of conventional dramatic mimesis. The advertisement within the play, for example, aestheticizes what would normally be considered extraneous, ephemeral publicity and problematizes the category of the aesthetic with this extension. References to the audience (posterity) and box office receipts (61) explore other aspects of the performance as a social and cultural institution. The extravagant narrative description of impossible scenery—for example, "ponderous arabesques of red cloud, whose lines did not stop at door's frame, but pressed on into shadows within the hut, in tyrannous continuity" (67)—highlights the psychological, rather than physical, importance of objects and milieu. On the other hand, the narrative also imparts a physical presence to the characters and events that they do not usually enjoy in the dramatic text. For example, rather than remain the disembodied voices of dialogue, the characters are transformed by the narrative into "enormous youngsters, bursting everywhere through heavy tight clothes" (55). This vivid physicality continues throughout the play:

> Arghol lay silent, his hands a thick shell fitting back of head, his face grey vegetable cave. (65)

> [Hanp] sprang from the bridge clumsily, too unhappy for instinctive science, and sank like lead, his heart a sagging weight of stagnant hatred. (85)

The narrative in this play, besides commenting upon the world of dramatic representation, has become a creature of that world. One generally associates with narrative a marked freedom, the ability to move quickly and effortlessly from subject to subject, from one time and place to another, but in *Enemy of the Stars* this freedom has been stripped away. While able to explore the dark, secretive recesses of dramatic representation—that is, the institutional apparatus surrounding the spectacle and the interior surfaces of the characters' bodies—the narrative of this play is tied inextricably to the present place and time of the representation.[9] The words have been transformed from the instruments employed by a narrative voice to manipulate a scene of action in which it is not immediately implicated to elements of the scene in which the action

transpires. The words take on a sense of solidity and presentness un-
usual for narrative. They have become part of the play's spectacle and
part of the milieu in which the characters move and act. Note, for
instance, the furious verbal setting created during the fight between
Arghol and Hanp:

> Arms of grey windmills, grinding anger on stone of the new
> heart.
> Messages from one to another, dropped down anywhere when
> nobody is looking, reaching brain by telegraph: most desolating and
> alarming messages possible.
> The attacker rushed in drunk with blows. They rolled, swift
> jagged rut, into one corner of shed: large insect scuttling roughly to
> hiding. (75)

When Materer complains that "the action of the *Enemy of the
Stars* . . . is not powerful enough to shine through the thick layers of
static images" (*W. L., the Novelist*, 52), he misunderstands the formal
logic of the play. Clogging the action with static images is the natural
outcome of forcing narrative into the mimetic confines of drama. Wees
has a better grasp of the aesthetic rationale of the piece and notes that,
while the narrative vignettes do not propel forward the overarching ac-
tion, they are not in themselves unmoving:

> The action and language are violent, but individual moments of
> action are strangely isolated and static. Events are broken down and
> reconstructed like the interrelated fragments of Vorticist pictures.
> (*Blast 3*, 48)

If, as Wees suggests, a montage effect of fragmentation and reassembly is
the central point of Vorticism, then *Enemy of the Stars* surpasses this
movement in its iconoclastic aesthetic. The collision of drama and narra-
tive orchestrated in this play breaks up its representational space as thor-
oughly as do the shifted and distorted surfaces in Lewis's visual art, but
the play lacks a unifying universe of discourse equivalent to the picture
plane, in which it can reconstruct itself.

The static, fragmenting weight of the words is formally emphasized
and compensated for by the use of numerous episodes. The narrative
concentration on the here and now in each verbal vignette prevents the

action from moving forward without the abrupt changes of narrative scene afforded by the episodic structure.[10] The thin theme of the central action does connect the episodes but is not prominent enough to push the action forward from one episode to the next. Consequently, each episode stands virtually on its own as a narrative performance. Each creates its own unique representational scene. Benn's Pameelen plays exhibit a similar episodic structure, but in Benn this structure arises from the fragmenting effect of ontological skepticism, while in Lewis's play it arises from the shifting imagistic focus of the narrative.

All the scenes in Lewis's play are actually just different ways of observing the same central agon, but the differences in perspective are so extreme that the unity of the object observed is often not obvious. One episode scans the audience and box office surrounding the drama; another plunges into the dream of sleeping Arghol; another moves through the nerve endings of a battered Hanp. Here are two examples of the bewildering shifts in perspective and mode of observation that rise above the representational unity of the story:

> Two hundred miles to north the Arctic circle swept. Sinister tramps, its winds came wandering down the high road, fatigued and chill, doors shut against them. (67)

> A strong flood of thought passed up to his fatigued head, and at once dazed him. (76)

In these examples we see how Lewis exploits both the unified stage image advocated by Craig, in which the characters dissolve into the aesthetic composition of the scene, and the physical acrobatics and slapstick advocated by Meyerhold, in which the gestures and movement of the actors' bodies are paramount (see figs. 5 and 6). That these two inimical principles of theatrical aesthetics can exist side by side in a narrative text gives some indication of the turbulent cross-currents at work here.

Although the narrative scene moves in and out of the characters, it remains fundamentally dramatic in the terms it deploys. The entire world of this work, whether in the heads or pasts of the characters, is always described in terms of physical things and actions. Thoughts leap and strike; a soul is an ocean town (69). The narrative voice manipulates and distorts the properties of this world with anarchic abandon but with no real freedom. The writing traces a tightly closed world in which desires

for freedom turn to vandalism, shifting the properties of things about compulsively but unable to break away from the universe of discourse prescribed by drama. This narrative play script is more fundamentally dramatic than Benn's dialogue play scripts, in that it focuses on concrete images of a here and now, while Benn's Pameelen plays often dissolve the dramatic here and now in favor of abstract meditations on the components of existence.

Lewis's narrative delineation of drama gives his play both an immediacy and distance unusual for drama. Narrative brings the action closer to the reader than do the dramatic conventions of the play script, in that the words of the narrative give the scene directly to the reader, while the words of a play script lay the scene upon a stage that the reader is asked to observe. On the other hand, while narrative presents the action directly to the mind, it withholds it from the eye: the reader hears the narrative voice describing the scene but is denied a direct observation of the dramatic scene. The physical impossibilities, volatile transformations, and polymorphous personifications that the scene in this play undergoes within its narrative presentation emphasize the unobservable quality of the action's locus, while the concrete dramatic terms in which the narrative is couched invade the reader's ear with disturbingly visual imagery.

Lewis's dramatic concretion of narrative causes the representational existence of the work to vibrate giddily before the reader, while the narrative delineation of the drama sweeps the scene around and within the reader. Just as the narrative freedom *within* the scene violates the boundaries between objects and can turn characters inside out, the narrative presentation *of* the scenes violates the space of the reader, at times incorporating the reader in the scene, at others forcing the reader to the position of distant spectator.

Word versus Image

While trapping his narrative in the cumbersome concretion of the dramatic here and now, Lewis also sinks both narrative and drama within the physical presence of the printed page, fusing the representation of the words with the presentation of the book through the visual appeal of the layout and the illustrations that intrude upon the text. Here, as with the tension between narrative and drama, the printed page does not unequivocally dominate the literary representation, but it does set up a competing center of activity and a competing mode of aesthetic existence within the artwork.

The boldly designed layout of the text's first three pages, particularly the "advertisement," encourages an appreciation of the text as visual image, but the images conjured verbally within the advertisement disrupt the visual enticements of advertising by inviting the viewer to a world beyond sight ("some bleak circus . . . packed with posterity . . . silent like the dead and more pathetic. . . . Very well acted by you and me."). The rupture in the text of the play caused by the six following pages of pictorial imagery is repeated in the relationship between the highly abstract arrangement of swirling, colliding tonal planes within the pictures and the provocatively denotative titles given to them ("Plan of War," "Timon of Athens," "Portrait of an Englishwoman," etc.). The pictures and their titles are out of place in relationship to one another, just as the pictures are out of place in their textual relationship to the play.

Lewis never allows the viewer or reader a comfortably secure approach to the artwork. The bold graphic design used in the layout of the advertisement encourages the artwork's recipient to view it as much as read it, while the titles of the pictures and their intrusion upon the literary text encourage the recipient to attempt to read them as much as simply view them. Thus, reading and seeing vie with each other for possession of the artwork. Breaches of the boundary between word and image are fairly common in the history of Western art,[11] but Lewis does more than breach this boundary. He confounds the territory of word and image so much that a unique and inhospitable aesthetic realm arises in the disputed space. Because the play refuses to fix its existence entirely within the realm of the literary or entirely within the realm of the visual or even to demarcate which aspects of it are visual and which literary, it remains autonomous from the constitutive logic of particular forms of art. It establishes its existence in an aesthetic category of its own making that floats eerily above the categories in which artworks usually exist.

Even the visual images resist formal, thematic, or stylistic coherence. The styles vary from the distorted, tense proto–deco of "Decoration for the Countess of Drogheda's House" and "Enemy of the Stars" through the broad, blocklike structures of "Portrait of an Englishwoman" and "Plan of War" to the tumbling fragments of "Timon of Athens" and "Slow Attack." Some of the images suppress perspectival depth, while others exploit it. The themes vary from the highly stylized but recognizably human figure in "Enemy of the Stars" through the extreme, architectural abstractions of "Portrait of an Englishwoman" and "Timon of Athens" to the forthrightly nonrepresentational studies of

motion and force in "Plan of War" and "Slow Attack." The discursive rationale that each image claims for itself varies from an avant-garde celebration of energy and movement similar to futurism in, say, "Slow Attack" to a parodic attack on the social and aesthetic conventions of portraiture in "Portrait of an Englishwoman" to the reverential submission to social hierarchy and the marketplace of high culture implicit in the "Decoration for the Countess of Drogheda's House" to the textual illustration provided by "Enemy of the Stars."

While the irregularities in the artwork's claim on a unified existence are cranked to their densest extremity by the heteroclite visual imagery, the work gradually returns to the signifying field of literature as the play proper develops. The opening of the play (57–65) continues to emphasize the visual layout of the printed words, but, rather than inimically competing with the literary representation, the visual appeal of the page contributes to an analytically staged construction of the drama. Page 57 sets the semiotic expectations for what is to follow (and erases the ambiguities that accompany the series of graphic images) by announcing in half-inch letters: "THE PLAY"[12] Page 59 introduces the characters with three different font sizes and styles (two of which are roughly illustrated here):

ONE IS IN IMMENSE COLLAPSE OF CHRONIC PHILOSOPHY. YET HE BULGES ALL OVER, COMPLEX FRUIT, WITH SIMPLE FIRE OF LIFE . . .
SECOND CHARACTER, APPALLING "GAMIN," BLACK BOURGEOIS ASPIRATIONS UNDERMINING BLATANT VIRTUOSITY OF SELF.
His criminal instinct of intemperate bilious heart, put at service of unknown Humanity, our King, to express its violent royal aversion to Protagonist, statue-mirage of Liberty in the great desert. (59)

Page 60 describes the stage arrangements with remarks on the two scenes to come in the play and the position of the "audience." Two font styles in three sizes, underscoring, and boxing are used. Page 61 presents the opening of the play: Arghol's entrance and the audience's shift of attention to the spectacle. The layout of three fonts in four sizes is used to make the printed text contract and expand as "THE ACTION OPENS":

Posterity slowly sinks into the hypnotic trance of Art, and the Arena is transformed into the necessary scene.

THE RED WALLS OF THE UNIVERSE NOW SHUT THEM IN, WITH THIS CONDEMNED PROTAGONIST.

THEY BREATHE THE CLOSE ATMOSPHERE OF TERROR AND NECESSITY TILL THE EXECUTION IS OVER, THE RED WALLS RECEDE, THE UNIVERSE SATISFIED.

THE BOX OFFICE RECEIPTS HAVE BEEN ENORMOUS. (61)

Page 62 is entitled "THE YARD" and presents the representational scene of the action (as distinct from the stage arrangements described on p. 60): "The Earth has burst, a granite flower, and disclosed the scene" (62). From here on the narrative has moved into the representational space of the drama and is blind to the audience, box office, and other extrarepresentational apparatus of drama. At this point the typography is also subdued to two fonts, one for titles, another for the body of the text, and a fairly conventional format. The description of the yard is stretched out across the page by the use of short paragraphs with broad spacing between them and a short, thick dash separating the last sentence from the rest of the page. Subsequent pages present longer paragraphs and less obtrusive dashes for section divisions.

The first dramatic event occurs on page 63: "Arghol crosses the yard to the banks of the canal: sits down" and is beaten unconscious by an unidentified assailant. This page's title, "THE SUPER" refers to the supernumerary third character introduced here to punish Arghol. Later we learn that the "Super" is Arghol's uncle, but in this, his only major appearance, he is identified only as a voice, a shadow, and a boot. The representational sphere is fired by violence on this page, while the visual presentation of the page becomes relatively modest and self-effacing. Despite the modesty of the layout, however, the page's visual presentation is emphasized by its neat encapsulation of the action. The page begins with Arghol's movement, ends with his loss of consciousness, and contains the supernumerary's violent bit part in its entirety.

After the uncomfortably confining scene on page 63, which focuses obsessively on the points of contact between flesh and boot, the scene on page 64 is giddily far-flung. As Arghol regains consciousness, the narrative eye of the scene moves from the stars that shine "madly in the archaic blank wilderness of the universe, machines of prey," to the interior of Arghol's mind, where "a chip of distant hardness, tugged at dully like a tooth, made him ache from top to toe." Again the typography does not

draw undue attention to itself, but it does separate this page from the rest of the play by the title "THE NIGHT." With this initial separation made, the thematic focus of the page enhances its physical integrity. Just as page 63 showcased Arghol's uncle, this page showcases the stars of which Arghol is the enemy.

A slightly larger title, "HANP," and a roman numeral I head page 65 and mark the beginning of the central dramatic event, the confrontation between Arghol and Hanp, that dominates the rest of the play. From here on the visual aspect of the text submits entirely to the conventions of narrative literature and becomes as insignificant as the large, distinctive format of *Blast* will allow. Henceforth, major section divisions are marked simply by roman numerals at the top of a page, and minor divisions and breaks are made with a dash between paragraphs.

I hope the detailed summary of pages 57 to 65 demonstrates their participation in both the visual pleasures of the printed page and the sensuous sphere of literary representation. In passing from the domination of the eye in the pictures to the domination of the reading faculty beginning on page 65, Lewis manages to make literary representation visible upon the material page and to impart a tactile as well as specular quality to the act of reading through the calculated use of page breaks, layout, and titles. The readers' hands and arms as well as their eyes and reading faculty are involved in constructing the scene of the drama as they turn the pages to reveal character descriptions (59), stage arrangements (60), the creation of aesthetic autonomy (61), the conjuring of the mimetic scene (62), an initiating act of violence (63), the universe that encloses the scene (64), and, finally, the beginning of the central dramatic event (65). These pages form a performative vignette in their own right as the motion of the reader's arm in turning the pages seems to wave away the unruly visual impact of the page while conjuring up the dramatic setting.

Action versus Allegory

The central agon in *Enemy of the Stars* comes as close as modern drama usually can to constituting a dramatic action, as that concept is defined by Aristotle and Hegel. This action begins with Hanp's growing animosity toward Arghol and Arghol's self-destructive indifference to the threats that surround him. The terms of the dramatic conflict are established in the dialogue then theatrically manifested in a physical battle between

Arghol and Hanp. At the end of the battle Arghol has beaten Hanp unconscious and fallen asleep. Here, as in Vitrac's "Entrée libre," the mechanisms of action retreat from the physical scene to the separate mental worlds of the two characters (Arghol dreams, and Hanp meditates murder), but the consequences of their interior monologues carry the central action to its denouement within the communal dramatic scene: Hanp kills Arghol while he sleeps then drowns himself in the canal that flanks the field of their battle.

The dramatic action we find in this play does not indicate Lewis's capitulation to a conventional aesthetic of representation but, rather, forms another facet of an aesthetic built upon conflicting conventions of representation. While subduing the conflict between reading and seeing, Lewis continues the conflict between narrative and drama and opens up a conflict between mimesis and metaphysics. The clear, persuasive line of the dramatic action is pitted against a metaphysical allegory that threatens to dissolve the foundations of the drama, while the drama, in turn, attempts to sensualize the metaphysics into the inconsequential pleasures of a mental game. This confrontation leads to an entwinement of allegory and representation that makes the ontic character of the space in which the play unfolds perplexingly ambiguous.

Although Roman Ingarden speaks of the "ontic character" of "represented objects" and how this character is altered by the object's presence in "represented space" (see 220–29), I think it makes better philosophical sense to speak of the ontic character of the space in which objects exist. After all, when an object exists, does it not take up space or find itself, at least, within a particular universe of discourse? From my point of view the ontic character of a particular object is "real" if the object exists in real space, "oneiric" if the object exists in a dream, "ideal" if the object inhabits a universe of carefully defined ideas, etc. Focusing on the ontic character of a space as a whole is also useful for grouping objects and events—for example, real people and real actions by them.

Literary space presents a special problem because it can mimic the ontic character of other kinds of space. Indeed, Blanchot considers literary space the most dangerous and deceptive kind of all, always ambiguous and shifting.[13] Nevertheless, I think we can generally speak of the ontic character of a given literary space (i.e., the space in which objects in a given literary work exist) as being, or, at least, claiming to be primarily either representational or allegorical. Blanchot disputes the possibility of making this distinction but does distinguish between writing that (dishonestly or

naively) tries to make the distinction and writing that exploits the impossibility of doing so. Kafka and Mallarmé are two of his favorite examples of writers working in the literary space. *Enemy of the Stars* also sabotages the distinctions between allegory and representation to create ontological disturbances within the literary space.

The disturbances of literary space created by Kokoschka, Benn, and Vitrac are not so much ontological as discursive. The aesthetic material they churn together is predominantly representational, although the manner in which they mix it prevents it from forming pictures with a univocal discursive line. Roussel's work creates an ontological disturbance within the development of twentieth-century drama due to its peculiar aesthetic material, but Roussel avoids ontological disturbances within his works.

To understand how Lewis overlays and confounds inimical ontic characteristics, it is useful first to examine in some detail the metaphysical allegory that he pits against mimesis. In an appendix to the second version of *Enemy of the Stars* Lewis states that his play "is intended to show the human mind in its traditional role of the enemy of life, as an oddity outside the machine."[14] The human mind he equates with the intellect and with the principle of "not-self," which is characterized by its strict rationality and ability to understand and identify with other human beings and the world in general. This principle of the not-self turns out to be very unhuman in its rarity. The enemy of the mind is life, the machine-like existence of the universe, which is driven by egoism. Whereas the intellect is interested in truth and will sacrifice itself to it, the ego is interested only in power, in the sphere of its own influence. The egoistic self sees the passive intellectualization of the not-self as a threat to its existence and attempts to crush it. *Enemy of the Stars* charts this destruction.

In Lewis's allegory of self and not-self Arghol represents the self-effacing mind. The entire scene surrounding him is life. The scene demonstrates its animosity toward him early, with the disembodied beating he receives and the hatred that pours down from the stars. The ego, which is in alliance with the forces of life and nature, is represented by Hanp. Originally, Hanp is Arghol's disciple, because he sees in Arghol's vast store of knowledge a potential source of power. Over the course of the play, however, Hanp tires of Arghol's studied passivity and aloofness and lashes out against him. The powers of the self turn out to be no match for the powers of the not-self when Arghol defeats Hanp in hand-to-hand combat, but Arghol becomes vulnerable when he is overcome by his own

dreams, and Hanp dispatches him. That Hanp also kills himself signifies, presumably, that life means nothing without mind, that the intellect of the not-self gives form and direction to the existence of the self.[15]

This is the allegorical reading to which the bare outlines of the characters and action are susceptible. In the actual delineation of the action upon the page, however, reading the allegory is much more complex and problematic, because it is often obscured or canceled out by either the riot of verbal imagery within the narrative or the psychological depths of the representation. In the opening pages of the play a certain harmony exists between the allegory and the imagery. But, whereas a straightforward allegorical play would mold the scenic imagery to the contours of the allegory, here the allegorical elements are transformed into images and placed among other images: the allegory's metaphysics have been injected into the scene rather than used to create the scene.[16]

The lack of action in the opening pages allows the allegory to coexist peacefully with the imagery and with Arghol's entrance, but, when Hanp enters and the dramatic action begins, the allegory begins to clash with the other elements. Tension develops among the dramatic representation of subjects, the imagistic representation of the scene, and the argument of the allegory.[17] The allegory is deflected by the elaborate subjectivities that occupy the pages, these subjectivities are overwhelmed by the undulations of the scene, and then the scene is in turn swallowed up by the machine-like logic of the allegory. At times the struggle between allegory and mimesis is delineated with strict dramatic logic, Arghol championing the cause of allegory by subjugating his psyche to his philosophy and Hanp asserting the mimetic exigencies of emotion and life. As the struggle between the two develops, however, their positions are adulterated. Arghol descends to the mimetic world of combative psyches and Hanp asserts the allegorical primacy of certain metaphysical ideas. Arghol's trouncing of Hanp contributes to the allegorical argument for his superiority but also weakens his allegorical consistency, as Hanp bitterly notes:

> Sullen indignation at Arghol ACTING, he who had not the right to act. Violence in him was indecent . . .
>
> He gave men one image with one hand, and at same time a second, its antidote with the other. (80)

As the fight begins, Arghol also realizes he is compromising the selfless ideal by which he lives, but he is not particularly disturbed by this (74).

The confusion among allegory, mimesis, and imagery is only slightly mitigated by the gradual submission of the scenic imagery to the rhythm of the representational and allegorical action. Whereas in sections 1 and 2 the verbal imagery often overwhelms the dramatic moment almost as devastatingly as the graphic images overwhelm the opening of the play, by section 5 the verbal imagery is reinforcing the dramatic moment by shifting riotously during the fight, lying subdued in the aftermath and augmenting Hanp's emotional state from murder to suicide (see esp. 84–85).

In the agitated sphere of the dramatic action, despite the animosity between mimesis and allegory, the allegorical thread is strengthened and refined. The terms of the allegory are at first obscure or confused. Arghol speaks initially of a conflict between "self" and "mankind" (66), but later he suggests that self is a "social excrescence" (71), a burden placed upon the individual by society, a mask that hides the essential solitude of existence (78). With these revelations the, at first, desultory antagonism between Arghol and Hanp hardens into the allegorical confrontation that reaches its most refined moment at the end of Arghol's dream:

> He had ventured in his solitude and failed. Arghol he had imagined left in the city.—Suddenly he had discovered Arghol who had followed him, in Hanp. Always à deux!(80)

After this moment one would expect Arghol's death to proceed (in the allegorical space established) like a ritual sacrifice, but Lewis allows mimesis to wrest control of the action just when the allegory is about to turn it toward a closure: Hanp decides to murder Arghol on a whim rather than in defense of the allegorical position he (Hanp) occupies:

> Tip him over into cauldron in which he persistently gazed: see what happened!
> This sleepy desire leapt on to young man's mind, after a hundred other thoughts—clown in the circus, springing on horses back, when the elegant riders have hopped, with obsequious dignity down gangway. (82)

This clownish thought trots in to disrupt the classical structure of the dramatic action as well as its allegorical consistency. The offhand, casual nature of Hanp's decision to murder Arghol eschews the central impor-

tance Aristotle attaches to decision making in dramatic mimesis. Hanp is more a desultory clown than a dramatic agent, and, in failing to live up to the demands of Aristotelian drama, he also fails to give the play a firm superstructure on which to hang its allegory. In *casually* tipping Arghol into the cauldron of death, he also tips the drama into the volitionless bog of naturalism, degrading it from an action to an event. By this point, however, the interplay of allegory and mimesis has agitated the play too much for it to sink into a naturalist representation as Hanp sinks in the canal. The ending only raises the volatility of the work by adding the third factor of naturalist representation to the agon already established between classical dramatic mimesis and allegorical symbolism. This struggle plays counterpoint to the confrontation between Arghol and Hanp throughout *Enemy of the Stars* and continues to rage even as the characters meet their ends.

Displacements of Performance

The aspects of *Enemy of the Stars* examined thus far emphasize confrontation and disintegration. The disintegrative elements decisively distance this play from the constructive principles of the organic artwork and from the discursive consistency of the programmatic avant-gardes, but Lewis does check the disintegration with three forms of cohesion: (1) a demonstration of aesthetic construction, (2) the through line of the dramatic event, and (3) the performative display of the work as a whole.

The first two sources of cohesion do not encompass the whole play but, rather, run a relay race through it (as the continuity of action does in the third act of Benn's *Karandasch*): after the dramatic situation solidifies from the chaotic interplay of word and image in the opening pages of the text, the struggle between Arghol and Hanp provides a line of continuity through to the end. Only in its performative display does the play form a unity, but this unity exists only in the continuous discord of its elements.

By the phrase "performative display" I intend all the potential ontological ambiguities of performance and theater. The objects displayed on the stage are always at least two things: themselves and what they represent.[18] Thus, the world of the real and world of the represented overlap during a theatrical performance. Lewis exploits this overlapping and multiplies it. In place of the theater's usual tension between presentation and representation, Lewis develops tensions between narrative and drama, word and image, allegory and mimesis, reading and the page.

In addition, because Lewis performs his version of theatrical display within a printed text, rather than upon the boards of a stage, the constancy of place common to most theater evaporates. Lewis's play is set simultaneously or in alteration within *Blast*, within the institution of art (p. 61: trance of art, box office receipts), within a narrative voice, within the act of reading, between "you" and "me," self and not-self, personality and humanity, before posterity, and in a wheelwright's yard on the Russian steppes. The constant fluctuations in the narrative focus, allegorical portent, and dominant imagery prevent the ground in the wheelwright's yard from becoming any more reliable a place to stand than any of the other more or less ontologically distinct spaces that are developed in the text. The primarily textual existence of the play also denies it the grounding of a physical presence. The layout of the pages does plead for the primacy of physical presence early on in the play, but Lewis is careful to undercut this source of stability as decisively as he does every other.

The closest physical corollary to the performative display of this text would be a multi-ring circus. The text's aesthetic performances take place in a number of distinct ontological rings. Sometimes these performances follow one another; sometimes they overlap, sometimes they proceed simultaneously. Indeed, the groundlessness of Lewis's theatrical display is achieved not by dissolving the particularities of place but, rather, by multiplying them, by placing the drama in a bewildering array of conceptually disparate milieux. Unlike the multi-ring circus, however, the particularities of place in *Enemy of the Stars* are extremely volatile.

In discussing Lewis's narrative style, Fredric Jameson identifies "hypallage" as a central trope. Jameson suggests that Lewis creates, in his novels and short stories, "a world in which the old-fashioned substances, like marbles in a box, have been rattled so furiously together that their 'properties' come loose and stick to the wrong places" (27). In *Enemy of the Stars*, in which the narrative voice must make its way among other modes of aesthetic construction, hypallage transcends the status of a central trope to become a metaphysical principle. The various ontological spheres of the work (the material reality of the printed page, literary and imagistic representation, allegory, meta-aesthetic commentary) constantly rattle against one another and exchange properties, producing hybrid spheres of existence that develop and dissolve into one another.

The ontological turbulence of this artwork is so great that neither montage nor collage can contain it. The work eschews montage by refusing to subdue the heterogeneity of its constituent elements to a central

purpose in the way that, say, Brecht does in his drama. Because the visual imagery, narrative voice, and allegory are allowed so much a life of their own, we might be tempted to liken the construction of *Enemy of the Stars* to that of collage, in which the heterogeneous elements disrupt the unity of the work with persistent gestures to their independent existences. But, if Lewis is using collage, to what is he gluing the heterogeneous elements? In the case of Roussel and Vitrac the dramatic form usually provides a baseboard, but Lewis attenuates and dilutes the dramatic form too thoroughly with other elements for it to offer any significant cohesive strength.[19] Jameson's metaphor for hypallage proves very apt for describing the unifying principle of *Enemy of the Stars*. The title of the work and the theatrical gesture with which it is presented upon the pages of *Blast* serve as a kind of box within which the elements of the artwork rattle against and intermingle with one another. The work is a vortex of conflicting constructive principles and universes of discourse, all swirling between the two still points of the creator and recipient.

Later in twentieth-century drama and performance the still points of creator and recipient also come into question. The happenings of the 1960s and more recent conceptual performance art have sought in various ways to eliminate either the creator or the recipient from the artwork's sphere of existence. But *Enemy of the Stars* is exemplary of one extreme in the early-twentieth-century avant-garde. It borrows an iconoclastic flippancy from manifesto-inspired movements such as futurism (with which Lewis was very familiar) but then ironically manages to enhance its own commitment to aesthetic anarchy by retreating from commitment to a particular anti-aesthetic program. Rather than making a protest against the conventional concept of art, as Bürger suggests the most radical avant-gardes do, Lewis creates a performance with elements of such a protest. Rather than dismissing the active-passive relationship between artwork and audience, he infuses it with disturbing shifts in perspective and significance. The vortex of this avant-garde aesthetic cannot converge because each source of stability is confronted with a nemesis, each image is undercut by its antidote. An aesthetic of performance has eliminated the stability of the artwork.

Given the primarily textual nature of *Enemy of the Stars*, what is implied in calling it a performance? Since most theories of performance focus their attention on the human performing agent and many locate the essence of performance in the felt experience of engaging in it (what Victor Turner has called "flow"),[20] it may seem perverse to suggest that a

text can perform. Nevertheless, on close examination, I think, the ontic character of performance can tell us a great deal about the ontic character of Lewis's play. A performance is not a statement, although it may contain or make a statement, nor is it simply a signal, although it may emit signals of various kinds. A performance is an action. Theories on the subject suggest that the action of performance can take place in a wide variety of contexts, ranging from the narrowly aesthetic to the more broadly cultural, from the psychospiritual interior of the individual to the wide stage of international politics.[21] In all these contexts I would like to suggest that three elements are required to make an action a performance: (1) an audience (either real or imagined), (2) a formalized setting in space and time that separates the performance from other objects and activities, and (3) a consciously performing agent, that is, someone engaged in an activity for a particular audience in a particular setting.

Literary texts cannot normally be considered performances for a number of reasons. First, the reader is not always constituted as an audience. Texts often exclude the reader from the world they represent in a way in which even the most naturalistic theatrical performance does not. Even when the reader is brought into the text through various forms of direct or implied address, the readers tend to remain individual and isolated in space and time both from the text and from one another. Thus, although many literary texts do acknowledge and manipulate their reception, their reception still lacks the collective, spatially and temporally focused existence of the audience/performance nexus. Reading is not constituted as a group activity and is not tied physically or conceptually to the place of the text.

This brings us to the second major difference between literary texts and performance: texts do not generally occupy particular settings in the way performances do. The text floats free of all outside circumstances. Of course, the context in which a particular literary work is created, or canonized, or read certainly influences the way in which the text exists and what it means, but the specific places and times of such contexts are matters of the text's performance in a particular cultural milieu rather than evidence of the text being a performance in itself. We should distinguish between a literary text and its involvement in the cultural activities of a particular place and time in the same way that we should distinguish between a performance and its involvement in the culture that surrounds it. If we grant that both text and performance can be considered, at least provisionally, in themselves, we see that their autonomous existences are

quite different. Taken autonomously, the text is a disembodied series of gestures and movements within a particular (literary) space.

Finally, although the literary text may contain voices that in some sense perform, the text does not normally constitute itself as a performing agent. The text is actually more analogous to the site of performance than to the performance itself. Thus, the major difference between literature and performance is that literature creates the parameters of its aesthetic space and performance fills an aesthetic space with its activity.

I hope my reading of *Enemy of the Stars* has demonstrated some of the ways in which it crosses over the distinctions between literature and performance. First, it turns its readers into an audience by means of the various theatrical motifs involved in entering the text: the "Synopsis in Programme" and "Posterity, assembled in silent banks," for example. Appearing in the periodical *Blast* focuses the place and occasion of the text's existence and draws together its initial readers in the collectivity of the subscribers. The text creates a formalized setting for itself by its placement within the bold format of the large, pink-covered *Blast* and by its rather spectacular layout upon the pages. As noted, the play makes much of setting and shifting other boundaries within which it performs. Finally, the text constitutes itself as a performing agent by the self-conscious way in which it displays itself upon the page and before "posterity" and by the impressive dexterity with which it juggles modes of being rather than simply narrative voices. The multiple aesthetic frames within which the text works allows it to make itself seem an activity rather than a constituting entity. Even when it is creating the context for the agon of Arghol and Hanp, the text's act of creation becomes a performative gesture tied to a physical here and now by the turning of the pages.

The emphasis on setting, gesture, and audience in *Enemy of the Stars* makes its subversive, vertiginous qualities less those of Blanchot's literary space (in which the sirens call one to the absence of the imaginary) than those of a performative space (filled with activity rather than absence). The literary qualities of the text do, however, infiltrate the performance, robbing the agent of the performative activity of the comfortably fixed existence of standard performers. The text shifts and overlays the ontological terms within which it performs to create a performative space as deceptive as any literary one. Rather than converging upon the still point of the performer, the aesthetic turbulence of *Enemy of the Stars* remains in a constant motion fueled by its literary existence.

Chapter 8

Conclusion: Brecht, Artaud, and the Limits of the Artwork

Why stop an analysis of early-twentieth-century avant-garde drama after examining the plays of Kokoschka, Benn, Roussel, Vitrac, and Lewis? What about Apollinaire, Cocteau, Tzara, Ribemont-Dessaignes, Aragon, Cangiullo, Marinetti, Goll, Mayakovsky, or Stein, for instance? While all of these playwrights are certainly innovative and experimental, they do not all embrace an aesthetic of disturbance that incorporates elements of anti-art. The plays of Apollinaire, Cocteau, Goll, and Stein are more surprising than disturbing.[1] While moving far from the mainstream conventions of dramatic mimesis, they seek only to surpass these conventions, never to insult, dismantle, or distort them. Their celebrations of the New do carry modern society's interest in innovation to noteworthy extremes, but their privileging of the expressive enrichment of drama's aesthetic material over the disturbance of expressive conventions draws them closer to the ideology of modernism than to the anarchies and fragmentation of the anti-art avant-garde. The playfulness and flippancy these playwrights bring to aesthetic construction do run counter to the focused seriousness that Adorno and Blanchot attribute to high modernist innovation, but their work lacks the dissident heterogeneity of the five playwrights on which this study focuses. Apollinaire, Cocteau, Goll, and Stein break conventions in search of novelty. Their work aims at opening up new areas of artistic expression. Kokoschka, Benn, Vitrac, and Lewis break conventions to force artistic expression to a point of crisis. Their work aims at fragmenting and recombining existing forms of expression. Rather than say something new with drama, they seek to suppress aesthetic discursivity in favor of the mute figural presence of heteroclite aesthetic material.

Roussel's artistic intentions are closer to those of Apollinaire, Cocteau, Goll, and Stein, but his artworks lie closer to the anti-aesthetic works of the four other playwrights in this study. Although Roussel certainly wishes to open up new areas of artistic expression with his imaginative images and anecdotes, he develops his aesthetic innovations from his own idiosyncratic notion of aesthetic material rather than from the aesthetic material that the history of European drama and culture presents to the modernist playwright. Hence, Roussel's plays clash against the expressive expectations of drama in the early twentieth century rather than building upon them. His plays project a disturbing otherness rather than a playful novelty. Despite his intentions, his works are saturated with anti-aesthetic elements.

Tzara, Ribemont-Dessaignes, Aragon, Cangiullo, Marinetti, and Mayakovsky have all produced drama that eschews celebrations of the New in general in favor of more pointedly engaged or anti-art avant-garde stances.[2] My main reason for excluding them from this study is their tendency to rely on manifestoes to stabilize the ontological status and clarify the discursive intent of their works. One could, nevertheless, point to a number of interesting aspects of these dramas that depart from or undercut their programmatic stances. My only excuse for not doing so is the limit placed on this study by practical considerations of time and space. My purpose in this book has not been to survey all the drama that makes use of an aesthetics of disturbance but, instead, to examine in detail what I consider notable examples of this aesthetic, examples that demonstrate the complexity and range of dexterously unstable aesthetic stances developed in early-twentieth-century avant-garde drama. To survey all avant-garde drama for instances of aesthetic disturbance would have necessitated moving too quickly to appreciate the ways in which this aesthetic animates and strains the structures of the artwork. By focusing on five playwrights, I have tried to reveal in some detail the quivering, multilayered life of the anti-art avant-garde work.

I hope this study has put to rest the notion that anti-art is exclusively interested in shock, fragmentation, or the destruction of art. The development of the concepts of collage, montage, and performance are most responsible for allowing the avant-garde to remain distinct from high modernism without being reduced to the endless repetition of bluntly self-destructive, anti-aesthetic gestures. Indeed, as we have seen, collage and montage allow for an extraordinary range of anti-aesthetic, disturbing, self-consuming, and anarchistic elements to enter into the life of an

artwork, to become aestheticized and at the same time contaminate the aesthetic nature of the artwork with the critical discontent of the avant-garde. The chief contributions of our five playwrights to the developing forms of twentieth-century drama are their diverse and sophisticated use of collage and montage for anti-aesthetic purposes within the aesthetic realm of drama and theater.

Kokoschka pastes sundry theatrical conventions and visual images together with a potpourri of sexual anxieties and desires to create collage parodies of his society's misogynistic fantasies or to create polymorphous lyrical spectacles of his own private obsessions. In *The Mysteries of Love* Vitrac carries the collage of theatrical images a step further than Kokoschka by multiplying the heterogeneity of the elements. Kokoschka's stage imagery more easily and disturbingly changes shape than does Vitrac's, but Vitrac's declares more varied origins for its elements. Whereas Kokoschka concentrates on staging the sexual phobias and obsessions of himself and his society, Vitrac juxtaposes images of sexual longing, political power, cultural mores, and gratuitous violence drawn from both reality and sundry aesthetic traditions. In Kokoschka's plays the stage becomes a psychological terrain peopled by libidinal and egoistic forces; in Vitrac's *Mysteries of Love* libidinal and egoistic forces become performers on a stage that is always tauntingly simply itself.

For Roussel the stage is more respectfully itself. He treats it not so much as a space in which to create images as a platform upon which to erect arguments for the glorification of his personal genius. He sees the stage as a place in which celebrities can both create and bask in their fame. Roussel, in effect, employs both collage and montage in his plays. Within the representational frame of the play his narrative vignettes are simply glued together by virtue of being spoken within the mise-en-scène. These vignettes maintain their autonomy from the action of the play and from any potentially unifying themes. Their foreignness stands out within the framing action as resolutely as do the bits of wood, bottle caps, and ticket stubs in a Schwitters collage. But, whereas Schwitters wishes to highlight the materiality of the picture plane by maintaining its connections with the detritus of the physical world, Roussel wishes to highlight the brilliance of his inventive powers. Thus, Schwitters produces pure collages, but Roussel subordinates the collage of anecdotes within his plays to a montage of elements on the stage (or, more broadly, within the institution of Parisian bourgeois artistic culture—the publicity and performance of *boulevard* theater, newspaper and magazine reviews,

the gossip of the literati, etc.) that declare his personal and intellectual worth.

The more strictly literary closet dramas of Benn, Vitrac, and Lewis make the stage an element in their aesthetic constructions rather than the ground or medium of the construction (as is the case with the plays in this study that are designed for performance). Benn and Vitrac (particularly in *Poison*) mount confrontations within their plays between the literary and the theatrical. The aesthetic control in these plays is tighter than in collage, but not as univocal as montage becomes in the work of, say, Heartfield. As in montage, the elements of these plays speak more to one another than of their independent sources, but the elements do not agree with one another. Here montage becomes dialogue rather than statement, and theatrical, literary, and philosophical issues enter into an agon that overwhelms and disintegrates the dramatic scenes that engender it.

In Lewis's *Enemy of the Stars* the struggle between heterogeneous elements becomes so complex and extreme that the elements cease to speak directly to one another. Here the montage-like focus and stability of dialogue (used by Benn and Vitrac) disintegrates into a collage-like constellation of heterogeneous aesthetic forms. Visual imagery, theatrical gestures, narrative and dramatic literary forms, philosophical, social, and psychological themes are constantly intersecting, overlapping, and displacing one another. As noted, the interplay of these elements is too fluid to characterize as collage. Rather than speak to one another or even simply cling to one another, the aesthetic elements of *Enemy of the Stars* move about one another; they join in a protean performance rather than a dialogue or tableaux.

A chief aim of this study has been to show how these five playwrights take up both the aesthetic forms and anti-aesthetic challenges of collage and montage and adapt and expand them within the realm of drama and theater. The projects of these playwrights have involved dismantling the representational apparatus of drama and theater, hampering the conventional social functions of the art form, and infusing it with foreign elements, both aesthetic and nonaesthetic. These five playwrights have, however, tended to neglect the intricate anti-aesthetic potentials of one major element of theater: performance. To be sure, they have exploited the possibility of performance (implicit in the dramatic text) in innovative ways, but predominantly in ways that eschew addressing the aesthetically disturbing potentials of actual performance. Roussel's approach to performance is entirely conventional. His construction of theat-

rical spectacle, with its emphasis on inventive convolutions of narratives within narratives, is certainly unique, but his assumptions concerning the realization of this spectacle upon the stage are those of conventional *boulevard* theater (e.g., well-known actors, conventionally expert setting and direction, and capital-intensive promotion).

Benn, Vitrac, and Lewis comment more self-consciously on the possibilities of performance in their iconoclastic closet dramas, in which the implicit significances of mise-en-scène are driven against contradictory vectors of more literary meaning. But in these works the possibilities of performance are still enclosed within the literary text. The difficulties and potentials of the play's performance exist as heterogeneous elements within the collage or montage of the play. These issues of performance have an independence and dynamism that is unusual for dramatic texts, but they are still held within the dramatic text. Only Lewis, in the theatrical gestures involved in publishing *Blast*, pushes the notion of performance beyond the text into the realm of print culture (where it is usually not acknowledged or exploited), but even with Lewis this extratextual performance is still literary, taking place, as it does, within the institutional apparatus of print rather than before a live audience.

Vitrac's stage play *The Mysteries of Love* and all Kokoschka's dramas address the issues of theatrical performance most directly and enliven the performance substantially with their collage and montage of disparate, discordant performance gestures and traditions, but the purpose to which they put their performance innovations does not move substantially beyond the shock and assault of the avant-garde in general. The depth and sophistication of their work remains substantially literary. It is in their juxtapositioning of various performance activities, rather than in the nature of the performance activities themselves, that the chief richness of their innovations lie.

Avant-garde theatrical performance only begins to move beyond a relatively simple interest in shock and surprise in the work of Brecht and Artaud. Just as the five playwrights in this study carry the avant-garde play text beyond the conventions of bourgeois art, the aesthetic stabilities of modernism, and the simple shock and disdain of anti-art artifacts, Brecht and Artaud carry performance beyond the culinary dynamics of bourgeois theater, the contemplative autonomy of modernist performance, and the simple riot of anti-art events. Brecht and Artaud are clearly working within the avant-garde tradition but are also responding to limitations in the avant-garde performance styles prevalent at the beginnings of their

careers, particularly those styles associated with expressionism, dada, and surrealism.

Brecht engages most closely with the issues of the anti-art avant-garde in his learning plays (*Lehrstücke*). Indeed, only in this rather special-ized form of dramatic experimentation does he articulate a complex, anti-art form of performance, a form that alters significantly the relationship between audience and spectacle common to modernist and most earlier avant-garde performance forms.[3] Brecht's learning plays were performed for and with small, relatively cohesive groups, such as local Communist Party chapters, union groups, and cultural clubs with working-class or socialist interests. The performances were part of larger cultural activi-ties, which were themselves part of broad, Marxist-oriented concepts of sociopolitical collective action. Thus, learning plays are not conceptually part of the cultural activity generally designated "theater."

Theater in Weimar Germany and more generally in early-twentieth-century Western Europe involves a somewhat diverse audience dedicated to viewing a spectacle. The audience has come together to watch human performances and visual effects upon a stage. The theater is controlled by and generally reflects the interests of the bourgeoisie but is open to broad sectors of the public and allows for controlled and relatively subdued representations of social critique and political dissent. The plays Brecht wrote for a general theater audience, such as the highly successful *Three-penny Opera* (1928), do make some effort to alter the habits of passive contemplation typical of theater audiences by altering the style of theatri-cal performance.[4] Nevertheless, Brecht's innovations in drama destined for a general audience do little to alter the fundamental social and phe-nomenological dynamics of theatergoing.

A performance of *Threepenny Opera* or *Mother Courage* (1939) is as much an object of straightforward contemplation as a performance of Shakespeare or Neil Simon. Brecht's conventional theater plays do de-mand that the audience engage with the object of contemplation in a significantly different manner than Simon's plays do, but in both cases the performance remains an aesthetic object with which the audience engages their attention—an intellectual form of attention for Brecht's plays, a more sentimental attachment for Simon's. In contrast, Brecht's learning plays are not so much aesthetic objects as theatrically schema-tized social problems or moral issues. The audience of the learning play engages not simply with their attention but with their volition: they do not observe a performance but, instead, create a performance in collabora-

tion with theater artists. Unlike amateur theatricals, the learning play does not create a spectacle; rather, it creates an interactive space within which ethical and political issues can be explored by means of enactment.

Brecht's learning plays could be seen as an attempt to combine selected avant-garde features of expressionism and Berlin dada to create an antitheatrical performance possibility for drama.[5] Brecht separates dada's participatory anarchy from its moral cynicism and separates expressionism's mise-en-scène of social morality from the bourgeois idealism of its plot lines. His learning plays sculpt the contours of social issues with the clear, crisp lines and vibrant urgency of expressionism but then transform the theatrical event into a confrontation of competing values that must be resolved by a leaderless discussion rather than the dictates of authorial peripeteia and denouement.[6] Eliminating the bourgeois idealism of expressionism banishes the connecting logic of discursive content from the plays. Whereas expressionist plays make statements about social reality, Brecht's learning plays open social reality to the experience of the audience/participants. Expressionist plays press social and political issues into a plot that drives inexorably to evaluative conclusions. Learning plays create situational spaces in which social and political issues can expand to reveal the felt qualities of their ethical and strategic aspects.

The Measures Taken, for instance, in which communists working covertly in China are forced to kill one of their comrades, is not advocating a Stalinistic disregard for human life, as some critics have supposed,[7] but, rather, allowing the participants in the drama to feel for themselves the constraints of ignorance and miscalculation, the moral dilemmas, and the heroic sacrifice involved in revolutionary activity. The spectacle of *The Measures Taken* may seem to justify murder, but the performance of the play undercuts the discursive stability of such justifications by asking the audience/participants to be both perpetrator and victim. *The Measures Taken*, as a learning play, does not seek to justify the murder; rather, it seeks to involve the audience in the ethics of decision making and make the audience feel the inadequacies of all decisions and the constraints social reality places on the exercise of ethics.

A conventional viewing of the play sees the comrade's loss of life as a kind of climax around which moral judgments should turn, but, as a learning play, the piece turns more upon the loss of individual identity that is demanded of all the characters participating in revolutionary activities and of the audience/participants playing the various parts. The Young Comrade's inability to efface his individual (but generally admirable)

desires leads him into the danger from which death is the only escape. In the performative process of the learning play this death is just a particularly pointed example of the kind of ego loss all the communist characters and participants are asked to engage in throughout the play. The play does not celebrate or advocate this ego loss so much as strive to make all its implications (both positive and negative) vivid for the audience/participants. [8]

The moral cynicism of Berlin dada allows it to plunge into anarchic participatory performance with little worry about the consequences. By eliminating dada's playful disregard for the practical consequences of action, Brecht makes participatory performance a more serious matter. The performative space of the learning play is not a carnivalesque zone of extravagant wish fulfillment dancing on the moral decay of all discursive order. Instead, it is a treacherous obstacle course in which the audience/participants must seek out a discursive ethical strategy for action that will lead them to whatever conditioned safety social realities might grudgingly concede. Rather than allow for the celebration of complete disorder, the learning play demonstrates both the shortcomings of all forms of order and the necessity of choosing one of these forms.

Like Brecht's learning plays, Artaud's theater of cruelty borrows from and blends elements from the avant-garde movements of his country—in this case, Parisian dada and surrealism—to heighten the aesthetically disturbing aspects of performance. [9] From dada Artaud takes an aggressive performance style and from surrealism an anti-aesthetic interest in broadening and deepening the metaphysical implications of art. Whereas surrealism cultivates a confrontational aloofness from its audience, Artaud wishes to surround and penetrate his audience. Whereas the threat of dada performance (particularly in its Parisian manifestation) is to a large degree just bluff and, even when in some sense serious, confined to the aesthetic sphere of performance, the threat from a theater of cruelty is a broader, more committed attack on both the social and psychological foundations of the spectator's existence.

One of the reasons for Artaud's break with the surrealists was his interest in theater and performance. The surrealists mistook this interest for a capitulation to bourgeois interests in the social institutions of art. [10] Artaud was, I think, certainly naive (if not mad) in supposing the ambitious performance projects he envisioned would find the monetary backing (from bourgeois sources) needed for realization, but the fatal dependency of his projects on an inimical institution of art does not lessen the

radical qualities of these projects. Indeed, Artaud's failure to realize a theater of cruelty points to the uncompromising purity of this concept of performance.

Surrealism, although committed to giving expression to suppressed psychological and social forces in society through an intellectual alliance with psychoanalysis and communism, is hesitant to thrust its expressive insights upon its audience. Surrealist works maintain an aesthetic autonomy. The mysteriousness of free association and accidental effects in these works adds to their conventional aesthetic autonomy by withdrawing from the work the discursive communication through which conventional art establishes contact with its audience. Surrealist works display a figural density that seems to turn in upon itself in a private convolution of opaque symbols. No matter how disturbing or aggressive the content of a surrealist work might be, the disturbance or aggression is contained by the work. The audience comes to the work, where it can focus or withdraw its attention at will. The work does not reach out and attach itself to the audience. Artaud wanted a more aggressive form of artwork, one in which the ineluctable forces of the subconscious and society would be mirrored in the artwork's forceful grasp of its audience. Whereas surrealism dabbles in the representation of irrational forces, Artaud wants to conjure up avatars of these irrational forces on the stage.

The aggressive irrationality of dada performance gives Artaud a model upon which to build his theater of cruelty. By eliminating the trivial or inconsequential subject matter with which dada often plays and putting in its place the more weighty and gripping themes of surrealism, the theater of cruelty takes hold of its audience with an inexorable power worthy of its name. Dada might attack the aesthetic sensibilities of its audience or withhold the gratifications and compliments generally associated with an evening at the theater, but it rarely confronts the audience with its own libidinal nightmares or the instabilities and voracious powers implicit in social history. Such themes are the talismans of surrealism that theater of cruelty involves in a profane rite in order to unleash suppressed and violent spirits upon the audience's heads. Artaud uses surrealist themes to introduce live ammunition into the gunplay of dada's anarchic theatricality. Whereas dada attacks the pretensions of art, theater of cruelty turns to a surrealist-inspired attack on the stability and significance of life.

Vitrac's *Mysteries of Love*, with its entwining of political images, a love affair, and Grand Guignol, is moving toward theater of cruelty but is

still more concerned with creating unstable collage structures within the medium of drama. Artaud's theories advocate dismissing the dramatic text, with its stable theatrical images, in favor of the fluid, image-laden, and psychologically threatening presence of performance. Artaud's *Spurt of Blood*, for instance, sweeps away its few stock characters (Young Man, Girl, Knight, Wet Nurse) with images of colliding stars, severed limbs, scorpions, and a nausea-inducing frog.[11] The fragile and rather cliché interactions of characters in *Spurt of Blood* give way in *Conquest of Mexico* to convoluted, protean imagery that does not represent the conquest of Mexico so much as seek to provoke in the audience feelings of panic and disorientation appropriate for witnesses to the destruction of the Aztec civilization:

> The Zodiac, which formerly roared with all its beasts in the head of Montezuma, turns into a group of human passions made incarnate by the learned heads of the official spokesmen, brilliant at disputation—a group of secret plays during which the crowd, despite circumstances, does not forget to sneer. (*Theater and Its Double*, 130)

To contrast the performative power of theater of cruelty with the more flippant irrationality of dada performance, one might turn to Tzara's "La Première Aventure céleste de M. Antipyrine" (English trans., *Dada Performance*, 53–62). Tzara's piece, like *Conquest of Mexico*, plays upon images of colonialism and clashing cultures through its pointed use of quasi-African nonsense phonemes and evocation of tropical scenes. Tzara's play, however, remains a series of vaguely familiar but disorienting images, while Artaud's performance scenario enacts rather than simply displaying the disorienting otherness that shadows the rise of European imperialism. Artaud wants to move beyond disturbing images to a region of performance action in which images dissolve in the agitated emotional atmosphere of events. The power of spectacle, developed in various directions in the plays of Kokoschka, Vitrac, and Lewis, is transformed by Artaud into the power of presence and experience. Stage images lose their integrity by becoming entwined in the reactions of the audience, and theater is no longer, as the original Greek word implies, a place for viewing but, rather, the site of an emotionally wrenching event in which spectacle and audience are inseparable participants.

Brecht's learning plays dissolve the audience in the activity of portraying a social problem and its possible solutions. Artaud's theater of cruelty

makes the activity of spectatorship unusually burdensome. These innova-
tions in performance no longer simply disrupt the normal social function
of the artwork but demand new social functions for the artwork. For
Brecht theatrical performance becomes an adjunct to the developing social
formations of class struggle. For Artaud theatrical performance becomes a
substitute for religion and psychoanalysis.

Thus, whereas the five playwrights of this study problematize the
dramatic artwork, Brecht and Artaud call for its transformation into a
new cultural practice. Nevertheless, Brecht and Artaud owe a great deal
to the formal innovations exemplified in the work of these five play-
wrights. An aesthetics of disturbance is as central to the work of Brecht
and Artaud as it is to the work of Kokoschka, Benn, Roussel, Vitrac, and
Lewis. But, whereas these five playwrights use this aesthetic to make
their artworks tremble, to infuse their works with the quickening quaver
of anti-art, Brecht and Artaud use it to drive art toward other forms of
cultural activity.

Brecht and Artaud use collage and montage as much as the play-
wrights of this study, but in contrast to these five playwrights, who are
content to confront the audience with their heterogeneous constructions,
Brecht and Artaud place the audience within theirs. The affinity of
Brecht's work, in general, with montage has been noted by Bürger
(*Theory of the Avant-Garde*, 89, 91), but only in the learning plays does he
place, or rather dissolve, the audience in the montage. The performative
montage of the learning plays differs from the contemplative montage of
Brecht's conventional stage plays (e.g., *Threepenny Opera*) in that, instead
of confronting the montage form from across the proscenium arch, the
audience must construct the montage around themselves by participating
in the performance of the play. In the learning plays the various heteroge-
neous elements (props, music, plot, allegorical implications, current po-
litical conditions, etc.) do not so much submit to a central purpose as
offer themselves to the audience/participants for the negotiation of a
central purpose. The montage construction can only be completed
through the cooperative performance of the audience/participants.

If, then, Brecht's learning plays involve performative montage,
Artaud's theater of cruelty involves a kind of experiential collage.
Given the strongly advocated purpose of theater of cruelty articulated
in *The Theater and Its Double*, one might be tempted to see the central
constructive principle of this theater as montage: Is not the purpose of
all the heterogeneous elements to prove that we are all metaphysically

vulnerable, that "the sky can still fall on our heads" (79)? The important point to remember here is that this central purpose is performative rather than discursive.

A montage is constructed around a statement or judgment, not around an activity. We can call Brecht's learning plays performative montage because their performance activity centers on the construction of statements or judgments by the participants on the material in which they are involved. The performance activity of theater of cruelty, however, is inimical to the fixity of discursive statements. It seeks to break down the audience's ability to make judgments. Rather than place a statement at the center of theater of cruelty, Artaud places the audience there. From this central position the audience does not draw the spectacle to it but, rather, feels the disturbing foreignness of the spectacle's elements. The audience is, in essence, an element of Artaud's collage performance and is central only insofar as it is the element of the collage upon which the other elements act. The sensations of the audience are the focus of the performance. But what Artaud wants the audience to feel is their lack of a meaningful centrality and the disturbing variety and autonomy of the universe's fragments. Theater of cruelty presents, thus, a collage whose heterogeneous fragmentation must be experienced rather than simply observed.

We can see in these brief remarks how far Brecht and Artaud are able to move from the innovations of Kokoschka, Benn, Roussel, Vitrac, and Lewis by using performance innovations to shift significantly the social function of theater. We can, however, also see the affinities between these five playwrights and Brecht and Artaud. While not shifting the function of drama and theater, these five playwrights do put a strain on that function and develop the constructive principles that Brecht and Artaud expand upon by carrying them into the realm of performance. Given the concept of anti-aesthetic drama that these five playwrights hold in common, we should expect advances in the tradition they establish to be marked by an abrupt break with the traditional function of art. Since these playwrights are not interested in improving the expressive powers of drama, their work cannot be located within the modernist march toward more subtle and sophisticated transformations of aesthetic material into figural and discursive expression, even though their work may become part of the aesthetic material that later (post)modernists transform. Because these five playwrights use collage and montage to suspend the transformation of aesthetic material in disturbing configurations that

mock or turn away from the conventions of artistic construction, the only way to pursue the (anti-)aesthetic practice they initiate is to discard literary construction for performance. To build upon the collage and montage techniques that the five develop would be to return to modernist construction, with anti-art gestures simply serving as another element of the aesthetic material on the artist's palate. To move the concept of montage and collage into the realm of performance continues the interest in shifting ground and turbulent zones of contrasting principles that the five playwrights pioneer.

It would be unfair, however, to think of Kokoschka, Benn, Roussel, Vitrac, and Lewis merely as timid forebears of more far-reaching innovations by Brecht and Artaud. The five playwrights of this study are, in fact, much more successful at establishing their idiosyncratic aesthetic positions than are Brecht and Artaud. Brecht and Artaud forward theories of theatrical performance that are not extensively realized for several decades following their conception. The five playwrights of this study write plays that fully embody their amibitious artistic dissidence. These five playwrights have fleshed out their aesthetics of disturbance in artworks that exist in the world precisely as they intended, even if, as with Roussel, their works fail to attain the popularity or appropriation desired. These playwrights understand the possibilities and impossibilities of artistic creation within the bourgeois institution of art and deftly maintain their precarious balances right on the edge of the possible. Even Roussel understands what the insitutions of art will allow him to create. He is disappointed in his artistic career because he fails to understand what kinds of creations these insitutions will endorse or even receive with a good grace.

Brecht and Artaud, in contrast, by advocating performance innovations, rather than innovations only in the dramatic text, slip out of the range of the existing possibilities granted art within bourgeois culture in the early twentieth century. As Derrida reminds us, Artaud's theater of cruelty was always, for him, an unrealized idea.[12] Brecht never made more than tentative essays at the idea of learning plays and could only accomplish these limited endeavors within the very distinct cultural conditions of late Weimar Germany. Thus, the "advance" that Brecht and Artaud make over the five playwrights of this study is an advance out of the realm of real possibilities for the artwork in the cultural formations existing at that particular time and into the realm of more purely theoretical concepts.

Brecht and Artaud have been, of course, highly and deservedly honored for their provocative ideas, ideas that have found practical applications in more recent cultural configurations.[13] Credit, however, should also be given to playwrights who work to provocative extremes the existing (rather than wished-for) potentials of the artwork in the early twentieth century. Brecht and Artaud idealize the concept of anti-art; Kokoschka, Benn, Roussel, Vitrac, and Lewis give us the concept of anti-art in the gloriously contaminated and abused bodies of its worldly incarnations. Sunk within the bourgeois institution of art, chained to the contemplative function accorded art by social custom, avant-garde drama breaks from the mold of both conventional and high modernist art to assert for itself a disturbing presence in the aesthetic field of early-twentieth-century European culture.

Notes

Notes to Chapter 1

1. See, for example, Renato Poggioli, *The Theory of the Avant-Garde* (New York: Harper and Row, 1971); Pierre Cabanne and Pierre Restang, *L'Avant-garde au XXe siècle* (Paris: Balland, 1969); Richard Kostelanetz, *The Avant-Garde Tradition in Literature* (Buffalo, N.Y.: Prometheus Books, 1982); and Marjorie Perloff, *The Futurist Moment* (Chicago: University of Chicago Press, 1986). All these critics value the avant-garde primarily for its tireless commitment to innovation.

2. Examples of this attitude are often quoted by those who favor the avant-garde, their purpose being either (1) to show how effective the avant-garde is in raising the ire of conventional tastes or (2) to demonstrate inadequate understandings of the artwork at hand. I will make use of both these rhetorical ploys throughout this study. One of the most formidable critics of the avant-garde is Theodor Adorno. His arguments are noteworthy because he condemns avant-garde movements while appropriating certain elements of the avant-garde aesthetic for his general theory of the modern artwork. See his book *Aesthetische Theorie* (Frankfurt a.M.: Suhrkamp, 1970).

3. See *Opinions littéraires, philosophiques et industrielles* (Paris: Galérie de Bossange Père, 1825), 331ff. The article appears under Rodrigues's name in *Oeuvres de Saint-Simon et d'Enfantin* (Paris: E. Dentu, 1875), 39:201–58. The "avant-garde" metaphor appears on 210–11. For a discussion of this passage and the general attitude toward art in Saint-Simon's utopian philosophy, see Calinescu, *Five Faces of Modernity* (Durham, N.C.: Duke University Press, 1987), 101ff.

4. Jost Hermand discusses these groups in his article "Das Konzept 'Avantgarde,' " in *Faschismus und Avantgarde*, ed. Reinhold Grimm and Jost Hermand (Königstein/Ts: Athenäum, 1980), 1–19; esp. 2–3.

5. See, for example, John A. Henderson, *The First Avant-Garde, 1887–1894* (London: George G. Harrap, 1971).

6. See Julia Kristeva, *La Révolution du langage poétique* (Paris: Éditions du Seuil, 1974); translated as *Revolution in Poetic Language*, trans. Margaret Waller (New York: Columbia University Press, 1984); and Michel Zéraffa, "Pré-avant-gardes et avant-gardes: le tournant français du XXe siècle," in *The Roaring*

Twenties: The Avant-Garde Movements in Europe, ed. Zbigniew Folejewski (Ottawa, Ont.: University of Ottawa Press, 1981), 9–38.

7. The circles that formed around Mallarmé and George are good examples of the loose collective organization of the aesthetic movements.

8. Mallarmé, "Réponse à des Enquêtes: Sur l'evolution littéraire," *Oeuvres complètes* (Paris: Gallimard, Bibliothèque de la Pléiade, 1945), 870.

9. Richard Huelsenbeck, "Collective Dada Manifesto" (1920), in *The Dada Painters and Poets*, ed. Robert Motherwell (Cambridge, Mass.: Harvard University Press, 1989), 244, 246.

10. See Bürger, *Theorie der Avantgarde* (Frankfurt a.M.: Suhrkamp, 1980); or *Theory of the Avant-Garde*, trans. Michael Shaw (Minneapolis: University of Minnesota Press, 1984). Bürger defines the institution of art as follows: "The concept 'art as an institution' as used here refers to the productive and distributive apparatus and also to the ideas about art that prevail at a given time and that determine the reception of works" (*Theory of the Avant-Garde*, 22). In his subsequent development of the term, however, Bürger has emphasized the normative "ideas about art" much more that the "productive and distributive apparatus." See Peter Bürger and Christa Bürger, *The Institutions of Art*, trans. Loren Kruger (Lincoln: University of Nebraska Press, 1992).

11. See Dolf Oehler, "Hinsehen, Hinlangen: Für eine Dynamisierung der Theorie der Avantgarde. Dargestellt an Marcel Duchamps *Fountain*," in *"Theorie der Avantgarde" Antworten auf Peter Bürgers Bestimmung von Kunst und bürgerlicher Gesellschaft* (hereafter abbreviated *"Antworten"*), ed. W. Martin Lüdke (Frankfurt a.M.: Suhrkamp, 1976), 143–65.

12. All translations, unless otherwise indicated, are my own. (Hypostasierung von *Institution Kunst* reduziert jedes Objekt auf die eine immergleiche Geste des Protests . . . Haben das *Fahrrad-Rad* [1913], . . . das Urinoir *Fountain* [1917], . . . der Vogelbauer mit den Marmor-Zuckerstücken *Why Sneeze Rose Sélavy?* [1921] etc. nur den einen Wesenszug, dass sie Kategorie der individuellen Produktion negieren? Mehr noch: Ist dieser Zug ihr wichtigster? Wieso negiert Duchamp diese Kategorie ausgerechnet mittels eines Urinoirs? Negiert er damit nicht vielleicht zuvördest andere Kategorien, andere Institutionen als die der Kunst?)

13. See, for example, Vladimir Mayakovsky, *Mystery-Bouffe* in *Masterpieces of the Russian Drama*, vol. 2, ed. George Rapall Noyes (New York: Dover, 1961), 801–81.

14. Kurt Schwitters and Hugo Ball, for instance, were never really happy with the notion of "anti-art." See Schwitters's manifesto in *The Dada Painters and Poets*, 57–65, and Ball's journal *Die Flucht aus der Zeit* (Lucerne: J. Stocker, 1946). For an extended discussion of this issue, see Hans Richter, *Dada: Art and Anti-Art* (New York and Toronto: Oxford University Press, 1965).

15. Although I take the phrase "bourgeois institution of art" from Bürger, I think it should have a wider and more material significance than he, in practice, grants it. I intend the institution of art to take in the organizations of people, money, and physical resources that shape and perpetuate the normative concept of art in bourgeois society. Raymond Williams defines what I am calling the

institution of art very well under the rubric of the sociology of culture (see *The Sociology of Culture* [New York: Schocken Books, 1982]).

One must acknowledge that the bourgeois institution of art is very fluid, changing its shape and character from country to country and period to period, but we can keep a general idea of it in mind by simply thinking of it as the business of art and culture as it is organized by and for the bourgeoisie of a particular place and time.

16. See, in particular, Calinescu (*Five Faces of Modernity*); and Peter Bürger (*Theory of the Avant-Garde*).

17. Note, for example, the dada artifacts at MOMA and the financing of abstract expressionism by the AID. See Serge Guilbaut, *How New York Stole the Idea of Modern Art* (Chicago: University of Chicago Press, 1983), for a discussion of how *avant-garde* becomes a privileged term in U.S. high culture during the cold war. See Richter, *Dada*, for remarks on the integration of dada into bourgeois art markets (esp. "Neo-Dada," 203–14).

18. See *Modern Culture and Critical Theory* (Madison: University of Wisconsin Press, 1989), 84. While drawing sharp distinctions between the modern and postmodern, Berman still sees postmodernism as a part of modern culture (see esp. chaps. 3 and 5 of his book). For further discussions of how postmodernism relates to modern culture and the avant-garde, see Matei Calinescu, *Five Faces of Modernity* (Durham: Duke University Press, 1987), esp. 310–12; and Andreas Huyssen, *After the Great Divide* (Bloomington and Indianapolis: Indiana University Press, 1986).

19. See Theodor Adorno, "Versuch, das Endspiel zu Verstehen," *Noten zur Literatur* (Frankfurt a.M.: Suhrkamp, 1981), 281–324.

20. See Piscator, *The Political Theater* (New York: Avon, 1978).

21. For examples of Kruger's work, see her book *We Won't Play Nature to Your Culture* (London: Institute of Contemporary Arts, 1983). For accounts and discussions of Berlin Dada, see Richter, *Dada*, 101–36; Motherwell, ed., *The Dada Painters and Poets* (Cambridge, Mass.: Harvard University Press, 1989); and Peter Sloterdijk, *Critique of Cynical Reason* (Minneapolis: University of Minnesota Press, 1987), 391–409.

22. See Hans Magnus Enzensberger, "Die Aporien der Avantgarde," *Einzelheiten: Poesie und Politik* (Frankfurt a.M.: Suhrkamp, 1962); English translation in *The Consciousness Industry*, ed. Michael Roloff (New York: Seabury Press, 1974), 16–41 (quote on 29).

23. Harold Rosenberg, "Collective, Ideological, Combative," in *Avant-Garde Art*, ed. Thomas B. Hess and John Ashbery (London: Collier-Macmillan, 1968), 84.

24. See Williams, *Sociology of Culture*.

25. See Calinescu: "At some point during the first half of the nineteenth century an irreversible split occurred between modernity as a stage in the history of Western civilization—a product of scientific and technological progress, of the industrial revolution, of the sweeping economic and social changes brought about by capitalism—and modernity as an aesthetic concept" *Five Faces*, (41).

26. See, for example, Mary Shelley's *Frankenstein* or Hugo's *Hernani*.

27. Herbert Marcuse, "The Affirmative Character of Culture," *Negations*, trans. Jeremy J. Shapiro (Boston: Beacon Press, 1968), 98. Originally published in German in 1937.

28. Jochen Schulte-Sasse makes a similar point to explain the discontent and constant innovations in critical art beginning in the early nineteenth century. See his foreword to Bürger, *Theory of the Avant-Garde*, vii–xlvii, esp. xi.

29. Adorno, *Ästhetische Theorie* (Frankfurt a.M.: Suhrkamp, 1970), 9: "Zur Selbstverständlichkeit wurde, daß nichts, was Kunst betrifft, mehr selbstverständlich ist, weder in ihr noch in ihrem Verhältnis zum Ganzen, nicht einmal ihr Existenzrecht."

30. Authentische Künstler wie Schönberg haben heftig gegen den Stilbegriff aufbegehrt; es ist ein Kriterium radikaler Moderne, ob sie diesen kündigt.

31. For a discussion of the distinction Adorno draws between the immanent and social development of the artwork, see "Institution Kunst als literatursoziologische Katagorie," in Bürger, *Vermittlung—Rezeption—Funktion* (Frankfurt a.M.: Suhrkamp, 1972); translation in Peter and Christa Bürger, *Institutions of Art*, trans. Loren Kruger (Lincoln: University of Nebraska Press, 1992).

32. Daß Werke der Kommunikation absagen, ist eine notwendige, keineswegs die zureichende Bedingung ihres unideologischen Wesens. Zentrales Kriterium ist die Kraft des Ausdrucks, durch dessen Spannung die Kunstwerke mit wortlosem Gestus beredt werden. Im Ausdruck enthüllen sie sich als gesellschaftliches Wundmal; Ausdruck ist das soziale Ferment ihrer autonomen Gestalt.

33. See Maurice Blanchot,"The Gaze of Orpheus" (1955), *The Gaze of Orpheus and Other Literary Essays*, ed. P. Adams Sitney, trans. Lydia Davis (Barrytown, N.Y.: Station Hill Press), 100.

34. As far as I am aware, Adorno and Blanchot are not familiar with each other's work. The similarities in their remarks stem from a common subject of inquiry (modern literature) and common philosophical predecessors (e.g., Hegel and Heidegger).

35. Blanchot, "From Dread to Language" (1943), *Gaze of Orpheus*, 8.

36. Blanchot, "Literature and the Right to Death" (1949), *Gaze of Orpheus*, 21.

37. See Kristeva, *Revolution in Poetic Language*.

38. Blanchot, "Reading" (1955), *Gaze of Orpheus*, 95.

39. See Bürger, "Das Vermittlungsproblem in der Kunstsoziologie Adornos," in *Materialien zur ästhetischen Theorie Th. W. Adornos* (hereafter abbreviated "*Materialien*"), ed. Burkhardt Lindner and W. Martin Ludke (Frankfurt a.M.: Suhrkamp, 1980), 169–84, esp. 182.

40. Theodor Adorno, "Rückblickend auf den Surrealismus," *Noten zur Literatur* (Frankfurt a.M.: Suhrkamp, 1981), 104: "Nicht als eine Sprache der Unmittelbarkeit, sondern als Zeugnis des Rückschlags der abstraktes Freiheit in die Vormacht der Dinge und damit in blosse Natur wird man den Surrealismus begreifen dürfen. Seine Montagen sind die wahren Stilleben. Indem sie Veraltetes auskomponieren, schaffen sie nature morte."

41. For a discussion of anti-art as noise, see Gregory Ulmer, "The Object of

Post-Criticism," in *The Anti-Aesthetic*, ed. Hal Foster (Port Townsend, Wash.: Bay Press, 1983), 83–110.

42. For a comparison of views on collage and montage, see Denis Bablet, ed., *Collage et montage au théâtre et dans les autres arts durant les années vingt* (Lausanne: La Cité—L'Age d'Homme, 1978); Burkhardt Lindner and Hans Burkhard Schlichting, "Die Destruktion der Bilder: Differenzierungen im Montagebegriff," *Alternative* 22–23 (1978): 209–24; Perloff, "The Invention of Collage," *Futurist Moment*, 44–79; Schlichting, "Historische Avantgarde und Gegenwartsliteratur," *Antworten*, 209–51, esp. 231–32; Jean-Jaques Thomas, "Collage/Space/Montage" in *Collage*, ed. Jeanine Pariser Plottel (New York: New York Literary Forum, 1983), 79–102; and Anne Ubersfeld, *Lire le théâtre* (Paris: Éditions Sociales, 1982), 212, 265. Rosalind Krauss draws a rather different but interesting distinction between what she calls "dada montage" and "cubist collage." (see "The Photographic Conditions of Surrealism," *The Originality of the Avant-Garde and Other Modernist Myths* [Cambridge, Mass.: MIT Press, 1985], 106–7. Her distinction is useful for understanding the differences between dada and cubism but is not helpful in establishing a general distinction between collage and montage.

43. In suggesting that collage and montage are part of the same process, Gregory Ulmer actually confirms the distinction I am drawing (see "Object of Post-Criticism"). Ulmer suggests: " 'Collage' is the transfer of materials from one context to another, and 'montage' is the 'dissemination' of these borrowings through the new setting" (84). Thus, collages emphasize the transfer of elements, drawing attention to their uprootedness and their previous life, while montages emphasize the new setting in which the heterogeneous elements have gathered.

44. See Ubersfeld, *Lire le théâtre*; and the articles by Bablet (12), Michel Decaudin (33), and Odette Aslan (203) in Bablet, *Collage et montage*.

45. Schlichting makes this point (see *Antworten*, 231–32).

46. Das Material büßt seinen realitätsabbildenden Charakter fast vollständig ein, der auch durch die Bildkomposition keineswegs restituiert wird. Dabei wird keineswegs generell die Tilgung der Handschrift des Malers angestrebt, vielmehr werden die kunstfremden Materialien gerade in ihrer Deformation und Neuanordnung einem singulären Formungsprozeß unterworfen.

47. The connection between collage and bricolage is made by Bablet (see *Collage et montage*, 12).

48. Lindner and Schlichting define the work of Heartfield and Ernst as two distinct forms of montage, as different from each other as they both are from collage. While I would agree that the ultimate purpose and effect of their work is quite different, I think this is due to the different subject matter and purposes they are concerned with rather than due to any great difference in the constructive principle they employ.

49. Heartfield, *Photomontages of the Nazi Period*, trans. Nancy Reynolds (New York: Universe Books, 1977), 40–41; translation and commentary, 120.

50. For other discussions of Heartfield's photomontages, see *Theory of the Avant-Garde*, 75–78; Lindner and Schlichting, 213–14; and Annegret Jürgens-Kirchhoff, "Heartfield und/oder Schwitters?" *Alternative* 22–23 (Oct.–Dec. 1978): 252–59.

51. See Ernst, *The Hundred Headless Woman (La femme 100 têtes)*, trans. Doro-
thea Tanning (New York: Braziller, 1981), 197.

52. See also the images that follow this one in *Hundred Headless Woman*,
199–203.

53. My discussion of the distinction between the figural and discursive is
drawn in part from Jean-François Lyotard, *Discours, figure* (Paris: Édition Klinck-
sieck, 1971); and Norman Bryson, *Word and Image* (Cambridge: Cambridge Uni-
versity Press, 1981).

54. If "aesthetic" is to embrace everything from the most conventional and
now forgotten bourgeois dramas through the works that enjoyed critical acclaim
at the time, such as Galsworthy's *Strife*, to modernists such as Ibsen, Kaiser, and
Pirandello, it will be, of course, a very broad category. For all the differences
these works have, however, they still have certain similarities. A masterful devel-
opment of the raw materials of one's art and the discursive stability of the finished
project are the two aesthetic qualities that I think both conventional and high
modernist art would acknowledge as ideals (even if most potboilers don't live up
to these ideals). Collage, however, violates these ideals at least until such time as
the gluing together of found objects is acknowledged as an artistic technique
involving particular skills and developing over time. In other words, collage was
inherently anti-aesthetic in the early twentieth century but is so no longer.

55. For a comparison of Braque's fairly conservative constructive strategies
with Picasso's more adventurous ones, see William Rubin, *Picasso and Braque:
Pioneering Cubism* (New York: Museum of Modern Art, 1989), esp. 36–39.

56. See, for example, Huelsenbeck's anti-art statement, "En Avant Dada: A
History of Dadaism" (1920); and Schwitters's counterstatement, "Merz" (1920),
in *Dada Painters and Poets*, 21–47, 57–65.

Notes to Chapter 2

1. See Aristotle, *Poetics*, trans. Richard Janko (Indianapolis: Hackett,
1987), 7.

2. Aristotle's exemplary play is *Oedipus Rex*; Hegel's is *Antigone*. For fur-
ther discussion of the distinctions between the dramatic theories of Aristotle and
Hegel, see Michelle Gellrich, *Tragedy and Theory: The Problem of Conflict since
Aristotle* (Princeton, N.J.: Princeton University Press, 1988).

3. Hegel, *Vorlesungen über die Ästhetik, III* (hereafter abbreviated "*Poesie*")
(Frankfurt a.M.: Suhrkamp, 1970), 474.

4. Consider, for example, Goethe's *Faust*, part 2, particularly in the context
of nineteenth-century theatrical possibilities.

5. For a survey of the complaints against theater that have marginalized it
from high culture, see Jonas Barish, *The Antitheatrical Prejudice* (Berkeley: Univer-
sity of California Press, 1981).

6. The phrase is Brand's. For a summary of his and similar points of view,
see Marvin Carlson *Theories of the Theatre* (Ithaca, N.Y.: Cornell University
Press, 1984), 266, 278.

7. See Szondi, *Theorie des modernen Dramas* (Frankfurt a.M.: Suhrkamp,

1965); or *Theory of the Modern Drama*, trans. Michael Hays (Minneapolis: University of Minnesota Press, 1987).

8. Cf. Hegel, *Vorlesungen über die Ästhetik, I* (Frankfurt a.M.: Suhrkamp, 1970), 257–83.

9. The exact source of problems in situation-oriented mimesis depends on the kind of situation staged. Szondi identifies four basic forms: naturalism, conversation plays, one-act plays, and existentialist confinement. See Szondi, *Theorie*, 86, 87, 91, and 96 (trans.: 52, 53, 55, and 58).

10. See Lukács, "The Sociology of Modern Drama," in *The Theory of the Modern Stage*, ed. Eric Bentley (New York: Penguin, 1968).

11. See Heinz Kindermann, *Theatergeschichte Europas*, vols. 8 and 9 (Salzburg: Otto Müller, 1968 and 1970).

12. For a sampling of the innovative theories of theater current at the turn of the century, see Manfred Brauneck, ed., *Theater im 20. Jahrhundert* (Reinbek bei Hamburg: Rowohlt Taschenbuch, 1982); and Bentley, *Theory of the Modern Stage*.

13. Kandinsky's *Das gelbe Klang* (1912) is a good example of a play designed for this type of production. See *The Blaue Reiter Almanac*, ed. Kandinsky and Marc (New York: Viking, 1974), 207–25. Some of the Bauhaus performances in Weimar Germany develop this style of theater with a variety of theatrical innovations. See, for example, Oskar Schlemmer, *Théâtre et abstraction* (Lausanne: L'Age d'Homme, 1978). E. Gordon Craig designed a purely emotive, wordless spectacle entitled "The Steps" (1905). See *Craig on Theatre*, ed. J. Michael Walton (London: Methuen, 1983), 108–15.

14. See Lukács, "Sociology of Modern Drama"; and Raymond Williams, *The Sociology of Culture* (New York: Schocken Books, 1981), 166–71.

15. See Brauneck, *Theater im 20*, 67–78.

16. Brauneck, *Theater im 20*, 69: "Waren in der Anfangszeit die Schauspieler für Appia nur ein Element unter anderen in der Hierarchie aller Inszenierungselemente, so erhält unter dem Einfluss von Dalcroze, der in seiner pädagogischen Arbeit den Menschen stets in den Mittelpunkt stellte, nun auch für Appia der Schauspieler eine zentrale Bedeutung. Typisch für diese neue Akzentsetzung sind Appias Bühnenentwürfe von 1909, die er 'Rhythmische Räume' nannte."

17. *Die Inszenierung als Schöpfung der Musik* (1899); excerpts quoted in Brauneck, *Theater im 20*, 39–46.

18. Joachim Fiebach, *Von Craig bis Brecht: Studien zu Kunstlertheorien in der ersten Hälfte des 20. Jahrhunderts* (Berlin: Henschelverlag, 1975), 52.

19. See E. Gordon Craig, "The Actor and the Ueber-Marionette," *On the Art of the Theatre* (London: William Heinemann, 1912), 54–94:

> Acting is not an art. . . . For accident is an enemy of the artist. Art is the exact antithesis of pandemonium, and pandemonium is created by the tumbling together of many accidents. Art arrives only by design. Therefore in order to make any work of art it is clear we may only work in those materials with which we can calculate. Man is not one of those materials. (55–56)

20. See Brauneck, *Theater im 20*, 176.

21. See Craig, *On the Art of Theatre*, 240.

22. See F. T. Marinetti, *Selected Writings*, ed. R. W. Flint (New York: Farrar, Straus, and Giroux, 1971); and Michael Kirby and Victoria Nes Kirby, *Futurist Performance* (New York: PAJ Publications, 1986).

23. Neither the Italian futurists nor Schwitters break with the concept of art as thoroughly or explicitly as, say, the Berlin dadaists, but they do, I think, develop and deploy some antiaesthetic principles within their interestingly idiosyncratic notions of art.

24. See, for example, Hugo Ball's description of an evening at the Galerie Dada in Zurich and his general privileging of spontaneity over mastery in *Die Flucht aus der der Zeit* (Lucerne: J. Stocker, 1946), 98, 101–2, 107, 150–52. The genuine and fraudulent descriptions of Berlin-dada events emphasize further the importance of an unpredictable and unrepeatable spontaneity. See *Dada Performance*, ed. Mel Gordon (New York: PAJ Publications, 1987), 80–91.

25. Cited and quoted at length in Dolf Oehler, "Hinsehen, Hinlangen: Für eine Dynamisierung der Theorie der Avantgarde. Dargestellt an Marcel Duchamps *Fountain*," in *"Theorie der Avantgarde" Antworten auf Peter Bürgers Bestimmung von Kunst und bürgerlicher Gesellschaft* (hereafter abbreviated *"Antworten"*) ed. W. Martin Lüdke (Frankfurt a.M.: Suhrkamp, 1976), 149.

26. I use *medium of the theater* in its widest possible sense, which includes the audience, the building, and the practical apparatus that determines and maintains the theater as an aesthetic practice within bourgeois culture. Some of the plays I examine can, for example, be easily realized upon the stage but, due to certain radical innovations in form and content, cannot be accepted by the audience. For a discussion of the various elements of the medium of theater, see Marvin Carlson, *Theatre Semiotics: Signs of Life* (Bloomington and Indianapolis: Indiana University Press, 1990); Keir Elam, *The Semiotics of Theatre and Drama* (London: Methuen, 1980); John McGrath, *A Good Night Out* (London: Methuen, 1981), esp. 5; Bert O. States, *Great Reckonings in Little Rooms* (Berkeley: University of California Press, 1985); and Williams, *Sociology of Culture*.

Notes to Chapter 3

1. Kokoschka, *My Life*, trans. David Britt (New York: Macmillan, 1974), 29. For the German original, see *Mein Leben* (Munich: Verlag F. Bruckmann, 1971), 66–67.

2. Paul Kornfeld, trans. and qtd. Henry I. Schvey, in *Oskar Kokoschka: The Painter as Playwright* (Detroit: Wayne State University Press, 1982), 7. For the original, see Paul Kornfeld, in *Expressionismus: Literatur und Kunst, 1910–1923*, the catalog to an exhibition at the Schiller-Nationalmuseum, Marbach a.N., 8 May–31 Oct 1960 (Munich: Albert Langen, Georg Müller, 1960), 86.

3. Alfred Kerr, *Der Tag* (Berlin: 26 May 1919); reprinted in Günther Rühle, *Theater für die Republik, 1917–1933 im Spiegel der Kritik* (Frankfurt a.M.: S. Fischer, 1967), 69:

Bildwirkungen. Seelentupfen, gepinselte. Zwischendurch das Gefühl, dass man den stärksten aller heut lebenden Regisseure vor sich hat. Nicht etwa, Gott behüte, den stärksten Dichter. Denn eben, wo Begriffe fehlen, da stellt O. Kokoschka, Kunstmaler, zur rechten Zeit sich ein.

Alles zerschwimmt, entnebelt, verfliegt.

Manchmal denk' ich: das ist, als ob man eine Klingersche Radierung farbig gemacht und in einem zauberhaften, ganz langsam sich abwickelnden Kinemakolor auf die Planken gestellt hätte . . .

See also Robert Breuer, *Die Schaubühne* (Berlin: 1917); reprinted in Rühle, *Theater*, 64, Lothar Schreyer, *Expressionistische Theater* (Hamburg: J. P. Toth, 1948), 113; and Joseph Sprengler, "Kokoschkas Bühnendichtung," *Hochland* 2 (1922): 672.

4. See Weininger's *Geschlecht und Charakter* (Vienna: W. Braumüller, 1904).

5. See Horst Denkler, "Die Druckfassungen der Dramen Oskar Kokoschkas," *Deutsche Vierteljahrsschrift für Literaturwissenschaft und Geistesgeschichte* 40 (1966): 90–108. See his study *Drama des Expressionismus* (Munich: Wilhelm Fink, 1967), for a more detailed account of the relationship between Kokoschka's plays and the drama of expressionism.

6. Hans Schumacher, "Oskar Kokoschka," in *Expressionismus als Literatur*, ed. Wolfgang Rothe (Bern: A. Francke AG, 1969), 513:

Unsinn und Tiefsinn vermischen sich hier
ununterscheidbar. Die Wahrheit ist nur noch in der
Parodie sagbar; indem alles auf den Kopf gestellt wird,
wird die Illusion, die sich ernst nahm, entlarvt.

7. Bernard Diebold, *Anarchie im Drama*, 4th ed. (Berlin-Wilmersdorf: Verlag Heinrich Keller, 1928), 296:

Man hat aus Erklärungen dieses Dramas erfahren, dass sich hier der Mann vom nur geschlechtlichen Weibe loslöse und dadurch sich und es befreie. Man mag das gutwillig hinnehmen—aus dem spröden Text ist jegliche Auffassung zu erklären. Der Mann schreit, die Frau schreit; der Mann brennt ihr eine Wunde mit heissem Eisen in das rote Fleisch. Was is das? Der Phallus oder die Zuchtrute? . . . Mag es sich um Befreiung vom Tiere oder um Versklavung in die Bestie handeln—hier wird ohne Antiphone von reinerem Stimmen so bestialisch gegröhlt und gemimt, dass die Muse einer solchen Brunstorgie nur Vagina heissen kann.

8. *Murderer Hope of Womankind* (1916 version, erroneously dated 1907), in *Seven Expressionist Plays*, ed. and trans. J. M. Ritchie (London: Calder and Boyars, 1968), 32 (trans. emended). For the original, see Oskar Kokoschka, *Das*

schriftliche Werk, Band I, Dichtung und Dramen, ed. Heinz Spielmann (Hamburg: Hans Christians Verlag, 1973), 51:

> Der Mann geht ihnen [Krieger und Mädchen] gerade entgegen. Wie Mücken erschlägt er sie. Die Flamme greift auf den Turm über und reisst ihn von unten nach oben auf. Durch die Feuergasse enteilt der Mann. Ganz ferne Hahnenschrei.

9. See, for example, Kaiser's *Von Morgen bis Mitternacht*; and Hasenclever's *Der Sohn.*

10. *Murderer the Women's Hope,* trans. Michael Hamburger (1910 version, erroneously dated 1907), in *Anthology of German Expressionist Drama,* ed. Walter Sokel (Ithaca: Cornell University Press, 1984), 20. For the original, see *Werk,* 1:39:

> Sie schleicht wie ein Panther im Kreis um den Käfig. Sie kriecht neugierig zum Turm, greift lüstern nach dem Gitter, schreibt ein grosses weisses Kreuz an den Turm, schreit auf.

11. Sokel, *Anthology of German Expressionist Drama,* 21 (trans. emended). For the German original, see *Werk,* 1:40:

> Ich will Dich nicht leben lassen, Du Vampyr, frisst meinem Blut, Du schwächst mich, wehe Dir, ich töte Dich—Du fesselst mich—Dich fing ich ein—und Du hältst mich—lass los von mich, Blutender. Deine Liebe umklammert mich—wie mit eisernen Ketten—erdrosselt—los—Hilfe. Ich verlor der Schüssel, der Dich festhielt.
> (Lässt das Gitter, wälzt sich auf der Stiege wie ein verendendes Tier, krampft die Schenkel und die Muskel zusammen.)

12. Ritchie, *Seven Expressionist Plays,* 31 (trans. emended). For the German original, see *Werk,* 1:50–51:

> FRAU *(immer heftiger, aufschreiend):* Ich will dich nicht leben lassen. Du! Du schwächst mich—Ich töte dich—Du fesselst mich! Dich fing ich ein—und du hältst mich! Lass los von mir—umklammerst mich—wie mit eisernen Ketten—erdrosselt—los—Hilfe! Ich verlor der Schlüssel—der dich festhielt.
> (Lässt das Gitter, fällt auf der Stiege zusammen.)

13. For the original, see *Werk,* 1:46: Der Schmerzensmutter verscheuchter Knabe, mit Schlangen um die Stirn, entsprang.

14. For the original, see *Werk,* 1:47:

> ERSTES MÄDCHEN *(listig):* Unsre Frau ist eingesponnen, hat noch nicht Gestalt erreicht.
> ZWEITES MÄDCHEN *(grosstuend):* Unsre Frau steigt auf und sinkt,
> Doch kommt nie auf die Erde.

DRITTES MÄDCHEN: Unsre Frau ist nackt und glatt,
Auch schliesst nie die Augen.

15. weissliches Licht, offene Türe, die jetzt Licht einwirft, Lichtstrahlen kreuzen und suchen sich aus den zwei Zimmern in der Mitte der Höhe.

16. Mann und Frau gegenüber auf zwei Felskanzeln . . . Solange er spricht, weisses Licht, das mit roten intermittiert, sobald sie antwortet.

17. Es schlief das Wassertiefe,
 Es stand der Berg schattenleer
 Und es war keine Zeit
 Und da hörte kein Tier
 Und da wärmte kein Feuer
 Und verbrannte kein Flammen,
 Als keine Liebe war.

18. MANN: . . . Das Feuer fragt, wo soll ich mich denn hintun!
Und legt sich in die Asche.
Schon seltsam und untraurig . . .
 FRAU: . . . schliesst über mir Tagesschein.

19. CHOR Frage: Warum bist du nicht gut?
Warum bist du nicht gut
 CHOR Antwort: Weil sein sie sollten,
im Schein verharren sie wollten.

20. Sphinx and Strawman: A Curiosity, trans. Victor H. Meisel, in Expressionist Texts, ed. Mel Gordon (New York: PAJ Publications, 1986), 32. For the original, see Werk, 1:56:

HERR FIRDUSI (zum Publikum): Wie rührend, wenn ich ein Nasentuch zur Hand nehme, fangen Sie an zu weinen.

Warum sehen Sie mich jetzt kühl an, hundert Indifferente gegen einen aufgeregten. Nur eine Nuance, die den Helden vom Zuschauer unterscheidet.

Glauben Sie an einem Bluff?

Ich arbeite nur mit Ihrer Intelligenz, Ihren Nerven und den Resultaten unserer gemeinsamen Gespensterromantik.

Erroneously dated 1907 in Expressionist Texts and Das schriftliches Werk, this is, in fact, the 1913 version of the play originally published in Kokoschka's Drama und Bilder (Leipzig, 1913) and performed by the dadaists in Zurich in 1917. For further publication information, see Schvey, Oskar Kokoschka, 136.

21. For the original, see Werk, 1:55:

Ich hatte ein Weib, ich machte einen Gott aus ihr, da verliess sie mein Bett. Sagte zur schmerzlichen Kammerjungfrau "knüpfe mir meinen Reiseschleier um" und verschwand mit einem gesunden Muskelmann.

22. "Sphinx und Strohmann, Komödie für Automaten," written in 1907 and printed in Wort in der Zeit (Graz) 2, no. 3 (1956): 145ff.

23. *Job*, trans. Walter H. and Jacqueline Sokel, in *Anthology of German Expressionist Drama*, 160. For the original, see *Werk*, 1:69:

> HIOB (*singt*): Wie verdrehte mich die Liebe,
> Seit in diesem leeren Haus
> Von einem Frauenzimmer eine sanfte Stimme,
> Sie zu suchen, mich gerufen hat
> —Mich ein Labyrinth vexiert.
> Aus dem ein Echo neckt,
> Mich in kreuz und quer ein Lufthieb schreckt
> Wie's in den Wald ruft, so schallt es heraus.
> Ich schelt' sie, sie foppt mich und kommt nicht heraus.
> Weil im Augenblicke schnell
> Sie sich verwandelt durch irgend eine Hintertür,
> In ein Wesen das—ich selber bin!

24. For the original, see *Werk*, 1:84:

> Zu hoch hast du dein Weib
> In den Himmel versetzt.
> Erst da sie fällt, kannst du ihr auf
> Den Boden sehn.

25. For the original, see *Werk*, 1:82:

> Die menschliche Seele oder laterna magica . . .
> Früher malte sie Gott und den Teufel an die Welt;
> Heute Weiber an die Wand!

26. See Fritz Brehmer, "Bedingte und unbegingted Klarheit," *Das junge Deutschland* (Jahrgang) 2, no. 6 (1919): 161–62:

> If the playwright had left his audience with this work [*Das brennende Dornbusch*], the majority would have gone away in some way moved, albeit, perhaps, with some shaking heads and puzzled disputes. But then down swept the Job play like a blast of wind upon the, until now, only lightly agitated surface of the theater stalls.

> [Hätte der Dichter seine Zuhörer mit diesem Werke [*Das brennende Dornbusch*] verlassen, die Mehrheit wäre, vielleicht mit etlichen Kopfschütteln und in einer von Fragezeichen durchsetzter Disputa, jedoch in einiger Ergriffenheit davongegangen. Aber da fegte das Hiobdrama wie eine Fallbö auf den bis dahin nur leichtbewegten Wasserspiegel des Theaterparketts herab.] (162)

27. Der keinen Körper hat, doch mächtig uns bewegt, hat aus freien Luft Dich, Geist, für eine Weile entbunden, hier Eurydike zu dienen.

28. die Du Gestalt wie sie, Gespielin ihr, die Blitze mildern und ein-
herstürmendes Geschick, das durch Dich sich fortflicht, sollst rückwärts leiten!

29. *die Schlange beisst Eurydike in die Ferse*

ORPHEUS: Warum ist mir denn, als ob ich vor Glück Trunken wäre?

EURYDIKE: So sehen wir nur zu gut, dass wir uns in gleichen Gedanken
begegnet sind. Unglück blieb mir in der Hand noch. Nimmst Du dieses, ei,
Unglück, schenk ich Dir.—

fällt tot in die Arme der Furien

30. The six moments I have in mind are (1) Psyche's encounter with the
Furies (act 1, sc. 2); (2) Eurydike's death (act 1, sc. 3); (3) Psyche's and Orpheus's
descent to Hell (act 2, sc. 1); (4) Orpheus and Eurydike on the boat (act 2, scs. 3–
4); (5) the lynching of Orpheus (act 3, sc. 1); and (6) the final encounter between
Orpheus and Eurydike (act 3, sc. 3).

31. See Strindberg, *A Dream Play, Ghost Sonata,* and *To Damascus.*

32. Kokoschka, *Schriften, 1907–1955,* ed. Hans Maria Wingler (Munich: A.
Langen, G. Müller, 1956), 432–33:

Das Stück "Orpheus und Eurydike" bedeutet heute noch sehr viel für mich,
weil es . . . nicht mit Tinte geschrieben wurde, eher mit Blut, das damals
noch reichlich aus meiner Lunge kam, die verwundet war—und nicht
geschrieben, weil meine Hand noch unbrauchbar durch die Kopfverletzung,
sondern gesprochen, geflüstert in Ekstase, in Delirium, geweint, gefleht,
geheult in Angst und Fieber der Todesnähe.

Notes to Chapter 4

1. See Friedrich Wilhelm Wodtke, *Gottfried Benn,* 2d ed.(Stuttgart: J. B.
Metzlersche Verlagsbuchhandlung, 1970), 18 and 25:

Benn's "Dramatic Scenes" from his Brussels period, which display a
strongly experimental character . . . , seem today, in comparison to the sty-
listic perfection of the Roenne novellas, more dated and ephemeral.

[Benns *dramatische Szenen* der Brüsseler Zeit, die einem stark experi-
mentellen Charakter tragen . . . , wirken gegenüber der stilistischen Vollen-
dung der Rönne-Novellen heute eher zeitgebunden und ephemer.] (25)

Wodtke's judgment is implicitly seconded by the noticeable lack of attention
given to Benn's early drama in most scholarly studies of his work.

2. See Else Buddeberg, *Gottfried Benn* (Stuttgart: J. B. Metzlersche Verlags-
buchhandlung, 1961), 137–44, 176; Elmar Haller, *Gottried Benn: die Entwicklung
seiner Weltanschauung im frühen Werk* (Dornbirn: Vorarlberger Verlaganstalt, 1965),
93–94, 109–12; Barbara Schulz Heather, *Gottfried Benn: Bild und Funktion der Frau
in seinem Werk* (Bonn: Bouvier Verlag Herbert Grundmann, 1979), 68–74; and

Eckart Oehlenschläger, *Provokation und Vergegenwärtigung: eine Studie zum Prosastil Gottfried Benns* (Frankfurt a.M.: Athenäum Verlag, 1971), 5–39, 46–74.

3. Der Wirklichkeitszerfall, wie er in den monologischen Rönne-Stücken sich vollzieht, ist in den beiden "Dramen" um "Pameelen" noch eindringlicher spürbar. Das dramatische Gegenspiel scheint die Realität wenigstens des Gegenüber vorzugeben. Aber auch dieses Gegenüber ist nur Kulisse. Denn Rede und Gegenrede verlaufen jeweils auf zwei verschiedenen Eben; sie berühren sich nicht und können sich auch gar nicht ansprechen.

4. *Morgue*, which is arguably more shocking than the plays, was written two years before his first play, *Ithaka*. His subsequent prose and poetry is more subdued.

5. Gottfried Benn, *Vermessungsdirigent*, in *Gesammelte Werke*, 4th ed., 4 vols. (Wiesbaden and Munich: Limes, 1978), 2:334 (hereafter abbreviated as "*GW*"): "Geht auf die Frau zu. . . . Fasst sie an. . . . Es gibt sich etwas."

6. als ob Worte Sinn hätten. Wir glauben es doch nicht mehr, Renz, wir glauben es doch nicht mehr. Alle Vokabeln, in die das Bürgerhirn seine Seele sabberte, jahrtausendelang, sind aufgelöst, wohin, ich weiss es nicht.

7. In Krieg und Frieden, in der Front und in der Etappe, als Offizier wie als Artzt, zwischen Schiebern und Exzellenzen, vor Gummi- und Gefängniszellen, an Betten und an Särgen, im Triumph und im Verfall verliess mich die Trance nie, dass es diese Wirklihkeit nicht gäbe.

8. wir erfanden den Raum, um die Zeit totzuschlagen, und die Zeit, um unsere Lebensdauer zu motivieren; es wird nichts und es entwickelt sich nichts, die Kategorie, in der der Kosmos offenbar wird, ist die Kategorie der Halluzination.

9. Immer wieder stossen wir auf eine Form des Ich, das für einige Augenblicke sich erwärmt und atmet und dann in kaltes amorphes Leben sinkt.

10. Jedes ES das ist der Untergang, die Verwehbarkeit des ICH; jedes DU ist der Untergang, die Vermischlichkeit der Formen.

11. *Ithaca* (1914), trans. J. M. Ritchie, in *Expressionist Texts*, ed. Mel Gordon (New York: PAJ Publications, 1986), 92 (trans. modified). For the original, see *GW* 2:298: "Ich habe den ganzen Kosmos mit meinem Schädel zerkaut! Ich habe gedacht, bis mir der Speichel floss. Ich war logisch bis zum Kotbrechen. Und als sich der Nebel verzogen hatte, was war dann alles? Worte und das Gehirn. Worte und das Gehirn. Immer und immer nichts als dies furchtbare, dies ewige Gehirn."

12. For the original, see *GW* 2:303: "Schon schwillt der Süden die Hügel hoch. Seele, klaftere die Flügel weit; ja, Seele! Seele! Wir wollen den Traum. Wir wollen den Rausch. Wir rufen Dionysos und Ithaka!"

13. Cf., for example, Georg Kaiser, *Die Bürger von Calais*; Reinhard Sorge, *Der Bettler*; and Ludwig Rübiner, *Die Gewaltlosen*.

14. PASCHEN: . . . wer macht hier neues Vaterland, Sie oder ich?
(*Schlägt mit der Faust auf*) Ich!
OLF: Wer ist das, als was bezeichnen Sie sich?

15. PASCHEN: . . . fünfhundert Millionen Menshchheit säubert sich im Krieg, und Sie Schnösel—
SOLF: Säubert sich? Was? Dies koddrige Geschmeiss, immer noch

hingerissen von der Komponente aus Luftdruck und Peristaltik, die sie Seele nennen, ergriffen bis zur Wehmut von ihren aufrechten Gang . . .

16. ich träume von einer Männer-Menschheit, die, des rein formalen Characters ihres geistigen Aufbaus sich aufs konkreteste bewusst, nur noch in Formen denkt, tangential, funktionell, mit ausgehöhlten Begriff und abgelassenem Wort. Das wäre der Tanz, das wäre das Glück.

17. heran, Gehirne, Muttersäue mit euren Wortferkeln, jetzt ist das Land zerstückt, Europa taumelt, schreiender Mond und wildernde Gestirne—wo ist der Stern für meine Brut?

18. Leiber, schön rauschend um ihre Scham, anemonenwälder der Liebe.

19. Der Trieb nach Definition, in ihm qualvoller als der Hunger und erschütternder als die Liebe, kehrt sich in ihm gegen das sogenannte eigene Ich.

20. Ich habe hier absolut nichts zu suchen. Ich komme von ganz woanders her. Aber ich will euch einbeziehen in mein Dasein. Hinzutreten sollt ihr zu meiner Gesamtkonstitution.

21. Ein Mungo, wer noch linear lebt—: ich schwelle knotig.

22. Pameelen's behavior throughout the play is a good example of this. The Head Doctor's quips in the first scene are another.

23. die brutale Hypothese des Ich als Gesamtumfasser.

24. Renz, der Worte sind so viele: Spreu der Tenne, Schatten der Verlorenen, aber die alten Worte, Renz, die uralten Worte—Karandasch—Karandasch.

25. Für [Pameelen] fängt das Glück da an, wo die Lippe stumm ist und starr und weiss eine Zahnreihe klafft zum Frass und gegen Fische (Triton).

26. An meine Knie, süsser Triton: zwei Zahnreihen, starr und klaffend— Kiefer und Gegen-Kiefer, geliebte, stumme—

27. ich nie Personen sehe . . . , sondern immer nur das Ich, und nie Geschehnisse, sondern immer nur das Dasein, . . . ich keine Kunst kenne . . . und keinen Glauben, keine Wissenschaft und keine Mythe, sondern immer nur die *Bewusstheit*, ewig sinnlos, ewig qualbestürmt . . .

28. Mich sensationiert eben das Wort ohne jede Rücksicht auf seinen beschreibenden Charakter rein als assoziatives Motiv und dann empfinde ich ganz gegenständlich seine Eigenschaft des logischen Begriffs als den Querschnitt durch kondensierte Katastrophe.

29. Um die Knochensplitter meiner Weltanschauung nochmals hervorzukotzen . . .

30. Angriff und Widerstand als die Formen unserer Betrachtungsweise

31. STERNHEIM: *Der Sanitätsrat!* Typischer Seelenkampf!! Rechts und links vom Zuschauer! Seitlich Eingang ins Klosett! Personen: Der Sanitätsrat. Der junge Mann.

32. Sie Schösel, der Bürger will, daß etwas klafft: Konflikte! Verwesungssodem! Abgründe über die weisse Weste!

33. STERNHEIM: Das Publikum will Frühstück sehn.

 PAMEELEN: Behaglichkeit?

 STERNHEIM: Tout comme chez nous!

34. The Young Man's inability to stand up to the hypocrisy and corruption of the Health Officer is probably meant as a jab at utopian expressionism, which

puts tremendous faith in the ability of the young to change the world for the better. Throughout Benn's drama ironic and deprecatory references are made to the promise of the New Man. See *GW* 2:303, 334, and 356.

35. See *GW* 4: "Epilog und Lyrisches Ich," 7–14; "Lebensweg eines Intellektualisten," 30–49; and "Schöpferisches Konfession," 188–89.

Notes to Chapter 5

1. Henri Béhar makes a similar observation. See his book *Le Théâtre dada et surréaliste* (Paris: Gallimard, 1979), 113.

2. Raymond Roussel, *La Doublure* (Paris: Pauvert, 1963).

3. "Chiquenaude" is published in *Comment j'ai écrit certains de mes livres* (Paris: Pauvert, 1963), 39–48. For an analysis of this short story, see Michel Foucault, *Raymond Roussel* (Paris: Gallimard, 1963), 37–40.

4. Translations of these plays are printed in *Raymond Roussel: Selections from Certain of His Books*, ed. Alastair Brotchie (London: Atlas Press). In writing this chapter, I have only had access to the French originals.

5. See Roussel, *Épaves* (Paris: Pauvert, 1972), 97–261.

6. Quoted in J. H. Matthews, *Le Théâtre de Roussel* (Paris: Minard, Archives des Lettres Modernes, no. 175, 1977), 12:

Le nouvel ouvrage de M. Raymond Roussel, *L'Étoile au front*, est comme ses précédents, une pièce sans suite et hélas! sans fin. Il ne s'y passe rien; il n'y a pas d'intrigue, pas même une intrigue stupide. Elle ne contient qu'une masse de propos absurdes.

7. Quoted in Béhar, *Le Théâtre*, 128:

debarrassé de tous ses faux-semblants d'exactitude matérielle ou de ces vains détails de moeurs qu'un auteur ordinaire se croirait obligé d'y introduire. Rien, tout au long de la pièce, que les répliques sans phrases que la situation exigeait et qui semblent les premières venues.

8. En méprisant involontairement le savoir-faire dramatique, il ouvre le rideau sur un théâtre merveilleux, répondant à la seule necessité de l'imaginaire, ce courant inconscient qui parle sous la provocation du "procédé."

9. "L'Étoile au front par Raymond Roussel," first published in *Revue Européenne* no. 28 (June 1925); reprinted in *Europe*, nos. 517–18 (May–June 1972): 191–93:

Les protagonistes de ces trois actes ne sont pas seulement sur la scène, ils sont dans la salle. Les acteurs pourraient aussi bien être répartis de galeries au fauteuil d'orchestre, le théâtre est transformé en un grand salon où un millier de personnes écoutent sept ou huit d'entre elles qui racontent des histoires. (192)

10. le langage s'incline vers les choses, et la méticulosité des détails qu'incessament il apporte le résorbe peu à peu dans le mutisme des objets. Il n'est prolixe que pour se diriger vers leur silence. Comme s'il s'agissait d'un théâtre qui aurait basculé sans comique ou tragique . . . dans l'inanité du spectacle et n'aurait plus à offrir que le contour de sa visibilité.

11. Roussel, *How I Wrote Certain of My Books*, trans. Trevor Winkfield (New York: Sun, 1977), 3 (hereafter abbreviated as *"How I Wrote"*). For the original, see *Comment j'ai écrit certains de mes livres* (Paris: Jean-Jacques Pauvert, 1963), 11–12.

12. See Winkfield's notes in *How I Wrote*, 23–24.

13. See, for example, *How I Wrote*, 9, 10, and 12.

14. Many of the word pairs in *Impressions d'Afrique*, for example, are taken from billiard terms (see *How I Wrote*, 4), while phrases are created from popular songs (9), a poem by Hugo (10), and sundry other unrelated, arbitrary sources.

15. Michel Butor, "Sur les Procédés de Raymond Roussel," *Répertoire: études et conférénces, 1948–59* (Paris: Les Éditions de Minuit, 1960), 174–75: "Dans les suites qu'il dérive du hasard complice . . . il . . . donner toute leur précision et leur plénitude; il s'efforce de tirer le maximum de leurs tensions et de leurs particularités."

16. Martial [pseudonym for Roussel] a une conception très intéressante de la beauté littéraire, il faut que l'ouevre ne contienne rien de réel, aucune observation du monde ou des esprits, rien que des combinaisons tout à fait imaginaires.

17. Paul Éluard, "L'Étoile au front," *La Révolution surréaliste*, no. 4 (15 July 1925): 32: "Toutes les histoires du monde sont tissées de leurs paroles, toutes les étoiles du monde sont sur leurs front, miroirs mystérieux de la magie des rêves et des faits les plus bizarres, les plus merveilleux. . . . Que Raymond Roussel nous montre tout ce qui n'a pas été."

18. For discussions of surrealism, see Anna Balakian, *Surrealism: The Road to the Absolute* (New York: Dutton, 1970); André Breton, *Manifestes du surréalisme* (Paris: Gallimard, 1979); J. H. Matthews, *Theatre in Dada and Surrealism* (Syracuse: Syracuse University Press, 1974); and Maurice Nadeau, *Histoire du surréalisme* (Paris: Éditions du Seuil, 1964).

19. See, for example, *Comment j'ai écrit*, 128 and 129.

20. Michel Leiris, "Conception et réalité chez Raymond Roussel," in Roussel, *Épaves* (Paris: Jean-Jacques Pauvert, 1972), 11–12.

21. Roger Vitrac, "Raymond Roussel," in *La Nouvelle Revue Française* 30 (1928): 172:

loin de s'intéresser au drame, il ne s'appliquait qu'à rechercher les différences de mise en scène, à contrôler l'ordre d'entrée des figurants, à épier les gestes des acteurs, leur intonation, la disposition des décors, la chute du rideau, bref, tout ce qui joue dans les limites des indications données par l'auteur, tout ce qui est en marge, flottant. . . . Ce souci de précision est à la base de toutes les préoccupations de Roussel.

22. See, for example, Foucault, *Raymond Roussel*, esp. 133–34, 144, and 172. Other works devoted to Roussel's rendition of the visible are mentioned by Leiris in *Épaves*, 12.

23. See Roussel, *La Vue* (Paris: Pauvert, 1963).

24. Michel Leiris takes note of the darker side of Roussel's work as well as the critics' tendency to ignore or minimalize it:

> Marcel Jean and Arpad Mezei (*Genèse de la pensée moderne*, 192) have noted that in his works, Roussel appears to imagine objects only beneath a cover of dust, and Pierre Schneider (*La Fenêtre ou piège à Roussel*, "Les Cahiers du sud," Nos. 306–7) defines his art as a "poetry of high noon, where the objects throw no shadows." This in a completely symbolic manner because, in fact, night and shadow are far from absent in Roussel's work just as in the play among disgarded objects the scatological also has a part.

> [Marcel Jean et Arpad Mezei (*Genèse de la pensée moderne*, 192) ont noté que, dans ses oeuvres, Roussel paraît n'imaginer que des objets à l'abri de toute poussière, et Pierre Schneider (*La Fenêtre ou piège à Roussel*, "Les Cahiers du sud," Nos. 306–7) définit son art comme une "Poésie de grand midi, où les objets ne projettent aucune ombre autour d'eux," cela de façon toute symbolique car, en fait, la nuit et l'ombre sont fort loin d'être absentes de l'oeuvre de Roussel tout comme la mise en jeu d'éléments entre tous rebutants qu'est la scatologie y a sa part aussi.] (*Épaves*, 12)

25. See Jean Ferry, "L'Étoile au front et les bonnes moeurs," *L'Afriques des impressions* (Paris: Jean-Jacques Pauvert, 1967), 197–200.

26. Foucault uses a different notion of horizontal versus vertical in discussing Roussel's use of his process (see *Raymond Roussel*, 46).

27. See *Pages choisies d' "Impressions d'Afrique" et de "Locus Solus"* (1918).

28. For treatments of Roussel's aesthetic as a whole, see Foucault, *Raymond Roussel*; and Sjef Houppermans, *Raymond Roussel: Écriture et désire* (Paris: Librairie José Corti, 1985).

29. For information on the stage versions of both Roussel's novels, see Roussel, *Épaves*, 41–56, 91–261. For an English synopsis of the stage version of *Impressions d'Afrique*, see *Dada Performance*, ed. Mel Gordon, (New York: PAJ Publications, 1987), 25–35. For a discussion of the theatrical qualities of the novels and their stage adaptations, see David Graver, "Avant-Garde Aesthetics and Early Twentieth-Century Drama" (Ph.D. diss., Cornell University, 1987), 182–96.

30. en honorant ainsi le passé, [a] oublié de savourer complaisamment l'ivresse de se sentir encadré par son arc de triomphe.

31. Ayant sélectionné un objet trop banal pour retenir normalement l'attention du spectateur. . . . Roussel se met en devoir de lui assurer, grâce à l'histoire qu'il racontera à son sujet, une valeur tout inattendue.

32. Matthews notes this lack of dialogue but considers it due to Roussel's lack of skill rather than due to his aesthetic stance (see Matthews, *Théâtre*, 16).

33. I use the phrase "immediate medium" to distinguish the semiotic system

within which the work of art is constructed (in the case of the novels, the printed words) from the semiotic systems appealed to within the work of art, that is., the mediated media of representation (e.g., in the case of the novels again, theatrical tableaux, a mosaic of teeth, ripples on a river, and animated corpses). The mediated media of representation, which figure prominently in Roussel's work, have an importance that will become clearer as my argument develops.

 34. GENEVIÈVE: . . . je voudrais toujours t'avoir auprès de moi pour te communiquer mes moindres pensées, t'initier à mes joies et à mes peines . . .

 CLAUDE: Est-il vrai? Ainsi je te manque un peu durant les heures où le travail me tient éloigné de toi?

 GENEVIÈVE: Oh! oui, car nulle chose ne peut avoir de prix pour moi si tu n'y es mêlé. Quand je m'émeus, devant un spectacle de la nature, sur mon émotion se greffe aussitôt le désir impatient de te la dépeindre. Une lecture m'a-t-elle charmée, il faut qu'à la première occasion qui s'offre j'en fasse entre nous un sujet de causerie.

 CLAUDE: Est-tu toujours plongée dans Lope de Véga?

 35. The thematic focus of locations and conversations mentioned here does not imply a unity of mise-en-scène and spoken word, because the scenes in question do not explicitly enunciate their themes. We only know that the locations are sacred to lovers because Jacques tells us so.

 36. The less frequent use of thematic connection among the anecdotes in the novels may, of course, be a way of undercutting the more conventional unifying tendencies usually expected of a narrative voice.

 37. Matthews takes note of this fact but does not attempt to explain it (see *Théâtre*, 24).

Notes to Chapter 6

 1. See Henri Béhar, *Vitrac, Théâtre Ouvert sur le Rêve* (Paris and Brussels: Nathan, Labor, 1980), 53 (hereafter cited as "Béhar 1980").

 2. See Klaus-Dieter Vilshöver, *Die Entwicklung der Dramatischen Gestaltung im Theater Roger Vitracs* (Geneva: Librarie Droz S.A., 1976), 81; and Jürgen Grimm, *Das Avantgardistische Theater Frankreichs, 1895–1930* (Munich: Verlag C. H. Beck, 1982), 302.

 3. Artaud, *Oeuvres complètes* (Paris: Gallimard, 1980), 2:153–54:

Un mot, une rencontre de mots, une image, une idée même, l'automatisme d'une entrée, l'imprévu d'une apparition, semblent devoir produire le charme, provoquer le déclic sacré, mais à la fin tout s'effiloche, devient banal, rentre dans l'ordre ou le désordre d'une simple terrasse de café.
Entre le surrealisme, gratuit mais poétique, des *Les Mystères de l'amour* et la satire explicite d'une pièce de boulevard ordinaire, Roger Vitrac n'a pas su choisir; et sa pièce sent le parisianisme, l'actualité de boulevard.

See also Artaud's letters to Vitrac, some of which are published in Henri Béhar's *Roger Vitrac: Un Reprouvé de surrealisme* (Paris: A. G. Nizet, 1966),

278–301, and all of which appear in Artaud, *Oeuvres complètes*, vol. 3 (Paris: Gallimard, 1970).

4. See Sven Ake Heed, *Le Coco du Dada, "Victor ou les Enfants au Pouvoir" de Vitrac: texte et représentation* (Lund: CWK Gleerup, 1983), for an indication of the expertise with which Vitrac exploits the complex semiotic potentials of drama. In corroboration of the relatively traditional structure of *Victor*, Heed uncovers a deep structure in the play that corresponds well to one of Greimas's quest-related categories of dramatic action (15–19). As this chapter will, I think, show, Greimas's catagories have little relevance for the concerns and objectives of Vitrac's early works.

5. Béhar and even Vitrac himself sometimes make this unwarranted generalization.

6. Henri Bèhar, *Roger Vitrac: Un Reprouvé du surréalisme* (Paris: A.. Nizet, 1966), 161: "Ici Vitrac n'explique pas, ne démontre pas, il donne à voir . . ."

7. David I. Grossvogel compares the genuineness of laughter with the artificiality of agony for the theater audience in his book *The Self-Conscious Stage in Modern French Drama* (New York: Columbia University Press, 1958), 7–8.

8. The dadaists often took delight in encouraging altercations with or among the spectators because such events would be much more real than anything they had planned and rehearsed.

9. See *Littérature*, n.s.: "Monuments," no. 2 (1 April 1922): 22–23; "Mademoiselle Piège," no. 5 (1 October 1922): 17–19; and "Poison," no. 8 (1 January 1923): 10–13.

10. Ces instantanés, ces traces de la réalité permettent d'imaginer une intrigue sommaire: la femme du premier tableau a un fils aux colonies; celui-ci meurt en laissant quelques objets à l'intention de la famille Pelucheux, entrevue en trois occasions, à qui elle adresse une lettre explicative avant de perdre la raison.

11. Je joue au cerceau sur les toits avec une baguette rouge la nuit. Le jour j'ai une boule de verre dans chaque main.

12. dans le sens ancien du mot, désignant non pas un édifice public mais un objet qui conserve la trace ou le souvenir d'une personne, un document, une pièce d'archives en quelque sorte.

13. *Littérature*, n.s., no. 8 (1 January 1923): 13: "La scène représente une bouche qui fait le simulacre de parler."

14. Roger Vitrac, *Théâtre* (Paris: Gallimard, 1973), 3:11:

> LE PEINTRE: Comment t'apples-tu?
> L'ENFANT: Maurice Parchemin. (*Silence*) Et toi?
> LE PEINTRE: Moi aussi.
> LE PETIT MAURICE PARCHEMIN: Ce n'est pas vrai.
> LE PEINTRE: Ce n'est pas vrai? (*Silence.*) Tu as raison.
> *Il lui peint le visage en rouge. Le petit Maurice Parchemin sort en pleurant.*

15. See Artaud, "Le Théâtre Alfred Jarry et l'hostilité publique," *Oeuvres complètes*, 2:39: "Pour la première fois un rêve réel fut réalisé sur le théâtre."

16. *Les mystères* sind ein höchst heterogenes Stück, in dem sich dadaistische und surrealistische Elemente in schwer zu differenzierender Weise überlagern.

17. *The Mysteries of Love*, trans. Ralph J. Gladstone, in *Modern French Drama*, ed. Michael Benedikt and George E. Wellwarth (New York: Dutton, 1964), 233. For the original, see *Théâtre* 2:17–18:

> PATRICE. — . . . (*Hurlant*) Oh! Oh! oh! oh! Je le crierai. Je le crierai par-dessus les toits, l'étoile, par-dessus les étoiles! (*Prenant la salle à témoin.*) Léa m'aime, Léa m'aime, Léa m'aime. Elle l'a avoué. Elle m'aime. (*À Léa*) À ton tour maintenant. Crie-le, Léa. Va, ma petite Léa, ma Lélé, ma Léa-Léa. Crie, mais crie-le donc, ma Léaléaléa.
>
> LÉA, *à la salle.* — J'aime Patrice. Ah! j'aime ses tripes. Ah! j'aime ce pitre. Ah! j'aime ce pitre. Sous toutes ses faces, sur toutes ses coutures, sous toutes se formes. Regarde-les, Patrice. Ecoute-les. Ah! ah! ah! . . .
> *Elle rit aux éclats.*
> UNE VOIX, *dans la salle.* — Mais, pourquoi? Juste ciel! Pourquoi? Etes-vous malades?

18. For the original, see *Théâtre* 2:42:

> *Sifflets. Bruits de vapeur. Le train démarre.*
> LÉA, *à la portière.* — Arrêtez! Arrêtez! On m'a confié un enfant. . . . Oui, cet enfant n'est pas le mien . . . la femme . . . là! C'est son enfant . . . la femme . . . là . . . là-bas . . .
> LE CONTROLEUR, *riant.* — Allons, allons, madame. On nous l'a déjà faite celle-là. Gardez-le donc, cet enfant. Vous le regretteriez plus tard.
> *Léa se rassied.*
> LÉA. —Qu'a-t-on fait? Moi, voleuse d'enfant? Ah non, par exemple! Mais le moyen de me débarrasser maintenant. Un amour c'est bien encombrant.

19. For the original, see *Théâtre* 2:14:

> PATRICE. —Acceptez ces quelques fleurs.
> *Il la gifle.*

20. d'où la logique des faits est bannie et où chaque sentiment devient à l'instant un act, où chacun des états de l'esprit s'inscrit avec ses images immédi-ates, et prend forms avec la vitesse d'un éclair. La fantoche abstrait devient objet et reste sentiment, et ne prend pas de matière.

Notes to Chapter 7

1. Wyndham Lewis, *Enemy of the Stars*, *Blast* 1 (1914); reprinted in *Blast 1* (Santa Barbara: Black Sparrow, 1981), 55.

2. See Kenner, *Wyndham Lewis* (Norfolk: New Directions, 1954); and *The Pound Era* (Berkeley: University of California Press, 1971); and Materer, *Wyndham*

Lewis, the Novelist (Detroit: Wayne State University Press, 1976); and *Vortex* (Ithaca: Cornell University Press, 1979). In Kenner's study of Lewis he finds *Enemy of the Stars* exceptional rather than exemplary and groups it with *Childermass* by virtue of its "muscular and intimidating dream landscapes" (*Wyndham Lewis*, 26). In *The Pound Era* he claims "the arch-Vorticist was Lewis unmistakably" (240) and "(June 1914) the Vortex was massively circulating" (245), but he ignores *Enemy of the Stars* and draws on Lewis's paintings and theoretical writings for his understanding of Vorticism. In Materer's study of Lewis's novels he sees *Enemy of the Stars* as an interesting but flawed exercise overshadowed by later more substantial achievements. In *Vortex* Materer draws on a few isolated themes in Lewis's play but tends to discount the work of the *Blast* period as "content to shock rather than inform the public" (219).

3. Wees makes a few general remarks on the play in "Wyndham Lewis and Vorticism," in *Blast 3*, ed. Seamus Cooney (Santa Barabara: Black Sparrow, 1984), 47–50. His more detailed reading of the play can be found in *Vorticism and the English Avant-Garde* (Toronto: University of Toronto Press, 1972), 182–86.

4. For fairly detailed comments on *Enemy of the Stars*, see Robert Chapman, *Wyndham Lewis: Fictions and Satires* (London: Vision, 1973); Wendy Stallard Flory, *"Enemy of the Stars,"* in *Wyndham Lewis: A Revaluation*, ed. Jeffrey Meyers (Montreal: McGill-Queen's University Press, 1980), 92–106; and Thomas Kush, *Wyndham Lewis's Pictorial Integer* (Ann Arbor: UMI Research Press, 1981); as well as Wees, *Vorticism and the English Avant-Garde*. Kush (86) and Wees, *Vorticism* (182ff.) discuss the relationship between the play and Vorticism.

5. Wees provides a detailed account of the development of the Vortex image for *Blast* (*Vorticism*, 161–63).

6. *Vorticism*, 186–87. While Wees is careful to distinguish Lewis's Vorticism from Pound's, he attributes to Lewis a desire for "clear-cut, hard, rigid" forms (178) that does not do justice to his play. Even in Lewis's pictures one can see that the clear-cut, hard, rigid lines actually break up the picture surface to create ambiguous abstractions and an intricate interplay of forms. Clearly, Lewis's theoretical pronouncements are not always equal to the complexity of his art.

7. As with most avant-garde attempts to make art part of life or life a part of art, the aesthetic closure involved in the project is always problematic. For a discussion of this problematic, see Huyssen (esp. chaps. 1 and 8–10); Burkhardt Lindner, "Aufhebung der Kunst in Lebenspraxis?" 72–104; and Dolf Oehler, "Hinsehen, Hinlangen: Für eine Dynamisierung der Theorie der Avantgarde. Dargestellt an Marcel Duchamps *Fountain*," 143–65, both in *"Theorie der Avantgarde" Antworten auf Peter Bürgers Bestimmung von Kunst und bürgerlicher Gesellschaft*, ed. W. Martin Lüdke (Frankfurt a.M.: Suhrkamp, 1976).

8. Lewis published a second version of *Enemy of the Stars* in 1932. The second version uses standard dramatic set descriptions and dialogue and is arguably a better play but also a more conventional one. In the 1914 version the constituent elements of the play often struggle through or against the dramatic genre; in the 1932 version the constituent elements exist happily within the dramatic genre. Both versions are found in *Collected Poems and Plays*, ed. Alan Munton (Manchester, Eng.: Carcanet, 1979).

9. A number of critics stress Lewis's emphasis on place over time in this play, suggesting that this emphasis makes *Enemy of the Stars* a literary model of the philosophical stance Lewis takes in *Time and Western Man* (see Kush, *Wyndham Lewis's Pictorial Interger*, 85–86; Chapman, *Wyndham Lewis*, 9–10; Materer, *W. L., the Novelist*, 52; and Wees, "W. L. and Vorticism," 48). My reading suggests that Lewis's emphasis on place is not the foundation of his aesthetic but only one aspect of it.

10. The second version of *Enemy of the Stars* dispenses with the episodes. Flory is right to point out that this makes for a smoother presentation of the action, but she fails to appreciate the aesthetic complexity of the first version's roughness.

11. For discussions of this point, see Rosalind E. Krauss, "The Photographic Conditons of Surrealism," *The Originality of the Avant-Garde and Other Modernist Myths* (Cambridge, Mass.: MIT Press, 1985), 87–118; and W. J. T. Mitchell, *Iconology* (Chicago: University of Chicago Press, 1986), 98, 155. For a discussion of how word and image are intertwined in Western visual art, see Norman Bryson, *Word and Image* (Cambridge: Cambridge University Press, 1981). The first chapter makes some general remarks; the rest are devoted to French painting of the ancien régime. For a more theoretical discussion of the phenomenological status of word and image, see Lyotard, *Discours, Figure* (Paris: Klincksieck, 1985); and Blanchot, "Two Versions of the Imaginary," *The Gaze of Orpheus* (Barrytown, N.Y.: Station Hill Press, 1981), 79–89.

12. An errata notice claims that THE PLAY should have appeared between pages 60 and 61. This placement would have created a more gradual transition from the aesthetic heterogeneity established in the illustrations to the textual unity of the play, since the introduction of the characters and the stage arrangements would have been left outside the play, hovering between the dramatic action and the visual imagery.

13. See Blanchot, *L'Espace littéraire* (Paris: Gallimard, 1955).

14. "Physics of the Not-Self," *Collected Poems and Plays*, 195.

15. Materer offers a similar reading of the allegory but points out the implicit connections between Arghol and the modern artist (see *W. L., the Novelist*, 50). Wees (*Vorticism*, 184–86) notes how the theme of life versus art is also elaborated in Lewis's "Vortices and Notes" (*Blast 1*, 129–49).

16. Compare the traditional integration of allegory and imagery in, say, Ben Jonson's masques.

17. Mitchell's analysis of "the family of images," which notes that images can be graphic or verbal (10), helps us see that Lewis continues to mix the representational realms of word and image even after *Enemy of the Stars* seems to settle into a straightforward textual format. For more on the ontological breadth and epistemological specificity of word and image, see Bryson, *Word and Image*; and Blanchot, "Parler, ce n'est pas voir," *L'Entretien infini* (Paris: Gallimard, 1969).

18. For a discussion of the phenomenology of theatrical display, see Bert O. States, *Great Reckonings in Little Rooms* (Berkeley: University of California Press, 1985).

19. Compare, for example, how Vitrac collages Lloyd George and Mussolini

into "The Mysteries of Love" and how Roussel uses the dramatic scene to hold together disparate narrative tales in *L'Étoile au front*.

20. For a sampling of these theories, see Richard Schechner and Willa Appel, eds., *By Means of Performance* (Cambridge: Cambridge University Press, 1990). Turner discusses flow in "Are There Universals of Performance in Myth, Ritual, and Drama?" in Schechner's and Appel's volume (13).

21. Schechner's article in Schechner and Appel (*By Means of Performance*, 19–49) surveys the various forms that performance can take.

Notes to Chapter 8

1. See, for example, Guillaume Apollinaire, *Les Mamelles de Tiresias* (1917); Jean Cocteau, *Les Mariés de la Tour Eiffel* (1921); Yvan Goll, *Methusalem* (1922); and Gertrude Stein, *Geography and Plays* (1922).

2. See, for example, Tristan Tzara, *La Première Aventure céleste de M. Antipyrine* (1916); *La Deuxième Aventure céleste de M. Antipyrine* (1920); and *Le Coeur à gaz* (1923); Georges Ribemont-Dessainges, *L'Empereur de Chine* (1916); and *Le Serin muet* (1919); Francesco Cangiullo "Detonation" (1915); "There Is No Dog" (1915?); and "Lights" (1919); Filippo Marinetti, "Feet"; and "They Are Coming" (1915); and Vladimir Mayakovsky, *Vladimir Mayakovsky: A Tragedy* (1913); *Mystery Bouffe* (1918–21); *The Bedbug* (1928–29); and *The Bathhouse* (1930).

3. The learning plays most well-known and readily available in English are *The Measures Taken* and *The Exception and the Rule*. Both can be found in Brecht's *The Jewish Wife and Other Short Plays*, ed. Eric Bentley (New York: Grove, 1965). The critic most responsible for pointing out the unique character and importance of Brecht's learning plays is Reiner Steinweg. For a collection of Brecht's theoretical comments on his learning plays and Steinweg's extended discussion of the topic, see Reiner Steinweg, *Das Lehrstück; Brechts Theorie einer politisch-aesthetischen Erziehung* (Stuttgart: J. B. Metzler, 1972). For further discussion, see Steinweg, ed., *Brechts Modell der Lehrstücke: Zeugnisse, Diskussion, Erfahrungen* (Frankfurt a.M.: Suhrkamp, 1976).

4. See Brecht's concept of epic theater, in *Brecht on Theatre*, ed. John Willett (New York: Hill and Wang, 1964).

5. "Antitheatrical performance possibility for drama" is certainly an awkward phrase, but it points to the perennial awkwardness of the dramatic text's connection to performance. A dramatic text can never dictate the exact terms of its performance; it can only suggest or open up certain possibilities. The realization of these possibilities depends on the talents and interests of the theatrical producers and upon the broader cultural configurations of the sociohistorical moment at which the performance takes place. My discussion of Brecht and Artaud here concentrates on the performance possibilities they work into their texts and has little to say about the extent to which these possibilities are realized.

6. Most English-language studies of Brecht miss this point. See, for example, Martin Esslin, *Brecht: The Man and His Work* (New York: Norton, 1971); and Ronald Gray, *Brecht: The Dramatist* (Cambridge: Cambridge University

Press, 1976). Because they fail to see the importance of audience participation in the learning plays, they see the works as crude propaganda (Gray, *Brecht*, 48–54) or an inadvertent indictment of their own political position (Esslin, *Brecht*, 164). But these plays can appear as propaganda only from the perspective of the detached viewer. Brecht, however, does not intend these plays to have detached viewers. The audience/participants are not supposed to receive a message from one of these plays but, rather, struggle with and interpret for themselves the circumstances of the play by enacting them (see Steinweg, *Das Lehrstück*, 180–84). Among English-language critics Roswitha Mueller understands and discusses perceptively the structure and purpose of the learning plays. See her book *Bertolt Brecht and the Theory of Media* (Lincoln: University of Nebraska Press, 1989), 23–43.

 7. See Alfred Kurella, "What Was He Killed For?" *Literature of the World Revolution* (Moscow) no. 5 (1931); reprinted in *Jewish Wife*, 159–72; or Theodor Adorno "Engagement," *Noten zur Literatur* (Frankfurt: Suhrkamp, 1974), 409–30, esp. 415–22; English translation in Ernst Bloch et al., *Aesthetics and Politics* (London: Verso, 1980).

 8. Peter Horn suggests that *The Measures Taken* is not simply designed for the participants (rather than for a conventional audience) but for very particular participants: Communist Party activists. Horn argues that only people with such a background can appreciate the complex implications of the situation Brecht asks them to enact. See "Die Wirklichkeit is konkret. Bertolt Brechts *Maßnahme* und die Frage der Parteidisziplin," in *Brecht-Jahrbuch 1978*, ed. John Fuegi, Reinhold Grimm, and Johst Hermand (Frankfurt: Suhrkamp, 1978), 39–65.

 9. For the concept of theater of cruelty, I am relying on Artaud's theoretical writings in his *Oeuvres complètes*, vols. 4 and 5 (Paris: Gallimard, 1964, 1978, and 1979), a sampling of which is available in *The Theater and Its Double* (New York: Grove, 1958); and *Antonin Artaud: Selected Writings*, ed. Susan Sontag (Berkeley: University of California Press, 1976). Of interest for fleshing out Artaud's theory are his three play scripts/performance scenarios: "Spurt of Blood" (1925), "The Conquest of Mexico" (1934), and "The Cenci" (1935), published in *Oeuvres complètes*, vols. 1, 5, and 4 respectively.

 10. See Maurice Nadeau, *Histoire du surréalisme* (Paris: Éditions du Seuil, 1964), 118.

 11. See *Antonin Artaud: Selected Writings*, 72–76.

 12. Jacques Derrida argues that by its very nature Artaud's theater of cruelty is impossible to realize. See "Le Théâtre de la cruauté et la clôture de la représentation" in *L'Écriture et la différence* (Paris: Éditions du Seuil, 1967), 341–68.

 13. Peter Brook, Jerzy Grotowski, and Survival Research Laboratories have realized many of Artaud's ideas onstage. The legacy of Brecht's learning plays is most visible in adversarial social and political theater in the Third World, for example, Augusto Boal's "theater of the oppressed" experiments in Peru and Brazil, the (now suppressed) Kamiriithu Cultural Center in Kenya, and the Philippine Educational Theater Association.

Index